The Painted Tetrarchic Reliefs from Nicomedia

STUDIES IN CLASSICAL ARCHAEOLOGY

VOLUME 12

THE PAINTED TETRARCHIC RELIEFS FROM NICOMEDIA

Uncovering the Colourful Life of Diocletian's Forgotten Capital

by

Tuna Şare Ağtürk

BREPOLS

British Library Cataloguing in Publication Data

A catalogue record for this book is available from the British Library.

© 2021, Brepols Publishers n.v., Turnhout, Belgium

D/2021/0095/140
ISBN: 978-2-503-59478-1
ISSN: 2565-8921

Printed in the EU on acid-free paper

To my children Can Aras Ağtürk and Arden Alp Ağtürk,
and to my partner Hakan Ağtürk

Contents

List of Illustrations

The Reliefs – A Catalogue

Appendix I. Catalogue of the Smaller Relief Fragments

ABBREVIATIONS

The following abbreviations have been used for works cited in the notes:

AASS Bolland, J. (ed.). 1863–1940. *Acta sanctorum*, 71 vols (Paris: Palmé)

DFHG Digital *Fragmenta historicorum Graecorum*
<http://www.dfhg-project.org/> [accessed 1 April 2021]

LIMC *Lexicon iconographicum mythologiae classicae*
(Zürich: Artemis & Winkler)

 LIMC III: *Atherion–Eros/Amor, Cupido* (1986)

 LIMC IV: *Eros (in Etruria)–Herakles* (1988)

 LIMC VI: *Kentauroi et Kentaurides–Oiax* (1992)

 LIMC VII: *Oidipous–Theseus* (1994)

LSA *Last Statues of Antiquity (LSA) Database*, University of Oxford, 2012
<http://laststatues.classics.ox.ac.uk/> [accessed 1 April 2021]

RIC v.2 Webb, P. H. 1968. *The Roman Imperial Coinage*, v.2: *Marcus Aurelius Probus–Maximian (276–310)* (London: Spink)

RIC VI Sutherland, C. H. V. and R. A. G Carson. 1967. *The Roman Imperial Coinage*, VI: *From Diocletian's Reform (A.D. 295) to the Death of Maximinus (A.D. 313)* (London: Spink)

SNG *Sylloge nummorum Graecorum, Deutschland* (Berlin: Sammlung von Aulock, Mann, 1957–1968)

Notes on the Technical Imaging of the Nicomedia Frieze

Professional photographs of most of the reliefs were taken and processed by Orhan Cem Çetin and Saygın Serdaroğlu with the help of Multiblitz Profilite series sunlight colour-matched (5500°K) external electronic flash units and colour-neutral light shaping fixtures. Still camera was a Nikon D800 and various SIGMA Art series lenses were utilized. Final colour corrections were made based on colour checker and neutral grey targets exposed at the site.

VIL and UV imaging of the reliefs were conducted by Dr Mark Abbe, who owns the copyright of these images. VIL images were obtained using a XNite modified Nikon D330s (the built in ultraviolet and infrared filter removed and replaced by a quartz filter). The radiation source was an Excled Par64 LED Beamer with LB300R, 50W with emission centred at 629 nm. The camera was fitted with one of two filters depending on the amount of luminescence and ambient conditions: B+W 72 IR filter (830 nm) and LDP LCC X-Nite 1000B filter (1000 nm). UV images were obtained using an unaltered Nikon D810 camera with radiation from a XNite BFLUV/HID, 35/50 W light source. Dr Abbe was also responsible for the USB microscopy, he used an AM7915MZTL (10-140x) Edge Series Dino-Lite USB Microscope for this type of imaging.

In-situ pXRF analysis was conducted by Dr Abdullah Zararsız, from the Turkish Atomic Energy Authority, using a portable INNOVX, Alfa model spectrometer with a silver (Ag) anode tube with settings at maximum 35kV and 5.0 µA and acquisition times of 60 seconds or longer, depending on the geometry of the sample areas. The p-XRF spectrometer irradiates areas with a circular exposure spot size of *c.* 0.75 cm^2.

Scanning for 3D models was made by Sadık Demir with Leica RTC360 Laser Scanner. 3D models were later processed in Adobe 3DSMax 2017. Unless indicated otherwise, copyright of the images used throughout this volume belongs to Çukurbağ Archaeological Project and the author.

PREFACE

My first encounter with the painted marble reliefs of Nicomedia discovered in the Çukurbağ neighbourhood of Izmit was in 2013. I had visited Kocaeli Archaeology Museum in search of a few terracotta figurines from Assos housed in the storage of the museum. There, in the storage, I was startled when I saw the fragment of a relief with two embracing figures with astonishingly well-preserved colours, and my amazement has not diminished a bit at the sight of this astounding sculpture to this day. Back then İlksen Özbay was the museum director. She was later replaced by Rıdvan Gölcük, and very recently by Serkan Gedük. I would like to thank all three of the directors and all the staff of Kocaeli Archaeology Museum, for opening the doors of the museum for me and my team and bearing with my endless inquiries and passion for the finds from Çukurbağ. Of course, none of this research would be possible without the support and permission of the Turkish Ministry of Culture and Tourism's General Directory of Cultural Heritage and Museums. In 2015, my research on these reliefs was funded by a grant provided by the Scientific and Technological Research Council of Turkey (TÜBİTAK) (Project #115K242) and coined as the Çukurbağ Archaeological Project. Thanks to this grant, besides officials from Kocaeli Archaeology Museum, and my graduate students Tolga Özak and Fırat Gökdemir, I was able to team up with wonderful institutions and people for the project. I would like to thank Anka Restorasyon for their careful attention during the transportation and restoration of the reliefs; Muka Mimarlık for help with on-site measurements, plans, and 3D models; Orhan Cem Çetin and Saygın Serdaroğlu for wonderful photographs taken in difficult environmental conditions; Abdullah Zararsız from the Turkish Atomic Energy Authority for pXRF analysis; Mark Abbe from Georgia University for his meticulous work on the polychromy; and the residents of the Çukurbağ district who endured our research — basically on their doorstep. Later in 2019, the Çukurbağ Archaeological Project (TÜBİTAK #115K242) evolved into the Project Nikomedia (#834799), thanks to the funding I received from the European Commission's Marie Sklodowska-Curie Individual Fellowship.

I published some of the results of the Çukurbağ Archaeological Project separately in articles and book sections: the project was first discussed in a project gallery article in *Antiquity* in 2015; later in the proceedings of *Kocaeli Tarihi Sempozyumu* (the symposium on the history of Kocaeli) in Turkish in 2017. A detailed examination of the important relief showing the co-emperors Diocletian and Maximian embracing was published in the *American Journal of Archaeology in* 2018. The preliminary results of our analysis on polychromy with Mark Abbe came out in journal *Techně*'s special issue on ancient polychromy in 2019. Just recently, I published the thematic programme of the frieze, in a book on the cities of Nicaea and Nicomedia in antiquity, which I edited with colleagues from Münster University. Another article on two of the reliefs with mythological depictions was recently published in the *Journal of Roman Archaeology*'s 2020 issue.

The writing and editing process of the present book took about two years. I would like to thank the Archaeology Department at Çanakkale Onsekiz Mart University, for providing me a long sabbatical leave to take up two fellowships I received from the Radcliffe Institute for Advanced Study at Harvard University in 2018–2019 and also the European Commission's Marie Sklodowska-Curie Individual Fellowship taken up at the Faculty of Classics at the University of Oxford between 2019–2021. These outstanding fellowships provided me much-needed time to write, opportunity to research in specialized libraries, and also to consult face to face with colleagues from around the world.

I have presented parts of the contents of the present manuscript in several lectures at numerous universities and institutions. I would like to thank all those who invited and welcomed me across three continents. This book would not be possible without their questions, comments, and suggested improvements, which all helped clarify my ideas and writing. They include: Clemente Marconi at NYU; Francesco de Angelis at Columbia University; Klaus Zimmermann, Achim Lichtenberger, and Engelbert Winter at Münster University; Brigitte Bourgeois at the Louvre Museum; Catherine Draycott at Durham University; Jan Ziolkowski at Dumbarton

Oaks; Brian Rose at the University of Pennsylvania; Beate Böhlendorf at the Philipps University of Marburg; Stephan Westphalen and Katinka Sewing at the University of Heidelberg; Marian Feldman from John Hopkins University and Antigoni Zournatzi from the National Hellenic Research Foundation, as directors of the Getty Foundation's 'Material Entanglements in the Ancient Mediterranean and Beyond' project held in Greece; Cemal Kafadar and Gülru Necipoğlu at the Center for Middle Eastern Studies at Harvard University; Adrian Stähli at the Classics Department of Harvard University; John Kenfield at Rutgers University; Markus Löx at Ludwig Maximilians University, Munich; Roger Rees at the University of St Andrews; and the class of 2019 fellows at the Radcliffe Institute for Advanced Study at Harvard University.

Further scholarly conversations with many friends including Bahadır Yıldırım, Mark Abbe, Katherine Dunbabin, Esen Öğüş, Emmanuel Mayer, Adrian Stähli, Chris Hallett, Jan Østergaard, Kutalmış Görkay, Tolga Özhan, Sencan Altınoluk, Semiha Altıer, Clive Foss, Yavuz Ulugün, Efthymios Rizos, Ine Jacobs, Maria Stamatopoulou, and Phil Stinson helped improve my ideas. Most importantly, I am very grateful to R. R. R. (Bert) Smith; without his guidance and endless support, this book would not be possible.

The incomplete nature of the excavations at Çukurbağ, problems we inherited from the original rescue excavations, and the challenges of urban archaeology discouraged but did not stop the completion of the book. I am well aware that further excavations and research could change my conclusions and claims in this manuscript. Yet, new excavations — which in the case of Çukurbağ could take a long time to start due to dense modern habitation and a complicated expropriation process — are to review and revise the results of the old ones. It is my hope that this book is just the start of a journey to the archaeology of Nicomedia; which will help further research, enhance the cultural awareness, and aid in the creation of a well-deserved display hall for the astonishing Nicomedia frieze.

For assistance in preparing the manuscript in the editorial process, I would like to thank Tolga Özak, for his continuous help with images and drawings, as well as Sasha Barish, Rachel Tyson, Tim Barnwell, and Rosie Bonté. Many thanks also to the general editors of the Brepols Studies in Classical Archaeology Series, Achim Lichtenberger and Rubina Raja; their interest and care made the production process fast and smooth.

I am especially grateful to the support I received from family. My dear father, Arif Şare's fight with a disease over the last two years have erased some of his memories, but my memory of him as a great teacher of history and life and an advocate of intellectual inquiry will remain indelible. I would like to dedicate this book to my children Can Aras Ağtürk, Arden Alp Ağtürk, and my partner Hakan Ağtürk. I followed my passion and they followed me to three different continents changing houses, schools, and missing their friends. Thanks to this long journey they belong to not one single nation but to the whole world, just like the Nicomedia frieze, which as a major world's cultural heritage will get a chance to travel around the globe through this book.

Oxford, June 2020

Introduction — Nicomedia, Archaeology, and History

The devastating 1999 earthquake in Izmit, Turkey led to the loss of thousands of lives, but it also revealed a similar fate that befell the city's inhabitants hundreds of years before. From beneath the heavily damaged modern buildings of Izmit emerged the astonishing remnants of ancient Nicomedia, the forerunner of Constantinople as Emperor Diocletian's capital of the Eastern Roman Empire and 'the rival of Rome'.[1]

Salvage excavations conducted between 2001 and 2016 at Çukurbağ at the heart of modern Izmit have revealed a monumental imperial complex adorned with marble state reliefs and colossal statues with excellently preserved colours. The set of sixty-six marble relief panels from the Tetrarchic period, from the centre of Diocletian's empire at Nicomedia, form a 50 m long frieze with an astonishing combination of imperial, agonistic, and mythological scenes. Understanding this remarkable collocation of narratives requires detailed study of the sociopolitical history of the late third-century Roman Empire and the function of such visual language in the new imperial capital. The importance of this discovery is hard to overstate. The Late Roman Empire in the East now has a defining monument to set beside, and to place in striking counterpoint with, the Arch of Constantine in the West, in Rome. Its reliefs fill an important gap in an entirely unexpected way. Many aspects of the monument require attention, conservation, local validation, and heritage management, all of which will depend on this fully documented primary monograph of its reliefs.

Thus, the present volume deals with the technical, stylistic, and iconographic analysis of these reliefs and the Diocletianic complex to which they once belonged, and their contextualization within Roman art and history. Its main objectives are to shed light on the art and history of Late Roman Nicomedia, especially the aspects of the new state art and architecture under Diocletian's imperial administration; to investigate polychrome relief sculpture, a little-known medium in Roman art; and to understand the origins of Late Antique art.

Three essential aspects of this discovery, which also shape the objectives of the present book as listed above, have a great importance for the world's cultural heritage in general, and for archaeology and art history more specifically. First, the complex is the most extensive archaeological discovery ever found in Nicomedia, and provides welcome material collateral to ancient literary sources about Nicomedia, such as the writings of Strabo, Pliny the Elder, Pliny the Younger, Lactantius, and Libanius.[2] Founded in the third century BC, at the north-eastern corner of the Propontis (Sea of Marmara), Nicomedia became the administrative capital of Emperor Diocletian's empire in the late third century. Diocletian initiated his famed tetrarchic system, the rule of four emperors, here in Nicomedia. Numerous earthquakes devastated the city throughout the ages, but it has always been resettled, from the Roman period to the present. Despite the obvious archaeological potential, there has never been systematic excavation in Nicomedia, which now lies right underneath the modern Turkish city of Izmit. Thus, the present volume aims to publish the greatest archaeological discovery of recent years. This undertaking will also hopefully promote cultural heritage awareness of a lost Roman capital — something that is fading in the face of Turkey's current construction boom — and provide future opportunities for the integration and preservation of Izmit's past and present through further urban archaeology.

Second, these reliefs are the only surviving examples of Roman relief sculpture with extensively preserved colour. When studied with recent technology in photography, chemistry, and computer science, ancient paint reveals many aspects of ancient art, such as pigment-making, the painter's role in sculpture, and symbolism of colour. Indeed, over the last decade, there has been immense scholarly interest in studying the lost colours on ancient sculpture;[3] the new scientific methods used to detect and reconstruct the colours on Classical sculp-

[1] Lactant., *De mort. pers.* VII.8–10.

[2] See below, pp. 6–7.

[3] Panzanelli, Schmidt, and Lapatin 2008; Brinkmann, Wünsche, and Wurnig 2004. See Chapter 2, p. 35 n. 40 for further bibliography on ancient polychromy on sculpture.

ture have displaced the romanticized notion of white marble figures. Our understanding of the aesthetics of Classical art has been revolutionized. The Nicomedia reliefs, with their exceptionally well-preserved colours, offer a first-hand source for studying the techniques of polychromy in ancient art.

Third, the style and subjects of the Nicomedia reliefs are precious new examples of art from the Tetrarchic period, in which symbolic and abstracted forms came to provide a new visual system for a distinctive Late Antique art.[4] The shift in stylistic and iconographic trends in the reliefs can be correlated with changes in political ideology, court ritual, symbolism, colour-coding, and contemporary imperial panegyric. A thorough stylistic and iconographic examination of the reliefs in this volume will shed light on the creation and reception of a new state art in Nicomedia under Diocletian's rule. Other Tetrarchic complexes and monuments known from Rome, Trier, Thessaloniki, Gamzigrad, Split, and Luxor are well studied in the extant literature.[5] A contextual and comparative study of this newly discovered complex in Nicomedia, where the Tetrarchy and Tetrarchic art were actually born, is essential for a fresh understanding of Late Roman art and archaeology.

Some of the reliefs and statues of the imperial complex in Nicomedia were initially recovered in 2001 (following the 1999 earthquake), from underneath a heavily damaged modern building in the Çukurbağ neighbourhood in Izmit. These finds, mostly on stylistic grounds, were mistakenly dated to the late second century AD in a preliminary publication by Zeyrek and Özbay.[6] A consecutive rescue excavation conducted by Kocaeli Archaeology Museum on the same site in 2009 has added much more material from the same complex. Unfortunately, some of the archaeological data was lost during the hasty rescue excavations and recovered finds were never properly studied and identified until 2015. Between 2015 and 2018, I was awarded a grant from the Scientific and Technological Research Council of Turkey to initiate the Çukurbağ Archaeological Project. With the help of a new multidisciplinary team, including architects, engineers, and photographers, I have conducted further fieldwork and completed the initial analysis of the Nicomedia finds. The sculptural finds studied during the Çukurbağ Archaeological Project include no less than sixty-six relief panels of Proconnesian marble (*c.* 1.00 m

in height), over a hundred smaller fragments of reliefs, some sixty-five pieces of freestanding statuary of varying scales, some colossal, and hundreds of architectural elements including an opus sectile floor, wall blocks, columns, capitals, and architrave blocks. Another rescue excavation held in the summer of 2016 on the site also revealed monumental stairs leading to the imperial complex. This secondary investigation of the Çukurbağ finds led to their identification as parts of an imperial complex dating from the later third century, when Nicomedia was living its golden age as Emperor Diocletian's administrative capital. The archaeological evidence also showed that the complex collapsed all at once while still in use, perhaps with the major earthquake in AD 358. Further archaeological excavation will of course provide us with a much clearer picture of the imperial complex but is currently impossible because the site is in the middle of a dense modern neighbourhood. The expropriation process of the modern buildings around the site for future excavations has been taking a long time, and during this time pigments preserved on the recovered reliefs have faded away. Thus, despite the incomplete nature of the archaeological investigation, it has become necessary to publish the most prominent aspects of the complex recovered and studied so far. Accordingly, this volume primarily focuses on the figurative architectural reliefs of the complex.

Several different disciplines are deployed to contextualize the material discussed in the book. Epigraphic methods were used to understand the inscribed blocks of the complex; ancient literature and history (social, economic, political) helped interpret the function of the complex and its sculptural decoration; photography (multispectral imaging systems) and chemistry illuminated many aspects of ancient sculptural polychromy; modern computational techniques applied to the finds — such as 3D-scanning of relief blocks and geo-radar maps of the site — assisted the technical investigation; and of course different methods of art historical inquiry — such as formal/stylistic and semantic approaches — were used to interpret the effect, meaning, and reception of the figured friezes.[7] I also deployed comparative methods to relate the Nicomedia evidence to other

[4] See Chapter 3 pp. 46–48 for art under the Tetrarchy.

[5] See Chapter 3 pp. 49–53 for art under the Tetrarchy.

[6] Zeyrek and Özbay 2006.

[7] Both a traditional art historical approach which emphasizes the production process of the artist and the formal aspects of the end product and a modern historical approach which investigates the visual material from the point of its buyer, viewer, and function within the original context have been adopted. For a theoretical overview of both approaches see Smith 2006.

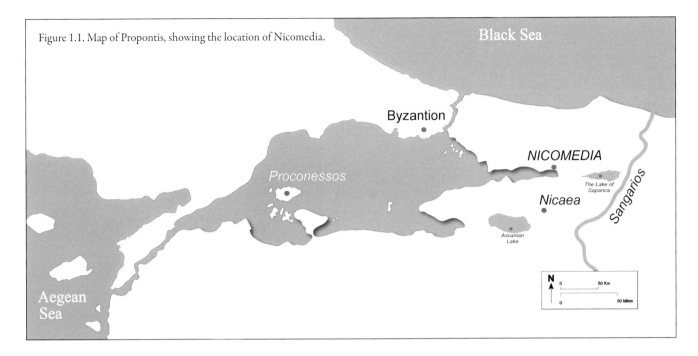

Figure 1.1. Map of Propontis, showing the location of Nicomedia.

well-studied monuments in Asia Minor and to the other Tetrarchic monuments around the Roman Empire.

In the remaining part of Chapter 1, I will discuss the history and topography of Nicomedia in light of ancient literary sources and early modern scholarship; a brief overview of the archaeological research in Nicomedia will be followed by a history of the Çukurbağ Rescue Excavations and our ongoing Çukurbağ Archaeological Project. As two of the reliefs were illegally smuggled during the initial rescue excavations, the next subsection will focus on the challenges of urban archaeology and cultural heritage preservation. During the course of the Çukurbağ Archaeological Project both reliefs were recovered and brought back to Kocaeli Archaeology Museum; this subsection will also include the story of their re-recovery. The chapter will conclude with a general overview of the architectural finds and the assessment of the imperial complex within the context of Roman architecture. Chapter 2 is devoted to the investigation of the technical aspects of the reliefs, from their initial commissioning to their carving, lifting, fitting, and painting. The working mechanisms of the executing sculptural workshops, patterns of colour and coloration on the reliefs, and the visibility of the frieze are among the issues discussed in detail. The reliefs of the Nicomedia frieze can be thematically grouped into three categories: imperial scenes, mythological scenes, and agonistic scenes. Accordingly, the following three chapters iconographically examine and provide an interpretation for each theme: Chapter 3 analyses imperial depictions as referencing the triumph

of co-ruling emperors; Chapter 4 analyses mythological depictions as referencing the founders of Nicomedia; and Chapter 5 analyses agonistic depictions as referencing the grand imperial festivals of Diocletian's new capital. The conclusion in Chapter 6 includes a discussion of the overall thematic programme of the frieze and a summary in Turkish. The final chapter of the book (Chapter 7) is the catalogue of sixty-six relief panels of the Nicomedia frieze. Smaller relief fragments are catalogued in Appendix I. A concordance table for the catalogue and inventory numbers reliefs received so far is provided in Appendix II.

Tale of a City from Nicomedia to Izmit

Ancient Nicomedia, once the administrative capital of the Eastern Roman Empire, now lies just beneath the industrial city of Izmit in Turkey (c. 100 km east of Istanbul). Strategically located between West and East, Nicomedia, along with its protected harbour in the Propontis, maintained its significance as a major naval, industrial, and trade centre throughout the ages despite numerous devastating earthquakes (Fig. 1.1). Lush forests reaching to the Black Sea in the north, fertile valleys of the River Sangarios (Sakarya) in the east, and the Propontis and Lake Ascania (Lake İznik) in the west and south contributed to the city's development into a prosperous centre in antiquity. The earliest settlement recorded in the vicinity is Astacos, supposedly a Megarian colony settled in 712 BC on the southern

part of the Gulf of Izmit.[8] According to Strabo (*Geographica* XII.4.2), Nicomedia was founded in 264 BC by Nicomedes I (*c.* 300–255 BC) and shortly after became the capital of the Hellenistic kingdom of Bithynia. In 74 BC it was designated the capital of the Roman province of Bithynia and, after the ascent of Diocletian to the imperial throne in AD 284, it became the capital of the Eastern Roman Empire. Following the transfer of the imperial capital to Constantinople in AD 330 and the catastrophic earthquakes of AD 358, 363, and 386, the significance of the city diminished somewhat, but it was always rebuilt and thus maintained its role as an urban centre through the Byzantine, Seljuk, Ottoman, and modern Turkish periods.

From the Roman period onwards, the size of the city and its impressive structures have been described by many sources.[9] According to Dio Cassius, as early as 29 BC, Nicomedia received the great imperial privilege of building a temple dedicated to Thea Rome and to Emperor Augustus.[10] Pliny the Elder mentions Hannibal's monumental tomb in Nicomedia (*HN* V.43.148). As governor of Bithynia between AD 109 and 111, Pliny the Younger (*Ep.* X.37, 49, and 51) refers to a Temple of Isis and numerous other architectural structures when explaining the prosperity and extravagance of the inhabitants in his letters to Trajan. Among these, two very expensive aqueduct projects for better water supply seem to have been left unfinished. Two other plans mentioned by Pliny the Younger were never completed: to build a new forum next to the existing one, and to build a canal to connect Lake Sophon (modern Lake Sapanca) with the sea so that the marble, timber, and agricultural products of the region could be transported more easily. Hadrian helped restore the public square and the walls after the major earthquake in AD 120 and visited the city in AD 123.[11]

Caracalla, who spent the winter of 215 in Nicomedia to prepare his campaign, endowed the city with a new, grandiose public bath.[12]

The rivalry between Nicaea and Nicomedia to become the leading city of Roman Bithynia is well attested in literary and epigraphic sources.[13] This constant competition with its neighbour seems to have kept the urbanization and building activities of Nicomedia alive. After the first temple dedicated to the cult of Emperor Augustus and Roma, the city received the temple-warden (*neocoros*) status (the right to build an imperial temple granted to a favoured city by the emperor's individual decision) two more times, once during the time of Commodus (withdrawn and reissued by Septimius Severus) and once during the time of Elagabalus (withdrawn and reissued during the time of Valerian).[14] Based on numismatic evidence Burrell suggests that the Nicomedians built an eight-columned Corinthian temple with cult statues of Augustus, Victory, and Roma for the first *neocoros*; and another at least eight-columned Corinthian temple with the cult statues of Septimius Severus and his sons inside for the second temple. She thinks that the imperial cult granted by Elagabalus was probably included in the already existing temple/cult of Demeter in the city, which was referred to as the source of the city's fertility in literary sources.[15]

The Gothic invasion of Bithynia and the sack of Nicomedia in AD 258 must have destroyed many buildings and led to the flight of its terrified inhabitants. About twenty-five years later, however, the city's fate changed forever. With the death of Emperor Numerian in Nicomedia, high-ranking military official Diocles was declared emperor here. Changing his name to Diocletian, the new emperor chose Nicomedia as his administrative capital. Lactantius, who initially worked as a professor of rhetoric at the imperial court in Nicomedia but became an opponent of the emperor after converting to Christianity, refers to Diocletian's building activity as part of his attempt to transform Nicomedia into 'a rival of Rome' (*De mort. pers.* VII.8.10). According to Lactantius, Diocletian demolished large parts of the

8 Memnon DFHG III, 536, F 20 (Digital *Fragmenta historicorum Graecorum*). For a discussion of the foundation date of this city in different sources, see Asheri 1978. Asheri suggests (1978, 93) that this Megarian city was destroyed during the Cimmerian invasion and refounded by Chalcedonians after 686 BC. Recent excavations at Başiskele on the south-eastern corner of the gulf across from Nicomedia revealed a settlement with pottery from the Classical period. This site is identified as Astacos, see Koçel-Erdem 2012. For Astacos see also pp. 72–73 in this volume.

9 For an overview of the history of Nicomedia in light of ancient literary sources see Foss 1996; 2020; Çalık Ross 2007a; Ulugün 2004; 2007.

10 Cass. Dio LI.20.6–9. Also see the paragraph below for discussion of the *neocoros* temples of Nicomedia.

11 Boatwright 2000, 121–22.

12 Güney 2012, 98; also see Foss 2020, 8.

13 For an overview of the rivalry between the two cities recorded in historical and epigraphic sources see mainly Robert 1977, Bekker-Nielsen 2020, and Foss 2020.

14 The first *neocoros* status was given by Augustus in 29 BC, who also gave the same right to Pergamon. See Burrell 2004, 147–65 for an overview of the *neocoros* title of Nicomedia and the numismatic evidence on coin types. Also see Chapter 5, p. 80 n. 11.

15 Lib., *Or.* LXI.7.

city and moved its residents in order to create a monumental centre worthy of a capital. He built palaces for himself and for his wife and daughter, a basilica, a circus, a weapons factory, and a mint, and he restored the bath-gymnasium complex that had been built by Caracalla.[16] Sections of a wall built of brick and fieldstones on cut limestone blocks, which survives partially on the north side of the fortress today, suggest that the emperor also built an approximately 6 km long fortification wall with towers surrounding the centre of the city, just like the walls in Constantinople and Thessaloniki.[17] The famed Peutinger map, a thirteenth-century copy of an ancient Roman road map, an archetype of which might have originated in Diocletian's Nicomedia, shows the city enclosed with fortification walls and several towers.[18] In his laments after the devastating earthquakes that levelled the city in the mid-fourth century, Libanius also offers an insight into the city's mostly Diocletianic urban landscape with colonnaded streets, a theatre, a palace, baths, temples, and houses covering the hills that stretched down from the acropolis to the harbour (*Or.* LXI.7–18):

> What city was more beautiful? I will not say larger, for in size it was exceeded by four, but contemned all that increase of extent, which would have wearied the feet of its citizens. In beauty, also it yielded to these, and was equalled, not excelled, by some others: for, stretching forth its promontories, with its arms it embraced the sea. It then rose from the shore and was divided by two pairs of colonnades extending the whole length. Its public buildings were splendid, its private contagious, rising from the lowest parts to the citadel, like the branches of a cypress, one house above another, watered by rivulets, and surrounded with gardens. Its council chambers, its schools of oratory, the multitude of its temples, the magnificence of its baths, and the commodiousness of its harbor I have seen, but cannot describe. [...] the form of the city, much more fascinating, by its beauty tyrannized over our eyes, and fixed their whole attention on itself. Similar were the sensations of him who had never seen it before and of him who had grown old within its old walls. One shewed to his companion the palace, glittering over the bay; another the theatre embellishing the whole city; others various other rays darted from various

objects: which surpassed it was difficult to determine. Revering it as a sacred image, we proceeded; in our way to Chalcedon.[19]

After an explanation of the devastating earthquake, Libanius also describes the city in ruins in the aftermath:

> Where are now thy winding walks? Where are thy porticoes? Where are thy courses, thy fountains, thy courts of judicature, thy libraries, thy temples? Where is all that profusion of wealth? Where are the young and the old? Where are the baths of the Graces and of the Nymphs, of which the largest, named after the prince, at whose expense it was built, was equal in value to the whole city? Where is now the senate? Where are people? Where are women? Where are children? Where is the palace? Where is the circus, stronger than the walls of Babylon? Nothing is left standing; nothing has escaped; all are involved in one common ruin. O numerous streams, where now do you flow? What mansions do you lave? From what springs do you issue? The various aqueducts and reservoirs are broken. The plentiful supply of the fountains runs to waste, either forming whirlpools, or stagnating in morasses; but drawn or quaffed by no one, neither by men nor birds. These are terrified by the fire which rages everywhere below, and where it has a vent, flames into the air. This city, once so populous, now in the day time is deserted and desolate, but at night is possessed by such a multitude of spectres.[20]

Ammianus Marcellinus also describes the earthquake of 358 as a disturbing disaster (*Rerum gestarum libri* XVII.7) and mentions the second earthquake in 363, which destroyed whatever was left standing. Nicomedia's twist of fate, however, starts earlier than these earthquakes. Following the abdication of Diocletian and Maximian in Nicomedia in 305, the city continued to serve as the capital of the Eastern Empire. In 330, Emperor Constantine, who spent his childhood and adolescence in the imperial court in Nicomedia, moved his capital to Constantinople.[21] After serving as the administrative capital of the Eastern Roman Empire for about forty-six years and after the devastating earthquakes of 358, 363, and 386, Nicomedia had lost most of its magnificence by the early fifth century. In the mid-fifth century, Justinian restored Caracalla's gymnasium and built a bridge over the Sangarios, but throughout the Byzantine period the

16 Lactant., *De mort. pers.* VII.8.10. See the translation of the full text in Chapter 2, p. 43.

17 Foss 1996, 29–31.

18 For the Diocletianic origin of the map as a Tetrarchic wall map see Talbert 2010. Bekker-Nielsen 2013 however rightly objects to this theory as Nicomedia is not shown as prominent as worthy of a capital on the map.

19 Lib., *Or.* LXI.7–10; translation Duncombe 1784, II, 233–35.

20 Lib., *Or.* LXI.14–18; translation Duncombe 1784, II, 237–40.

21 The official dedication of Constantinople took place in 330, the city however, became the seat of Constantine after his defeat of Licinius in 324.

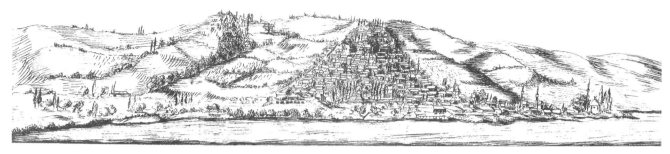

Figure 1.2. Peyssonel's drawing of Nicomedia in 1745, based on the drawing in Peyssonel 1745.

city — constantly battered by earthquakes — remained as a small town, subordinate to Constantinople.[22]

In 1337, Nicomedia fell to the Ottoman Turks. As the city acquired new Turkish Islamic buildings such as mosques and a theological school initiated by Orhan Bey, its name changed into İznikmid (derived from *eis Nikomedeian* 'to Nicomedia') in the Ottoman records, later shortened to İzmid.[23] Thanks to its strategic location, throughout the Ottoman Empire, İznikmid served as a main commercial and military base as well as a source of skilled labour for the nearby capital Istanbul. In 1452, Mehmet the Conqueror brought artisans and labourers from İznikmid to build his castle on the Bosporus, Rumeli Hisarı.[24] Ottoman records also indicate that throughout the sixteenth century, marble blocks left over from Diocletian's grand constructions were recut and shipped to Istanbul for the construction of new Ottoman imperial buildings, such as Sinan's Süleymaniye Mosque.[25] In 1639, Emperor Murat IV built a palace at the centre of the city, which partially survives today buried beneath the Neoclassical palatial hunting pavilion built by Emperor Abdulaziz in the nineteenth century. The Turkish traveller Evliya Çelebi who visited the city around 1650 describes it as prosperous with rich timber merchants, janissaries, and a force of cavalry.[26] He mentions a square castle by the sea, 2300 tile-roofed houses in twenty-three districts (two of them Christian, one Jewish), and many mosques and baths. To the east of the city he mentions the 'sea of trees' and timber along with silk and wine being the major local products. In the eighteenth century, with its restored shipyard, the city housed the Turkish fleet in its protective harbour. From the eighteenth century onwards, the remnants of ancient Nicomedia also appear in the books of European travellers.[27] Peyssonel, in 1745, for example, describes the ancient ruins and inscriptions he saw and also provides a cartography of the city based on his observations (Fig. 1.2). In the nineteenth century, with its new railroad and newly built factories by the harbour, Izmit started to transform into a big industrial city, further obscuring the remnants of Diocletian's capital lying under its feet. Today, İzmid is officially called Izmit. It is the capital of the province of Kocaeli and is considered the heart of modern Turkey's industrial economy.

Archaeological Research and the Ancient Layout of Nicomedia

Nicomedia has never been systematically excavated and most of its ancient ruins waned under the growing modern Izmit built right on top of it. Prior to the discovery of the Çukurbağ finds, the most concrete archaeological data about this celebrated ancient city came from rescue excavations conducted in the courtyard of a modern paper factory called Seka in the 1930s (see Fig. 1.3 for the location of Seka archaeological site). These rescue excavations unearthed a bath complex, parts of a residential district with a paved colonnaded square, foundations of a large building (perhaps a warehouse, now completely destroyed), parts of Diocletianic city walls reaching towards the sea on the west of the site, and several sculptures and inscriptions. The proximity of the finds to the ancient harbour, which must have been situated along the modern Seka Park, suggests the existence of a lower agora with surrounding public buildings in this area of the ancient city. Most of the sculptural finds, including the famed portrait often said to represent Diocletian, are now in the Istanbul Archaeology

22 See Foss 1996, 11–12 for Nicomedia in the age of Justinian and 16–28 for Byzantine Nicomedia. Also see Ulugün 2010 for Byzantine Nicomedia.

23 For an overview of Ottoman Izmit and sources, see Bostan 2001, Güneş 2015, and Öztüre 1981. For the transformation of the city's name from Nicomedia to Izmit also see Polatel 2012.

24 Bostan 2001.

25 Bostan 2001 and also Foss 2020, 15.

26 Çelebi 1998, 39.

27 Peyssonel 1745; Lechevalier 1800; Hammer 1818; Fraser 1838; Fellows 1852; Texier 1862; Perrot, Guillaume, and Delbet 1872.

Figure 1.3. Google Map of modern Izmit with the approximate location of major archaeological sites and city walls of the Roman period.

Museums.[28] Large Corinthian capitals, columns, and inscribed blocks found in another rescue excavation in 1968 in the Tepecik neighbourhood at the centre of the modern town have been identified as parts of a second-century nymphaeum (see Fig. 1.3 for the location of the nymphaeum).[29] Other miscellaneous discoveries found during the construction of modern buildings within the city were brought to Kocaeli Archaeology Museum, but construction continued without further archaeological exploration.[30] Some Hellenistic and Roman tumuli around the city have been investigated and published.[31] Other archaeological research on Nicomedia includes publications on surviving inscriptions as well as local publications on the history of the city based mainly on

ancient and early modern literary sources.[32] The role of the ancient city in the Roman imperial economy has been reconstructed on the basis of literary, epigraphic, and numismatic evidence.[33] Foss has investigated the fortification walls of the ancient city, and has recorded parts of a massive circuit wall with towers at undetermined intervals, which once encircled Diocletian's capital.[34] Recent scholarly surveys of the topography of Nicomedia by Zeyrek and Çalık Ross have drawn further attention to the archaeological potential underneath modern Izmit.[35] Çalık Ross's survey showed that Nicomedia was integrated into the rich surrounding territory through at least twenty-three aqueducts and an extensive network of roads and bridges. This survey also documents rem-

28 Dörner 1941a; 1941b; 1972; Duyuran 1947; Koyunoğlu 1953; Bayburtluoğlu 1967; Ebcioğlu 1967; Zeyrek and Asal 2004. Head of Diocletian: Istanbul Archaeological Museum, Istanbul, inv. no. 4864.

29 Fıratlı 1971, 14.

30 The storage of Kocaeli Archaeology Museum is filled with such finds, mostly sculptural, with provenance indicated simply as coming from the foundation of a modern construction site. A colossal marble head of a male divinity (inv. no. 1576) which came to the museum in 1988, for example, appears to have come from an unspecified construction site in the Ömer Ağa neighbourhood, just south of the Çukurbağ neighbourhood.

31 Fıratlı 1953; 1960; Turgut and Aksoy 1996.

32 Surviving inscriptions: Dörner 1941b; Şahin 1974. History of the city: Fıratlı 1971; Öztüre 1981; Ulugün 2004; 2007; 2010.

33 Ward-Perkins 1980a; 1980b; Güney 2012.

34 Of a massive fortification wall stretching about 6 km from the shore to the hill high above the city, Foss (1996, 29–31) identified only two small surviving sections at and above the level of the fortress today, with the rest dissolved into the expansion of the modern town. One section on a hill on the north-east of the fortress reaches about 10 m in height and is 3 m in width. On the other surviving section in Turgut Mahallesi, one can see the masonry consisting of bands of bricks at regular intervals and fieldstones in mortar placed above well-cut limestone blocks.

35 Zeyrek 2005; Çalık Ross 2007a; 2007b; 2013.

nants of a massive theatre on a prominent hill within the city walls, overlooking the shore in the Orhan neighbourhood (see Fig. 1.3 for the location of the theatre).[36] With its estimated 164 m span and 60 m height, the theatre would have been larger than the theatre at Ephesus, and would have seated over twenty thousand people.[37] Just recently a rescue excavation conducted by Kocaeli Archaeology Museum (between 2017 and 2019) during the construction of a modern governmental office building (for İSU-İzmit Su ve Kanalizasyon İdaresi) in the Serdar neighbourhood has revealed parts of a necropolis (see Fig. 1.3 for the location of the western necropolis). Located just outside the western section of the walls of Diocletian (to the north-west of the Roman structures found at the Seka factory in the 1930s), the excavated part of the necropolis contained at least fifty-eight burials: five inscribed sarcophagi, fifty-one tile-graves, and two amphora burials. Burial finds and inscriptions have shown the active usage of the western necropolis between the second and fourth centuries AD.[38]

Although its remnants vanished beneath modern Izmit, one can draw an approximate layout of Late Antique Nicomedia based on the literary and archaeological evidence outlined above.[39] The city, then as now, was built on steep hillsides overlooking the gulf. A network of public and private buildings stretched from the harbour up to the acropolis. As is typical of Roman cities, two large colonnaded streets, meeting at right angles, might have extended over the hills.[40] The *decumanus* (the main road in the west–east direction) might have extended in a line between the south of the western necropolis and the north of the buildings found in the Seka excavations.[41] A massive circuit wall with tow-

ers at certain intervals encircled the city down to the shore.[42] There were necropoleis outside the city walls. The most conspicuous buildings inside, at least for Libanius who lived in the city in the mid-fourth century, were the theatre and the palace.[43] The theatre rose high above the city centre. Diocletian's palace must have had a prime location overlooking the harbour. Two possible locations for the palace within the modern city are the Çukurbağ neighbourhood, on a hill at the central-east section of the city where we found the imperial complex with the painted reliefs or alternately Hünkar Kasrı, the aforementioned Ottoman palace (of emperors Murat IV and Abdulaziz) located on a prominent central hilltop overlooking the sea (see Fig. 1.3 for the location of Çukurbağ and the Ottoman palace). For the palace, of course we should not envision a single building, but a complex series of interrelated buildings spread throughout almost a quadrant of the city, just like the palatial complex of Galerius at Thessaloniki.[44] The circus, mentioned by Lactantius,[45] for example, was probably connected to the palace and must have been built on flatter ground near the sea.[46] Archaeological finds of the Seka excavations at the western end of the ancient city indicate the existence of an agora by the harbour, with nearby residential buildings and a bath complex. It appears this section of the city at the western end was never rebuilt after the major earthquakes of the fourth century. We cannot be sure about the exact location of other monumental buildings cited in the sources such as the Antonine Baths, mint, weapons factory, palaces for Diocletian's wife and daughter, the bouleuterion near the agora and the Temple of Fortuna,[47] several other temples (including those of Demeter, Isis, and Zeus),[48] basilica,[49] fountains, libraries, and courts. The location of the church/cathedral in a high prominent position, burned down by Diocletian during the massacre

36 Çalık Ross's team further revised Foss's investigation of the city walls of Nicomedia and suggested that the city walls would have extended from the borders of Orhan Mahallesi in the west and Cedit Mahallesi (Baç neighbourhood) in the east down to the modern Seka Park: Çalık Ross 2007a, 96–97.

37 Çalık Ross 2007a, 123; Güney 2012, 149.

38 Gölcük, Aydıngün, and Çibuk 2020; Öztürk and Demirhan 2019; Öztürk, Gölcük, and Çibuk 2019.

39 For the approximate reconstructions of the layout of the ancient city see Foss 1996, 14–15 and Güney 2012, 172–73. For a comparative study of the layout of Nicomedia and Thessaloniki see Çalık Ross 2016.

40 Foss 1996, 14–15. Jacobson 2007, 653 suggests a grid plan laid on the steep slope for the Hellenistic layout of the city, just like Hellenistic Pergamon. In the absence of any archaeological data, it is hard to prove this Hippodamian planning.

41 Gölcük, Aydıngün, and Çibuk 2020 note that all the inscriptions found on the western necropolis face to the south indicating

the existence of a main road, the northern boundary of which is the necropolis and the southern boundary the Seka buildings.

42 See above, note ? for Foss's description of the city walls.

43 See above, Libanius's text on p. 7.

44 For an architectural overview of Tetrarchic imperial complexes in Tetrarchic capitals see Üçer-Karababa 2008.

45 Lactant., *De mort. pers.* VII.8.10, see the text on p. 43.

46 Jacobson 2007.

47 Lib., *Or.* LXV.74.

48 Güney 2012, 171 for temples of Nicomedia referenced in ancient sources.

49 *Expositio totius mundi* XLIX. The text mentions that the ancient basilica was burned by divine fire from heaven and was restored by Constantine afterwards, Foss 1996, 7.

of several Christians, including St George, in 303 and rebuilt by Constantine,[50] is also unknown.

Clearly, much more archaeological research is needed for a better understanding of the ancient urban layout of Nicomedia and the location of major public buildings. With the scarce physical data we have, however, one can suggest that the imperial complex in Çukurbağ might have been an audience hall and a judicial court which also functioned for the imperial cult of emperors Diocletian and Maximian. As will be discussed in detail below, such audience halls for the use of both imperial and civic governing bodies were typical of the Tetrarchic palatial complexes.

Figure 1.4. Statue of 'Farnese type' Herakles recovered from Çukurbağ in 2001. Kocaeli Archaeology Museum, Izmit, inv. no. 2001/12 (A).

The Çukurbağ Rescue Excavations (2001, 2009) and the TÜBİTAK Çukurbağ Archaeological Project (2015–2018)

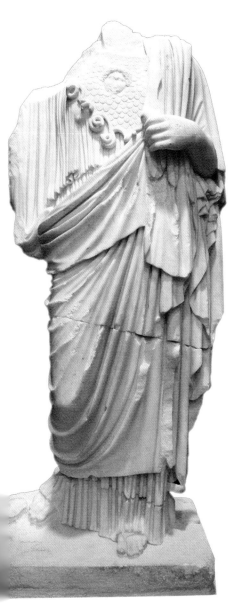

The first reliefs and architectural elements from the site were recovered during rescue excavations conducted by Kocaeli Archaeology Museum in 2001. During the 2001 salvage operation, which took place in the neighbourhood of Çukurbağ, about 22 m above sea level, excavators retrieved parts of about eleven relief panels. They also took possession of two colossal statues of Herakles and Athena, parts of which had already been dug out from the basement of an abandoned building and were intended for illegal export. The Herakles statue belongs to the Farnese type and, being almost 3 m in height, is one of the largest ever discovered of this type; Athena is of the Giustiniani type and is about 2 m in height (Figs 1.4 and 1.5).[51]

After a lawsuit that dragged on for several years, this building and another nearby building (already heavily damaged during the 1999 earthquake) were expropriated and

Figure 1.6. Photo from the 2009 rescue excavations, showing reliefs being lifted for transport to Kocaeli Archaeology Museum.

demolished, leading to the rescue excavations of 2009. During two months of excavations in an area measuring approximately 700 m², several more reliefs were

Figure 1.5. Statue of 'Giustiniani type' Athena recovered from Çukurbağ in 2001. Kocaeli Archaeology Museum, Izmit, inv. no. 2001/14 (A).

50 Lactant., *De mort. pers.* XII; see the discussion in Foss 1996, 3–4.

51 Zeyrek and Özbay 2006, 280–91. The headless Herakles statue measures 256 cm with its base and the headless Athena measures 194 cm with its base.

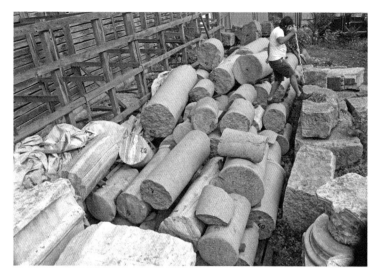

Figure 1.7. Ditch with architectural elements stacked up on the eastern side of the archaeological site at Çukurbağ (photographed in 2018).

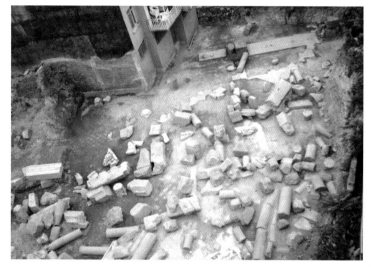

Figure 1.8. Aerial photo of the Çukurbağ excavation site taken during the 2009 rescue excavations.

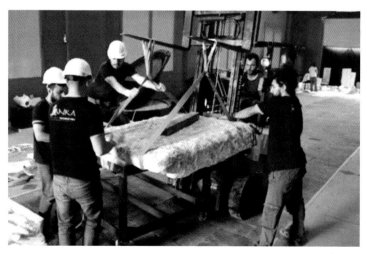

Figure 1.9. Transportation of the Nicomedia relief panels during the TÜBİTAK Çukurbağ Archaeological Project.

discovered and transferred to Kocaeli Archaeology Museum, while architectural finds were stacked on top of one another and left on site (Figs 1.6 and 1.7). During the 2009 expedition, archaeologists did not have time to record the positions of the finds or systematically draw them in situ, and excavation diaries were also lost. Only some excavation photographs were archived, which we relied on later to partially reconstruct the in-situ position of the finds (Fig. 1.8; see also Fig. 2.1). Because of an ongoing legal investigation into the smuggling of some reliefs during the 2009 salvage expedition, the remaining reliefs were kept in boxes and were never properly inventoried or studied. Although the reliefs were kept in boxes, an initial conservation and restoration conducted by the museum in 2012 has shown that exposure to the elements contributed to significant colour loss.

The new archaeological investigation of the site and analysis of the sculptural finds started in 2013 and was funded in 2015 by the Scientific and Technological Research Council of Turkey (TÜBİTAK), and thus is called the TÜBİTAK Çukurbağ Archaeological Project. Initially, we gathered all the Çukurbağ finds scattered around the storage area of Kocaeli Archaeology Museum in the nearby old train shed (Fig. 1.9).[52]

We cleaned, examined, catalogued, partially restored, photographed, and 3D-scanned about sixty-six relief panels of Proconnesian marble, 115 pieces of smaller relief fragments, and some sixty-five pieces of freestanding statuary of varying scales, some colossal (Fig. 1.10). Pigments on the sculpture underwent preliminary examination with multispectral imaging and portable X-ray fluorescence spectroscopy. The architectural remains on the excavation site were recorded, including an opus sectile floor, inscribed wall blocks, columns, capitals, and architrave blocks. A new excavation of the southern part of the building, initiated in 2016, revealed the monumental stairs of the imperial complex to which the sculpture and the architectural elements had belonged. An over-life-sized statue of Hygeia had fallen onto the stairs (Figs 1.11–1.12).

[52] This old train shed is also part of the museum and is being used as one of the museum storage areas. Some of the reliefs from Çukurbağ were already in the shed but put high up in closed cases. Thanks to the help of the members of Anka Restorasyon who joined our project we were able to move them down.

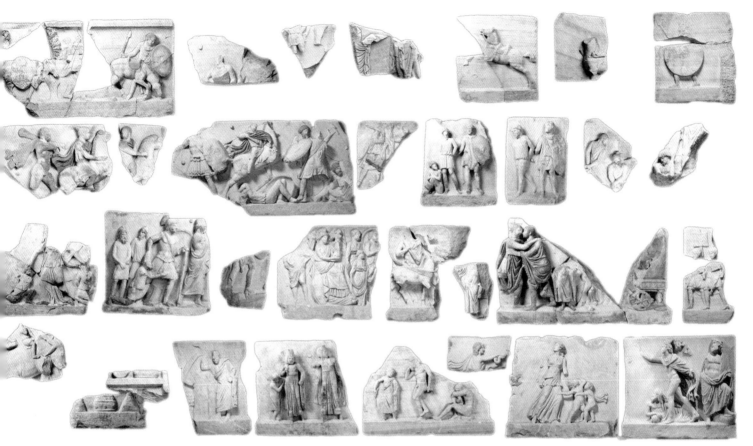

Figure 1.10. Twenty-eight of the sixty-six Nicomedia relief panels catalogued during the TÜBİTAK Çukurbağ Archaeological Project.

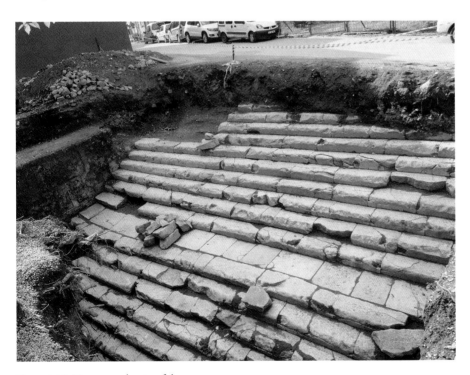

Figure 1.11. Monumental stairs of the Çukurbağ imperial complex discovered during the 2016 rescue excavation.

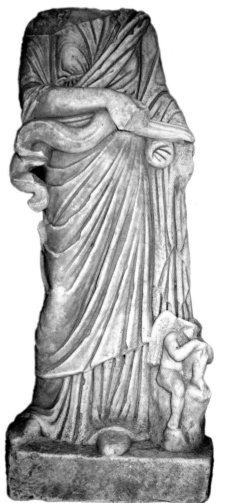

Figure 1.12. Statue of Hygeia found fallen on the monumental stairs of the Çukurbağ imperial complex during the 2016 rescue excavation.

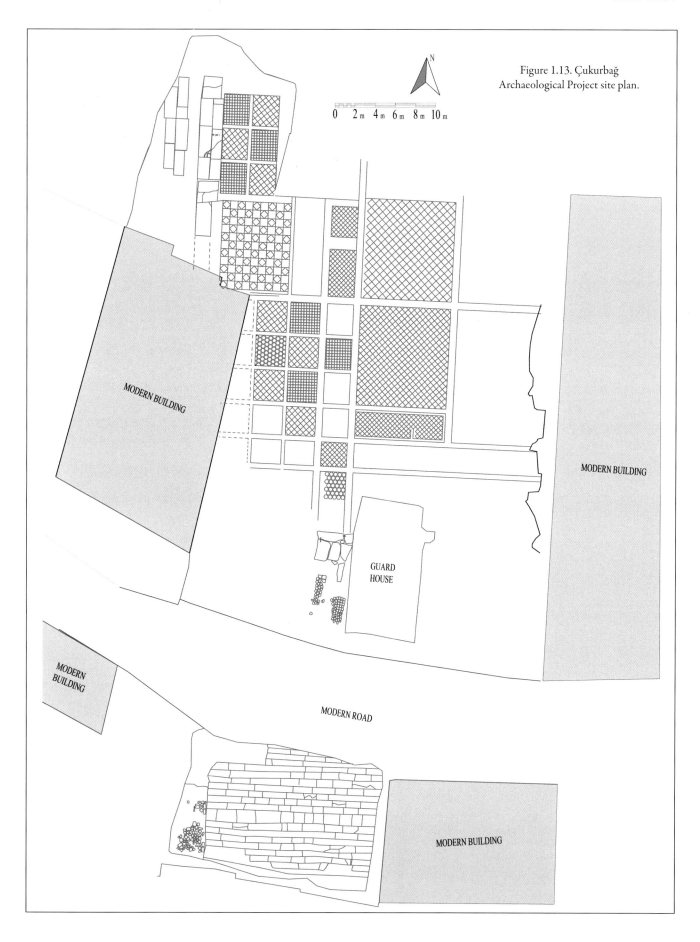

Figure 1.13. Çukurbağ
Archaeological Project site plan.

Based on our re-examination of the site, we were able to construct a site plan for the first time (Fig. 1.13).

We studied a heavily-worn inscription on a reused block in the foundation of the western wall of the building (Fig. 1.14). The inscription mentions an honorific decree celebrating an emperor, perhaps Alexander Severus or Caracalla. The block was then used as a spoila in the construction of the building.[53]

Ἔτους δι΄ τοῦ κυρί[ου] ἡμῶν
Αὐτοκράτορος Καί[σα]ρ[ο]ς
...[]Υ[]Α[]
[]
[]
[]
[Ε]ὐσεβ[ῖ Εὐ]τυχ[εῖ Σεβ(αστῷ)(?)]
[] μεγίστῳ, δ[ημα]ρχικ-
[ῆς ἐξουσίας τὸ], πατρὶ
[π]α[τρ]ίδος, ἀνθυπάτῳ ᵛᵃᶜ.
[]ΤΡΑ[μ]ε[τ]ὰ ψη[φ]ίσματος
[]ΑΣ]Κ[]
ΤΙΟΜ[]τεκτ[]Ν
τοῖς ἐν Νεικομεδείᾳ.

(In the fourteenth (?) year of the reign of our lord, Emperor Caesar [...] *Pius Felix Augustus*(?) to [...] *maximus*, in the [...] tenure of his tribunician power, father of the country, *proconsul* [...] with decree [...] to artisans (sculptors) those who are in Nikomedeia.)

A crack running along the width of the inscribed block must be the trace of an earthquake which may have brought down this building built sometime after the mid-third century. Indeed, as will be discussed below, all the other archaeological evidence indicates that this building came down all at once while still in use, perhaps during the devastating earthquake of AD 358.

We carried out a further survey interviewing the elderly locals living in the Çukurbağ neighbourhood, who mentioned that some antique architectural pieces found during the construction of modern buildings were sent to Istanbul in the 1960s. Following the lead, we investigated the collection of the Istanbul Archaeology Museums, where we found the relief panel with the

Figure 1.14. Inscribed foundation block from the western wall of the Çukurbağ imperial complex.

53 Special thanks to Mustafa Adak and Tolga Özhan for their help in the initial reading of this inscription. If the referred emperor is Caracalla, the erasure in the inscription must have been carried out after his death in AD 217, marking a *terminus post quem* for the building. A recent secondary reading by Mustafa Adak, however, revealed that the emperor mentioned in the block might actually refer to Alexander Severus, and the block could date from AD 230 or 231. This new transcription and commentary will be published by Adak.

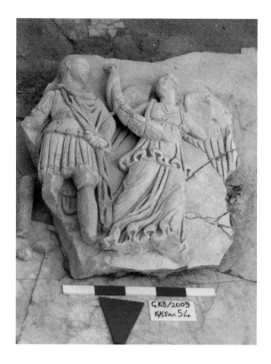
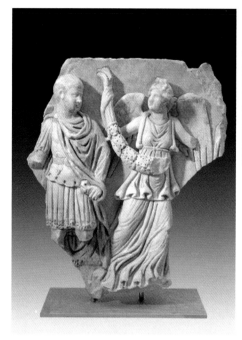

Figure 1.15. Photo of the stolen relief panel (**cat. no. 20** in this volume) taken before the theft in the 2009 excavations, and its image as it appeared in the catalogue of Gorny & Mosch in 2013.

founder of Nicomedia (here see, **cat. no. 26**) along with other sculptural and architectural finds from Nicomedia which were brought to the Istanbul Archaeology Museums in the 1960s. Locals also informed us about the existence of an underground tunnel to the west of the archaeological site at Çukurbağ. Indeed, we identified a vaulted cistern of brickwork extending about 30 m underneath a private property, located approximately 100 m to the west of the imperial complex.[54] Some other spolia pieces have been identified in the modern neighbourhood, such as column drums embedded in the modern constructions.

Prior to the 2009 discoveries, Zeyrek and Özbay had examined the reliefs and statues found during the rescue excavations of 2001. They suggested, mostly on stylistic bases, that the reliefs belonged to a victory monument built in honour of Septimius Severus in the late second century AD.[55] But the above-mentioned inscription from the foundation of the building that the reliefs once adorned, as well as the style and themes of most of the reliefs, support our proposal of a late third-century date, when Nicomedia was the administrative capital of the Eastern Roman Empire.

Our investigation of the Çukurbağ finds during the TÜBİTAK Çukurbağ Archaeological Project later evolved into two further projects, one taken up as a per-

sonal fellowship by myself at the Radcliffe Institute for Advanced Study at Harvard University (2018–2019) and another ongoing project titled Nikomedia, granted by the European Commission's Marie Curie Individual Fellowship at Oxford University (2019–2021). Besides the publication and presentation of the several parts of our research (cited in the preface of this book), our scholarly exploration also involved sociological analysis of the Çukurbağ neighbourhood and local bureaucracy in order to benefit further urban archaeology as well as the search for the reliefs stolen during the 2009 excavations.

Return of the Stolen Reliefs

One of the relief panels illegally smuggled during the 2009 rescue excavation first appeared in 2013 in an auction of the art dealer Gorny & Mosch Giessener Münzhandlung GmbH in Munich, Germany (Fig. 1.15).[56] The relief panel (**cat. no. 20** here) with the depiction of the emperor and a garland-bearing Victory was put up for sale for 40,000 euros. The provenance information given in the catalogue falsely indicated that the panel had been part of a private English collection since 1971. Shortly after the auction, officials of the Turkish Ministry of Culture and Tourism initiated a lawsuit for the return of the relief panel. The lawsuit dragged on for years and finally the panel was returned to the Anatolian Civilizations Museum in Ankara and later was trans-

[54] Another vaulted cistern, known as İnbayırı Sarnıcı is located about 200 m to the east of the Çukurbağ complex.

[55] Zeyrek and Özbay 2006.

[56] Gorny & Mosch 2013, no. 8.

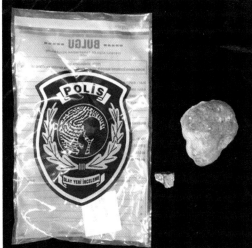

Figure 1.16. Photo of the stolen relief panel (**cat. no. 39** in this volume) taken before the theft in the 2009 excavations, and part of it discovered in a murder investigation in 2019.

ferred to Kocaeli Archaeology Museum in 2019. Upon its return, the relief panel was examined in detail; some of its missing parts, which were left on site when the relief panel was stolen, were found in Kocaeli Archaeology Museum depots. These pieces, including the emperor's right lower leg, the tip of Victory's left wing, and the drapery of another imperial figure on the right, were joined to the relief panel. Actual restoration, however, was complicated by two metal bars inserted into the panel and by a modern artificial base that the restorers of the auction house had added to the relief panel. We have also applied multispectral and microscopic imaging techniques to examine the very well-preserved colours on the panel.

Another relief fragment with an imperial rider holding a sword was lost shortly after the rescue excavations of 2009 (here **cat. no. 39**). Two antique pieces found in the house of a suspect in a murder investigation were brought to Kocaeli Archaeology Museum. Upon museum director Rıdvan Gölcük's inquiry we examined the pieces and identified one of them as the head of the imperial rider, carefully cut from the rest of the relief panel by smugglers possibly for easy transport (Fig. 1.16).

Besides a systematic excavation, local validation of the site at Çukurbağ as a major place of historical heritage is essential for continued research and site protection. Yet safety of residents and expropriation of land are still major issues for the neighbourhood, which is densely populated with economically challenged families. A future archaeopark at Çukurbağ and display of the colourful reliefs at the local museum could ease some of

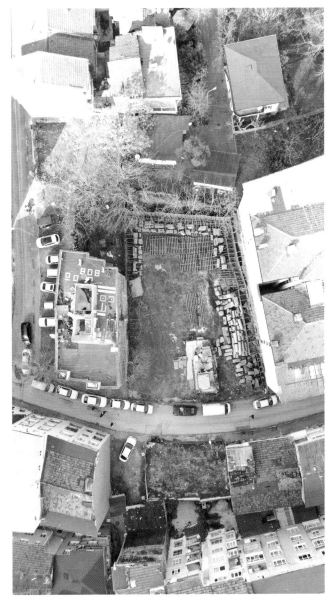

Figure 1.17. The aerial view of the Çukurbağ Archaeological Site in 2020.

these ongoing problems. We are continuing to work with local authorities promoting the cultural awareness of the site and its unique finds. Currently, all the architectural remains are on site with a twenty-four-hour museum guard. The steep monumental stairs discovered in 2016 on one side of a passing modern road were refilled with soil for reasons of public safety (Fig. 1.17). Reliefs are in the museum depot, eagerly waiting to meet with viewers in their new exhibition hall.

Architectural Assessment of the Çukurbağ Imperial Complex in the Roman Context

One of the major challenges of the Çukurbağ Archaeological Project was the proper investigation of the architectural finds found during the 2009 rescue excavation and left on site. In order to open up space and carry the reliefs to the museum, excavators had gathered most of the large architectural pieces — wall blocks, architrave blocks, columns, and capitals — and stacked them up on top of one another in a 2 m deep ditch at the eastern end of the excavation site (Fig. 1.7). Due to the time limitations of the rescue excavation neither these architectural remains nor the wonderfully preserved opus sectile floor had been examined and recorded in detail. The opus sectile floor, left exposed to outside conditions, deteriorated and partially dissolved in time. Yet, during our fieldwork in 2016, we were still able to record and make a plan of the floor based on the imprints of the lost marble pieces of the mosaic floor (Fig. 1.13). The measuring and recording of the architectural finds in the ditch were especially difficult as some pieces deep down in the stack were almost inaccessible and the site is surrounded by modern buildings, so physically there is no space for a crane to lift up each individual piece and study it. Discussion below of the on-site architectural elements are mostly based on our observations and measurements under these circumstances and also on some photos taken during the 2009 excavations. Future excavations and cleaning of the site will clearly allow a better understanding of the building complex.

The initial site plan we prepared shows that the complex was badly damaged by construction on all sides and a modern street cutting across it (Fig. 1.13). Yet, one can clearly trace its monumental stairway leading up to an opus sectile paved area onto which the polychrome reliefs and other architectural elements fell. The opus sectile floor suggests that this is the interior of an approximately 26 m wide building, protected by a mas-

sive roof spanning the area.[57] The podium at the western end of the monumental stairs is in direct alignment with the western wall of the building, the foundations of which (including the above-mentioned inscribed block) are still intact. The foundation of the eastern wall can be traced under the modern building (in the side section of the ditch) at the eastern end of the site. Its existence gives an approximate width of about 23.4 m for the opus sectile paved floor and roughly 26 m for the building itself.[58] The length of the excavated opus sectile floor is 28.7 m so far, but how far the building extends to the north is unknown for now. The monumental stairs discovered during the 2016 rescue excavation descend to the south for about 4.7 m down from the level of the modern road. Approximately 12 m of the width of the marble staircase has been recovered, which clearly extends to the east but is now under the modern building on the right (Fig. 1.11). The western edge of the staircase, where it meets a high podium coated with large marble revetments on the inside walls and smaller stones on top, is still intact. Of the nineteen stairs uncovered so far, the average width is 42 cm, with the outlier of the twelfth stair from the top, which has a width of 76 cm. Again, we do not know how far the stairs descend, as there is another modern building built there on the south. If we think that the large twelfth step is placed in a regular interval within the staircase there should be at least four more steps going down. A headless statue of Hygeia with Hypnos at her side was found fallen on the western part of the stairs, possibly after a major earthquake (Fig. 1.12).[59] Indeed, most of the stairs carry traces of a major earthquake in the form of cracked lines. The top part of the staircase is damaged by the modern road, so we do not know how many more steps ascended to the

[57] We think that such an intricate pavement would have been protected by a roof, but there are some surprising examples of such floors, so wide that no existing roofing technology could span across, such as the Marble Court of the Bath-Gymnasium complex at Sardis, see Yegül 1986.

[58] The surviving width of the opus sectile floor is actually 17 m, but the plan indicates that the opus sectile pavement extended to the eastern wall and thus had a width of 23.4 m. The pavement towards the east is destroyed by the ditch in which most of the architectural elements lie today.

[59] The surviving height of the headless statue of Hygeia together with the base she stands on is 191 cm. She holds a snake in her right hand. Winged Hypnos sits on a rock on her left side. In terms of its style and iconographic details the statue shows a stark resemblance to the statue of Hygeia at the Boston Museum of Fine Arts (1974.131), which was identified as a second-century statue from Western Asia Minor.



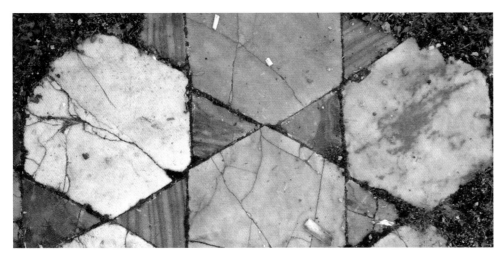

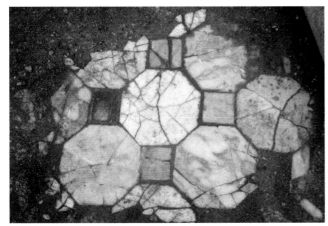

Figure 1.18. Details of the preserved part of the opus sectile floor of the Çukurbağ imperial complex.

alternating patterns in the mosaic decoration, such as green cipollino and purple-veined white pavonazzetto (Fig. 1.18). There is no sign of a support placed on the recovered part of the opus sectile floor. Similar opus sectile floors appear most commonly in third- and fourth-century architecture; the restoration of the Curia in the Roman Forum during the Tetrarchic period included a geometric-patterned opus sectile floor; the large Octagonal Hall and the Rotunda within Galerius's palatial complex in Thessaloniki had a geometric-patterned opus sectile floor, and the Audience Hall (Aula Regia/Basilica) of Emperor Maximian's palatial complex at Trier also had an opus sectile floor consisting of multicoloured marbles arranged in different geometric patterns laid within rectangular fields just like the floor at Çukurbağ.[61] The bottom register (dado) of the Tetrarchic frescoes at Luxor is painted with asymmetrically arranged geometric patterns imitating opus sectile. Indeed, McFadden argues that the trompe l'oeil effects and the chromatic variety attested on the opus sectile designs are a popular feature of the Tetrarchic art with ideological underpinnings.[62]

As can be evidenced from the excavation photos of 2009, there was no noteworthy layer of soil between the opus sectile floor and the superstructure that fell on top of it (Fig. 1.8). This clearly indicates that the building came down all at once while still in use. Elements of superstructure examined during the Çukurbağ Archaeo-

entrance of the building, which must have had a colonnaded façade. Large foundation wall blocks to the west of the guard's house indicate an entrance wall and a door leading to the opus sectile paved hall inside.

The floor decoration consists of marble stones of different colours cut in triangular, square, rectangular, hexagonal, octagonal, and circular shapes forming different geometric layouts, arranged within differently sized rectangular and square frames which are separated from each other by borders (Fig. 1.13). Rectilinear/square frames with delicately embroidered geometric patterns inside are arranged in an asymmetrical layout. The large rectangles measure roughly 6.4 cm × 6.8 m, while the small squares measure roughly 2 m × 2 m.[60] The overall arrangement of the opus sectile dissolves the solidity of the floor and gives a three-dimensional perspective. Just like the elements of the superstructure, different types of marble with different colours are used in

60 The two large rectangles on the eastern side of the opus sectile floor measure 638 cm × 686 cm, while smaller squares and rectangles variously measure 212 cm × 212 cm and 187 cm × 207 cm.

61 Kelly 1986, 77. For all other examples of Tetrarchic opus sectile designs see Kelly 1986, 73–78. For a recent project on the reconstruction of the opus sectile pavement of the Audience Hall at Trier see Ruppienė 2021.

62 McFadden (2015, 116) further argues that opus sectile revetments of multicoloured panels had an ideological function within Tetrarchic art; they signified a map of territory the empire commanded, each colour representing a far-off quarry such as porphyry from Egypt and verde antico from Greece. For the case of Nicomedia, however, except for the cipollino from Greece (Euboea), most other types of marble used are not from far-off quarries of the empire but from quarries near Nicomedia, see below, n. 63.

Architectural elements from the Çukurbağ excavation and their dimensions.

Columns		Total Number of Pieces	Average Diameter	Estimated Height
	Large granite columns	20	62 cm	500 cm
	Medium granite columns	41	48 cm	360 cm
	Cipollino columns	10	47 cm	350 cm
	Pavonazzetto columns	3	32 cm	230 cm
Corinthian Capitals		**Total Number of Pieces**	**Average Diameter**	**Average Height**
	Large capitals (Proconnesian)	2	52 cm	66 cm
	Medium capitals (Proconnesian)	7	39 cm	49 cm
	Small capital (Proconnesian)	1	25 cm	30 cm
Pieces of Large Entablature		**Total Number of Pieces**	**Average Height**	**Average Width**
	Architrave blocks	12	71 cm	56 cm
	Cornice blocks	12	56 cm	105 cm
Pieces of Small Entablature	Pediments	3	74 cm	50 cm
	Cornice blocks	6	34 cm	51 cm
	Architrave blocks	3	22 cm	55 cm
	Unknown blocks	8	?	?

logical Project include columns, capitals, and several parts of the entablature. Just like the marble pieces of the opus sectile floor, a sumptuous variety of marble is used for the elements of superstructure. According to archaeological study and macroscopic geological examination, this includes: three sizes of Corinthian capitals of Proconnesian marble, two sizes of Aeolian granite columns, cipollino columns from Euboea that are close in size to the smaller granite columns, small pavonazzetto columns from Docimium that perhaps originally supported small-scale Proconnesian pediments of the aediculae, and large cornice and architrave blocks of Proconnesian marble.[63] As monolithic columns are produced in somewhat standard sizes in quarries, based on the diameter of the broken columns, the approximate

height of each different type of column has been calculated as shown in the table above.[64]

These initial dimensions of the architectural elements give an idea about the possible elevation of the building; column sizes indicate at least two levels inside, rising a minimum of 10 m in height, while the small pediments and corresponding small capitals and columns point to aediculae, possibly some with niches decorated with wall mosaics and statues standing at the front (Fig. 1.19). Indeed, we recorded yellow, blue, and green tesserae in the Çukurbağ excavation boxes in the museum depot (Fig. 1.20), and the top part of a concave niche block with a plaster setting bed for mosaics is traceable among the architectural elements accumulated on the eastern side of the excavation site. The architectural reliefs with a standard height of 1 m and in varying lengths might have been decorated the entablature, following the contours of the aediculated hall. Yet some relief panels could have also been placed in a lower level, on a podium

63 Thanks to the observations of Prof Lazzarini, the two types of granites used for the columns have been identified as *marmor troadense* or *granito violetto* with violet hues quarried from the slopes of Çiğri Mountain near Alexandria Troas, and *marmor mysium* quarried from Kozak Dağı near Pergamon. Interestingly, two coloured marble types from Bithynia are missing from the marble repertoire of the architectural elements recovered so far: *marmor sagarium* with red hues quarried from the modern village of Vezirhan in Bilecik, and *marmor triponticum* again with dominant red hues quarried from the Kutluca province of Izmit. These two marbles quarried from the vicinity of Nicomedia might have existed in other details of the architectural complex in Çukurbağ.

64 For the Roman standardization of column sizes see Dodge 1991, 37. Williams-Thorpe (2008, 82) further notes that granite columns from the Troad and Kozak Dağı quarries, two sources for the granite columns at Çukurbağ, in particular have concentrations of columns of specific sizes, distributed around 50 cm and 40 cm respectively. The estimated heights of columns have been calculated based on the diameter.

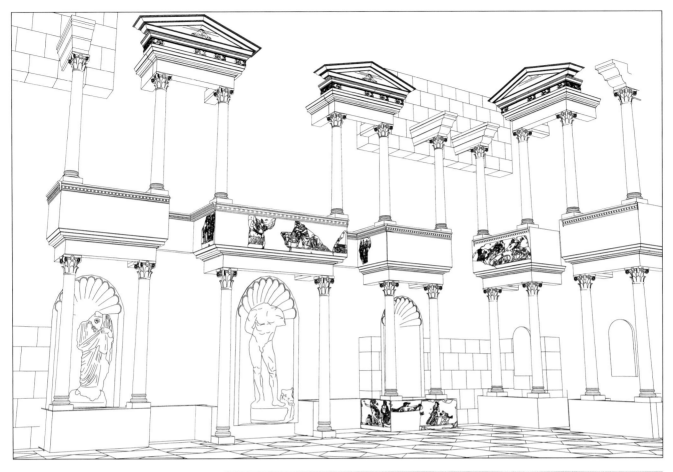

Figure 1.19.
Hypothetical
reconstruction of the
elevation of the
imperial
complex at Çukurbağ.

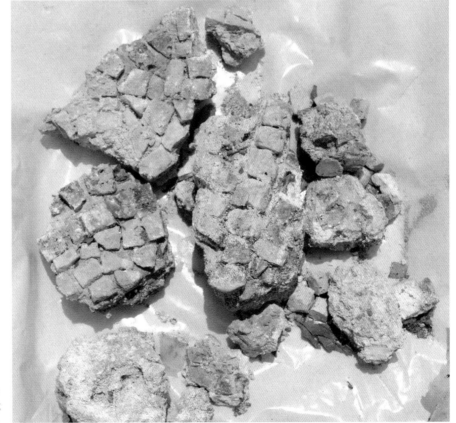

Figure 1.20. Tesserae
from the Çukurbağ
Archaeological Site.

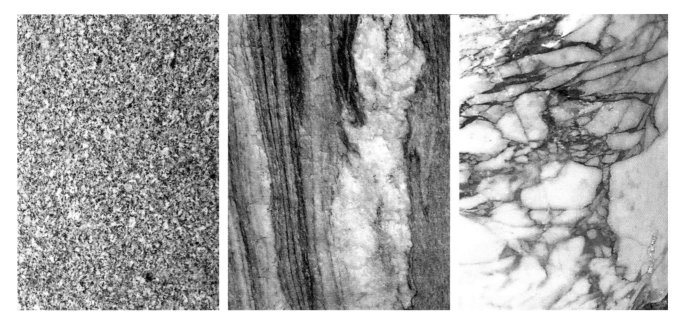

Figure 1.21. Close-up views of the columns: red and violet-toned granite, green-veined cipollino, and purple-veined white pavonazzetto from the imperial complex at Çukurbağ.

below the columns (Fig. 1.19). The colour scheme used for the opus sectile floor and columns with grey, red, and violet-toned granite, green-veined cipollino, and purple-veined white pavonazzetto, combined with the sculpted frieze brightly painted over medium-grained white Proconnesian marble with grey-blue banding, must have created a lavish and startling space (Fig. 1.21).[65]

As part of the inventorial scope of the Çukurbağ Archaeological Project, besides the colossal statues of the Farnese type Herakles and Giustiniani type Athena found in 2001, and the statue of Hygeia found in 2016, sixty-two other pieces of sculpture in the round have been examined. These pieces point to at least ten more statues decorating the hall, including another colossal Herakles, a colossal blonde-haired goddess, and a smaller-than-life-size Athena. Details of the sculpture in the round are the topic of another book, but it is important to note that statues as well are made of different marble types and exhibit different workmanship. Like some of the architectural elements (such as columns), statues might have been gathered from different earlier buildings and incorporated into this project.[66]

Even though we do not know whether it ends with an apse or not, such a large longitudinal hall without internal support brings to mind the Roman basilical form.[67] Indeed, such large audience halls (*aulae*) terminating with apses are typical of the Tetrarchic palatial complexes, parallel examples being the Aula Regia in Trier (67 m in length and 26.05 m in width), the Basilica in Thessaloniki (67 m in length and 24 m in width), and also the recently discovered Aula of Maximian's palatial complex at Milan.[68] With the changing court ceremonial during the Tetrarchic period[69] these basilical architectural forms must have helped emphasize the divine/authoritative power of the emperor, who was located in

stylistic approaches of various workmen brought from various parts of the empire can also be observed in the construction of Diocletian's Palace at Split. See Cambi, Belamarić, and Marasović 2009 for all the aspects of the palace in Split; and Marasović, Matetić Poljak, and Gobić Bravar 2012 for the variety of marble.

65 For parallel use of multicoloured marbles for the palace of Diocletian see Marasović, Matetić Poljak, and Gobić Bravar 2012, in which the authors record the use of twenty-one different marble types in the palace.

66 The variety of marble types used for the columns and other structural and decorative elements and the variety of workmanship testify to the complex marble-trade connections in the late third century. Indeed, the parallel use of a variety of marble and different

67 As mentioned above, Lactantius counts a basilica among the building projects of Diocletian in Nicomedia. The two other mentions of a *basilike* in Nicomedia in later sources bear witness to their usage as imperial judicial courts. First, AASS *Aug.* iv.523 records St Agathonicus being tried before Galerius in a *basilike*; and second, Philostorgius 171 records St Artemius being brought before Julian in a *basilike*: Foss 1996, 2 n. 10.

68 For well-lit audience halls as a distinctive feature of Tetrarchic palatial architecture, see Mayer 2013, 2002. For the apsidal aula with mosaic pavement and other structures of the palace complex of Maximian (with both state and residential function) see Mori 2018.

69 See pp. 47–48 in Chapter 3 for the changing court ceremonial during the Tetrarchy.

the apse through an axial approach. Apart from being simply a private reception room, such large halls might also have functioned as judicial courts and spaces of imperial cult.[70] Besides basilical forms, centrally planned monumental structures of the Tetrarchic palatial complexes, such as the octagonal halls of both the palace at Serdica and the palace of Galerius at Thessaloniki, have also been identified as spaces for imperial reception.[71] The hall in Çukurbağ has an almost identical width (26 m) to the audience halls at Trier and Thessaloniki, while its opus sectile floor design is also paralleled in other communal gathering places of the Tetrarchic buildings, such as the Curia in Rome, the octagonal hall in Thessaloniki, and the imperial cult room at Luxor. Thus, with the evidence we have so far, we can suggest that the building in Çukurbağ was an audience hall that might have functioned as a space for imperial justice and imperial cult. In the physical absence of the emperor, this hall might have also served as a gathering space for the civic governing body. In fact, the themes of the reliefs that once decorated the hall, which will be discussed in detail in the following chapters, are very fitting for such a function.

[70] Yegül 1986, 16 suggests that the massive Marble Court of the Bath-Gymnasium complex at Sardis, after a renewal in the Late Roman period, functioned as a meeting place for the civic bodies of the town in this period, and therefore acted as a forum.

[71] Üçer-Karababa 2008, 194–99. Mayer 2013, 114–15 suggests that the octagonal building in Thessaloniki functioned as a reception hall for the visitors that entered the palace from the south. With its over 100 m long apsidal hall and a domed octagon with a diameter of over 30 m, the octagonal hall was one of the largest centrally planned buildings known from antiquity.

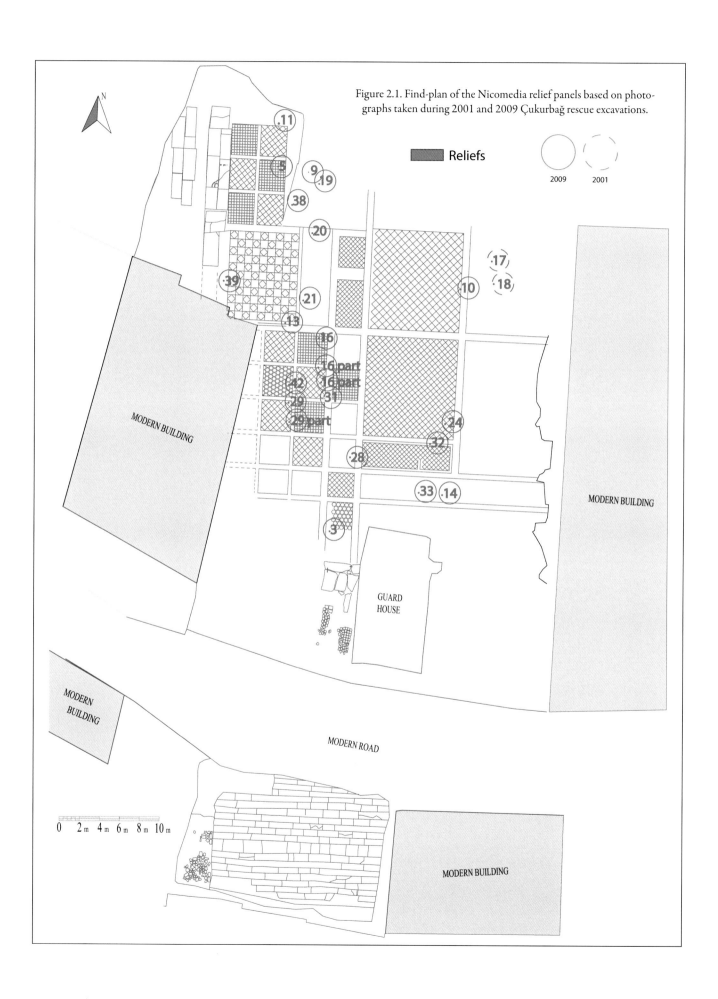

Figure 2.1. Find-plan of the Nicomedia relief panels based on photographs taken during 2001 and 2009 Çukurbağ rescue excavations.

TECHNIQUE, STYLE, AND COLOUR

This chapter provides a general overview of the material and technical aspects of the reliefs, including the processes by which they were initially designed, carved, fitted onto the building, and painted.[1] All of the reliefs are carved out of medium to coarse-grained white Proconnesian marble with grey-blue banding, from the quarries of the well-known nearby island. The average height of each panel is 1 m, including the projecting plinth on which the figures stand. The lengths of the panels vary from 73 cm to 4 m. Altogether, the surviving panels form a frieze approximately 50 m long. The variety of the lengths and tool marks on the lateral faces of the panels suggests that the frieze was an undulating one with indenting and protruding sections, perhaps following the contours of the aediculae, much like the reliefs of the *scaenae frons* of the theatre at Hierapolis.[2] With the current state of our knowledge, assigning to the frieze an exact position on the building is still problematic. With one exception, the bottom parts of the extant relief panels do not carry any evidence for secure bonding to an architectural neighbour below, such as clamp or dowel cuttings. This brings to mind the possibility that they were part of a podium frieze on the opus sectile floor. However, excavation photos from the 2009 expedition indicate that most of the relief panels were found together among architectural elements of an entablature, which fell down from above the columns (Fig. 1.8). In the absence of any excavation notebooks, these randomly taken photos are our only source for the find-situation of the reliefs and do not help further in reconstructing the sequence of the building. As discussed in the previous chapter, three differently sized sets of columns are present, with corresponding Corinthian capitals. The smallest order, consisting of pavonazzetto columns reaching up to 2.5 m in height, should have supported the small pediments of the aediculae inside. The other two orders, one of 5 m granite columns and one

of 3.5 m columns alternating between granite and cipollino, indicate two levels inside the building. Thus, either the frieze might have been in between the two floors, above the architrave of the 5 m granite columns, and thus about 6 m above the ground; or it might have been above the architrave of the 3.5 m alternating granite and cipollino columns of the second level, and thus about 10 m above the ground. The dimensions of the frieze, which must have been very hard to see from 10 m below, make the first possibility more likely. Alternately, the different parts of the frieze might have been situated in multiple levels. A better examination of the architectural elements in the future will surely help us understand the exact location of the frieze, and consequently its visibility, as determined by its height and lighting (Fig. 1.19). For now, in the most general terms, we can assume that the majority of the frieze came from the undulating entablature inside an imperial audience hall. Since in-situ positions of the individual relief panels, unearthed during the rescue excavations, were not documented in detail, it is also hard to determine their narrative order within the frieze. However, based on dozens of photographs taken from different angles during the 2009 excavations, we were able to prepare a provisional find-plan for the reliefs during the later Çukurbağ Archaeological Project (Fig. 2.1). This find-plan indicates that most relief blocks of the Nicomedia frieze extended along the western and eastern sides of the building before falling onto the opus sectile floor. Concentrations of similarly themed reliefs suggest that some agonistic-themed reliefs (**cat. nos 28, 32, 33**) decorated the south-eastern part, while some other reliefs with imperial scenes (**cat. nos 5, 9, 11, 19, 20**) adorned the north-western part of the excavated section of the building. Although tentative, these thematic-groupings have also influenced the sequence in which the reliefs will be discussed and presented in the catalogue of this book.

Design and Commission

The state-sponsored art serves an important role in promoting imperial ideologies, and the unique imperial motifs on the Nicomedia frieze indicate the involvement of artists from the imperial court in the design. Some of

[1] For material, technical, and commercial aspects of Roman stonework in general, see Ward-Perkins 1994; Adam 1994; Palagia 2006; Claridge 2015; Wootton, Russell, and Rockwell 2013.

[2] For the theatre reliefs of Hierapolis see D'Andria and Ritti 1985; Çubuk 2007; Benson 2014; Di Napoli 2015.

the relief panels, such as the embrace of the two emperors at the centre of a larger *adventus*, are heavily loaded with imperial propaganda, suggesting that the overall design was overseen by the artists of the imperial court, which was at the time based in Nicomedia itself. However, the inclusion of local motifs in the design, specific to the mythical history and civic pride of the city of Nicomedia, indicates the involvement of powerful Nicomedian officials as well, who would benefit from the publicity of their city as the seat of imperial power and glory.

Once the design themes were set, sculptural workshops in Nicomedia most likely took the commissions. The epigraphic and partial archaeological evidence confirm the existence of a powerful association of Nicomedian sculptors, architects, masons, and dealers working primarily with Proconnesian marble since the first century AD. In several of his publications, Ward-Perkins has proposed that Nicomedia had a monopoly on marble trade around the empire and even that a certain 'Asiatic' style was disseminated throughout the empire due to the influence of Nicomedian sculptors, architects, and masons.[3] According to Ward-Perkins, easy transportation of marble through harbours in the gulf and the River Sangarios facilitated the development of a complex organization of Nicomedian marble workers which controlled the trade of Proconnesian, Troadic, and Docimian marble, and other marble from minor quarries along the Sangarios Valley.[4] Indeed, except for the cipollino columns (which originated in the quarries of Euboea in Greece), all the architectural elements of the imperial complex at Çukurbağ represent the same combination: Proconnesian, Troadic, and Docimian marble. Güney's recent research on the economy of Roman Nicomedia has also proven that Nicomedia served as a major outlet in the transportation of Proconnesian and local marble from the Kutluca and Vezirhan quarries.[5] Her epigraphic review further verified the existence of an organization of Nicomedian sculptors, architects, and masons who worked primarily in Proconnesian marble not only in Nicomedia but also in the rest of Asia Minor, Italy, the Balkans, and North Africa.[6] To add to the collection of epigraphic evidence

referring to an organization of Nicomedian sculptors and masons, there is also the inscription on the reused block from the foundation of the western wall of the imperial complex in Çukurbağ, which appears to be an honorary decree to the emperor issued by the artisans of Nicomedia in the third century.[7] Another recently discovered inscription on a third-century sarcophagus from the western necropolis of Nicomedia refers to the occupation of the person buried inside as an architect. The inscription further states that whoever tries to open the burial should pay 15,000 myria to the union of architects and stoneworkers in Nicomedia.[8]

Considering its strategic location connecting Asia Minor, the Aegean, and the Black Sea, as well as its protected harbour, there is no doubt that Nicomedia served as a major outlet for marble supplies and processed products.[9] Despite this, whether or not it monopolized the marble market of the entire empire with a highly structured commercial system administered by imperial authorities and mediated through local agencies, as Ward-Perkins hypothesized, is hard to prove.[10] Sculptural and architectural finds from Çukurbağ, however, provide archaeological evidence for the existence of a group of local ateliers working with Proconnesian marble, perhaps as part of an influential Nicomedian sculptural 'school'.[11]

A Nicomedian Sculptural 'School' with a 'Distinct' Style?

Some eighty years have passed since L. Robert first drew attention to the possible existence of an influential organization of sculptors and stoneworkers in Nicomedia based on epigraphic evidence.[12] Later, as mentioned

ring to Nicomedian stoneworkers around the empire were initially listed in Ward-Perkins 1980a, 31–35.

[7] See above, p. 15.

[8] Öztürk and Demirhan 2019, 135.

[9] On the geopolitical importance of Nicomedia see Güney 2013. According to Güney, the timber trade was the primary source of income for the economy of Nicomedia, and marble trade was secondary.

[10] Other than the one in Nicomedia there were likely other organizations for the marble trade active on the island of Proconnesos itself and the nearby Cyzicus. See Russell 2013 for different economic models proposed for the Roman stone trade.

[11] The word 'school' is tentatively used to denote to a coherent set of technical and stylistic traditions followed by a group of artisans for at least a few generations.

[12] Robert 1960, 21–39.

[3] Ward-Perkins 1980a and 1980b.

[4] Ward-Perkins 1980a, 27–30.

[5] Güney 2012; for quarries in Kutluca and Vezirhan see above, n. 63, and Lazzarini 2010.

[6] Güney (2012, 207–08) provides a list of the sculptors, stoneworkers, and architects from Nicomedia working in Leptis Magna, Olbia, Tirgusor, and Nicopolis ad Istrum. These inscriptions refer-

above, Ward-Perkins elaborated on this hypothesis in his series of publications; he argued that this Nicomedian organization of stone dealers, sculptors, and stone-workers working with Proconnesian marble was very influential in the diffusion of a Nicomedian 'school' with distinctive motifs and workmanship that spread throughout the empire from the early first century to the late third century.[13] Both scholars' proposals mainly depended on epigraphy, although Ward-Perkins also looked at architectural material, especially Corinthian capitals and entablature blocks of Proconnesian marble from three remote territories of the empire (Triptolania, the Black Sea, and Pamphylia), in order to trace unique 'Asiatic' patterns in the workmanship.[14]

The best way to re-examine the possible existence and the influence of such a school is of course to look at the statues, busts, high-level sarcophagi and other sculptural material from Nicomedia itself. Until the discovery of the Çukurbağ material there was little sculptural evidence from Roman Nicomedia. The best-known Roman sculptures from Nicomedia, including an imperial portrait that has been identified as the Emperor Diocletian, were salvaged in the 1930s during the rescue excavations at the courtyard of a modern paper factory called Seka (see Chapter 1). In his initial evaluation of this sculptural material, Dörner implied the existence of a professional Nicomedian sculptural school.[15] There has never been a systematic excavation in Izmit, but since the 1930s, several other marble finds have been salvaged from different modern construction sites around Izmit, and they are now displayed in Kocaeli Archaeology Museum. In a recent article where she stylistically evaluates eleven of those randomly found sculptural pieces, Sezer also mentions a 'high-skilled' Nicomedian sculptural school.[16] Sculptural finds of 'high-art' from greater Bithynia, such as the Tyche of Prusias ad Hypium, have also been associated with an artistic school in Nicomedia.[17] However, none of these studies discuss any specific stylistic traits that mark the sculptures as products of a Nicomedian

school. So far, no sites of large-scale sculptural workshops have been found in the close vicinity of Nicomedia, and even if they were to be found, it is hard to connect an excavated archaeological workshop with a certain school as defined by stylistic analysis.[18]

The sculptures and architectural sculptures from Çukurbağ are the largest corpus of archaeological evidence that needs to be evaluated in the search for a Nicomedian school of sculpture. Even though recent trends in scholarship have proved that there are more important aspects of Classical art than just defining artistic schools through stylistic analysis,[19] the evaluation of sculptures from Çukurbağ in this context could help us to understand the evolution of imperial styles and motifs in the work of Nicomedian artists. At this point I want to clarify that I use the term 'style' not as a temporal designation, but to refer to types of formal qualities employed in the rendering of the artwork depending both on artistic traditions and situational circumstances of specific ideologies or commissions.

Compared to late third- to early fourth-century Roman sculpture from the West, in general, the Çukurbağ reliefs exhibit a lingering Greek taste for naturalistic representation and Hellenistic mannerisms.[20] The latter expressive tendency is well attested in the windblown hair of the Fury on **cat. no. 25**, in the lifeless leg of the exhausted marching horse on **cat. no. 11**, and in the open mouths of the anguished soldiers and the complex diagonal composition of the lively combat scene on **cat. no. 10**. Furthermore, the reliefs exhibit the use of a number of pictorial effects in their carving such as drilled outlines for the figures and the extensive use of drilling for details in the hair and drapery for a *chiaroscuro* effect. When compared to other known Tetrarchic reliefs from the Arch of Galerius and the Arch of Constantine, the similar motifs on the Nicomedia reliefs (such as the battle and *adventus*) are depicted in a distinctive synoptic way with less crowded compositions with elegant figures.[21] The mounted imperial figure on

13 According to Ward-Perkins (1980b, 334) this very influential Bithynian artistic school flourished in Hadrianic times and operated well into the end of the third century.

14 Ward-Perkins 1980a; 1980b.

15 Dörner 1941b.

16 Sezer 2015. Another recent study by Laflı (2018) catalogues second- and third-century Roman funerary portrait busts in Kocaeli Archaeology Museum and addresses the need for a detailed characterization of Nicomedian funerary sculpture.

17 Traversari 1993.

18 Güney (2012, 185) discusses the survey conducted by Çalık Ross in 2006, which revealed remnants of a Nicomedian marble atelier that may have produced sarcophagi near a local quarry in the Kandıra region of Izmit.

19 Kristensen and Poulsen 2012, 8–9.

20 In comparison for example to the Constantinian reliefs of the Arch of Constantine, Nicomedia reliefs appear more rooted in the Greek tradition.

21 Indeed, crowded scenes on elongated rectangular Constantinian panels on the Arch of Constantine and on the Arch of Galerius can be linked to the involvement of sarcophagi workshops in their

cat. no. 10, or the attacking warrior on **cat. no. 39**, for example, appear as just blown-up successors of the mounted figures on the Alexander Sarcophagus of the late fourth century BC. Likewise, the above-mentioned portrait head of the Emperor Diocletian(?) discovered in the Seka area, with its naturalistic features departs from the contemporary cubic and stylized tetrarch portraits known from elsewhere.[22] This persistence of Greek naturalism and Hellenistic mannerism even into the late third century AD, however, cannot be a unique feature of a Nicomedian sculptural school, as Roman sculpture from Asia Minor in general exhibits this tendency.[23] Studies on the distinctive stylistic features of the micro-Asiatic sculptural schools of Aphrodisias[24] and Docimium[25] (the latter especially noticeable in the sculpture of Hierapolis) all emphasize the persistent 'classicizing' and 'baroque' features typical of Hellenistic art that are incorporated in different levels in the Roman sculpture.[26] Perhaps the only contemporary analogous relief sculpture to the Çukurbağ reliefs that might help with tracing patterns in the style and workmanship of a potential Nicomedian sculptural school are the 'Tetrarchic reliefs' inserted into the later city wall of Nicaea.[27] However, they are too worn for the figures depicted even to be identified.

One other notable stylistic aspect of the Çukurbağ reliefs is the juxtaposition of calm and static compositions in imperial processional depictions (e.g. **cat. no. 17**) with active complex compositions in lively battle scenes (e.g. **cat. no. 10**). The contemporaneous use of different styles for different themes and messages,

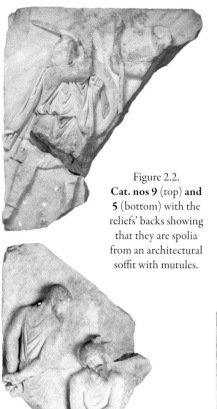

Figure 2.2. **Cat. nos 9** (top) **and 5** (bottom) with the reliefs' backs showing that they are spolia from an architectural soffit with mutules.

especially on later Roman reliefs, is well explained in Hölscher's ground-breaking work on semantic methodology.[28] Other well-known examples of the intentional combination of contrasting styles in Tetrarchic art include the frescoes of the imperial cult room at Luxor. In McFadden's view, the stylistic variety of these frescoes marks a shift in thematic content;[29] and Elsner further argues that on the frescoes, the emperor was represented in different styles corresponding to his human and divine roles: naturalistic for the former, and abstracted and symbolic for the latter.[30] Leaving aside the semantic underpinnings, though, if we think about the reasons for the stylistic variety on the Çukurbağ reliefs in practical terms, it would be hard to depict a lively battle in a calm and static scene, or an orderly procession in a complex scene. Thus, the stylistic variety on the Çukurbağ reliefs could not have been an idiosyncratic feature of a Nicomedian artistic tradition either, but a requirement of the chosen motifs.

carving, as they used similar rectangular layouts for the carving of sarcophagi, see Elsner 2000, 160. For scenes of a battle and an *adventus* on the reliefs on the Arch of Galerius see Rothman 1977, figs 11 and 22 for the *adventus* scene on the Arch of Constantine see Ferris 2013, 62, fig. 23. Also see Chapter 3, pp. 47–51 and n. 43.

22 Prusac 2011, 63.

23 This 'Greekness' is of course relative to the imperial art of the Italian Peninsula. For the distinctive aspects of the imperial art of the Greek East under Rome see Smith 2015 and Töpfer 2018.

24 Squarciapino 1943; Erim 1986, 133–52.

25 D'Andria and Ritti 1985, 187.

26 See Traversari 1993, 22–25 for a general discussion of micro-Asiatic sculptural schools.

27 Laubscher 1993.

28 Hölscher 2004.

29 McFadden 2015, 107–08.

30 Elsner 2000, 173–76.

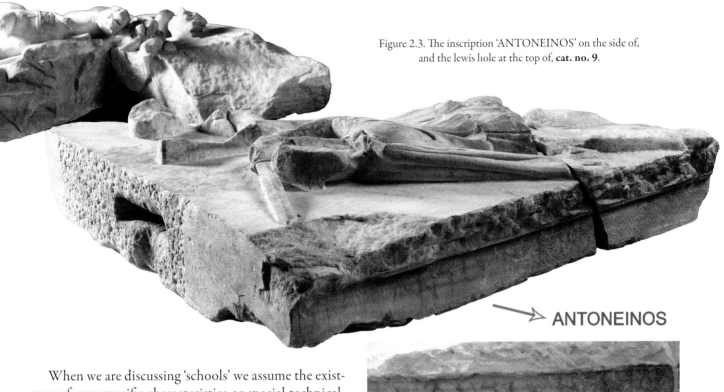

Figure 2.3. The inscription 'ANTONEINOS' on the side of, and the lewis hole at the top of, **cat. no. 9**.

ANTONEINOS

When we are discussing 'schools' we assume the existence of very specific characteristics or special technical-stylistic directions which were taught and continued for generations. The Çukurbağ reliefs exhibit distinctive stylistic and technical features, yet it is hard to know to what extent these features were influential around the empire and whether or not they formed a long-lasting tradition with distinct 'Nicomedian' notes in the eyes of the contemporary Romans. We do not know, for example, if they considered the unique 'Tetrarchic embrace' motif (see the discussion in Chapter 3) as an invention of a Nicomedian sculptural school. The style and technique of the Çukurbağ reliefs seem to have been affected more by the needs of the individual imperial design and its motifs than the stylistic traditions of a 'school'.

Executing Workshops

A close examination of the Nicomedia reliefs can provide clues about the organization of the executing Nicomedian workshops and their working processes.[31] The large scale of the project and the need for fast work suggest that more than one workshop was involved in the production process of the Nicomedia frieze and the freestanding sculpture which adorned the imperial complex. Commissioned workshops should not have waited

too long for the marble supply as Proconnesian marble might have been readily available in the marble yards by the harbour of Nicomedia and if not, it might easily have been shipped from the nearby Proconnesos island.[32] It seems that in some cases, marble blocks were even readily available in or close to the sculptural workshops, as at least four relief panels of the Nicomedia frieze were re-carved from earlier architectural spolia (**cat. nos 2, 5, 9, 44**). Among these, the backs of both **cat. nos 5 and 9** exhibit traces of an architectural soffit with mutules, indicating that they are both re-carved from the same architectural soffit, and thus possibly both produced by the same contracted workshop (Fig. 2.2).

Cat. no. 9 also carries a painted inscription on its lateral face, perhaps referring to the contracted workshop. The inscription written in Greek letters in red paint, with an approximate letter height of 5 cm, reads ANTONEINOS (Fig. 2.3). The location of the inscription on the lateral face of the block (which was not meant to be seen) and the sloppy manner in which the

31 For an overview of artisans and workshops in Roman art and archaeology in general see Kristensen and Poulsen 2012, and also Claridge 2015.

32 According to Ward-Perkins (1980a, 39) marble supplies for the market were available at the quarries, ports, and marble yards of the principal importing cities.

letters were written indicate that this note might refer to the workshop, or to the sculptor or painter who received the commission for this relief panel.[33] There are also illegible marks painted in red on the backs of **cat. nos 10 and 15**. Two letters engraved on the nape of a colossal goddess' neck are further proof of active mass production in Nicomedian sculptural workshops (Fig. 2.4).[34] If we think of the Greek letters Beta and Psi engraved on the back of the head as part of the Greek numerical system and thus used to label the individual sculptural pieces produced in one workshop (similar to a modern serial number) as part of a control or accounting system, then the head appears to be labelled with the number 702. It is more likely, however, that these letters refer to some sort of numerical system that indicates the other sculptural parts to which the head needs to be connected. In any case, the need for a numerical system for individually produced sculptural pieces indicates sculptural production on an industrial scale.

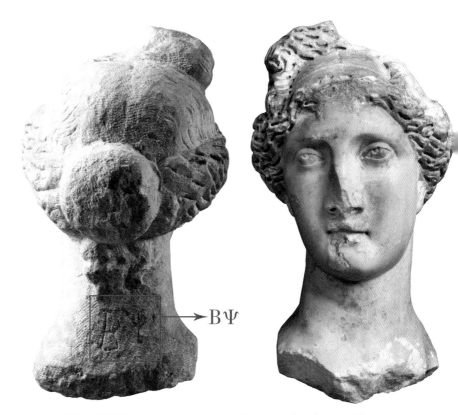

Figure 2.4. The inscription at the nape of the neck of a colossal goddess discovered in the imperial complex at Çukurbağ.

Carving and Tool Marks

Once the commissioned workshop acquired the marble block, the guidelines of the design must have been laid out with charcoal or paint. The sculptors must have carved from the front plane to the back plane with a sub-

tractive process, beginning by carving the rough shape of the plinths. Almost all of the reliefs were laid out with a plinth: that is, a protruding ledge on which the figures stand. The average height of the plinths is 15 cm. Of all the reliefs, **cat. no. 11** includes a projecting top band in addition to a plinth. Two fragmentary reliefs, **cat. nos 35 and 37**, also have a top band with an average height of 8 cm. The four reliefs surviving in fragments **cat. nos 29, 34, 35, and 36** seem to have been laid out with vertical protruding frame-bands on the sides and multiple horizontal bands within the relief, which served as different ground levels for smaller-sized figures on these reliefs. After the plinths were laid out, the figures were roughed out. Except for the above-mentioned reliefs (**cat. nos 29, 34, 35, 36, 37**) and **cat. no. 38** in which smaller figures are shown in multiple registers/bands, all the figures of the Nicomedia frieze are half of life-size, with the average height of a head from chin to crown ranging from 9 to 16 cm. Some of the figures are carved in high relief, projecting far out from the back plane. Most figures, however, are not fully three-dimensional and are left connected to the back plane. Thus, from the very beginning, the figures have been conceived as parts of architectural reliefs rather than as freestanding statues. The average depth of the figures on the reliefs

[33] Three Corinthian capitals and a column drum found in the quarries of the island of Proconnesos also bear a similar inscription. The letters spelling ANTON (perhaps an abbreviation of the name Antoninus or Antoneinos) carved on this Proconnesian architectural material may refer to the workshop in the quarry or to the person in charge of the imperial administration of the quarry, see Albustanlıoğlu 2006, 275.

[34] The variety of inscriptions on Roman architectural and sculptural marble blocks include crude inscriptions made in the quarry or in transit as part of a control and accounting system, inscriptions naming special qualities of the marble, inscriptions of the stone merchants, and inscriptions of the craftsmen. For an excellent overview of builders' and sculptors' marks and numerical systems in Classical architecture and sculpture, see Weber 2013. Albustanlıoğlu (2006, 104–61) also provides an overview of carved and painted inscriptions and marks on the architectural blocks found in the quarries of Asia Minor, including Proconnesos, and examines how these marks reflect the business organization of the quarries.

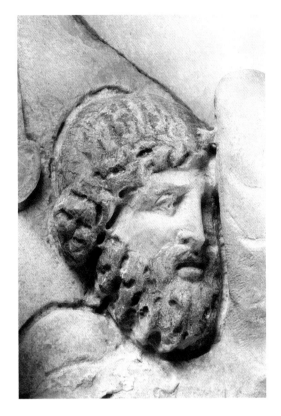
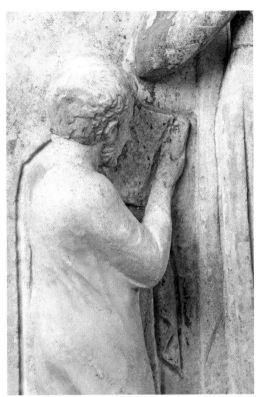

Figure 2.5. Details from **cat. nos 10 and 33** showing drilled outlines for the figures.

measuring from the front plane to the back plane is 8 cm, reaching 13 cm at the deepest. The average thickness or depth of the marble blocks out of which the reliefs are carved is 22 cm, though there is a considerable variety ranging from 10 to 26 cm.

Except for the reliefs re-carved from earlier spolia, the backs of most relief panels have rough quarry-pick marks. Side-ends (lateral faces) of the panels are roughly finished with point chisels. Likewise, the tops of the panels are roughly trimmed down with point chisels according to the height of their architectural setting. A great range of sculptural tooling can be observed on the relief surfaces. The background of the figures on the front plane is usually smoothed with flat chisels and rasps. Figures are outlined with drilled channelling. The drill is also used for the folds of drapery, hair, irises, and ren-

dering of foliage. The drill work on the figures, even the drilled outlines where the figures join the background, is left visible (Fig. 2.5).

The surfaces of the figures are worked with a variety of tools including fine claw, point, and flat chisels, as well as roundels and rasps. The top and front surfaces of the plinths show a considerable variety of finishing, from point chisels and claw chisels to much smoother surfaces treated with abrasives. Even on the surface of a single plinth, one can trace the use of multiple tools. Three-quarters of the front surface of the plinth on **cat. no. 1**, for example, is left with point chisel marks, while the rightmost quarter of the plinth is finished with a fine claw chisel (Fig. 2.6). On some panels such as **cat. nos 6 and 32**, the front surface of the plinth is smoothly finished with the use of fine rasps and even powder abra-

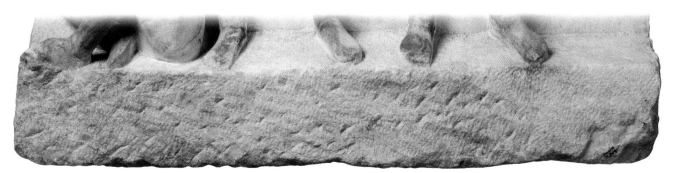

Figure 2.6. Close-up view of the plinth of **cat. no. 1** with multiple tool marks.

Figure 2.7. Comparison of two plinths (of **cat. nos 32 and 12**) with differently finished front surfaces.

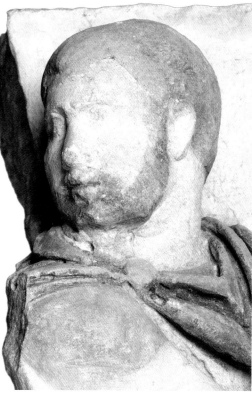

Figure 2.8. Detail of the emperor with partially carved neck and painted beard on **cat. no. 15**.

sives, while the plinth on the majority of panels has a textured front surface finished with claw chisels applied diagonally (Fig. 2.7).

There is no evidence for separately inserted metal or marble pieces on the reliefs. Extended limbs or objects such as projecting arms, spears, or even cart wheels, which require a lot of carving to be partially liberated from the backplane, are carved in one piece and remain connected to the original marble block. No matter how three-dimensional the figures look, this rendering of the figures as part of the original architectural block as opposed to separate pieces attached to it later, combined with the exposed drilled outlines on the backplane of the figures (which give a somewhat unfinished look to the reliefs), suggests that the sculptors conceived of the reliefs as structurally and materially integral to their architectural surroundings.[35]

The reliefs also exhibit great variety in the way the figures are detailed and finished using sculptural tools and paint. Most shoes, for example, are carved only summarily with their specification expressed mostly through paint. On some figures, the hair is initially detailed with fine carving, while on some others the details of the hair are left to paint. The hair and beards of the embracing emperors on **cat. no. 16**, for example, were stippled with

the use of a fine chisel before paint was applied, while the hair of the mounted emperor on **cat. no. 15** is defined only later in the decorating process with paint. Indeed, even a section of the mounted emperor's neck on **cat. no. 15**, which is barely visible to the viewer as it is closer to the background, is left crudely finished without any smoothing by sculptural tools (Fig. 2.8).

This variety of surface treatment of the reliefs and the sculptors' inconsistent reliance on paint rather than detailed carving are indicative of the high-speed work of the executing workshops, the physically high position of some of the reliefs in the architectural setting, and also of the close communication between the sculptors and painters. In fact, the reliefs might have been painted by the sculptors themselves.

Lifting and Fitting

At least nine of the relief panels still carry the traces of lewis holes: rectangular sockets for lewis irons which were used to lift up the panels during their installation in the building (Fig. 2.3). Lifting with lewises, the most popular lifting technique in Roman architecture, involved cutting a cavity in the stone for the insertion of a metal lewis, which grabbed hold of the stone dur-

[35] This treatment of the sculptural figures as mainly parts of the architecture, in contrast to the reliefs of the Hellenistic period in which extreme parts of the figures were made separately and added later, is also the case for the reliefs of the Sebasteion at Aphrodisias, see Smith 2013, 39.

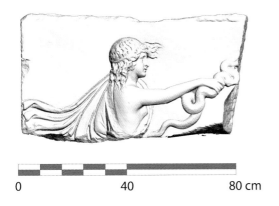

Figure 2.9. 3D model of **cat. no. 25**. The incised line used to measure the trimming from above is visible above the heads of the figures.

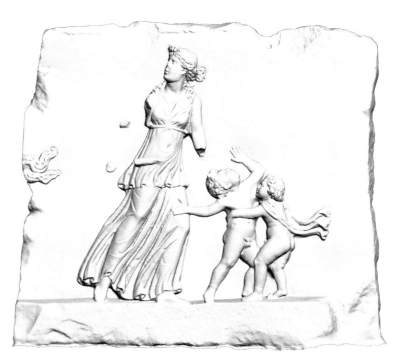

Figure 2.10. 3D model of **cat. no. 14** with details of lewis cutting at the top centre and clamp cutting top left.

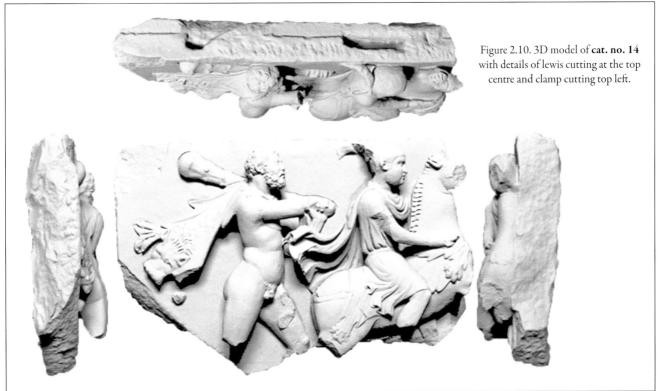

ing hoisting as part of a roped pulley system.[36] The location of the lewis holes on the top surface of the blocks behind the figured plane indicates that the reliefs were mostly carved on the ground; after carving, a rectangular cutting with slanting sides was made on the top surface of the block to insert a lewis iron; and then after hoisting, the lewis was removed and the top of the panel was trimmed to fit into the height of its architectural setting. On the front surface of **cat. no. 25**, above the figures, one can even see the original incised line that the builders used to measure the limits of trimming (Fig. 2.9).

Although it varies according to the volume of the stone to be lifted, the vertical depth of an average lewis socket needs to be at least 10 to 12 cm in order to safely

36 For lifting practices with lewis irons in Classical architecture see Coulton 1974, Adam 1994, 48–51, and most recently Aylward 2009.

carry an architectural stone block. The extant depth of the lewis cuttings on top of the relief blocks of the Nicomedia frieze ranges from 2 to 8 cm, allowing us to calculate approximately how much of the height was trimmed off from the top of a panel after it was initially carved on the ground. For secure lifting, the lewis sockets are usually carved at the axis of the centre of the gravity on the top parts of the blocks. Thus, the location of the lewis cuttings also helps us measure the approximate original length of a relief panel that is broken along the side-ends. For example, **cat. no. 14** is broken off on the right side and has an extant length of 105 cm, but based on the assumption that the lewis socket was placed centrally on the top of the block, one can deduce that the block was originally about 150 cm in length (Fig. 2.10). Similarly, the approximate original length of **cat. no. 16** (with an extant length of 270 cm today) can be calculated as 400 cm, and the approximate original length of **cat. no. 25** (with an extant length of 158 cm) can be calculated as 200 cm. The original length of the broken relief blocks is essential to understanding the original architectural setting of the reliefs. The positioning of the lewis hole on **cat. no. 16** above the embrace of the emperors, for example, suggests that it was the longest relief block, situated in a prime location and extending straight for about 4 m uninterrupted by the contours of the architectural elements below or above.

Since the sockets are negative impressions of a lewis iron, the typology of the lewis sockets in Roman architecture could even help reveal the changes in lifting practices and connections between the builders using similar lewis irons.[37] Due to the incomplete preservation of the sockets on the Nicomedia blocks, however, tracing the use of one specific type of lewis iron with certain dimensions is impossible. Because the widths of the sockets are preserved, the only conclusion we can make about the lewis irons used is that they were wide (at least 3.5 cm in width) compared to the lewises usually used in Hellenistic architecture.[38] The side walls of the lewis sockets slant inwards about 1.5 cm at the bottom corners in accordance with the shape of lewis irons inserted. Tool marks, especially rough point chisel marks on the sockets, indicate that the holes were cut hastily on the

spot before lifting. The fact that some of the relief panels with preserved top surfaces lack lewis holes does not mean that these panels were not lifted up. The builders might have completely shaved off the lewis socket in the process of cutting the relief panel to the right height on the building, or they might have used alternative lifting systems.

After hoisting, the builders seem to have used various methods to bind the relief panels to their architectural setting. The metal clamps and dowels used for this purpose did not survive, but cuttings made for them give us some information.[39] Sockets for clamps on top of the relief panels show that they were mainly bonded horizontally to the back wall. Metal clamps inserted on top of the panels (with widths ranging from 2 to 4.5 cm) seem to have connected them to the architectural element behind. Indeed, on most sockets one can even see the traces of channels cut along the width of the block towards the back of the panel with a point chisel (e.g. **cat. nos 10, 11, 24**). Some of the entablature blocks on site have cavities for clamps and some also have cuttings for dowels with small channels for pouring molten lead inside. However, a further and more thorough analysis of the architectural elements in Çukurbağ is needed to find the corresponding sockets for the extending clamps on the architectural blocks. Only two of the relief panels, **cat. nos 26 and 33**, have traces of lateral clamps, which tied the panels horizontally to the neighbouring architectural elements on the sides. The back wall of the lewis sockets on relief panels **cat. nos 9 and 20** were cut as channels after hoisting to insert some sort of clamp connecting the panels to the back (see Fig. 2.3 for **cat. no. 9**). Traces of mortar still detectable on the backs of some relief panels (**cat. no. 11** for example) indicate that mortar was also used as a binding agent to secure the panels to the back wall and prevent them from falling down in case of an earthquake. With the exception of two oval cuttings at the right bottom corner of **cat. no. 32**, there are no extant dowel sockets at the bottoms of the plinths used to bind the relief panels to an architectural neighbour below.

The tool marks left from the fitting process of the panels also indicate hasty work. In a hurry to install the mostly finished figured relief panels after hoisting them up, builders took extreme steps, even if this meant destroying already-finished parts of the figures. In trying to fit **cat. no. 12** to its architectural setting,

[37] Aylward 2009, 312.

[38] Aylward (2009, 313–20) in his examination of the lewis sockets of the Hellenistic and Roman buildings of Pergamon provides an excellent overview of the lifting system and shows how the thin sockets of the Hellenistic buildings became wider in Roman buildings.

[39] For types of clamps and dowels used in Roman architecture see Adam 1994, 51–59.

for example, builders roughly trimmed the right side-end of the panel, including the tip of the horse's tail. The large combat relief (**cat. no. 10**), with detailed carving, also underwent a transformation during the fitting process. Point chisel marks behind the armoured figure on the panel indicate that after being carved in detail on the ground, the upper left corner of the relief panel was shaved off to fit the panel into an architectural join. Rough point chisel marks along the left side of **cat. no. 26** indicate that the builders cut out an already-carved tree which the founding hero of Nicomedia was shown approaching. The trunk of the tree and the drill marks used for its foliage above are partially visible along the left side of the panel. Even though it meant jeopardizing the overall composition and meaning of the relief, the builders seem to have completely shaved off this tree in order to fit the panel into its architectural setting. There are also random concave cuttings made with a point chisel on the bottom surfaces of some plinths such as on **cat. nos 13 and 17**, suggesting that they were reworked on the building in order to fit them to an architectural element below.

The lewis cuttings and other tool marks discussed above indicate that the reliefs were mostly carved on the ground and then hoisted, but there is also evidence for extensive carving of some relief panels on the building. **Cat. no. 13**, for example, seems to have been extensively reworked on the building after the sculptor had roughly sketched out a soldier figure, the bottom plinth, and a protruding border on the right side. After the panel was joined to an architectural corner on the building, the relief, especially the upper left part as exposed to the viewer, was reworked. Point chisel marks where the head of the soldier would have been must be related to a repair. The face of the soldier could have been damaged or carved incorrectly after the panel was hoisted, and thus chiselled off and perhaps replaced by a plaster face mounted to the relief. Other than this example, overall, there are no traces of extensive repair on the reliefs which could suggest their redeployment (secondary use) after an earthquake or another kind of destruction.

Polychromy and Visibility

The excellent preservation of colour on the Nicomedia frieze is unprecedented in the corpus of Roman state relief sculpture. As the only extant imperial monument which preserves extensive applied polychromy, the frieze helps us investigate many technical aspects of sculptural polychromy, such as the application of colour and the paint-er's role in sculpture.[40] Furthermore, an iconographical approach to the polychromy of the Nicomedia reliefs helps us understand aspects of increasingly prevalent colour-coding in the imperial art of the later third century.

The polychromy research on the Nicomedia reliefs initiated in 2016 under the guidance of Mark Abbe includes in-situ microscopic examination (5–100×); ultraviolet (UV), infrared (IR), and visible-induced luminescence (VIL) imaging; and portable in-situ X-ray fluorescence spectroscopy (pXRF) analysis.[41] In the most general terms, the non-destructive microscopic and multispectral imaging techniques that were used involve recording the traces of now-lost pigments under IR and UV light, and pXRF analysis involves recording the chemical composition of pigment particles left on the marble surfaces.

Patterns of Colour and Coloration

The extant colour on the reliefs is dominated by iron-based reds, oranges, and browns, with more limited use of brilliant mercury-based reds (presumably cinnabar); lead-based orange reds; carbon black and different shades of Egyptian blue mixed with calcium whites; and isolated remnants of a pink colourant. In-situ pXRF indicates that a brilliant mercury-rich red cinnabar is used selectively for red lips, mouths, shoes, and other ornamental elements, with most foundational colours being executed in iron-rich yellows, reds, and browns. The distinctive imperial purple of the garments was created by overlapping cinnabar red with a mixture of a now-vestigial organic pink lake and Egyptian blue.

The close examination of the reliefs did not reveal any evidence for a painted background colour.[42] Roman state reliefs have often been assumed to have background colours, especially blue.[43] The contemporaneous Tetrarchic

[40] For sculptural polychromy and the main methods of research in Roman sculpture in general see Abbe 2015 and Østergaard 2018. For an investigation of vestigial remnants of colour on Trajan's Column see Del Monte, Ausset, and Lefevre 1998; on the Arch of Titus see Fine, Schertz, Heinrich, and Sanders (forthcoming).

[41] Initial findings are discussed in the recently published Abbe and Şare Ağtürk 2019. Selective microsamples have also been taken for more complete laboratory analysis by multiple methods in the future, including polarized light microscopy, scanning-electron microscopy, Raman spectroscopy, and X-ray diffraction spectroscopy.

[42] Abbe and Şare Ağtürk 2019.

[43] On background colour see most recently, informed: Liverani 2018; speculative: Pogorzelski 2015.

imperial wall paintings at the Luxor Temple in Egypt, specifically the apse with the figures of the tetrarchs were also painted with a background colour.[44] The absence of any such colour on the Nicomedia reliefs suggests that the hierarchy of the reliefs' diverse subjects and themes were defined within the frieze by position and presumably by readily legible variations in the values and amount of colour on the narrative elements. The reliefs did not display any remains of gilding either, though both architectural elements (including acanthus pilasters and decorative reliefs) and freestanding sculptures found in immediate proximity to the reliefs retain significant evidence for leaf gilding.

Figure 2.11. Details from **cat. nos 16**, **21**, and **23** with red-coloured drip lines.

The consistency in the extant colour palette and the colouring technique indicate that the frieze was painted in a single uniform phase after it was installed in its architectural setting. The paint itself is often heavily abraded from burial and excavation and generally only a single layer of colour has survived. Most of the extant painting was executed in thick opaque paint layers, and it is most thickly preserved in the protected recesses of the relief. The evidence for the use of overlapping layers of colours to build up colour values or create highlights or shadows can be observed on several reliefs (see Fig. 2.19c–d for the layers of the purple *paludamentum* and Fig. 2.13 for the layers creating a shadow effect). Much of the extant painting was quickly applied in large brushstrokes to block out large areas of colour. Painting frequently extending beyond the drilled outlines of the sculpted relief or overlapping with adjacent colours also indicates a rushed application without detailed attention to the edges of painted areas. Furthermore, drip lines,

most readily visible below the feet of embracing emperors on **cat. no. 16**, suggest that the reliefs were painted in a vertical position after being secured into their larger architectural setting. These drip lines are especially prominent on reliefs with imperial subjects where the thickly applied and distinctive deep reddish paint of their purple *paludamenta* ran in drip lines over the front edge of the relief blocks, such as on **cat. nos 16, 21, and 23** (Fig. 2.11) as well as **cat. no. 20**.

The artisans seem to have heavily depended on the colour for the detailed definition of the carved figures. Details like eyebrows or facial hair on the head of the emperor on **cat. no. 15**, for example, are defined merely by paint without prior sculptural definition (Fig. 2.8). The paint on the face of the imperial rider (originally chipped off, now restored) on **cat. no. 10** has mostly faded away since its excavation. However, a photograph

44 Jones and McFadden 2015.

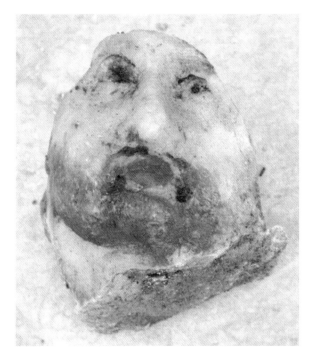 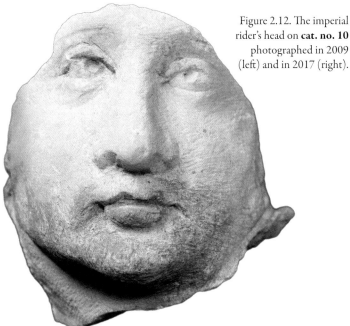

Figure 2.12. The imperial rider's head on **cat. no. 10** photographed in 2009 (left) and in 2017 (right).

from its initial discovery in 2009 shows that the mouth of the imperial rider was highlighted with a mercury-rich red and the beard was defined with a darker iron-based red, while black was used to define a horseshoe-shaped moustache. The same combination of black and brownish-red is also used in the detailed definition of the shadowy eyes (Fig. 2.12). The startling difference between the two (only eight-years-apart) photos of this head also testify to how much colour and thus definition we lost after the initial discovery.

Abbe focuses on the painting on the face of the standing captive on the far left of **cat. no. 3** to illustrate some aspects of the painting process.[45] The head, 10 cm in height, of this stock figure was painted to be seen from a distance. The mouth is highlighted with a mercury-rich red. The hair and beard are rendered in an iron-rich yellow, but a second layer of darker reddish paint is added over the inner forehead and the side of the beard near the background plane of the relief to create the impression of shadow (Fig. 2.13). Key facial features, including the eyebrows, bags under the eyes, pupils, and nostrils are rendered with quick brushstrokes a quarter of a centimetre wide in this same dark-reddish colour, while the lips, and border of the cap are highlighted in brilliant red cinnabar.

Stark colour contrasts used in the painting of the frieze must have improved the legibility of visual elements from great distances and enhanced perspectival

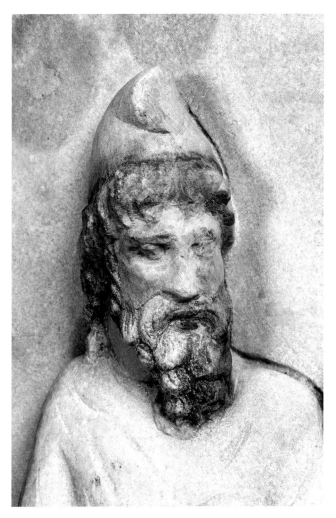

Figure 2.13. Standing captive on the far left of **cat. no. 3**, illustrating some aspects of the painting process.

45 Abbe and Şare Ağtürk 2019.

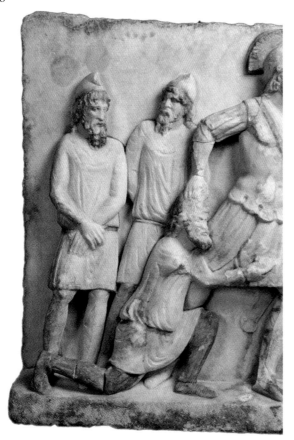

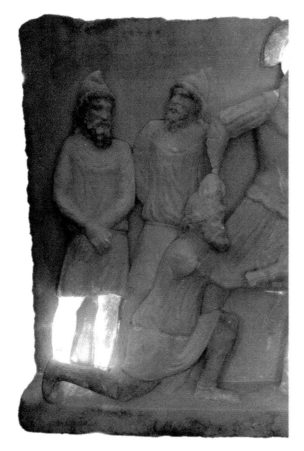

Figure 2.14. **Cat. no. 3**, detail of the captives' trousers in daylight and under IR light with Egyptian blue glowing white.

effects. For example, the trousers of two barbarian captives on **cat. no. 3** are painted in completely contrasting colours. The now-faded Egyptian blue of the standing captive's trousers can be clearly traced under IR light, while the brilliant red of the kneeling captive's trousers right in front of him can still be seen today with the naked eye. The two captives are dressed in the same costumes and their feet overlap, but the alternating colours of their trousers — a warm hue of red in the foreground and the cool blue for the receding figure in the background — must have aided in their differentiation from a distance, as well as strengthening the rhythmic sequence of the scene (Fig. 2.14).

The military and imperial figures and their costumes on the frieze seem to have received particular detail in their sculpted and painted definition. Egyptian blue mixed with calcium-based white is used abundantly on metal swords, spear tips, helmets and greaves, arrows, and shield bosses, as is evident from both examination and VIL imaging (Fig. 2.15). Some shields have diamond-shaped shield bosses and laurel leaves (discernible under UV light) with a mercury-rich red border (Fig. 2.16). Other more elaborate shields have red borders and black border elements framing sculpted and painted Medusa heads (Fig. 2.17).

Colour-Coding and Imperial Costume

The variations in the values and amounts of colour on the reliefs contributed to the hierarchy of figures and narrative elements. The different barbarians on the frieze, for example, have distinct hair colours and styles: for example, some have thick curly yellow hair and beards topped with floppy hats, while others have bob-cut hairstyles variously painted with yellow and reddish-orange (Fig. 2.18). As explained in detail in Chapter 3 (pp. 65–69), this differentiation of colour might not have designated specific barbarian ethnicities, but the variety of captives might have enhanced the triumphant message of the imperial frieze for viewers, evoking the idea of numerous different peoples being conquered.

The most elaborate and colourful costumes on the reliefs are reserved for emperors. On **cat. no. 14** an emperor, undoubtedly Maximian being crowned by Herakles, wears cinnabar-rich leggings and bordered garments (Fig. 2.19a). His reddish-purple *paludamentum*, created with a complex pigment mixture, appears to be reserved solely for imperial cloaks on the reliefs. This paint remains thickly preserved on this relief in the drill channels (Fig. 2.19b). It features two paint layers: first

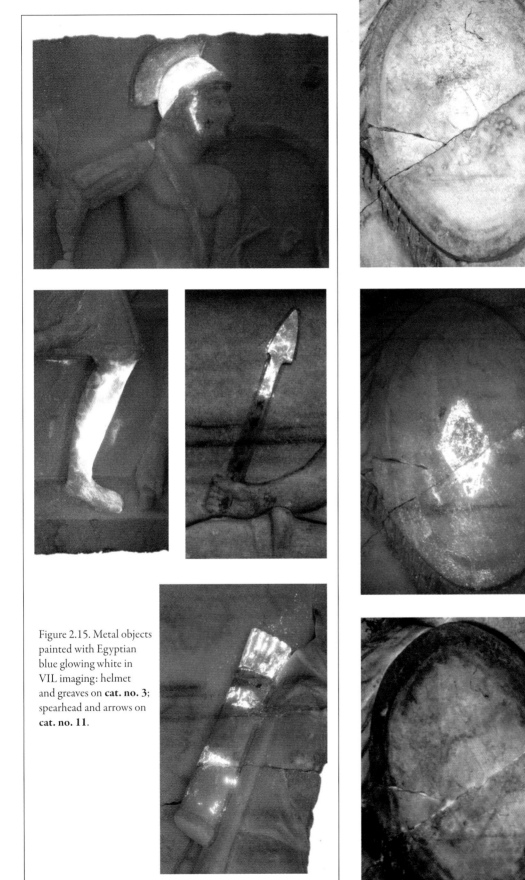

Figure 2.15. Metal objects painted with Egyptian blue glowing white in VIL imaging: helmet and greaves on **cat. no. 3**; spearhead and arrows on **cat. no. 11**.

Figure 2.16. Detail of the shield carried by the weary soldier on **cat. no. 11** in ambient, IR, and UV light.

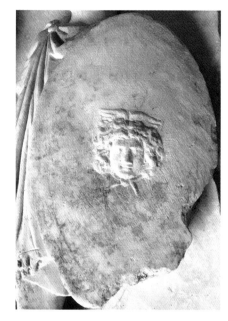

Figure 2.17. Detail of the shield on **cat. no. 1**, with VIL image of the Medusa head.

the thick, opaque mixture of iron-based red, cinnabar, and lead, and overlaid on top of it the fragmentary vestiges of a second paint layer of an organic pink precipitated on a calcium-white with particles of Egyptian blue (Fig. 2.19c–d). Such layering of reds and pinks was a standard method of achieving purple in Roman painting and here this complex combination of pigments and paint layers obtained the desired imperial purple colour. Only imperial subjects display this combination of pigments on their imperial *paludamenta*, indicating that this purple was a specifically imperial colour on the reliefs. Colour-coded costumes of this sort aided the immediate legibility and the hierarchy of the imperial subjects on the sometimes densely packed frieze.

Some of the best-preserved paint survives on a focal point in the narrative of the reliefs: the astonishing *adventus* scene of two emperors embracing on **cat. no. 16** (Fig. 2.20a–f), representing the culminating moment of an imperial procession. Victories, their sculpted blue-painted wings still preserved on the background relief, flank the central embracing emperors, both of whom appear to have been awash in purple, descend from flanking purple chariots. Despite their similarity they are clearly and emphatically differentiated, not only in their height and the height of their flying Victories but also in their hair colour: the hair of the taller emperor on the left (Diocletian) has a light grey-brown colour, while that of the emperor on the right (Maximian) has a red hue. When examined with pXRF, both portrait heads display traces of iron, lead, and copper, but with significantly more iron on Diocletian on the left and more lead on Maximian on the right. While no Egyptian blue appears to be preserved from flesh tones in general, microscopic examination paired with examination in UV light may suggest the partial preservation of flesh tones on the portrait heads of the emperors. The experimental digital reconstruction of the relief, based on the initial results of the technical analysis, reveals a startling image (Fig. 2.20g). Yet, this image should remain as experimental, as with the combination of various organic binders, colours might

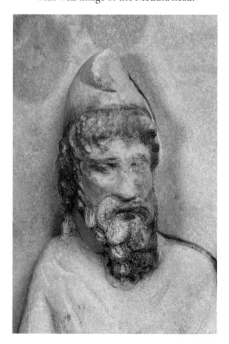

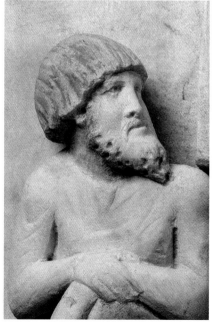

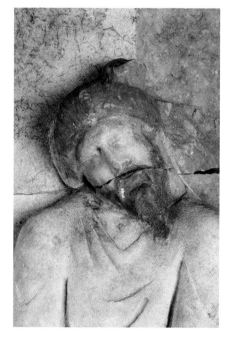

Figure 2.18. Detail of the barbarians with different hair colours (from left to right) on **cat. nos 3, 1, and 5**.

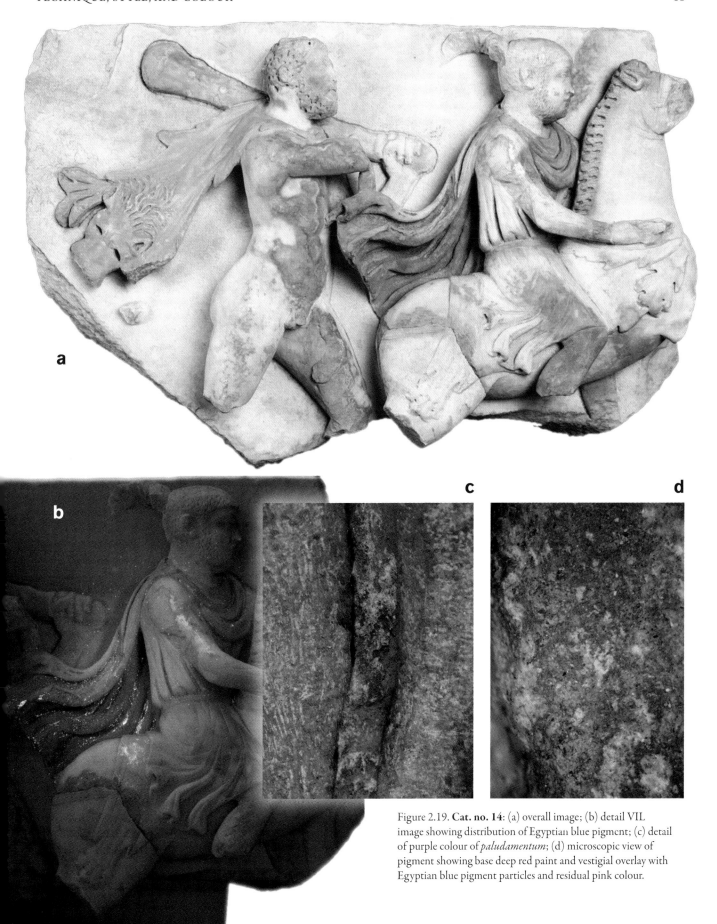

Figure 2.19. **Cat. no. 14**: (a) overall image; (b) detail VIL image showing distribution of Egyptian blue pigment; (c) detail of purple colour of *paludamentum*; (d) microscopic view of pigment showing base deep red paint and vestigial overlay with Egyptian blue pigment particles and residual pink colour.

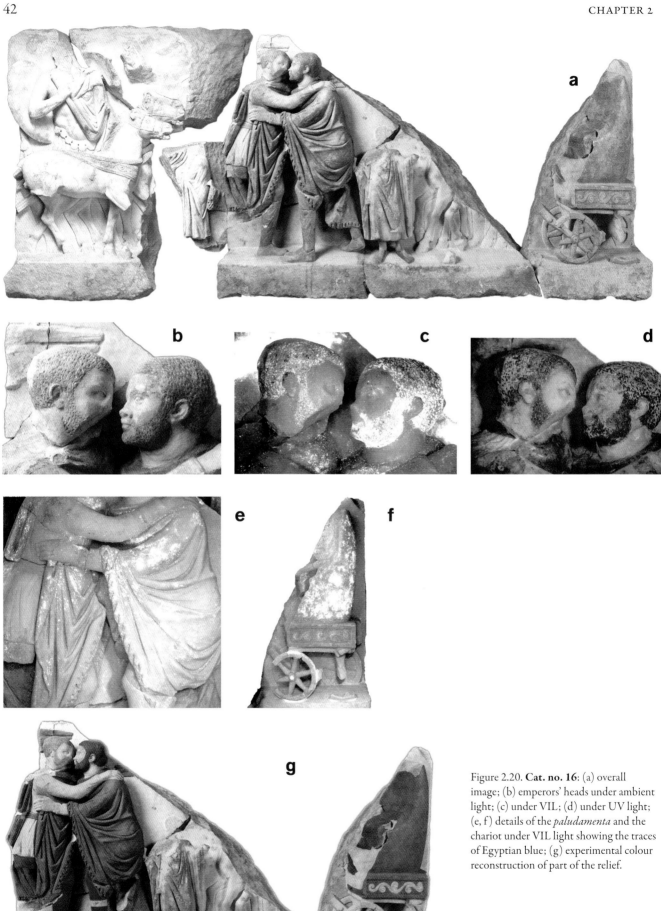

Figure 2.20. **Cat. no. 16**: (a) overall image; (b) emperors' heads under ambient light; (c) under VIL; (d) under UV light; (e, f) details of the *paludamenta* and the chariot under VIL light showing the traces of Egyptian blue; (g) experimental colour reconstruction of part of the relief.

have had completely different tones.[46] As discussed in Chapter 3, this relief and its remaining polychromy have much to add to our understanding of *similitudo*, *fraternitas*, and *aequalitas* in Tetrarchic imagery.

Concluding Remarks on the Technical Details

In summary, we can conclude that the Nicomedia frieze was overseen by imperial designers and the local elite as part of an imperial complex and was executed mainly by Nicomedian artisans who conceived it initially as part of an imperial architectural element and who collaborated in the sculpting and painting process. Tool marks and traces of lifting and connecting mechanisms reveal the hasty work of large-scale Nicomedian and Bithynian workshops. Besides sculpted details, in general we can see that the artisans heavily relied on coloration for the definition and legibility of the frieze, both visually and iconographically. The archaeological evidence shows that the complex and the reliefs collapsed all at once while still in use, perhaps in the major earthquake in AD 358. The good preservation of the colour on the reliefs may in part be due to the short extent of its exposure in the hall. Overall, the patterns of carving, fitting, and painting seem consistent with Lactantius, who implied constant and rushed imperial construction activity in Nicomedia when criticizing Emperor Diocletian's building craze to embellish the new capital city:

> Diocletian had a limitless passion for building, which led to an equally limitless scouring of the provinces to raise workers, craftsmen, wagons, and whatever is necessary for building operations. Here he built basilicas, there a circus, a mint, an arms-factory, here he built a house for his wife, there one for his daughter. Suddenly a great part of the city [Nicomedia] was destroyed, and all the inhabitants started to migrate with their wives and children, as if the city had been captured by the enemy. And when these buildings had been completed and the provinces ruined in the process, he would say: 'They have not been built rightly; they must be done in another way'. They then had to be pulled down and altered — perhaps only to come down a second time.[47]

[46] See Østergaard 2019 for the problematic issues in relation to the reconstructions of the polychromy of ancient sculpture.

[47] Lactant., *De mort. pers*. VII.8.10; translation Creed 1984.

ICONOGRAPHY AND INTERPRETATION I:
IMPERIAL DEPICTIONS — EMPERORS IN WAR AND TRIUMPH

At least eight of the extant relief blocks of the Nicomedia frieze feature one or more of the emperors.[1] The treatment of the imperial portraiture, and distinctive motifs on these blocks such as the embrace of the co-emperors (**cat. no. 16**), help us date the frieze to the last quarter of the third century, when Diocletian raised Maximian to the status of co-emperor — the Diarchy (in 286) and then instituted the rule of four emperors — the Tetrarchy (in 293). The known examples of later third-century imperial portraiture are rare compared to the large number of earlier imperial portraits, and they mark a stylistic change from the previous traditions, often seen as the origin of the abstraction and symbolism of Late Antique and Medieval art. Thus, a thorough iconographic investigation of the Nicomedia reliefs with imperial scenes is important in our understanding of the birth of this new type of imperial representation during the Tetrarchy. In this section, after an overview of imperial art under Diocletian and the Tetrarchy, I will discuss the imperial motifs on each individual relief block within the historical context and through comparison with contemporary imperial texts and images. I will also examine a series of Nicomedia reliefs with scenes of captive barbarians as visual manifestations of imperial triumph. The sequence of the reliefs discussed are random and are roughly arranged by theme. The overall investigation will show that the imperial depictions on the Nicomedia frieze are key to our understanding of the formulation of the new 'Tetrarchic image' which reflects the authoritarian, ceremonial, and collective rulership that shaped the reign of Diocletian and his co-emperors, as well as our understanding of Late Antique art following Diocletian.

Art under Diocletian and the Tetrarchy

The mid-third century was a turbulent period for the Roman Empire, with constant wars and rebellions at the edges of the vast empire, plague, depopulation, and unstable imperial administration due to usurpers and constantly changing emperors, most of whom came to power through military proclamations. One such leader who rose to power from the army (as opposed to the aristocracy) was the Balkan-born Diocletian (r. November 284–May 305), whose reign brought an end to the Third-Century Crisis and marked a period of recovery and relative prosperity before the final decline of the Roman Empire.[2] He seems to have achieved this stability through his reorganization of the imperial administration and introduction of several economic and military reforms imposed on the public through imperial pronouncements and codes. His twenty years in power, during which he ruled in an excessively authoritarian and military as well as increasingly ceremonial and bureaucratic style, transformed the empire both politically and culturally, and this transformation is well reflected in imperial art and architecture. Among his well-known acts is his introduction of a Price Edict in 301 (*Edictum de maximis pretiis*), which mandated price ceilings for around 1200 goods and services, communicated to the public through inscribed copies of the legislation hung in public buildings all around the empire.[3] Another of his edicts, enacted in Nicomedia in 303, activated the notorious 'Great Persecution' of Christians.[4] Above all, Diocletian is most well known for his introduction of the tetrarchic system: the co-rule of four emperors — two *Augusti* and the two *Caesares* — the latter intended as the successors of the former. Realizing the difficulty of ruling the vast empire alone and the threat of usurpations, Diocletian initially declared his loyal friend Maximian, also a Balkan-born soldier, as his Caesar in 285. In 286 Maximian became Augustus, marking the start of the diarchic rule. Despite his initial fail-

[2] For the political and military history of the late third century and Diocletian see Barnes 1982; 1996; Williams 1985; Kolb 1987; and most recently Corcoran 2000 and 2006, 35–58.

[3] For an overview of the imperial pronouncements during the reign of Diocletian, including the Price Edict, see Corcoran 2000. In Asia Minor, inscribed examples of the Price Edict have been found near the Macellum in Aizanoi, Stratonikeia, and Aphrodisias: see İznik 2011.

[4] Corcoran 2006, 51–52.

ure to deal with the usurper Carausius in Britain, by 288 Maximian had restored the north-western frontier through several trans-Rhine and trans-Danube campaigns against Germanic tribes, which is regarded as one of the greatest military victories in the region since the time of Emperor Augustus.[5] Meanwhile, Diocletian forced the Persians into a peace treaty in 287 and suppressed the Sarmatians in Dacia in 289. Already by 287, the co-emperors appear with their new adopted titles: *Jovius* (Jupiter) for Diocletian and *Herculius* (Herakles) for Maximian, which reflect the hierarchy of their imperial roles through the association with the god and his son.[6] Diocletian ruling over the East from his new capital Nicomedia and Maximian ruling over the West from his base in Milan soon realized that they needed further help to control the empire. Thus, in 293 by appointing Galerius and Constantius I as respective *Caesares* of the existing *Augusti*, Diocletian initiated his carefully devised tetrarchic system. Reforms and military campaigns of the four emperors continued after 293. Major military victories after this date include Constantius's final defeat of Carausius and invasion of Britain;[7] Galerius's defeat of the Sasanian king Narses; Maximian's suppression of several revolts in Carthage and Spain, and Diocletian's campaigns to Egypt. The tetrarchic system fell apart slightly after Diocletian and Maximian's retirement in 305; Galerius and Constantius became new *Augusti*, but after the death of Constantius, his son Constantine I and Maximian's son Maxentius fought to seize sole power.[8]

Although short-lived, the tetrarchic system entailed the establishment of new administrative capital cities (*sedes imperii*) for the co-emperors, including Nicomedia, Milan, Trier, Sirmium, Thessaloniki, and Antioch, and thus Rome lost its position as the eternal

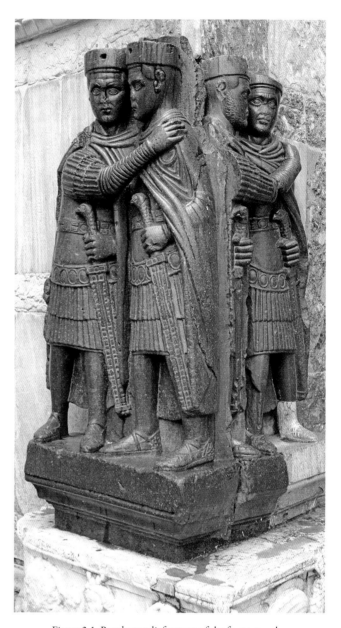

Figure 3.1. Porphyry relief statues of the four tetrarchs. Venice, Basilica of San Marco.

capital of the empire. As the tetrarchs started to monumentalize their new *sedes imperii*, a new type of imperial complex emerged in the history of Roman architecture, characterized by an enclosed palace with large and well-lit audience halls and attached amenities such as a circus, a family mausoleum, and baths.[9] The most well

[5] *Pan. Lat.* x.7.7.

[6] For the emperors' titles see Rees 2005.

[7] The most well-known usurper during the Diarchy was the Roman general Carausius, who seized control of Britain and northern Gaul and declared himself a co-ruler. After Maximian's several attempts to bring him down, he was killed by his own associate in 293. Britain came back under Roman control after Constantius's campaigns in 297.

[8] What is unique about the system is not the appointment of co-emperors, as Rome had already had several sets of co-rulers: Marcus Aurelius and Lucius Verus (161–169), Caracalla and Geta (209–211), Pupienus and Balbinus (238), and Valerian and Gallienus (253–260). The innovation was the fact that the co-emperors initially had no kinship at all (see Hekster 2014) and that Diocletian saw the tetrarchic system as a continuous newly structured way of imperial rule, with two *Augusti* and two succeeding *Caesares*. See Corcoran 2006, 40.

[9] For a general overview of the imperial architecture of the time see L'Orange 1972, 9–19; Mayer 2002; Bülow and Zabehlicky 2011; and Üçer-Karababa 2008. Mayer 2013 proposes that the well-lit large and usually apsidal audience halls such as the Aula Regia of the palatial complex at Trier, the apsidal hall of Galerius's palatial complex in Thessaloniki, and later the Aula of Maxentius in Rome were a reflection of the changing court ceremonial during the Tetrarchy and

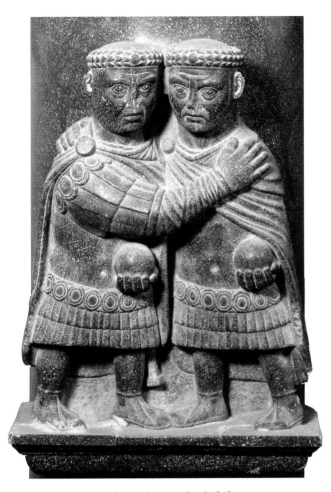

Figure 3.2. Porphyry column with relief of two *Augusti*. Vatican City, Vatican Library (© Scala/Art Resource, NY).

collection of panegyric orations given to the emperors between 289 and 389),[13] indicate that emperors were regarded as the embodiment of absolute and divine power and were identified with purple garbs encrusted with jewels and radiating crowns, holding emblems of supreme power (usually orbs and sceptres topped with eagle heads) with subjects prostrating before them in reverence and kissing the hems of the imperial costume. Since the concept of the imperial rule was transformed from a *Principate* to a *Dominate* with certain orders of rituals, emperors during this time are exalted to a higher celestial plane than the ordinary people and high officials of the court. As typical of the court ceremonial of the later empire, they are described as enthroned or seated when conducting business with their council of all-standing advisors.[14] Because the co-emperors with their new administrative capitals were constantly on the move for war or to meet each other, their formal entrance into a city (*adventus*) became a more frequently repeated official ceremony.[15]

Naturally, the changes in the imperial administration and the court ceremonial are visible in the extant imperial imagery.[16] Perhaps the most emblematic motif in Tetrarchic art is represented in the scenes of nearly identical co-emperors and their Caesars embracing, well known from the porphyry examples in Venice and the Vatican (Figs 3.1–3.2).[17] This motif is often seen as an

preserved and well researched of these imperial palatial complexes are the complex in Thessaloniki designed under Galerius;[10] the retirement palace, again designed for Galerius in his hometown of Romuliana (Gamzigrad);[11] and Diocletian's retirement palace at his hometown Spalatum (Split).[12] The new authoritarian administrative system of the co-emperors also led to major changes in the official court ceremonial. Literary texts, especially the imperial representation in the *Panegyrici Latini* (a

13 Nixon and Rodgers 1994; Rees 2002.

14 See Williams 1985, 111–12; Walden 1990, 227; and Corcoran 2006, 43 for the changes in imperial office and court ceremonial as reflected in contemporary literature.

15 Corcoran 2006, 43.

16 For Tetrarchic imagery in general see L'Orange 1972; Rees 1993; Walden 1990; Boschung 2006; Kiernan 2003; Hekster and others 2019.

17 See the detailed discussion of both porphyry groups by Bergmann on LSA 4 and 439 and LSA 840–41 (Bergmann 2012). The original context of both porphyry sculpture groups is not certain. The Venice tetrarchs were brought to San Marco from Constantinople after the Fourth Crusade of 1204. A recent study, based on the examination of a fragment of a porphyry column from the east of San Marco and the porphyry heel of one of the emperors found at the rotunda near the Myrelaion church in Constantinople, proposes that the embracing statues once topped porphyry columns which had already been fragmented before they left Constantinople. Thus, the columns might have been sculpted in a nearby Tetrarchic centre, most likely Nicomedia (or Thessaloniki), fragmented and carried over to Constantinople to embellish the new capital, and shipped to Venice in the sack of Constantinople in 1204: see Niewöhner and Peschlow 2012. The porphyry tetrarchs of the Vatican were first spotted in the Baths of Domitian. Although they do not embrace, identical-looking tetrarch portraits in pairs of two on limestone pil-

thus a pure development of Tetrarchic architecture. Mayer (2013, 114–15) also considers axial symmetry between the buildings of a palatial complex (such as in Thessaloniki and Split) as a unique feature of Tetrarchic architecture.

10 See Stefanidou-Tiveriou 2009; Hadjitryphonos 2011; and also <http://galeriuspalace.culture.gr/en/> [accessed 1 April 2021] for an overview.

11 See Srejović and Vasić 1994 and Popović 2011 for the most recent extended overview in English.

12 See Nikšić 2011 and Cambi, Belamarić, and Marasović 2009 for several contributions about Diocletian's Palace.

early example of the rejection of the classical tradition in favour of the increasingly abstracted, symbolic, and rigid representations that would become the main characteristics of Byzantine art.[18]

The identically clad embracing emperors on these porphyry examples have large heads with big eyes, and overall, they look 'cubic'[19] and symbolic, with minimal individual features. The stylistic break with the classical tradition that is manifested on these Tetrarchic portraits has been interpreted by scholars in different ways. Berensonian tradition sees this change as a decline in artistic competence and skill.[20] Kitzinger considers it to be a natural development within the social context of the time.[21] L'Orange closely links the changes in art and architecture of the late third century to the structure of the tetrarchic rule of Diocletian. He thinks that symmetry, mechanical coordination, and collegiate formations, which became the most important elements of the new government, also shaped the new state art.[22] Indeed, the most accepted view of this revolutionary imagery, which is distinct from earlier imperial portraiture both in style and in iconography, correlates it with the new tetrarchic political ideology and its most important themes, such as the *concordia* (harmony), *similitudo* (similarity), and *fraternitas* (brotherhood) between the co-emperors.[23] A recent article by Hekster et al., however, proposes that the new political structure was actually presented through the concept of 'double duality', as opposed to previous scholars' assumption of the inflexible collegiate body of four with *similitudo* and *concordia*.[24]

Unlike the imperial sculptural portraits of the early and mid-third century, some with classicizing and others with veristic features, the lack of individualism is so

prominent on the Tetrarchic portraits that it is almost impossible to differentiate the co-emperors when they are seen separately, in individual portraits.[25] Despite the slight differences due to the type of stone used and local workmanship, in most examples, portraits of tetrarchs follow a certain formula: they are depicted with large rounded heads and big eyes, with their hair and beards cropped short in the military style of the imperial portraiture of the soldier emperors. Often, they wear extravagant robes decorated with gems or fringes and combined with Pannonian hats (fur or felt soldier's caps that originated in the Balkans). Of around thirty-four imperial portraits in sculpture assigned to this period,[26] none of them can be definitely labelled with the name of the specific tetrarch. In the absence of inscriptions and distinctive physiognomic features, find-spots are often used as evidence for the identities of specific portraits. The Tetrarchic marble head from Nicomedia, for example, is identified as Diocletian,[27] while the porphyry head of a tetrarch found in Gamzigrad is identified as Galerius.[28]

A similar formula of imperial representation with emperors as a collage of two or four can also be detected on the Tetrarchic coinage, luckily this time accompa-

lars found in the imperial palace at Gamzigrad also have been considered an example of the Tetrarchic image, reflecting the collegiate rule of the emperors, see Srejović 1994.

[18] L'Orange 1972; Weitzmann 1979; Kolb 1987; Rees 1993, 2002; Walden 1990, Kitzinger 1995; Smith 1997; Elsner 2000.

[19] This term was first used to describe the new style of the Tetrarchic portraiture by Vermeule 1962; also see the discussion in Walden 1990, 228.

[20] Berenson 1954; see Elsner 2000 for a critique of this view.

[21] Kitzinger 1995.

[22] L'Orange 1972. For an overview of the scholarly literature on the third-century stylistic changes in Roman art, see Bergmann 1977; Wood 1986, 11–25; Rees 1993, 181–82; Elsner 2000, 149–52.

[23] L'Orange 1972; Rees 1993, 2002; Smith 1997.

[24] Hekster and others (2019), through literary and visual examples suggest that there was always an emphasis on one emperor, even when all four of them were present.

[25] For the imperial portraiture of the third century see Bergmann 1977 and Wood 1986. Despite the scarcity of material, one can detect the coexistence of a variety of styles of imperial portraiture; portraits of the Severan dynasty in the early third century still follow the Hellenistic traditions of the portraiture of the Antonines, in which an elegant and idealized treatment of the subject is accompanied by subtle modelling of the human face. After 235, most soldier emperors seem to have adopted the veristic style since it best displayed their tough and experienced military qualities, while the senatorial emperors of dynastic succession favoured the idealized Augustan style. Wood (1986, 20–23) links the shift from plastic anatomic forms to expressive abstraction in third-century imperial portraiture to the time of Emperor Gallienus. Thus, she sees the origin of the abstraction in Tetrarchic portraiture in the 250s.

[26] See sculptural portraits LSA 244, LSA 245, LSA 246, LSA 297, LSA 298, LSA 368, LSA 382, LSA 396, LSA 456, LSA 4, LSA 439, LSA 840, LSA 841, LSA 523, LSA 836, LSA 845, LSA 1005, LSA 1041, LSA 1042, LSA 1043, LSA 1045, LSA 1046, LSA 1047, LSA 1050, LSA 1091, LSA 1092, LSA 1118, LSA 2354; also L'Orange 1984, 95–113 and Bergmann 1977, plates 48–51.

[27] Istanbul Archaeological Museum, Istanbul, inv. no. 4864, see Bittel 1939, and Dörner 1941a.

[28] National Museum, Zaječar, inv. no. 1477. See Srejović 1994, 148–51. Besides the find-spot of the porphyry head, Srejović suggests that the low forehead, straight nose, chubby cheeks, thin lips, and thick neck were distinctive facial features of Galerius and thus identifies the head as his. Many of these facial features, however, can be detected on the representations of other tetrarchs. Both Diocletian and Maximian on the Nicomedia frieze (**cat. no. 16**) have low foreheads, chubby cheeks, and thick necks.

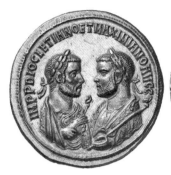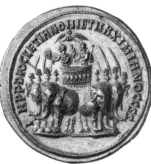

Figure 3.3. Gold medallion with busts of Diocletian and Maximian on the obverse, co-emperors on an elephant-drawn ceremonial chariot on the reverse. Münzkabinett der Staatlichen Museen zu Berlin, Berlin, inv. no. 18200802 (courtesy Münzkabinett der Staatlichen Museen zu Berlin).

nied by legends to identify them. Diocletian's monetary reform in 293–294[29] brought not only a uniformity in the value of coinage but also a new standardized type of a Tetrarchic bust, with a large head, thick neck, large almond-shaped eyes, and short-cropped hair and beard, overall rendered in a rather schematic manner.[30] Imperial busts on coins appeared either as individual portraits of a single emperor or facing busts of co-emperors. Among the hundreds of coin types produced in multiple centres of power during the Tetrarchy, many gold and silver coins show the *Augusti* as individual bust portraits, often together with their new appellations: Diocletian combined with types of Jupiter imagery on the obverse, and Maximian combined with types of Herakles imagery on the obverse.[31] Some coins with the bust of an individual tetrarch on the obverse feature a city goddess, a turreted architectural complex, or the *Genius Populi Romani* on the reverse. On many silver issues, the emperors appear around a tripod, making a libation together as an indistinguishable group of four.[32] On some of the Diarchic

and early Tetrarchic aurei (gold coins) and medallions, however, co-emperors appear with their individual physical features (see Fig. 3.3 and discussion below on p. 55).[33] This indicates that during the Diarchy and the early years of Tetrarchy, the concord of the co-rulers was not specifically conceived as a physical similarity.[34] The transformation of the Tetrarchic imperial portraits into a virtually indistinguishable unit of icons must have been an experimental process, specifically developed for the easy recognition of the co-ruling tetrarchs by their subjects all around the empire. The reverses of these medallic and gold issues, which were possibly issued on the occasion of specific events, such as enthronements, *adventus*, and imperial anniversaries as irregular distributions of payments to the troops,[35] also reflect more historically specific imagery than the generic motifs in regular coinage of silver or silver-washed bronze. In that respect the so-called Arras medallion, for example, commemorates Constantius's triumphal entry into London in 296, with the location identified by a legend.[36] Meanwhile the Mainz medallion, with a scene of enthroned co-emperors above and barbarian immigrants crossing the Rhine and marching towards Mainz (both identified by legends) below, is thought to have been issued to commemorate a largesse ceremony after the co-emperors' victorious campaigns across the Rhine sometime between 285 and 290 (Fig. 3.16).[37]

Although few in number, extant imperial reliefs and paintings of the Tetrarchy with known contexts are also helpful in our understanding of the new modes of

29 For Diocletian's monetary and economic reforms in general see Williams 1985, 115–26, Carrié 1994 and RIC VI. Besides several reforms in taxing and pricing, new gold coins (aurei), silver coins (argentei), and bronze coins (follis) with standardized values were introduced to regulate the economy. For a general overview of Tetrarchic coins and medals see RIC V.2 (covers pre-reform coinage), RIC VI, Kiernan 2003, 51–37 and Lukanc 1991. Publications on specific medallions and hoards include Bastien and Metzger 1977 specifically on the coins of the Arras hoard (a collection of about four hundred gold and silver coins with dates ranging from 285 to 310 found in 1922) and Bastien 1973 on the Mainz medallion.

30 RIC VI, 109; L'Orange 1984, 16; Gazdac 2018.

31 See RIC VI and Hekster and others 2019, 623–26 for an overview.

32 Hekster and others (2019, 618 n. 30) provide a statistical overview of the data presented in RIC VI: 'The 2678 coin types the

RIC lists for the period between 293 and 306 include 412 types that feature a depiction of the emperor on the reverse. Of these, 202 show a single emperor and most of the rest depict four emperors at sacrifice/libation.'

33 See the Diarchic aureus here on Fig. 3.3 and also the early Tetrarchic gold multiple issued in Trier showing the busts of Diocletian and Galerius on the obverse (legend: DIOCLETIANVS AVG ET MAXIMIANVS C), and the busts of Maximian and Constantius on the reverse (legend: MAXIMIANVS AVG ET CONSTANTIVS C) in RIC VI, 143 and Hekster and others 2019, figs 7a and 7b. L'Orange (1984, 14) argues that the capital cities of the individual tetrarchs, as well as those mint cities under their control, would have produced more iconographically realistic portraits of their respective rulers.

34 However, Smith 1997, 181 and Rees 1993, 188 see the origin of these changes and the propaganda of the harmony of the co-rulers in the Diarchy.

35 Kiernan 2003, 31.

36 Bastien and Metzger 1977, cat. no. 218 (p. 94).

37 Bastien 1973; Kiernan 2003, 45–50; also see the discussion below on pp. 62–63.

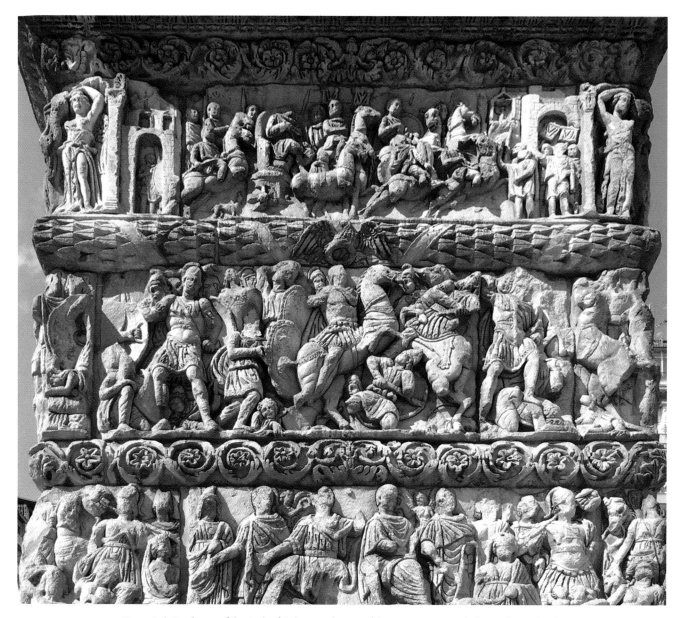

Figure 3.4. South pier of the Arch of Galerius: *adventus* of the emperor on a *cathedra* on the top level;
a battle in the middle; and libation scene with enthroned *Augusti* and standing *Caesares* at the bottom.

imperial representation during the Tetrarchy. Besides a handful of ornamental reliefs, mostly with floral designs and busts, in tondos from palatial complexes at Split, Thessaloniki, and Gamzigrad,[38] major monuments of this period include the reliefs on the Arch of Galerius in Thessaloniki, which was erected around 303 and commemorates Galerius's victorious campaigns over the Sasanians;[39] relief fragments of the Arcus Novus which were taken from an earlier monument and inserted in an arch dedicated to Diocletian in Rome perhaps in 303, and destroyed in the fifteenth century;[40] the reliefs on the column base of the so-called Decennalia

[38] For architectural sculpture from Gamzigrad see Srejović 1994 and Živić 2011; for the architectural frieze with mythological and floral depictions from the temple and the mausoleum in the palatial complex of Diocletian at Split see McNally 1996; for reliefs with floral and figural designs from the so-called 'Small Arch of Galerius' from Galerius's palace in Thessaloniki see L'Orange 1984, Tafel 21a–b and for figural pilasters from the Octagon in Thessaloniki see Vickers 1973.

[39] Rothman 1977. The arch was actually a monumental tetrapylon of which only the northern and southern piers survive today, and it was part of Galerius's imperial complex at the centre of Thessaloniki.

[40] Laubscher 1976.

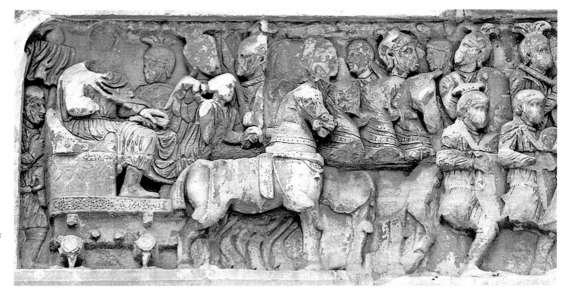

Figure 3.5.
Detail of the *adventus* scene from the Arch of Constantine in Rome, east side.

Monument which was once erected to commemorate the tenth anniversary of the Tetrarchy in the forum of Rome;[41] the frescoes of the imperial cult room at Luxor added to the existing Egyptian temple at around 300;[42] and slightly later, the Arch of Constantine in Rome.[43] In general, imperial representations on these monuments drew from the previous imperial visual vocabulary with

traditional scenes used to promote the virtues of an ideal emperor; such as the emperor's address to his subjects (*adlocutio*), conquest and clemency over suppliant barbarians (*clementia*), victorious entrance into a city (*adventus*) or departure for war (*profectio*), generosity (*liberalitas/largesse*), and imperial purification (*lustratio*). The treatment of the emperors on the Tetrarchic monuments, however, reflects the transformation of the emperor from *principate* to *absolute dominate*, and points to a more formalized imperial court ritual during the Tetrarchy. In an *adlocutio* scene on the north pier of the Arch of Galerius,[44] for example, the emperor (most likely Galerius) appears twice the size of the soldiers he is addressing, and he faces outwards without any connection to them.[45] This treatment is slightly different from the *adlocutiones* of Marcus Aurelius and of Trajan on their respective columns, in which the emperors are the same size as their soldiers, but speak from elevated platforms.[46] Likewise, the *adventus* scenes on Tetrarchic monuments such as Galerius's *adventus* on the Arch of Galerius (Fig. 3.4) and later the *adventus* of Constantine to Rome on the Arch of Constantine (Fig. 3.5) feature the emperors emerging from one side, seated on the elaborate throne-like *cathedra* of a chariot, within large formalized processional scenes. The emperor's entrance in both cases is reminiscent of the epiphany of gods, specifically of Dionysos in his chariot, and differs for instance from the modest *adventus* of Marcus Aurelius on one of

41 Marlowe 2016 provides the latest overview.

42 Jones and McFadden 2015, Barbagli 2020, and Deckers 2020 for the latest overviews. The frescoes of the west, east, and north walls are rather fragmentary in nature, but they seem to be divided into two levels and depicting an active imperial procession, an *adventus*, converging on the south wall with the depictions of the co-ruling emperors in the imperial court and in the divine sphere. McFadden (2015) thinks the frescoes represent the real *adventus* of Diocletian to Luxor sometime between 298–302. Deckers (2020) argues that the whole image programme of the frescoes at the cult room at Luxor was designed to lead the soldiers in a specific ceremony of the imperial cult when emperors were present. After entering the room, the processional convoys of soldiers on both the eastern and western walls culminate in their gathering at the feet of two enthroned emperors and pay homage to them on either side of the south wall. The niche at the centre of the south wall with tetrarchs and Jupiter is designed to evoke the epiphany of the god and god-sent emperors. Deckers compares this image-sequencing to the image programmes in slightly later Christian basilicas used to direct the visitor's path towards the epiphany of the god at the central apses. Thus, Deckers argues that the tetrarchic ideology and Diocletianic cult ritual geared towards the epiphany of god-sent emperors laid the foundation for the image programmes in Early Christian basilicas.

43 Elsner 2000, Carlson 2010, and Rose 2021 for recent overviews of the Arch of Constantine. Rose (2021) in his surprising new article argues that the sculpted frieze of the Arch, which is often regarded as 'Constantinian', was actually spoiled from a triumphal monument of Diocletian commissioned shortly after 303 in Rome.

44 Rothman 1977, 440, fig. 18.

45 Walden 1990, 226; Laubscher 1975, Tafeln 30–32.

46 Beckmann 2011, 104, figs 5.13 and 5.14.

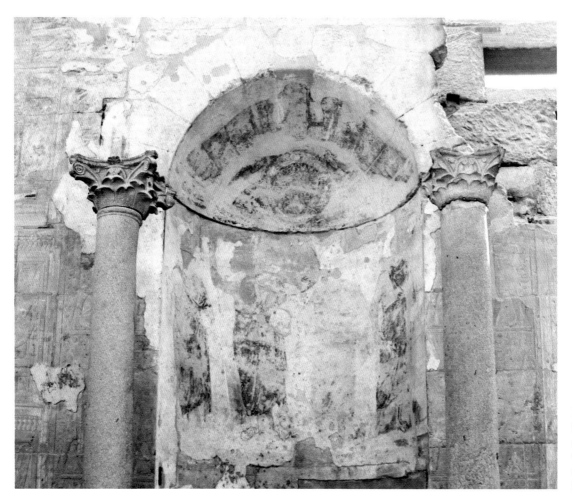

Figure 3.6. Luxor imperial cult room: south wall niche with standing tetrarchs dressed in imperial purple.

the relief panels re-carved and inserted into the Arch of Constantine.[47]

When all four emperors are together, the hierarchy between them is always implied through slight changes in scale and composition. The two *Augusti* on the south pier of the Arch of Galerius, for example, reflecting their superior authority, appear enthroned while flanked by standing *Caesares* on each side (Fig. 3.4). Diocletian's status as the leader of the four is communicated by the gesture he makes with his left hand and by his pronounced frontality.[48] In the same manner, in the larger-than-life frescoes of the similarly dressed and nimbate tetrarchs on the south wall niche of the cult room at Luxor, Diocletian is slightly taller than the other three and holds a sceptre and a globe as signs of his universal authority granted by Jupiter (Figs 3.6–3.7).[49] Bergmann notes that even in their most identical and symbolic representation in the Vatican porphyry group (Fig. 3.2), the older and superior Diocletian is distinguished by a deeply lined face and lachrymal sacks.[50]

The frescoes of the cult room at Luxor give us further information about the new colour-coded imperial costume and the formalities of the tetrarchic court ritual. The emperors on the south wall niche all wear the imperial purple *paludamentum* (Fig. 3.6). As mentioned earlier, the literary texts point to a new extravagant imperial costume during the Tetrarchy, decorated with jewellery, and awash in imperial purple. This increasing interest in purple as the embodiment of imperial rule seems to have also led to an increase in the use of naturally purple porphyry for imperial statues, hence the tetrarchs' installation of new porphyry workshops in Egypt.[51]

47 See Ferris 2013, 62, figs 23–24 for the *adventus* and *profectio* of Marcus Aurelius on the Arch of Constantine.

48 Rothman 1977, 444; Rees 1993, 186–87. Flattened and frontal style remains a sign of imperial status throughout the Byzantine period.

49 McFadden 2015, 129–32.

50 LSA 840 discussion (Bergmann 2012).

51 Bergmann 2019 and Del Bufalo 2012.

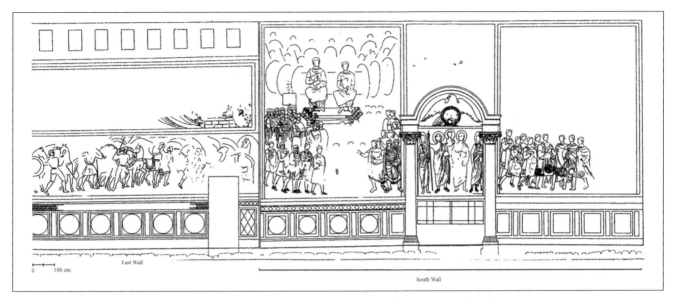

Figure 3.7. Luxor imperial cult room: drawing of the east and south walls,
with enthroned emperors on the top left south wall; after Deckers 2020, Tafel 34.a.

The partially preserved eastern part of the south wall at Luxor hints at the formal appearances in the imperial court: two large enthroned emperors in frontal pose rest their feet on a gigantic footstool encrusted with jewels in various colours, while well-dressed dignitaries of the imperial court, pictured beneath the emperors, pay their homage (Fig. 3.7). Some dignitaries appear with their hands veiled (*manus velatae*) as an act of humility in the presence of the emperors, giving the emperors an untouchable, superhuman quality.[52] The costume, hierarchical scale, and poses within the composition isolate the emperors from the real world and from their subjects in the court.

The divine elevation of the tetrarchs from their subjects can also be linked to the increased popularity of imperial monuments, with statues of tetrarchs mounted on column tops and placed mostly in city centres so as to dominate public spaces.[53] The most well known is the Decennalia or Five-Column Monument set up in the Roman Forum to celebrate the tenth anniversary of tetrarchic co-rule and the twentieth anniversary of Diocletian's reign.[54] All that survives of it today is one column base with a relief sculpture that depicts on its four sides shield-bearing Victories, a procession, a sacrifice, and the crowning of one of the tetrarchs by a

Victory. Although the monument itself is fragmentary, it is depicted within Constantine's *adlocutio* relief on the Arch of Constantine. The relief shows Constantine in front of the monument, which consisted of four honorific columns topped by statues of tetrarchs and another column in the middle topped with a statue of Jupiter. The embracing tetrarchs mentioned above, now in the Vatican, were too originally the tops of porphyry columns. Recent investigations show that the porphyry tetrarchs now in Venice also once topped such columns, perhaps in Nicomedia, before they were dismantled and carried to Constantinople and later to Venice after the Fourth Crusade in 1204.[55]

Overall, most of the monuments discussed above reflect the new political ideologies of the Tetrarchy, such as the co-rule of four emperors in harmony but with retained hierarchy between them, the absolute dominance and divine character of the imperial rulership, and its entailing formal court ritual. During the Tetrarchy, the image of the Roman emperor(s) gradually transformed from a mighty leader with some idiosyncratic features into an icon of divine-given imperialness. This new way of depicting not what the protagonist *is* but what he *means* and *stands for* would later become the major principle of Byzantine art. Now the question remains of where the imperial representations on the Nicomedia frieze stand in this transformation.

[52] McFadden 2015, 119–21.

[53] See Wolfgang 2006 and Yoncacı-Arslan 2016 128–32 for the honorific columns of the Tetrarchy in general.

[54] See most recently Marlowe 2016 for an overview of the monument.

[55] Niewöhner and Peschlow 2012.

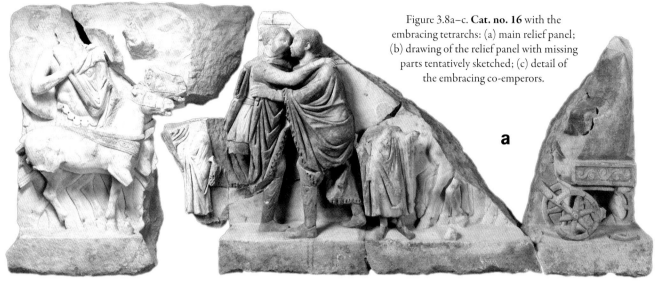

Figure 3.8a–c. **Cat. no. 16** with the embracing tetrarchs: (a) main relief panel; (b) drawing of the relief panel with missing parts tentatively sketched; (c) detail of the embracing co-emperors.

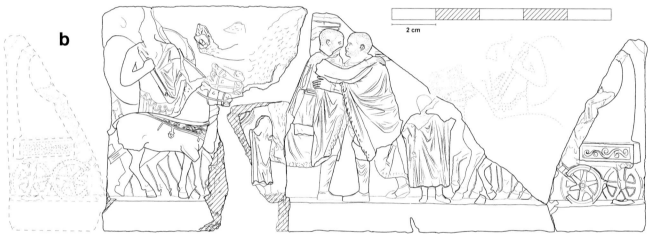

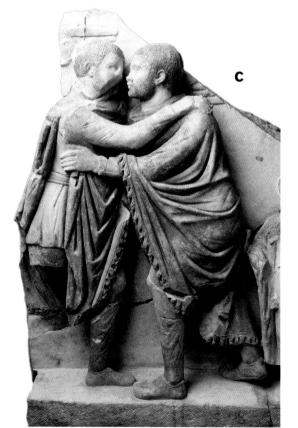

Embracing Co-emperors and the adventus *on the Nicomedia Frieze*

The longest surviving relief panel of the Nicomedia frieze shows the two emperors, Diocletian and Maximian, who have descended from their ceremonial chariots, in the act of embracing; this fully contextualized narrative image anticipates the reduction of the embrace to a symbolic formula in later Tetrarchic art (**cat. no. 16**) (Fig. 3.8a–c). Although the left side of the relief panel, which once had the seat of an imperial chariot, is missing, the overall symmetrical composition and the trace of a lewis hole (usually cut at the centre of the block) above the head of the emperor on the left indicate that the panel was originally about 4 m in length.[56] The great length of the panel compared to that of other fully preserved Nicomedia relief panels, and also its find-spot in the centre of the complex, indicate that it had a primary position

[56] Relief fragments belonging to gold-coloured wheels and horse legs (see Appendix I, SRF 60–73 and 95–100) possibly belong to the missing left part of the relief panel.

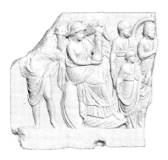 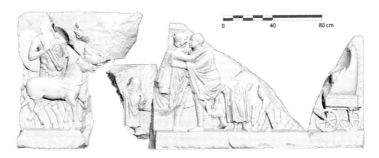

Figure 3.9. 3D model of the *adventus* procession reliefs of the Nicomedia frieze.

within the frieze, perhaps decorating the top part of a monumental central door or a niche (Fig. 2.1). Indeed, the embrace of the two emperors on the relief panel seems to be a culmination of a processional *adventus* with standard-bearers (**cat. no. 18**), on-looking divinities, and togate Romans (**cat. no. 17**) approaching from both the right and the left (Fig. 3.9). The captive barbarians led by divinities and Roman soldiers on several other relief panels (discussed below in the section on captive barbarians) could also have been part of this processional scene on the Nicomedia frieze.

The meeting of the emperors on the relief is presented with a symmetrical composition, a pictorial feature often seen as a unique feature of Tetrarchic art.[57] The emperors are accompanied on either side of the relief by diminutive charioteers leading the horses of the ceremonial quadrigas, which have throne-like purple seats (*cathedrae*). The emperors are also flanked by *fasces*-bearing armed imperial guards (*lictores*) on both sides (the lictor on the left is mostly preserved, but on the right only the feet remain). Both emperors have the same short, military hair and beard styles typical of the later third century and are clad in the same extravagant costume: fringed *paludamenta* awash in imperial purple over belted tunics and trousers decorated with gold bands. The emperors appear unarmed and lack the Pannonian hats, a typical element of Tetrarchic representations, though fragments from other panels within the Nicomedia frieze do show Pannonian hats (Fig. 3.10). Despite all of their *similitudo*, the emperors are clearly differentiated, suggesting their hierarchy. Diocletian, on the left, is slightly taller and older and has grey-brown hair, in remarkable contrast with the red hue of Maximian's hair (Fig. 2.20c–d). The Victory hovering behind Diocletian, of which one blue wing is partially preserved, is also positioned higher than the Victory behind Maximian's head on the right.[58]

The co-emperors facing each other also have slightly different physiognomies: larger eyes and prominent cheekbones for Diocletian, and a retroussé nose for Maximian. Their portrayal is very similar to the representations on the obverse of the specially issued antoniniani and gold medallions of early Diocletianic coinage.[59] On the obverse of a rare aureus issued in 287 in Rome, for example, two laureate emperors clad in ceremonial costumes face each other: Diocletian with distinctively large eye sockets and Maximian with a retroussé nose. On the reverse of the aureus, the co-rulers appear on a ceremonial chariot pulled by elephants (Fig. 3.3).[60] They carry the symbols of their appellations: Diocletian (*Jovius*) a thunderbolt, and Maximian (*Herculius*) a club, while a Victory hovers above their heads. This particular portrayal of the co-emperors, both on the Nicomedia relief and on the coinage, shows once again that the Tetrarchic imagery at the beginning of Diocletian's rule did not intend to establish physical similarity between the rulers.[61]

57 On symmetrical compositions as vital elements of Tetrarchic art, see L'Orange 1972, 89–90; Rees 1993, 187–88.

58 The tips of two blue-coloured wings preserved behind the

heads of both emperors could have also belonged to *aquillae* (eagle-topped standards for Roman legions), but within this imperial context they are identified as the wings of Victories.

59 On the obverse of these rare antoninianus coins, possibly issued in Siscia in 287, radiate, draped, and cuirassed busts of the co-emperors face each other while the legend reads IMPP DIOCLETIANO ET MAXIMIANO AVGG. On the reverse, Jupiter and Herakles, appellations of the co-rulers, clasp hands as a small Victory hovers between them, while the legend reads VIRTVS AVGVSTORVM, Margetić 2015, figs 1–3.

60 Elephants on a processional scene also appear on one of the surviving blocks of the Nicomedia frieze, see **cat. no. 38** in this volume.

61 According to Smith (1997, 180–81), the claim that Tetrarchic *similitudo* is reflected in the style of imperial portraiture is an exaggeration; it disregards regional and chronological variations, as well as manufactural difficulties associated with coinage and stone carving that might have prevented more individualistic representations. Citing *Panegyrici Latini* XI, a speech delivered to Maximian on his birthday in 291 in which the unknown orator clearly states that Diocletian and Maximian were similar in character rather than

As discussed above in detail, the 'imperial embrace' is a uniquely Tetrarchic motif reflecting the ideals of concord and harmony between the co-ruling emperors (Fig. 3.8c). Never before had Roman emperors been shown in such physically intimate contact even with their family members. The motif was probably derived from the *dextrarum iunctio* (clasping of right hands) motif, which was a common iconographic symbol of marriage in Roman art and literature.[62] In addition to signifying harmony and loyalty in marriage, the handclasp also functioned as a sign of political concord.[63] One such use of this motif is the *dextrarum iunctio* of Caracalla and Septimius Severus on the reliefs of the Arch of Leptis Magna.[64] Diocletian and Maximian's *dextrarum iunctio* is also emphasized in speeches in order to promote their harmonious rule as one family.[65]

Once established, the 'Tetrarchic embrace' seems to have become a popular imperial pattern. Besides the aforementioned porphyry tetrarchs from Venice and the Vatican (the former perhaps originating in Nicomedia)[66] three other fragmentary examples attest to the popularity of this specific imagery: the fragmentary body of an emperor in the embrace gesture in Istanbul Archaeological Museum,[67] and porphyry heads from Niš[68] and Tekija.[69] Indeed, Walden suggests that this effective motif might have derived from an influential Tetrarchic monument that originated in one of the Tetrarchic capitals.[70]

Unlike the tetrarchs from Venice and the Vatican, in the Nicomedia relief the co-emperors do not face forward; rather, having just descended from their ceremo-

Figure 3.10. Fragment of a figure wearing the Pannonian hat (Appendix I, SRF 4).

nial chariots, they surge towards each other almost as if they were two relatives reuniting. Their joint portraits at the centre resemble the early Diocletianic coin imagery discussed above. The difference between the porphyry tetrarchs and the Nicomedia relief seems to be due not just to the use of different materials (porphyry is much more difficult to carve than Proconnesian marble) but also to the particular circumstances of the years of the Diarchy. The intimate relationship between the diarchs is also emphasized in contemporary panegyric language. *Panegyrici Latini* XI, delivered in 291 to Maximian at Trier after the conference in Milan and after the *quinquennalia* of his co-regency with Diocletian, includes this passage about the meeting of the diarchs:

> Meanwhile, however, while I bring before my eyes your daily conversations, your right hands joined at every conversation, the trivial and serious matters you shared, parties spent in contemplation of each other, the thought comes to me of the magnanimity with which you separated to revisit your armies and overcame your sense of duty for the benefit of the state. What were your feelings at that time, what were your expressions! How incapable were your eyes of disguising the evidence of emotion! Of course, you looked back frequently, and this is not an empty fiction made up about you — you exchanged such assurances since you intended soon to return to see each other.[71]

Interpreting this passage, Rees draws attention to the fact that the language used to describe the meeting of the emperors — such as the emotionally charged gaze shared between them or their need for physical contact, implied by the constant handclasp — is predominantly reserved

appearance, Smith concludes that 'Diocletian's new imperial style was conceived both with some residual personal identity and with a highly normative collective aspect expressive of a unified political-moral character'. The degree of individualism on emperors' portrayal may have also depended on the intended function and audience of the image. As mentioned above (see p. 49) Tetrarchic medallions specifically issued for the immediate circle of emperors carry more individualistic portrayal of the emperors.

62 Rees 2002, 78–79.
63 Müller 2012.
64 Kleiner 1992, 341, fig. 310.
65 *Pan. Lat.* X.11.1.
66 See the above discussion on pp. 47–48.
67 Istanbul Archaeological Museum, Istanbul, inv. no. 1094 (LSA 456).
68 National Museum Niš, Niš, inv. no. 180/P (LSA 1041).
69 Private collection in Belgrade (LSA 1042).
70 Walden 1990, 228.

71 *Pan. Lat.* XI.12.3–5; translation Rees 2002, 78.

for the description of lovers in Latin literature.[72] The application of this language to the co-emperors can serve as a powerful metaphor for the collegiate harmony of their rule. The intimate gaze and enthusiastic embrace of the emperors on the Nicomedia relief can be regarded as a visual counterpart to contemporary panegyric language — a panegyric in stone.

This parallel with contemporary panegyrics, the portrayal of Diocletian and Maximian in profile (not frontal) with individual physiognomic features such as hair colour and Maximian's retroussé nose, and the absence of any other reference to Caesars on the extant frieze all suggest a diarchic date for the Nicomedia frieze, perhaps a date between 286–293. If that is the case, this relief stands out as one of the earliest examples of diarchic propaganda in the late third century. The motif of the intimate imperial embrace, before going on to become the hallmark of Tetrarchic art, may have first been seen on the Nicomedia relief.

The iconographic details of the embracing diarchs in Nicomedia exhibit many parallels with contemporary *adventus* depictions on state reliefs and frescoes (see above).[73] The *adventus* scene on the east side of the Arch of Constantine shows Constantine approaching Rome after his victory over Maxentius (Fig. 3.5). The throne-like chariot driven by Victory is very similar to the one in the relief from Nicomedia; both are decorated with floral motifs, have throne-like seats, and show horses equipped with ceremonial harnesses.[74] The same details — an imperial throne-like chariot, a bodyguard, and a small figure in front of the chariot — also appear on the *adventus* of Galerius into an undetermined city, on the north face of the south pier on the top register of the Arch of Galerius (Fig. 3.4).[75] The heavily damaged west wall frescoes of the imperial cult chamber at Luxor may also have included a ceremonial imperial chariot as part of a large *adventus* scene.[76] Despite the similarities with these contemporary *adventus* scenes, however, the emphasis in the Nicomedia relief seems to be on the meeting of the emperors in a city rather than their entry into a city.

Since they were constantly campaigning in remote corners of the empire in the East and West, Diocletian

and Maximian rarely saw each other.[77] Interestingly, there is no mention of Maximian ever arriving in Nicomedia as an Augustus in the extant literature.[78] Only two meetings between the two *Augusti* are attested: one in 288, at an unknown location following Diocletian and Maximian's joint operation against the German tribes, and another in early 291 in Milan, after successful campaigns at Bagaudae, across the Rhine, and against German tribes in Gaul in previous years.[79] Along with their Caesars, the co-emperors might also have been present together in Rome in November 303 for the *decennalia* celebrations.[80] As other panels of the Nicomedia frieze contain references to several victories over different Germanic tribes, the *adventus* scene here could have referred to a meeting of the two emperors in 288. In that case, the unknown location of the conference mentioned in the literary texts would have been Nicomedia.[81] One other possible date for the commemoration of the meeting of the emperors on the relief is 290/91, when the *quinquennalia* of their co-rule might have been celebrated.[82] As discussed above, the emphasis on the *Jovius* and *Herculius* iconography, and the lack of any obvious reference to *Caesares* on the parts of the Nicomedia frieze discovered so far, suggests a date slightly before the spring

[77] Rees 2002.

[78] Maximian might have been present in Nicomedia when Diocletian was proclaimed emperor in November 285: see Barnes 1982, 31–32.

[79] *Pan. Lat.* XI.8.1. For a list of the attested movements of the Emperor Diocletian, see Barnes 1982, 50–56. Kiernan (2003, 46–48) considers Mainz as the place of the 288 meeting based on the controversial iconography and dating of the Mainz medallion. This medallion with a representation of a largesse of the two enthroned emperors over the city of Mainz has been variously dated between 288 and 297.

[80] For the Decennalia Monument see Kleiner 1992, 413–17, Marlowe 2016, and the above discussion on p. 53.

[81] Williams (1985, 50) considers Mainz as the possible place for Diocletian and Maximian's meeting in 288.

[82] In 290, by the fifth year of their co-regency, the diarchs had achieved greater success than many third-century emperors by establishing stability through the new governmental system and suppressing attacks in both the east and west. In literary sources, there is no reference to *quinquennalia* celebrations that might have taken place in 290 or 291 to mark the fifth year of the Diarchy. Diocletian appointed Maximian as Caesar on 21 July 285, and as Augustus on 1 April 286. It is hard to determine which of the two dates the rulers considered as marking the beginning of their co-regency. In 290, Maximian visited Rome and Lugdunum, toured Gaul, and met Diocletian in Milan; before meeting Maximian, Diocletian had visited Adrianople, Byzantium, Antioch, Emesa, Laodicea, Pannonia, and Sirmium, see Barnes 1982, 52.

[72] Rees 2002, 77–81.

[73] For *adventus* scenes see Koeppel 1969.

[74] Elsner 2000; Carlson 2010.

[75] Laubscher 1975, Tafel 48; Rothman 1977.

[76] McFadden 2015, 118–19.

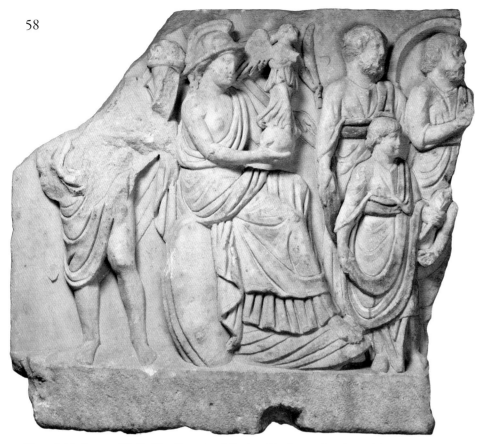

Figure 3.11. **Cat. no. 17**: Goddess Roma? and Genius of the Roman People? with Togate Romans.

to a specific place outside the city's boundaries to greet the emperor and his entourage of soldiers and associates. After the arrival, the entire group would enter the city to continue their celebrations. At this point, some emperors would participate in the *mutatio vestis* (change from military costume to civilian costume) before crossing the threshold of the city, and later in the day, they would formally meet the magistrates and accept the requests of the city. During this time, the emperor would act as benefactor or patron, planning buildings, monuments, or restoration. The following day, games were held to celebrate the presence of the emperor, at which he would distribute largesse.

Although there is no single formula for *adventus* depictions, major ingredients of the ceremony are often featured in Roman state art.[85] The common motifs of imperial *adventus* include architectural references to the city the emperor is entering; citizens, troops (especially standard-bearers), and divine figures accompanying the emperor to indicate their support; and captives or defeated enemies that mark his military victory. As mentioned above, all of these motifs appear on other *adventus* panels of the Nicomedia frieze.

Iconography and narrative sequence suggest that one of the relief panels, **cat. no. 17** (Fig. 3.11, also see Fig. 3.9), may have been situated somewhere to the left of the relief with the embracing co-emperors, behind Diocletian's entourage. The partially preserved figure holding a cornucopia on the left side of this relief panel is perhaps a representation of the *Genius Populi Romani*. Next to him is the armed goddess Roma,

of 293. The relief might also depict a meeting in or after 293, when the *Caesares* had already been appointed but had not yet become part of the embrace iconography.[83] Within the overall sculptural programme, however, rather than referring to an actual meeting, the relief panel with the embracing emperors is more likely to be understood as a symbolic and timeless representation of a continuous state of like-minded concord between the two emperors, who in reality rarely saw each other.

While the details of each individual ceremony vary, MacCormack formulates the following general pattern for the Roman *adventus* ceremony in both the imperial and Late Antique periods:[84] the arrival of the emperor would be announced in the city in advance, after which the residents would decorate monumental public buildings and streets. On the day of the emperor's arrival, a group of elite citizens, led by the Senate, would proceed

83 See Hekster and others 2019, who argue that the Tetrarchic imagery initially centred on the double duality of the co-ruling emperors. If the togate Romans walking in front of the goddess Roma and *Genius Populi Romani* on another relief panel (**cat. no. 17**, Fig. 3.11) are indeed representations of *Caesares* and their heirs, then this meeting might have even referred to a congregation for the declaration of the Tetrarchy in Nicomedia in 293.

84 MacCormack 1972, 723–27 and Kneafsey 2016.

85 As Klose (2015) demonstrated by re-examining the *adventus* scenes in Roman state art in two different media (coinage and reliefs), it is problematic to posit that a single visual formula was used for the arrival of the emperor and to label this formula using the ADVENTVS legend that appears on the reverse of Roman coinage, because state reliefs display a variety of *adventus* scenes that are mostly different from numismatic imagery and from each other as well. Thus, Klose correctly argued that each image should be examined in its own right.

seated on shields and holding a small Victory on a globe in her right hand and a spear in her left hand.[86] In front of the goddess, togate Roman dignitaries (both bearded adults and children) advance towards an arched structure at the upper right of the relief.[87] The inclusion of the children among the togate civilians and the crowning of one of the togate adults by the small Victory makes it more likely that these togate figures in a processional scene are the imperial family rather than some members of the Roman Senate.[88] The arch they are marching towards seems to be a generic reference to a city rather than being a special landmark of the city. In the same way, the goddess Roma may have symbolized not the city in which this meeting is taking place (Rome) but Roman *imperium* itself. Galerius also appears accompanied by Roma, when meeting with the Persian delegation on his eastern expedition on the reliefs of the Arch of Galerius.[89] The way Roma holds the small Victory is reminiscent of the stock representation of hand-held statues of gods that appear in imperial processional scenes.[90] Victories themselves carry statuettes of gods in their right extended arms on the lowest register of the north-east side of the south pier on the Arch of Galerius.[91] Statuettes of Victories with a wreath and a palm branch in their hands also appear in Late Antiquity especially in the context of consular diptychs.[92] Some of these representations are linked to the processions preceding the consular games, which ended with the presentation of the statue of Victory to the enthroned emperor.[93]

Another rather fragmentary relief panel with at least three standard-bearers (*vexillarii*) can also be considered as part of the *adventus* procession on the Nicomedia

Figure 3.12. **Cat. no. 18**: Standard-Bearers.

frieze (**cat. no. 18**) (Fig. 3.12, also Fig. 3.9).[94] The direction of the standard-bearers indicates that the panel might have been part of the entourage behind Maximian. As mentioned above, some other relief panels with divinities leading captive barbarians might also have been conceived as part of the extended *adventus* procession. They will be examined in the next subsection, after a discussion of the other reliefs showing the emperors themselves.

86 These two figures can alternatively be interpreted as Honos and Virtus. Bieber (1945) discusses how these two gods are usually mistaken for the *Genius Populi Romani* and Roma with their similar iconography. However, Virtus is usually shown as standing not seated on shields as on the Nicomedia relief.

87 Zeyrek and Özbay 2006, 293–95.

88 It is even tempting to identify the two bearded men as the new Caesars, Constantius I and Galerius, and one of the togate children as a young Constantine, Constantius's future heir. Yet, in the absence of any clear iconographic evidence, it is hard to draw such a conclusion.

89 Rothman 1977, 453.

90 For a detailed study on the hand-held statues in Roman imperial processions see Madigan 2012.

91 Madigan 2012, 26–35.

92 Olovsdotter 2005, 132–42.

93 Madigan 2012, 33.

94 Separately found fragmentary left hands holding poles in the same manner (Appendix I, SRF 16, 17, and 18) suggest the existence of two more standard-bearers on the missing right side of the relief panel.

Other Imperial Scenes of the Frieze: Battle,
Marching Soldiers, and Imperial Appointment

The two *Augusti* may have appeared on another relief panel on the Nicomedia frieze, not embracing but standing in full armour on either side of a garland-bearing Victory, **cat. no. 20** (Fig. 3.13 and also see Fig. 1.15). Only one of the emperors is preserved almost fully on this panel, which was stolen during the 2009 rescue excavations (see above, pp. 16–18) and was recovered in 2018. He wears body armour with *pteryges* (leather flaps) and a *cingulum* (military belt) under his long *paludamentum* painted in imperial purple, a colour reserved for the imperial domain on the frieze. He has a round head and short-cut hair and beard typical of the tetrarch portraits. Most of the right side of the relief panel beyond Victory is missing. The parts of drapery in high relief and painted in imperial purple next to Victory, however, imply the existence of another imperial figure on the right. Indeed, the lewis hole cut just above Victory's head on the top surface of the panel suggests that she was at the centre of the composition, possibly flanked by two emperors on each side.[95] Since the emperor on the relief appears in military costume, the representation brings to mind a *profectio* scene (ceremonial departure of the emperor(s) for war), with Victory alluding to future triumphs. According to the literary tradition, a real-life *adventus* usually involves *mutatio vestis*, the emperor's change from military attire to civilian costume before the city gates, while in a *profectio* he remains clad in military attire.[96]

On another relief panel the emperor appears in the midst of a military combat. The mounted emperor with short-cut beard and hair attacks the enemy with his spear, while his purple *paludamentum* blows behind him in action (**cat. no. 10**) (Fig. 3.14). Descendant of the Hellenistic battle imagery of Alexander, the overall composition is very similar to the crowded combat scene with the mounted Galerius attacking the Persian/Sasanian army on the south pier of the Arch of Galerius (Fig. 3.4) and also to the battle scene on one of the four very poorly preserved Tetrarchic reliefs inserted into the

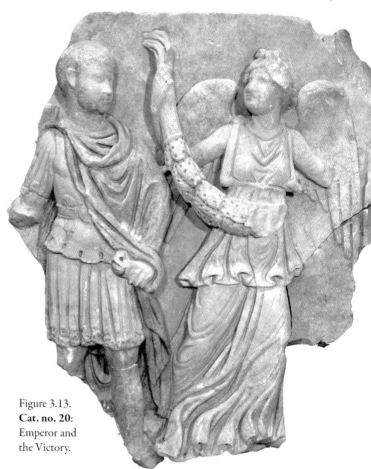

Figure 3.13.
Cat. no. 20:
Emperor and
the Victory.

Byzantine wall of Nicaea as spolia.[97] The better-preserved Nicomedia relief, however, offers more details within its specific context. The defeated enemy and the victorious Roman sides are clearly differentiated by the emblems on their shields; the Roman soldier's shield behind the emperor is embossed with the head of Medusa, while the soldiers of the defeated side have shields with diamond symbols. Shields with the Medusa head appear in the hands of other Roman soldiers on the Nicomedia frieze, such as in **cat. nos 1 and 2**. The shields with diamond-shaped bosses are shown as part of the armoury of exhausted marching soldiers in a military marching scene on **cat. no. 11** (Fig. 3.15a–b). Neither the diamond nor the head of Medusa appears on the official military insignia of Roman armoury recorded in the *Notitia dignitatum*, a detailed text on the Roman administration and army units during the later Roman Empire, surviving in a sixteenth-century copy. However, this interest in military insignia to designate a specific military party is not alien to other Tetrarchic monuments; Galerius's soldiers

[95] Indeed, small relief fragments of a figure(s) with a cuirass and military kilt of *pteryges* (Appendix I, SRF 11 and SRF 37) might have belonged to this relief panel.

[96] For the imagery of *profectio* and *adventus* see Koeppel 1969 and Klose 2005. Emperors do not appear in full military costume in all *profectio* scenes; for example, on the *profectio* scene on the Aurelian reliefs of the Arch of Constantine, the emperor appears unarmed.

[97] For the relief on the Arch of Galerius, Rothman 1977, 442–42, fig. 23; for the relief from the walls of Nicaea, Laubscher 1993, 380–84, figs 3–6. Similarly composed battle scenes are also typical on Roman sarcophagi.

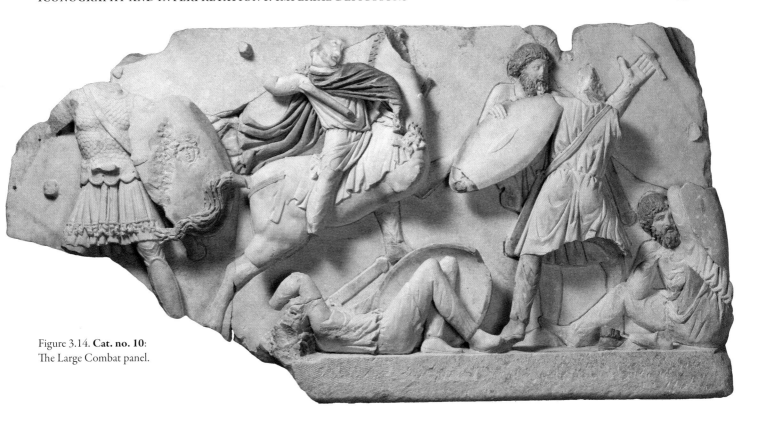

Figure 3.14. **Cat. no. 10**:
The Large Combat panel.

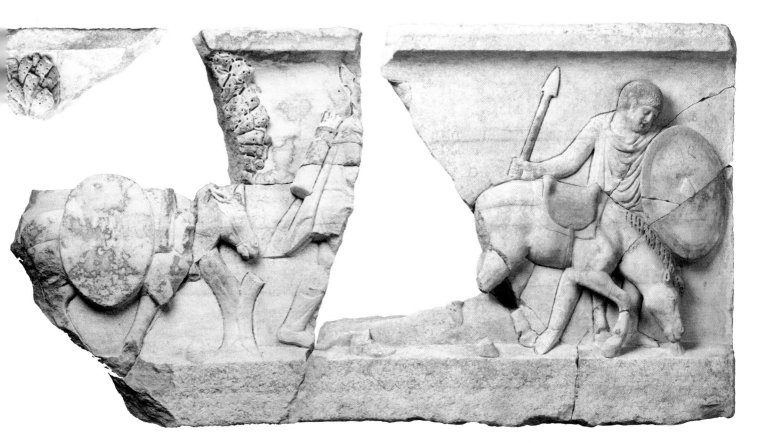

Figure 3.15. **Cat. no. 11**: Military March of the Immigrants in the Countryside,
with the exhausted soldier and the exhausted horse on the right.

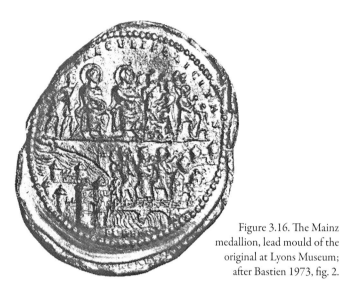

Figure 3.16. The Mainz medallion, lead mould of the original at Lyons Museum; after Bastien 1973, fig. 2.

on the Arch of Galerius for example carry shields with Herakles blazon, alluding to his imperial title.[98]

Besides two shields with diamond insignia (one hanging on the side of a mule and another in the hand of a soldier) other details on **cat. no. 11**, such as the costumes of the marching soldiers, may hint at the circumstances in the aftermath of the combat shown on **cat. no. 10**.[99] The clean-shaven young soldier leading a weary horse on the right of the relief panel has his head lowered, while his horse also appears with its head down, possibly sniffing a tuft out of hunger. Also part of the marching convoy, a heavily loaded mule and a quiver-bearing soldier pass oak trees on the left of the relief panel. All the visual cues point to a long march in the woods, perhaps in the aftermath of the actual battle shown on **cat. no. 10**. One is inclined to identify them as barbarians departing after their defeat, as victorious Roman soldiers would not be rendered with the shields of the defeated side (with diamond insignia). The absence of bridles and a rather low-class saddle for the horse compared to the saddles on other imperial horses of the frieze (**cat. nos 10, 14, 24**) also suggest a barbarian identity for the soldiers. Both of the marching soldiers, however, still carry their military equipment (spears, arrows, shields) and wear a military cloak (*sagum*), an element of dress used to distinguish the Romans from barbarians on other relief panels of the Nicomedia frieze. In light of this they may be *Laeti*, barbarians who were forced to migrate and resettle in the predesignated imperial territory on the condition

that they provide military service for the Roman army. Alternatively, the *sagum* they wear and the military equipment they bear might refer to their high military rank within the barbarian army.

In addition to actual battles against barbarians across the Rhine and Danube frontier, tetrarchic policies that led to state-forced barbarian migration and resettlement were praised as unique achievements in a panegyric given to Constantius in 296. Addressing Constantius, the anonymous orator says:

> And so as formerly on your orders, Diocletian Augustus, Asia filled the deserts of Thrace by the transfer of its inhabitants and as later, at your bidding, Maximian Augustus, the Laeti, restored by right of *postliminium*, and the Franks, admitted to our laws, have cultivated the empty fields of the Arvii and the Treveri, so now through your victories, Constantius, invincible Caesar, whatever land remained abandoned in the territory of the Ambiani, Bellovaci, Triciasses, and Lingones turns green again under cultivation by the barbarian.[100]

There is no other historical record of Diocletian transferring Asians to the deserts of Thrace. Yet Maximian's successful trans-Rhine campaigns to secure the German frontier in 286 and 287 seem to have also involved counter-alliances with barbarians, in which lesser Germanic tribes were forced to migrate and resettle at buffer zones, where they could guard the new territories from other raiding Germans.[101] Indeed, Nixon and Rodgers note that the earliest mention of the *Laeti* as an institution occurs in the passage from *Panegyrici Latini* VIII mentioned above, indicating their initial organization under Maximian and Diocletian.[102]

The parallel imagery with marching barbarian immigrants on the so-called Mainz medallion has also been linked to the trans-Rhine barbarian migration policies of Maximian (Fig. 3.16).[103] The lead cast of the corroded original medallion, found in Lyons in 1862, shows the nimbate co-emperors Maximian and Diocletian enthroned in a largesse scene on the top register. At the centre of the top register, barbarians with outstretched hands led by helmeted soldiers receive largesse from the enthroned emperor while on the right end, a man with a sack on his back and a baby in his arms marches towards the right. The march continues on the bottom register, as

98 Laubscher 1975, pl. 38.

99 The scene may have also alluded to what had happened before the combat: the soldiers (with diamond-shaped bosses on their shields) came from far away only to get defeated by the imperial forces on cat. no. 10.

100 *Pan. Lat.* VIII.9.21, trans. Nixon and Rodgers 1994, 141–44.

101 Williams 1985, 51.

102 *Pan. Lat.* VIII.9.21, trans. Nixon and Rodgers 1994, 142 n. 76.

103 Bastien 1973, Williams 1985, 50, Burns 1994, 14–15, and also Kiernan 2003, 45–50.

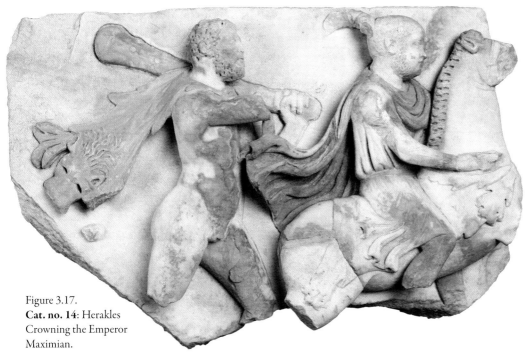

Figure 3.17.
Cat. no. 14: Herakles
Crowning the Emperor
Maximian.

our purposes is the use of this specific forced-migration motif. Although rare, fleeing barbarian soldiers heading to the woods and mountains sometimes appear in previous Roman state art. Some fugitive Dacian soldiers, for example, appear disembarking from a ship and running towards the woods after their defeat by Trajan's army on a scene on Trajan's Column.[108] In the earlier cases, however, the barbarians appear totally unprepared for this journey, without any armour, sacks, or loaded mules. The imagery on the Mainz medallion and the immigrant barbarian soldiers on **cat. no. 11** of the Nicomedia frieze might indicate that in addition to the victories in the battlefield, the tetrarchic policies of migration (to solve both the issues related to barbarian raids and depopulation) were considered a part of the tetrarchic triumph in imperial propaganda.

a similar crowd of armed men, women carrying oblique sacks on their backs, and children appear crossing the bridge over a river and walking towards a castled city; the river and the castle are identified as the Rhine and Mainz respectively through legends. A tree, similar to those on **cat. no. 11**, outside the city walls of Mainz, is perhaps a reference to the long march of the immigrants in the countryside to reach the city.[104] The medallion has been variously interpreted and dated between 287 and 297.[105] Bastien is probably correct that the medallion represents a commemoration of the transfer of barbarian populations to be resettled in Gaul.[106] But as Kiernan points out, there is no need to link the imagery to a specific ceremony held by Maximian after his campaigns across the Rhine in 288 or to another one after Constantius's resettlement of barbarians in 297 mentioned in the *Panegyrici Latini* VIII.[107] It could refer to any Rhine campaign between the 280s and the 290s. What is important for

On another relief panel of the Nicomedia frieze with well-preserved colours, we can identify the individual emperor as Maximian (**cat. no. 14**) (Fig. 3.17). The emperor on horseback is portrayed with a typical Tetrarchic rounded head, thick neck, and short-cut hair and beard, but also with a distinctively retroussé nose. He wears a windblown purple *paludamentum* over his sleeved tunic decorated with purple bands. Herakles with his lion-skin cloak and club stands right behind the emperor and reaches towards the emperor's head to crown him with a wreath. Since Emperor Maximian held the title of *Herculius*, and was depicted with a retroussé nose and as being crowned by Herakles on Diarchic and early Tetrarchic coinage,[109] it is almost certain that he is the one on this relief panel. On another fragmentary relief panel, another emperor on horseback, perhaps

104 Trees are commonly used in Roman state art, usually to indicate rural settings. The Roman army, for example, appears surrounded by oak and pine trees in the rural encampment scenes or while cutting such trees to open roads in the forest for the Roman army on Trajan's Column (Coarelli 2000, 101, plate 57). Trajan's Column also has a scene showing the deportation of captive Dacian women with babies in their arms, led to a ship by Trajan himself (Coarelli 2000, 73, plate 29).

105 Kiernan 2003, 45–50.

106 See Bastien 1973, 85.

107 Kiernan 2003, 49.

108 Coarelli 2000, 197, plate 150.

109 For the retroussé nose of Maximian as an individual physiological feature appearing in early Diarchic coinage see Smith 1997, 181. For a general discussion of Maximian's adoption of the *signum Herculius*, reflected on coinage, and its political implications see Rees 2005.

Diocletian, looks back, perhaps towards this crowning scene (**cat. no. 15**) (Fig. 3.18). The emperor wears a purple *paludamentum* over his belted tunic adorned with gold bands. Since the emperor's bust is not carved in a detailed manner — with his neck left almost unfinished and his short beard and hair only indicated with paint — it is, in this case, hard to be certain about the identity of the specific emperor. The exact find-spot of the relief within the Çukurbağ complex is unknown, and thus its relation to the panel with Maximian's crowning is also uncertain. The ceremonial harness of a partially preserved horse and the hand of its rider on **cat. no. 24** might have also belonged to an imperial figure in a ceremonial context.

Maximian might have appeared on another relief panel of which only the bottom part, with the feet of two frontally standing figures, is preserved: one foot of a figure wearing a fringed cloak painted in imperial purple and Herakles with his lion-skin cloak hanging down behind his legs (**cat. no. 21**) (Fig. 3.19). Just as Herakles and his lion-skin cloak are visual cues in the identification of *Herculius* Maximian on the Nicomedia frieze, the sceptre as the attribute of Jupiter seems to have been used in connection with *Jovius* Diocletian. Thus the figure clad in a fringed imperial *paludamentum* painted in purple and holding a golden sceptre with a knobbed end on **cat. no. 23** might have been Diocletian himself. He also appears wearing the imperial purple cloak and holding a gold-coloured sceptre on **cat. no. 22** (Fig. 3.20). Despite its fragmentary state, the latter relief has more to offer than the identity of the emperor depicted.

The emperor on the right side of the relief (**cat. no. 22**) hands a small codex to a heavily draped smaller figure on the left. The motif should be understood as a variation on the typical *liberalitas* scenes used to denote the emperor's generosity on other Tetrarchic monuments. The left hand of the figure receiving the codex is buried in the folds of the heavy tunic, reminiscent of the Roman dignitaries receiving jewelled belts with their hands veiled (*manus velatae*) in the presence of the enthroned tetrarchs, in a court scene on the above-mentioned fresco from the south wall of the cult room at Luxor (Fig. 3.7).[110] The Romans receiving the largesse of the enthroned Constantine on the *liberalitas* relief of the Arch of Constantine also wear similar heavily draped togas.[111] The emperor on the Nicomedia relief is not enthroned, but clearly larger than the recipient of the

110 McFadden 2015, 119–21.

111 Ferris 2013, 83, fig. 51.

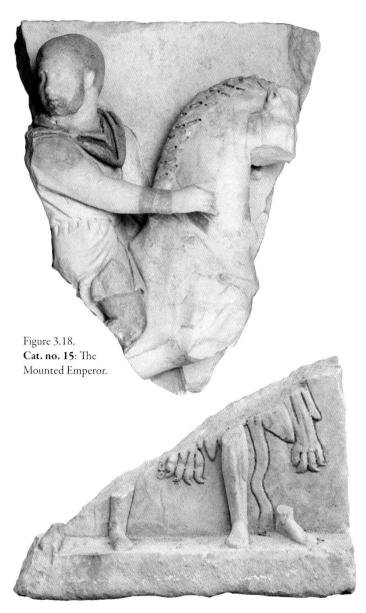

Figure 3.18. **Cat. no. 15**: The Mounted Emperor.

Figure 3.19. **Cat. no. 21**: Relief Fragment with Emperor? and Herakles?

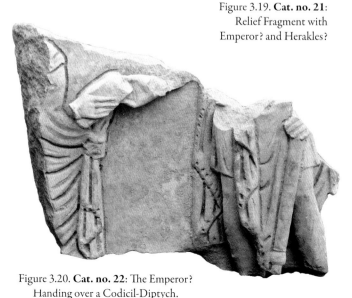

Figure 3.20. **Cat. no. 22**: The Emperor? Handing over a Codicil-Diptych.

codex. The typology of the codex indicates that it is actually a codicil-diptych, a formal letter of appointment to an office granted by the emperor.[112] This type of letter was in the form of a writing-tablet comprised of flat rectangular pieces of wood joined together with wax-coated inside surfaces bearing the official inscription.[113] Several such codicils granting various offices are illustrated in the *Notitia dignitatum*, depicted as rectangular in shape with lines on the side indicating the pages inside the diptych. The *Missorium* of Theodosius, a silver dish made in Constantinople to celebrate the tenth anniversary of Theodosius's rule in 388, perhaps offers the best parallel imagery (Fig. 3.21). On the fourth-century plate, the emperor seated in the middle hands a codicil-diptych to a heavily draped senior official shown in smaller scale on the left.[114] The codicil-diptych on the late third-century Nicomedia relief could be the earliest illustration of the type which became popular in the imagery of fourth- and fifth-century consular diptychs.[115] In his discussion of the origin and the function of Late Antique consular diptychs,[116] Cameron suggests that the actual institutionalization of consular games (which celebrated the inauguration of the consul in the first week of January) happened during the Tetrarchy in the new Tetrarchic capitals and that the whole ceremony started with the emperor handing the letter of appointment to

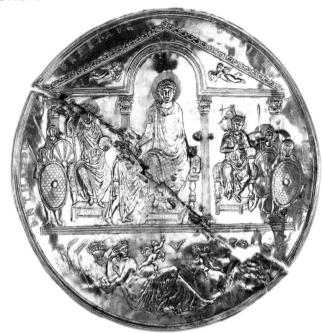

Figure 3.21. *Missorium* of Theodosius, Real Academia de la Historia in Spain, *c.* 388 (© Scala/Art Resource, NY).

the new consul.[117] If his argument is right, then we can even claim that the scene on the fragmentary relief, combined with references to games and festivals on other Nicomedia reliefs, commemorates the inauguration of a consul in Nicomedia. Besides emperors Diocletian and Maximian, who acted as the sole imperial consuls in 290 and 293, two plausible names appear in the consul lists of the late third century: Cassius Dio (whose family perhaps was a descendant of the well-known historian in Bithynia) who became the consul in 291, and Afranius Hannibalianus, Maximian's best comrade and the leader of the victory over the Germanic tribes, who became consul in 292.[118] With our current state of knowledge, however, it is safe to say that this codicil scene denoted an imperial appointment and that this ceremonial offering of an official position or title existed within the overall theme of the triumph of the emperor(s) as well as the triumph of Nicomedia.

Captive Barbarians on the Nicomedia Frieze

The captive barbarians led by Roman victors or divinities appear on at least eight of the surviving relief blocks of the Nicomedia frieze, **cat. nos 1 to 8**. These eight relief blocks, as well as possibly another relief fragment showing partially preserved feet that may belong to captives

112 For the origin of codicil-diptychs and their imagery see Grigg 1979, Olovsdotter 2005, 87, and Cameron 2013, 175–80.

113 Cameron 2013, 176.

114 Almagro Gorbea 2000.

115 For *codicilli* represented on the consular diptychs between AD 380 and 450, see Olovsdotter 2005, 87–88. A parallel example of a scene containing a small codex in imperial Roman sculpture occurs on the much earlier reliefs on the Altar of Domitius Ahenobarbus in Paris. The small codex in the hand of a standing figure approaching a seated figure with a larger codex on the relief has led scholars to identify the whole relief variously as a depiction of either a census or the *deductio* (foundation) of a new colony, two situations in which citizens were officially recorded in a codex. See Maschek 2018 for an overview of the literature and the identification of the reliefs of the Altar of Domitius Ahenobarbus. The introduction of a new system of census was among Diocletian's most significant reforms (see Rees 2004, 38–39). Nicomedia was not a newly founded colony but Diocletian's newly designated administrative capital of the empire. Yet there is nothing further on this fragmentary relief to suggest a reference to a census or Nicomedia's reception of a new title or rank.

116 Consular diptychs (usually of ivory) became especially popular in the fourth through sixth centuries among the Roman elite who celebrated the attainment of certain offices by distribution of commemorative diptychs to their close friends and family. Forty-three extant consular ivory diptychs are discussed in detail in Olovsdotter 2005.

117 Cameron 2013, 201–04.

118 Bagnall and others 1987, 116–18.

and Roman victors (**cat. no. 45**), and a small fragment showing bound captive hands (Appendix I, SRF 10), form part of a large triumphal processional scene. The panels all together could have referred to the emperors' triumph and *clementia*. In order to understand the meaning of the specific motif, an overview of the scholarship on captive barbarians in Roman art is necessary.

Captive barbarians are very common in Roman state art from the Republic to the Late Empire.[119] Their defeat and subservience to Roman power seem to have become part of the visual language of Roman triumphal art. The motif became especially popular during the late third and early fourth centuries. Almost all of the known public monuments of the Tetrarchic period display captive barbarians either led by victorious Romans in processional scenes or under the feet of emperors and Victories: several panels on the Arch of Galerius in Thessaloniki,[120] the surviving base of Diocletian's Decennalia Monument, the pedestal reliefs of the Arch of Constantine in Rome,[121] and the pedestal reliefs of Diocletian's lost arch (Arcus Novus), some surviving parts of which are now in Florence.[122]

The earliest detailed study on the captive barbarian scenes in Roman coinage and monumental sculpture was published in 1952 by Levi.[123] According to Levi, the motif reached its full-fledged form during the time of Trajan and became increasingly popular during the third and fourth centuries as a generic symbol of Roman victory and an attribute of the emperor. Levi further argues that, in the process, the motif became a stereotypical symbol of Roman power, losing any connection with a historical victory over a specific people.[124] Levi's argument is supported by the fact that the ethnographic identification of barbarians based on their physical appearance, costume, and accoutrements on the imperial representations in the second century has proven to be problematic, causing scholarly debate. The floppy hats of the barbarians on the battle scene of an Antonine altar from Ephesus, for example, gave the monument its mis-

nomer title of 'Parthian monument'. Landskron, however, has shown that these barbarians wear elements of both oriental and northern costume, and thus cannot be just Parthians.[125] The effort to distinguish the ethnicities of Germans based on their dress and equipment on the column of Marcus Aurelius has proven to be useless as well, since Beckmann has shown that not all the elements on the spiral frieze of the column are actual historical illustrations.[126] Gergel further shows that the costume cannot always be a geographic indicator of the 'kind' of barbarians depicted on cuirassed statue breastplates in Roman art. He stresses that the accuracy of detail in barbarian costume and equipment depicted on the breastplates became less important after the time of Trajan and thus the motif lost its role as a visual documentation of a certain military victory of the emperor.[127] Hunter, in his statistical study of the barbarian representations and their equipment in Roman provincial art, also concludes that there was no direct relationship between certain equipment, especially weaponry, and a particular group of barbarians.[128] The studies discussed above warn us to be cautious in our ethnographic definition of the bound prisoners on the third-century Nicomedia frieze. Yet we cannot perceive them simply as generic symbols of Roman victory either, as Levi suggested for the use of the motif in the third century. As will be discussed in detail below, the artists' variation in the hair colour and hats of the captives on the Nicomedia frieze indicates a clear intention to differentiate between the different groups over whom the empire became victorious. Obviously, we should not consider them as ethnographic studies of individual groups and events, since the main function of the motif within the frieze is propagandistic, but rather, the contemporary viewer might have identified the variety of barbarians in general terms based on the historical and geographical circumstances.

Despite the variety in their colour, all of the captive barbarians depicted on the Nicomedia frieze wear the same type of clothes: a knee-length sleeved tunic (fas-

[119] Ferris (2011) provides an excellent summary of the literature on the representations of barbarians in Roman art. He further draws attention to their 'dehumanization' in public art starting with the Antonine period.

[120] Rothman 1977, 436–37, fig. 12 and fig. 15.

[121] Kleiner 1992, 414, 453, 454; figs 382, 414, 415. Also see Elsner 2000, 173.

[122] Kleiner 1992, 311, figs 380–81.

[123] Levi 1952.

[124] Levi 1952, 27.

[125] Landskron (2006, 153–54) states that the barbarians on the reliefs have different configurations; some have a muscular but small body construction and relatively small heads; they wear Phrygian caps, but various costumes. The others have larger bodies and rumpled, shapeless heads with long beards and dense, disordered hair, usually without headgear.

[126] Beckmann 2011, 12, 155.

[127] Gergel 1994, 206.

[128] Hunter 2009. He thinks (2009, 797) most specifically that the iconography was understood as eastern or northern barbarians by the contemporary viewer.

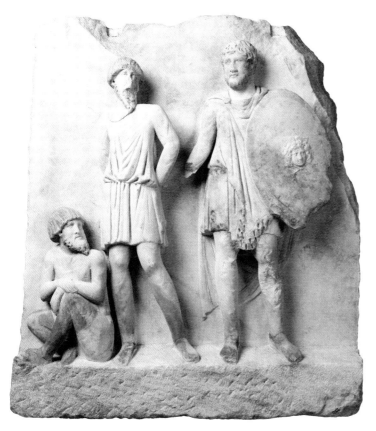

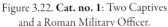

Figure 3.22. **Cat. no. 1**: Two Captives and a Roman Military Officer.

Figure 3.23. **Cat. no. 2**: A Bound Captive and a Roman Military Officer.

tened with a robe at the waist) over trousers and soft shoes (see especially on **cat. nos 1 and 2**) (Figs 3.22–3.23). Neither the sleeved tunic nor the trousers identifies them as barbarians, since most of the Romans (**cat. nos 1, 2, 22, 23**), including the emperors themselves (**cat. nos 10, 14, 15, 16, 20**), wear the same tunic over their trousers. In most cases, however, Romans are differentiated by cloaks (*sagum*) worn over their tunics. None of the barbarians except those on **cat. no. 11** wear cloaks. The hair colour and hair type indicate three different barbarian groups: barbarians with floppy hats and thick curly hair and beards (**cat. nos 3 and 6**); hatless barbarians with bob-cut blonde hairstyles and long messy beards (**cat. nos 1, 4, 6**); and hatless barbarians again with bob-cut hairstyles and messy beards, but this time painted reddish-orange in colour (**cat. no. 5**) (Fig. 2.18).

During the Diarchy and the early years of Tetrarchy, the soldier emperors had won several victories over foreign peoples on the frontiers of the empire:[129] Diocletian had won victories over the Sarmatians, Carpi (related

to Dacians), and Goths;[130] Maximian, as a diarch, had crushed the Bagaudae in Gaul and after a joint operation with Diocletian in 288 had defeated several Germanic tribes on the Rhine frontier; and as a tetrarch, he had conducted successful campaigns in Spain and North Africa; Galerius had successfully suppressed the rebellions in Egypt and had brought down the Sasanian king Narses and his army in the East, an event celebrated on the reliefs of the Arch of Galerius. Thus, the captive barbarians of the Nicomedia frieze could refer to several different barbarian tribes that the emperors had fought in northern and eastern Europe. The hats with floppy tops on some of the captives do not help to pin down a certain ethnic group either; Parthians, Dacians, Sarmatians, and Scythians all appear wearing the hat in Roman art.[131]

129 Rees 2004, 13–23 for the military campaigns of the tetrarchs. Also see Barnes 1982, 254–55 for all the victory titles the tetrarchs received by the year 301.

130 For epigraphic evidence for Diocletian's victory over Goths between 292 and 294 see Brennan 1984.

131 'Dacians' wear the Phrygian cap on Trajan's Column, while 'Parthians' wear it on the Arch of Septimius Severus and the 'Parthian Monument' at Ephesus, and 'Sarmatians' wear it on the Arch of Marcus Aurelius. See Şare 2011 for the iconography of the Phrygian cap and its meaning, which changes based on the context, in ancient art.

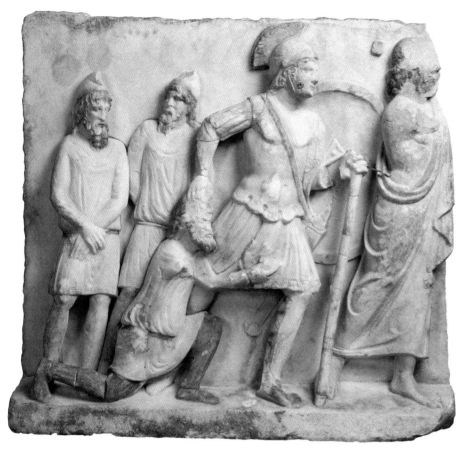

Figure 3.24. **Cat. no. 3**:
Captives with Pointed Caps Led by Romans.

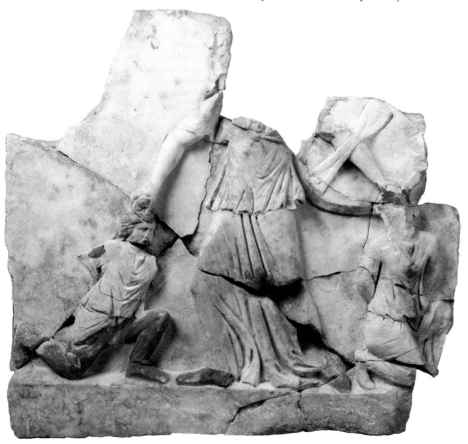

Figure 3.25. **Cat. no. 6**: Athena and Two Kneeling Captives.

This ambiguity of the specific identity of the barbarians could have been the case for contemporary viewers of the frieze as well. Clearly, however, no barbarian on the frieze was only generic. Their variety in hairstyle and hair colour might have forced the audience to subjectively identify them with different barbarians within the historical context, at the same time enhancing the message that the victory of the imperial power was not against one specific group of people but all over the empire.

Besides the differentiation of the barbarians' hair, the artists of the Nicomedia frieze also employed hierarchical scale, with Roman victors or divinities shown larger than the barbarians in order to emphasize their superiority. The difference in scale between the victor and the vanquished is especially pronounced on **cat. nos 3 and 6** (Figs 3.24–3.25). The Roman soldier on **cat. no. 5** is not fully preserved, but his arm pushing down a captive from the head is also slightly larger than the arms of the captives (Fig. 3.26). This emphasis might be due to the fact that in these three panels the captives are in the presence of divinities. On **cat. no. 6** the goddess Athena drags two small kneeling barbarians by their heads. Likewise, the armoured victor on **cat. no. 3** dwarfs the barbarian he is dragging by the head and the other standing captives on the left. The difference in size then suggests that the armoured victor and the partially preserved crowned figure on the right of the panel might be divinities as well. In the absence of clear attributes, it is hard to tell, but the armoured figure could be the war god Mars, and the crowned and bearded figure could be Neptune or Jupiter. On **cat. nos 1 and 2** the scale difference between the captive and the victor is much less pronounced but still present.

The kneeling barbarians on either side of Athena on **cat. no. 6** (Fig. 3.25) are clearly differentiated: one wears the Phrygian cap, while the other does not, and their otherwise similar costumes have contrasting colours. The panel metaphorically alludes to how the goddess of wisdom and war (Athena) sided with the emperors and brought different barbarians around the empire down to their knees. Levi, writing in the 1950s, declared that 'the type representing a walking emperor or a divinity dragging a small enemy [...] does not appear before the time of Constantine'.[132] She further stated that the motif might have appeared before the Tetrarchy, but because of the 'well-known gap' in the monumental sculpture in the third century, there was no way of proving this.[133] The Nicomedia frieze fills this gap, and shows the origin of this motif in Roman state art.

We do not know if all eight of the panels were envisioned and carved by the same group of artists, but the artists seem to have co-operated. For the legibility of the panels (both thematically and visually), the artists used symmetrical and contrasting pairing methods in both carving and colouring. For example, both the Roman victor and the barbarian prisoner appear young and beardless on **cat. no. 2**, while their counterparts on **cat. no. 1** appear mature, both bearded. On **cat. no. 3**, the contrasting colours of the costumes worn by the barbarians next to each other help the eyes of the audience to distinguish between the figures from a distance; the blue trousers of the standing captive on the left contrast with the cinnabar trousers of the kneeling captive below him. Once visually differentiated with differently coloured costumes, the quantity and variation of the captives must have also enhanced the triumphant message of the frieze, just like the divinities who help the emperors bring down barbarians of various ethnicities. Thus, the bound barbarian iconography on the Nicomedia frieze should be understood as semi-generic: a symbol not only of the emperor's victory, but of victory over several different ethnic groups with divine aid.

Concluding Remarks on Imperial Scenes of the Nicomedia Frieze

As the above investigation shows, the designers of the Nicomedia frieze employed a variety of pictorial means to define imperial power. Many of the motifs used were drawn from the traditional imperial propaganda scenes

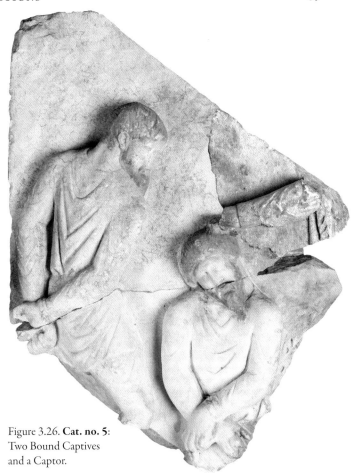

Figure 3.26. **Cat. no. 5**: Two Bound Captives and a Captor.

of Roman state art such as battle, triumph, *adventus*, *clementia*, and *liberalitas*, but they also reflect the new transformation in the imperial administration and court ritual under Diocletian. The use of symmetrical composition and hierarchical scale, visible for example on the longest relief panel with the embracing emperors, would later become a unique feature of Tetrarchic imagery with parallel scenes on other Tetrarchic monuments, such as the reliefs of the Arch of Galerius, the embracing porphyry tetrarchs of Venice and the Vatican, and the frescoes of Luxor discussed above. The embracing emperors on the Nicomedia relief appear similar in their imperial look but not in their physiognomy. Slight changes in scale, facial features, and hair colour imply the hierarchy between them. Yet these differences are not highlighted, as their main intention was not to create images of emperors themselves but to show a new united emperorship, recognizable by everyone.

The treatment of imperial costumes and paraphernalia on the Nicomedia frieze such as the imperial *cathedra*, fringed purple *paludamentum*, tunics decorated with gold bands, and golden sceptres reflects the emperors' new extravagant presence. Some other Tetrarchic patterns, like Pannonian hats (referencing military and

132 Levi 1952, 25.

133 Levi 1952, 34.

Balkan origins) and thrones with elaborate footstools (symbolizing authority), are not readily visible at first glance but fragments with the forehead of a figure wearing a Pannonian hat (Fig. 3.10) and a lion-pawed throne or stool leg (**cat. no. 42**) imply their possible existence within the original frieze. In none of the extant depictions from Nicomedia, however, do emperors appear in a complete frontal or enthroned pose, as is the case with the tetrarchs on the south-western wall at Luxor, Constantine's *adlocutio* on the Arch of Constantine, or many later examples such as the above-mentioned *Missorium* of Theodosius, where frontal enthronement signifies the absolute power and authority of the seated figure. Also missing are the common motifs of imperial *adlocutio* (emperor's address) and *lustratio* (imperial purification). Yet references to emperors on fragmentary panels such as **cat. no. 23** indicate that these themes might have been represented on reliefs that are not fully preserved. In general, emperors depicted on the frieze appear isolated from their associate soldiers, from senators, and also from common people. They are escorted by deities (such as Herakles and Victory) or have the attributes of deities (sceptre and lion skin) indicating the perception of their absolute and god-given power. Some landscape and cityscape elements, like the trees on **cat. nos 11 and 54** and the arch on **cat. no. 17**, were made part of the visual narrative; but these elements appear as generic motifs in the synoptic narrative rather than realistic references to real places, with trees designating simply the concept of countryside and an arch the concept of the city. Likewise, captive barbarians are differentiated through slight changes in their hairstyle and colour without historic references to particular ethnicities.

As discussed in the previous chapter, the artists used both static and hieratic compositions in imperial processional depictions (e.g. **cat. no. 17**) and active complex compositions in lively battle scenes (e.g. **cat. no. 10**). The contemporaneous use of different styles for different themes and messages, especially on later Roman reliefs, is well explained through semantic methodology in Hölscher's ground-breaking work.[134] Likewise, McFadden interprets the intentional use of different styles on the Tetrarchic frescoes at Luxor as a tool for indicating the change in thematic content;[135] and Elsner argues that on the Luxor frescoes, the emperor was represented in different styles corresponding to his human and divine roles: naturalistic for the former, and abstracted

and symbolic for the latter.[136] No matter how static the composition, on the extant Nicomedia reliefs, emperors were not rendered in the completely flattened and frontal style which started during the Tetrarchy and remained as a sign of imperial status throughout the Byzantine period. As is typical of Late Antique art, there is a clear emphasis in the details of dress and insignia as symbols of imperial power on the Nicomedia frieze, but not at the expense of bodily form. The emperors on the frieze were made to look fleshy and naturalistic through details of carving and paint. Besides their semantic implications, the variety of styles used in the imperial scenes of the Nicomedia frieze must have also had practical reasons, as it would be hard to depict an active battle scene in a static way and an orderly procession in a complex active composition.

The relief panels with references to an *adventus* procession culminating in the meeting of two co-emperors and also a fragmentary panel with an imperial codicial scene let us search for actual imperial ceremonies that took place in Nicomedia in which both Maximian and Diocletian might have been present. Ruling in different parts of the empire, co-emperors did not get a chance to meet often, and not every single move they made is recorded in historical records. Possible dates for such ceremonies are 288, when Diocletian and Maximian met and became victorious over German tribes across the Rhine in a dual campaign; 290/91, when they might have celebrated the *quinquennalia* of their co-rule; January 291 or 292, when consular inauguration ceremonies took place; 293, when the two diarchs declared the new Caesars as their tetrarchs; and around 303, when *decennalia* celebrations might have taken place. The emphasis on the *Jovius/Herculius* iconography, and the lack of clear reference to the Caesars on the parts of the Nicomedia frieze discovered so far, suggests a date between 286 and 293, when Caesars had not yet become part of the 'Tetrarchic embrace' motif. In any case, the design and themes of the Nicomedia reliefs related to an *adventus* might have been inspired by such an actual event in which both emperors might or might not have been present. Yet, the overall thematic programme of the frieze indicates that the meeting and ceremony depicted are mostly symbolic and timeless, referring to the like-minded rule and triumph of the two *Augusti*. Likewise, the battle and the procession of captive barbarians depicted on other reliefs generically celebrate all the successes of the emperors at the borders rather than referring to specific historical events.

134 Hölscher 2004.

135 McFadden 2015, 107–08.

136 Elsner 2000, 173–76.

ICONOGRAPHY AND INTERPRETATION II:
MYTHOLOGICAL DEPICTIONS — EPONYMOUS HEROES OF NICOMEDIA

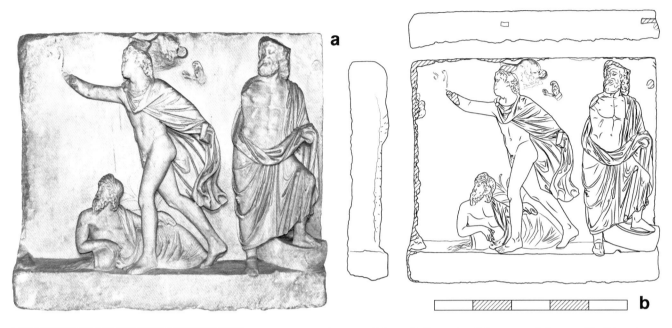

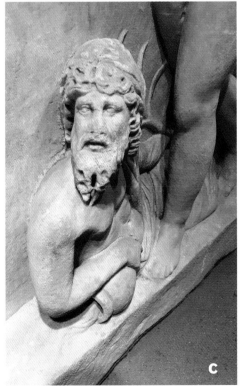

Figure 4.1. **Cat. no. 26**: Poseidon and
a Founding Hero (Nicomedes I?);
(a) main panel; (b) drawing of the panel;
(c) detail of the river god.

Only two of the relief panels of the extant Nicomedia frieze have mythological subject matter. As the iconographical examination below will show, both relief panels seem to relate to the foundation stories of Nicomedia: one perhaps referring to the mythical foundation of the city by Medea (**cat. no. 25**), and the other panel to its refoundation by Nicomedes I (**cat. no. 26**).[1] The latter panel, now in Istanbul Archaeological Museum and thus henceforth referred to as the Istanbul panel, was not found during the salvage expeditions of 2001 and 2009 at Çukurbağ. Yet, the provenance records in Istanbul Archaeological Museum and its technical and iconographical assessment led us to identify it as part of the Nicomedia frieze and more specifically to pair it with the panel **cat. no. 25** (henceforth referred to as the Medea panel) which was found during the 2001 Çukurbağ rescue excavations.

The puzzling imagery and the unknown context of a marble relief panel in Istanbul Archaeological Museum (inv. no. 5344 T) have long prevented its full scholarly publication (**cat. no. 26**) (Fig. 4.1a–c). The archives of the museum indicate that the relief came to Istanbul on 25 May 1957 from Izmit, from the vicinity of Çukurbağ; at the time there was no museum in Izmit, and it was standard practice to bring museum-worthy regional finds from the wider area to Istanbul. Just like the panels of the Nicomedia frieze, the Istanbul panel is made of Proconnesian marble. It measures 106 cm in height, including a plinth (15 cm in height) on which figures stand. Both the height of the relief block and

[1] Both reliefs are discussed in detail in Şare Ağtürk 2020b.

the height of the plinth match the average scale of the Nicomedia relief panels. The size and the stylistic rendering of the figures and the overall composition on the relief panel are very similar to the other relief panels on the Nicomedia frieze. The range of tool marks visible on the Istanbul relief also match with those on many of the blocks of the Nicomedia frieze: the figures and their background are well finished with flat chisels and rasps, while claw chisel marks are still visible on the front and top surface of the plinth; the back and the side-ends of the panel have rough pick marks; the drill is used for the details of hair and foliage, as well as for accenting drapery folds and outlining the figures. The position and the size of the clamp holes on top of the Istanbul panel also correspond with the placement of the existing clamp cuttings and their average size on the slabs of the Nicomedia frieze, indicating that they were all once installed in the same architectural setting.

Three main figures occupy the Istanbul relief. On the viewer's right, Poseidon stands with his left foot resting on a miniature ship's prow, as is typical of the Lateran Poseidon type.[2] Next to him, at the centre of the panel a young hero who appears nude, except for his windblown cloak and the partially preserved *polos*-like headdress, reaches towards the left. Although worn, his beardless face and his curly hairstyle are reminiscent of Hellenistic royal portraits, especially of Nicomedes I and Seleucus I (*c.* 358–281 BC), which were also modelled after royal portraits of Alexander the Great.[3] Above his head is the large right wing of a bird (possibly an eagle) and below the bird, behind the hero's left shoulder, curly hair-like carvings are preserved. These hair-like carvings might have once belonged to a (sacrificial) animal that the eagle carried in its talons. The broken strut visible next to the wing possibly held the body and left wing of the eagle projecting out from the relief. As will be discussed in detail below, the figure might be the founding hero of Nicomedia, King Nicomedes I, who is mentioned as guided by Poseidon in the literary sources.[4] Reclining on the ground under the hero is a river god, clearly identifi-

able from the jar he holds, turned on its side and with water flowing out of its mouth (Fig. 4.1c).[5] Just like Poseidon, he wears a wreathed crown and a cloak which covers his left shoulder and lower body. Despite the different body postures they have, all of the figures' heads and gazes on the Istanbul panel are directed towards the left, where the traces of a tree's trunk below and foliage above can be seen at the left end of the block.[6]

Now, iconographically, what do we make of Poseidon, a semi-nude hero accompanied by an eagle, and a river god facing towards a grove? The combination of Poseidon, very popular on the coins of earthquake-shaken Nicomedia,[7] and a river god on the Istanbul relief might suggest a geographical location for the event depicted. The most well-known combination of the two, of course, appears on the west pediment of the Parthenon in Athens. A reclining local river god (perhaps Ilissos) witnesses the contest between Poseidon and Athena for the patronage of Athens, geographically positioning the event taking place.[8] Indeed Altınoluk, in her investigation of the river gods of Asia Minor, identifies the river god on the Istanbul relief as that of the River Sangarios, which runs through Nicomedia.[9] Both Livy (*Ab urbe condita* XXXVIII.18.8) and Strabo (*Geographica* XII.3.7) mention the Sangarios as a major river in Bithynia and the source of Nicomedia's fertile terrain. Since the relief shows an event taking place in the vicinity of Nicomedia and with the presence of Poseidon, this may well be the foundation story of Nicomedia. In fact, Poseidon appears as a major actor in the foundation myths of Nicomedia in the literary tradition.

According to the accepted literary tradition, the earliest city founded on the eastern corner of the Propontis, across the Gulf of Nicomedia, was Astacos. It was a Megarian colony and its foundation date varies between 712 and 705 BC, according to different sources.[10] Arrian

2 LIMC VII 'Poseidon', no. 39, p. 478 (entry by E. Simon).

3 Smith 1988, plate 74. 15 and plate 76. 1–2. On the circulation of images of Hellenistic kings in Roman Asia Minor see Romeo 2017.

4 Another, earlier founding hero of Nicomedia is also related to Poseidon: Astacos, the son of Poseidon. See below (p. 73) for the literary sources on the foundation of Nicomedia. On another relief from the Sebasteion at Aphrodisias, Poseidon appears to be guiding another founding hero, Aeneas, the son of Aphrodite after whom the city is named. Block D5 from the south portico of Sebasteion, see Smith 2013, 206–07.

5 On the iconography of river gods see LIMC IV.1 'Fluvii', 139–48 (entry by C. Weiss); Ostrowski 1991; Gais 1978.

6 Very similar bulky tree trunks and their foliage above, rendered with the use of drill holes, appear on two other blocks on the Nicomedia frieze.

7 Güney 2015.

8 Palagia 2005. Earlier, the personifications of the Rivers Kladeos and Alpheios geographically frame the story in relation to the foundation of Olympic games (the chariot race between Oinomaos and Pelops) on the east pediment of the Temple of Zeus at Olympia. See Ashmole and Yalouris 1967.

9 Altınoluk 2010, 103–06.

10 For a discussion of the foundation date of this city in different sources see Asheri 1978. Asheri (1978, 93) suggests that this

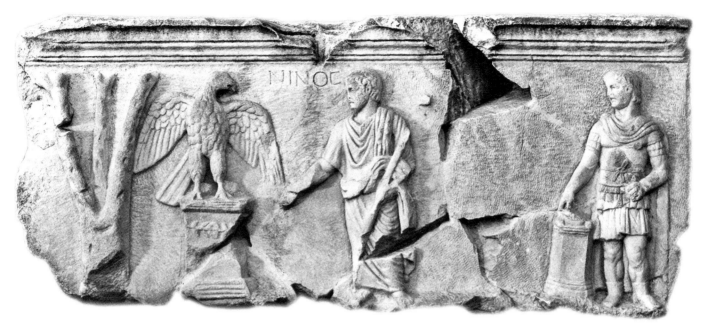

Figure 4.2. The Ninos relief from Aphrodisias's Civil Basilica, early second century (© NYU Excavations at Aphrodisias).

(a native of Nicomedia, the successor of old Astacos) tells us that the founding hero Astacos was the son of Poseidon and the sea nymph Olbia.[11] A later foundation story, most famously told in the lament of Libanius for the city of Nicomedia after the major earthquake in AD 358, also has Poseidon, guiding King Nicomedes I (son of Zipoetes I) to found the city around 264 BC. According to this account, the founder Nicomedes first tries to found the city on top of Astacos, but he then follows the (deceitful) omens of Poseidon and with the help of an eagle and prodigious snake founds the new city across the gulf (to the north-east) and names it after himself. Addressing Poseidon, who brought the disastrous earthquake to Nicomedia, Libanius says:

> Did not its first founder, designing to build a city on the shore opposite to that where it now stands, or rather where it once stood, begin his work from you? Were not the altars covered with victims, and surrounded by a crowd of worshippers? But by an eagle and a prodigious snake you diverted their attention to the hill; of these, the former with her talons snatched the head of the victim from the fire; and the latter, large and resembling

those which are bred in India, issued from the earth. The one cleaving the sea and the other the air repaired to the brow of the hill. The people followed, led, as they thought, by the guidance of the gods. These omens were all deceitful.[12]

Interestingly, this account is very similar to the origin myths of the cities founded by the Hellenistic king Seleucus, many of which are also told by Libanius. In his thorough examination, Ogden points to three major reoccurring motifs in the foundation stories of the cities founded by Seleucus, which are the cities of the Syrian Tetrapolis (Seleucia-in-Pieria, Antioch, Apamea, Laodicea-on-the-Sea) and Daphne. The three motifs are a guiding eagle (throwing sacrificial meat on an altar to show the location); a serpent or a serpentine river at the foundation site; and the planting of trees on the foundation site, the latter especially in the case of the foundation of Daphne.[13]

These reoccurring literary motifs in the foundation stories seem also to have been reflected in the visual depictions, especially during the first three centuries of Roman rule in Asia Minor, when finding (whether recreating or manufacturing) the oldest possible and

Megarian city was destroyed during the Cimmerian invasion and refounded by Chalcedonians after 686 BC. Recent excavations on the south-eastern corner of the gulf across from Nicomedia (at Başiskele) revealed a settlement with ceramic finds from the Classical period. This site is identified as Astacos by the excavator, see Koçel-Erdem 2012.

11 DFHG III, 591, F 29 (Digital *Fragmenta historicorum Graecorum*).

12 Lib., *Or.* LXI, translation Duncombe 1784, II, 230–31: <http://www.tertullian.org/fathers/libanius_monody_on_nicomedia_02_text.htm> [accessed 1 April 2021].

13 Ogden 2017, 99–174. Ogden (2017, 150) also discusses Libanius's account of the foundation of Nicomedia and how it is heavily influenced by the foundation stories of the Syrian Tetrapolis and Daphne.

the most noble origin had become an important phe-
nomenon among the Roman cities of Asia Minor.[14] On
the well-known Ninos frieze, for example, a tree and
a large eagle with outspread wings on an altar appear
in front of the Assyrian king Ninos, the legendary
founder of Aphrodisias, on the Flavian reliefs of the
Civil Basilica of Aphrodisias (Fig. 4.2).[15] On another
rather damaged relief from the south portico of the
Sebasteion at Aphrodisias, the founding hero (per-
haps Ninos again) guided by a frontal eagle carrying
a branch in its talons sacrifices to Zeus.[16] Foundation
myth representations on the Roman coins of Acmonia
in Phrygia also have an eagle and a river, as well as a
mountain accompanying the mounted Acmon, the leg-
endary founder.[17] The tree, as a sacred landmark indi-
cating where the city or cult should be founded, also
appears on imperial coins from Asia Minor that depict
cities' foundation myths. On the reverse of a bronze
coin from Prusa, for example, the founder of the city
(identified with an inscription) appears, sacrificing in
front of a large tree, while an eagle hovers above his
head.[18] A recent discovery from further south with a
slightly later date suggests the popularity and the out-
reach of this specific 'founder's motif'. In the middle
of a large fourth-century mosaic (now stolen) from
Apamea the two founders of Antioch on the Orontes,
Seleucus I and his son Antiochus I (identified with
inscriptions), appear on either side of a sacrificial altar
while an eagle holding a bull's head in its talons hovers
in the middle of them.[19]

A specific type of coin imagery, issued in Nicomedia
during the reigns of Gordian III and Maximinus Thrax,
pictures a wreathed beardless young man in front of a
sacrificial altar; next to the altar is a snake, and hovering
above the young man is an eagle (Fig. 4.3). At the right
side of the scene is another standing man with a staff, and
a small temple above his head. The representation on this
type of coinage is explained as the foundation story of

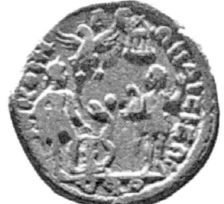

Figure 4.3.
Coin from Nicomedia, perhaps
depicting the city's foundation with
Nicomedes I, priest, guiding eagle, and
serpent; after SNG (von Aulock) 826.

Nicomedia by Nicomedes I.[20] Bosch identifies the beard-
less figure as Nicomedes and the other one as the oracle
of Poseidon, whose temple is shown above his head.[21]
He further explains the occurrence of such a theme on
the third-century coins as a celebration of the five hun-
dredth anniversary of the foundation of Nicomedia; this
anniversary roughly corresponds to AD 238, a date that
saw the rule of both Maximinus Thrax and Gordian III.
An eagle and a snake also appear on the reverse of the
Nicomedia coins from the time of Marcus Aurelius.[22]

Based on the iconographic similarity with the mid-
third-century coins of Nicomedia, one could sug-
gest a similar identification for the representation on
the Istanbul relief: the founding of Nicomedia by
Nicomedes I with the help of an eagle. Another possibil-
ity is an earlier foundation story that involved Astacos,
the son of Poseidon. In order to further support the
identification of the scene on the panel as an eponymous
myth, a brief historical overview of how local mytho-
logies were created and functioned in the Roman cities
of Asia Minor during the Imperial period is needed here.

As is well discussed in the scholarly literature, from the
Flavian period onwards there was a competition between
the Roman cities of Asia Minor to receive titles, higher
status, and thus privileges from Roman authorities.[23]
A major way to prove a city worthy of privilege was to
demonstrate that it had a prestigious history. Since hav-
ing the most antique past became more and more impor-
tant, cities started to revive or manufacture stories that

14 Bellefonds 2011; Price 2005; Weiss 1984; 1984. Weiss (1996)
through pictorial depictions on coinage cites three major elements in
the formulation of foundation iconography: an eagle, a statue (or an
altar), and a sacrificing hero.

15 See Yıldırım 2004 and 2008 for the date and discussion of
the reliefs of the Civil Basilica of Aphrodisias. Also see Bellefonds
2011, 33–39 and Mortensen 2017, 47 specifically for the discussion
of the Ninos and Semiramis reliefs.

16 Smith 2013, 209, Relief D7.

17 Price 2005, 118.

18 Bekker-Nielsen 2008, 23, fig. 2.

19 Olszewski and Saad 2017.

20 Bosch 1937, 18–21, fig. 5 and SNG (Sammlung von Aulock) 826.

21 Bosch 1937, 19–21.

22 SNG (Sammlung von Aulock) 757.

23 Bellefonds 2011; Price 2005; Weiss 1984.

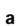
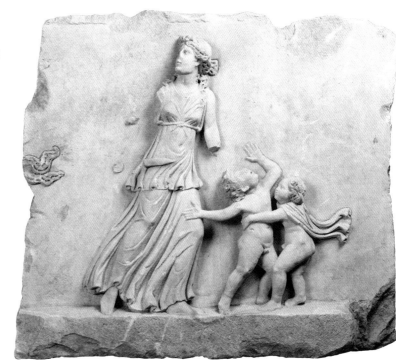

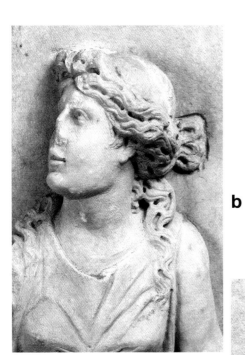

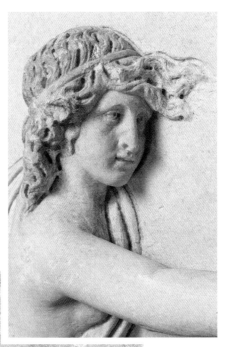

Figure 4.4. **Cat. no. 25**:
Medea Slaying her Sons:
(a) main panel;
(b) detail of Medea;
(c) detail of the Fury;
(d) detail of children.

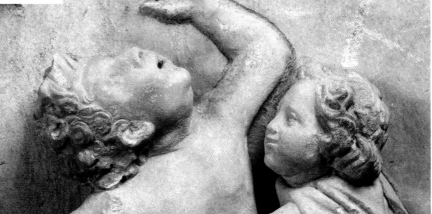

linked their land to the gods and heroes of the Greek past, or (as in the case of the Ninos and Semiramis reliefs of Aphrodisias) even to the Mesopotamian past.[24] Price shows that the local emphasis on the birth of Apollo and Artemis on the theatre reliefs of Hierapolis and on the birth of Dionysos on the theatre reliefs of Nysa are all visual reflections of these cities' endeavour for self-identification and promotion with the oldest and the most sacred mythical past.[25] Among the most famous inter-city rivalries was of course the one between Nicomedia and Nicaea, as both claimed the title of the First City of Bithynia in the second century.[26] Through literary and epigraphic evidence Bellefonds shows well how Nicaea tried to create a more antique and respectable past in this contest by recreating an earlier local mythical eponymy.[27] The literary tradition dates the foundation of Nicaea back to the Hellenistic Antigonus, after whom it was called Antigoneia. A few years later, the city received its new name after Lysimachos's first wife Nicaea (Str., *Geographica* XII.4.7).[28] But this historical Nicaea is later replaced by a much older mythical character, the nymph Nicaea, Dionysos's unwilling love.[29] Thus, the divine couple appear as the founders of the city on coins.[30] Just like Nicaea, Prusa, the third major city of Roman Bithynia seems to have predated its foundation with a new and semi-mythical origin from the sixth century BC. As in Strabo (XII.4.3), eponymous king Prusias I of the Hellenistic period assumes a new identity as 'Prusias who fought against Croesus'.[31]

Within this competitive environment, cities of Asia Minor traditionally founded by Alexander the Great and his generals seem to have searched for more distant local pasts and manufactured new legendary eponymous pasts. Most literary sources on these cities' newly manu-

factured local stories of legendary pasts are lost; but, as illustrated in the above cases of Aphrodisias, Hierapolis, Nysa, Nicaea, and Prusa, there is some epigraphic and iconographic evidence. In this historical context, then, we could expect to see a more ancient eponymous hero than Nicomedes I depicted on the Nicomedia frieze.

Indeed, another mythical representation on the Nicomedia frieze might be a reference to another local eponymous founder from the mythical past: Medea (**cat. no. 25**) (Fig. 4.4a–d). This relief slab showing Medea was initially published by Zeyrek and Özbay after the first rescue excavations in Çukurbağ in 2001.[32] The authors referred to the scene as Victory with two Erotes and dated it to the second century AD,[33] but a thorough iconographical examination clearly shows that the story depicted is Medea's slaying of her children. Moreover, the panel reveals similar technical and stylistic details to the Istanbul relief, suggesting that they were both executed by the same sculptural workshop.

The Medea panel measures about 101 cm in height, including a plinth (15 cm in height) on which the figures stand. The technical assessment of another Nicomedia frieze fragment with a Fury holding a snake, indicates that it belonged to the top left corner of the Medea panel (Figs 4.4a and 2.9). The lewis hole on the top of the main block with Medea behind the figured plane, does not only indicate that the relief was mostly carved on the ground and then lifted up into place but also gives us the approximate length of the original panel as 2 m, since lewis holes are usually carved at the centre of the gravity on the top parts of the blocks for secure lifting.[34]

In the middle of the relief slab Medea appears directed towards the viewer's right, but looking back to the left towards the snake-bearing Fury. She wears a thin-textured chiton with a long overfold through which the details of her body are visible underneath. Her dress is fastened with a rope underneath her breasts in the typical Hellenistic manner.[35] Her (now partially broken)

24 Yıldırım 2004; Bellefonds 2011. A major ancient source for the foundation myths of cities is the *Ethnicon* of Stephanos of Byzantium.

25 Price 2005.

26 Robert 1977. Also see Bekker-Nielsen 2008, 47–48 for a recent discussion.

27 Bellefonds 2011, 28.

28 Bekker-Nielsen 2008, 21.

29 The mythical story is told by Memnon of Herakleia, DFHG III, 547, F 41 (Digital *Fragmenta historicorum Graecorum*).

30 LIMC VI 'Nikaia 1', no. 30 (entry by R. Vollkommer). Also see Robert 1977, 6–11 for epigraphic evidence in regards to Dionysos being accepted as the founder.

31 Bekker-Nielsen 2008, 22–23. Also see Magie 1950, 1187 n. 16 for an overview of the literary discussion about the foundation and naming of Prusias.

32 Zeyrek and Özbay 2006, 304, Abb. 20.

33 Zeyrek and Özbay 2006, 311.

34 Thus, we are missing only about a 50 cm² area between the Medea and the Fury on the panel.

35 Because of the overfold the dress can also be called an over-girded peplos, see Lee 2015, 103–04. Indeed, the form of Medea's dress is almost identical to the peplos of Athena on **cat. no. 6** on the Nicomedia frieze. The only difference between the dress of Medea and Athena is the more transparent and thin handling of Medea's dress with deeply carved folds. Such thin long dresses girded over the chest are usually regarded as Hellenistic chitons. Thus, here I call the specific garment a chiton.

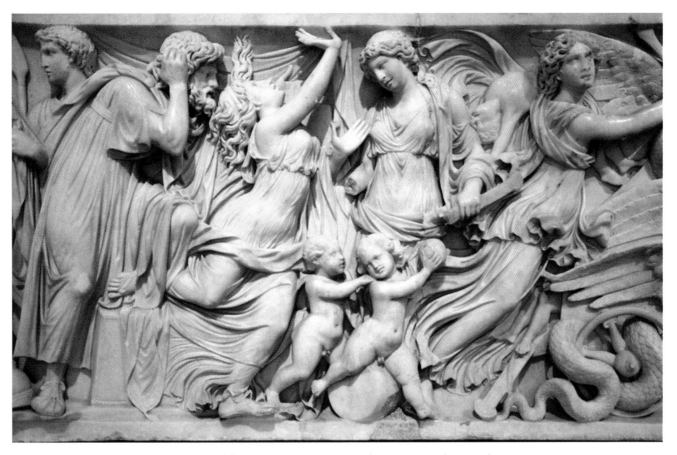

Figure 4.5. Detail from the Medea Sarcophagus, Altes Museum, Berlin, second century.

sword is directed towards two boys, one of which seems already to have been stabbed, as he appears with both arms outstretched, held from falling by the smaller boy on the right. Indeed, although her left hand is missing, the tips of Medea's fingers are still intact on the head of the boy on the left, as she is shown violently pulling his hair with this hand while forcing her sword on him with her other hand (Fig. 4.4d). On the broken left side of the main block, remnants of two flames or curly hair strands are visible swaying in the air. Painted in red, these could belong to the dying Glauce, Jason's new wife, to whom Medea gave a burning gown as a wedding gift before killing her own sons to revenge Jason's betrayal. Indeed, on Roman sarcophagi, representations of the painful death of Glauce after wearing the poisonous gown typically portray her as a woman with wild (perhaps burning) hair falling down before Medea, who escapes on a dragon-drawn chariot with the bodies of her sons, whom she also killed (Fig. 4.5).[36] The old-fashioned chiton and the sharp backward turn of Medea on the Roman sarcophagi are simi-

lar to the Medea on the Nicomedia relief.[37] However, the artist's choice of time in the narrative on the Nicomedia frieze radically departs from the representations of the story on Roman sarcophagi. On the Nicomedia panel, Medea is not shown in the aftermath, escaping with the bodies of her already dead sons, but in the very brutal act of slaughtering them, perhaps after killing Glauce. Despite the violence of the scene, Medea, on the Nicomedia frieze is portrayed as somewhat innocent as she appears guided by a Fury (Erinyes, a deity of curse and vengeance), whose upper body is preserved in a fragment from the top left corner of the relief panel. As typical of their representations, the Fury holds a snake and wears a cloak exposing one (right) naked breast.[38] Medea appears looking up

[36] LIMC VI 'Medeia', nos 51–58 (entry by M. Schmidt). Also

see Buchanan 2012 for a recent overview of representations of Medea on Roman sarcophagi.

[37] On the Roman sarcophagi, the chiton with a long overfold girded over the chest (or perhaps a hip-length girded chitoniskos worn over the chiton) are consistent.

[38] Among the common attributes of Furies are the coiling snakes in their hands and a dress exposing one breast as signifier of their wild nature, see LIMC III 'Eriyns', 22–84; 96–97 (entry by

almost in a trance as being commanded by this Fury in her brutal act.[39] This is a very unique version of the known Medea iconography. Although she is responsible for both the killing of her own brother and her sons, Medea does not frequently appear as being chased by a Fury in the existing Medea iconography of antiquity. She just drives off to heaven? with her dragon-drawn chariot. The only example of Furies accompanying Medea is the ugly-faced winged Furies on the so-called Medea crater now in Cleveland Museum. Their rare existence in the usual Medea imagery on this fourth-century BC vase has been linked to the future punishment of Medea and a less negative (or ruthless) perception of her by the vase-painter.[40] Likewise, in this new visual presentation in Nicomedia, either Medea is considered as not a Fury herself but driven crazy by a Fury (after her fratricide) for her filicide, or the aftermath of the filicide is hinted at through the inclusion of the Fury.[41]

There are several different versions of Medea's story in ancient literature.[42] In the most general terms, her story starts in Colchis, where she falls in love with Jason and, as a sorceress princess, helps him retrieve the Golden Fleece before escaping from Colchis with Jason and the Argonauts. On their way back to Greece, they encounter several events in different cities. They end up in Corinth, where Jason falls in love with the princess Glauce and marries her. Medea, to avenge Jason's betrayal, first kills Glauce by sending her poisonous wedding gifts and then slaughters her own sons that she had with Jason. With the help of Helios she escapes to Thebes and then to Athens and encounters several other events, and according to Herodotus ends up in Iran as the founder of Medes (Hdt., *Histories* VII.62). Indeed, many literary sources discuss Medea as an eponymous heroine, directly or indirectly involved in the founding of several cities.[43]

In none of the existing literary tradition, however, is there a part of Medea's story that situates her in Nicomedia, but the name of Nicomedia might have received a new identification in the process of creating an older mythical heritage for the city. This new local myth might not have survived in the known ancient literature, but only in a pictorial form on the Nicomedia frieze. Thus, it is tempting to think that a new local eponymous myth was manufactured through phonetic parallelism between the Greek words Medeia and Nikomedeia.[44] Indeed, we know of similar strategies of using fake or appropriated etymologies for city names and imagery. How the city name 'Nicaea' was appropriated according to a new mythical founder has already been mentioned above (see p. 76). There are of course other examples: the Carian town of Pedasa, for example, is re-etymologized as Pegasa by Stephanos of Byzantium because of the Pegasos of the neighbouring Halikarnassos.[45] This made-up association of 'Medeia' and 'Nikomedeia' could also explain the unusual existence of a Fury on the Medea panel compared to the typical Medea cycle depicted on Roman sarcophagi: you would not want to show the founding heroine of your city as a complete witch but as possessed by a supernatural power when inflicting her most brutal act.

Designed complementary to each other and possibly executed by the same sculptural workshop, the Medea and Istanbul panels could have stood together as references to the mythical eponymous local histories created for Nicomedia. Indeed, the rarity of mythological scenes within the Nicomedia frieze as a whole clearly suggests a close connection with the city rather than some other interest in the myth.

As discussed above with examples from Aphrodisias, Hierapolis, Nysa, Nicaea, and Prusa, references to foundation and place-related myths were common among the coinage and public monuments of the cities of Roman Asia Minor. They seem to have functioned as visual encomia claiming the pre-eminence of the specific city's people and land as well as celebrating their Hellenic identity within the larger Roman Empire. The two panels with foundation legends on the Nicomedia frieze seem to prove the continuity of this tradition into Late Antiquity right after the Third-Century Crisis.

H. Sarian). Furies are especially popular in the imagery of Orestes', Herakles', and Alkmeon's story cycles. All three heroes of Greek mythology are known to have killed their family members and then been driven crazy by Furies after their crime.

[39] On one Roman sarcophagus, she also appears looking up with the dead body of her son, on a dragon-chariot facing not backwards but forwards, perhaps to Helios. LIMC VI 'Medeia', no. 46.

[40] Sourvinou Inwood 1997, 271–72.

[41] Indeed, even though her witchy character and infanticide is the defining act of Medea's story in the mainstream literary tradition, there are also Roman texts which present her more sympathetically, not as a deliberate child-killer. See Griffiths 2006, 8, 98–99.

[42] Griffiths 2006 for an overview of the literary tradition.

[43] Krevans 1997 discusses all the existing stories that somehow picture Medea as a foundation heroine. Besides Herodotus's account in regards to Medes, Pindar mentions her as prophesying the founda-

tion of Cyrene, and Callimachus and Apollonius mention colonies founded by Colchians who were pursuing Medea and the Argonauts.

[44] Greek Νικομήδεια is Latin Nicomēdia; Greek Μήδεια is usually spelled Mēdea in Latin. The transliteration from Greek is Nikomedeia and Medeia.

[45] Santini 2017, 130. For folk etymologies and onomastics in general see Brixhe 1991.

ICONOGRAPHY AND INTERPRETATION III:
AGONISTIC DEPICTIONS — GAMES AND FESTIVALS
OF THE 'NEW' IMPERIAL CAPITAL

Eleven of the reliefs on the Nicomedia frieze display scenes relating to agonistic festivals and games, including racing charioteers, boxers, prize tables, prize crowns, and money bags for the winning athletes, a trumpeter and a herald, and tragic actors in performance (**cat. nos 27 to 37**). This section will iconographically analyse the individual motifs within the agonistic-themed reliefs. Their relevance to the imperial and mythological reliefs (discussed above) and the overall thematic programme of the Nicomedia frieze will be reviewed in the conclusion, in Chapter 6.

The increasing popularity of *agones* (games and festivals) in Roman Asia Minor in the second and third centuries is well reflected in Roman art, both in the public and private spheres.[1] Literary, epigraphic, and numismatic evidence indicates that hosting agonistic games and festivals was a means of showing off high status and prestige among the rival Roman cities of Asia Minor. *Agones* were not only great sources of economic revenue but also entailed a variety of privileges for the host city.[2] Besides the games of local importance, the emperor granted that major cities of Asia Minor could host imitations of grand Panhellenic and imperial festivals (Holy Wreath Games) such as the Olympia, Pythia, Actia, Heraia, Capitolia, Augusteia, Hadrianeia, and Severia.[3] These high-ranked festivals and games not only marked the superiority of the host city but also served the purposes of imperial propaganda.[4] Emperors took advantage of these grand organizations to acclaim their military and political victories. Hence, the imperial cult and its associated temple, the *neocorate*, were at the centre of most of these festivals. *Agones* took on different names and epithets as emperors changed and as they were connected with different cults and dedicatory events, or as the format of their games changed over time.[5]

Accordingly, Nicomedia appears to have hosted several *agones* throughout the first three centuries of the Roman Empire. Based on the epigraphic and numismatic evidence listed by Erol-Özdizbay, these included the Asklepeia, Augusteia Severia, Demetria Antonia, Pythia, *agones* of Koinon Bithynia, and several other *agones* (of unknown names).[6] A partially preserved relief panel containing the only surviving inscription from the Nicomedia frieze adds new names to Erol-Özdizbay's list of *agones* hosted by Roman Nicomedia (**cat. no. 29**) (Fig. 5.1a–b). Carefully written in a projecting band in between the depictions of agonistic money bags and prize crowns, the inscription on the panel reads [ΟΛΥΜ] ΠΙΑ · ΔΕΙΑ · ΚΑΠΕΤΩΛΙΑ (**cat. no. 29**). The inscription could refer to three different *agones* held in Nicomedia or one very important *agon*, which gained all three of these epithets: Olympia, Deia, and Capitolia.[7] All three are major agonistic festivals, imitations of which were held in major cities with the special permission of the emperor, despite their traditional places of origin. The Olympic festival, originally

[1] For the games and festivals of the Eastern Roman Empire, particularly Asia Minor, see Klose 2005; Graf 2015; Remijsen 2015, 70–89. For the imagery of games and festivals in Roman Empire see Dunbabin's recent groundbreaking work, Dunbabin 2016. Dunbabin (2016, 25) notes that agonistic imagery in the public sphere is more common in Roman Asia Minor compared to the Western side of the empire, where agonistic images have mostly been found in domestic contexts or semi-public settings of baths.

[2] Klose 2005, 125.

[3] There were two main groups of *agones*: the local *Thematikoi* awarded prizes with material value; the Crown or Stephanitic contests granted by the emperor initially had only honorary prizes, with glory being more important, but later in the Roman period awarded prizes with higher material value. See Remijsen 2011 and Klose 2005, 126 for the 'crown-games' and categories of *agones*. Based on numismatic and epigraphic evidence Klose also provides a list of the imitations of major Crown Games: thirty-eight imitations of Olym-

pic games, thirty-three imitations of Pythian games, fifteen imitations of Actia, and nine imitations of Capitolia.

[4] Klose (2005, 131) rightly argues that during the troubled third century, festivals and games became especially important as emperors could punish or reward Roman cities by granting or withdrawing privileges for festivals and games.

[5] Klose 2005, 127.

[6] Erol-Özdizbay 2011, 197–223.

[7] As mentioned above, in the third century, *agones* often received several different names, especially in association with the imperial cult for which the festival was held.

a

b

Figure 5.1a–b. **Cat. no. 29**: Inscribed Agonistic Relief.

organized for Zeus at Elis, is of course the most famous. The Deia festival emerged as an agonistic festival organized also for Zeus in Aizanoi and Laodicea in the second century in epigraphic sources.[8] Its name changed variously as it was associated with different imperial cults over time.[9] The Greek-inspired Capitolia, initially founded in Rome by Domitian in AD 86 to honour both his victories and Zeus, was exported to the Roman cities of Asia Minor.[10] As they were appointed to cities only by the emperor's individual decision, both Olympia and Capitolia would have been a great source of pride and money for the people of Nicomedia. Respectively, the names of both *agones* imply that Nicomedia had a close connection with the imperial cult and propaganda, especially because the city received the *neocoros* (temple-warden) status three times.[11] Granted by the emperor, the neocorate rank was a highly sought-after dignity among the rival cities of Asia Minor, and entailed the establishment of cults for the imperial family and temples. These temples, also called neocorate, were at the heart of the agonistic festivals and contests held in honour of the emperor. Indeed, Klose, in his examination of numismatic evidence from Asia Minor, notes that Capitolia on coins often appear in connection with campaigns against

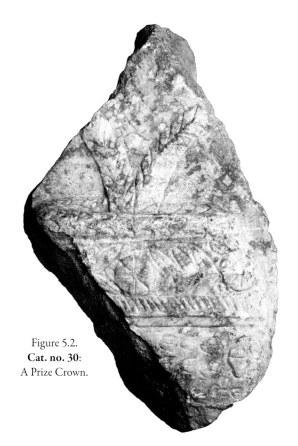

Figure 5.2.
Cat. no. 30:
A Prize Crown.

the Parthians and Sasanians, suggesting that this specific *agon* was granted to cities through which the emperor passed for his campaigns and issued to commemorate his victories over the Eastern enemies.[12]

8 Armstrong 1998, 143; Pelcer-Vujačić 2015, 117.

9 Armstrong 1998, 143.

10 Graf 2015, 95–98. Also see Caldelli 1993 for Capitolia.

11 The city received the title and the right to build a temple for the cult of Augustus and the cult of Rome in 29 BC for the first time. It was granted the second neocorate during the time of Commodus (possibly in AD 180), but lost the status slightly after the death of an influential Nicomedian courtier named Saoteros, regaining it during the time of Septimius Severus. The third *neocoros* title comes during the time of Elagabalus. Even though the title is lost after Elagabalus, it seems to have been reissued and used during the time of Valerian. See Burrell 2004, 147–65 for an overview of the *neocoros* title of Nicomedia.

12 Klose 2005, 132.

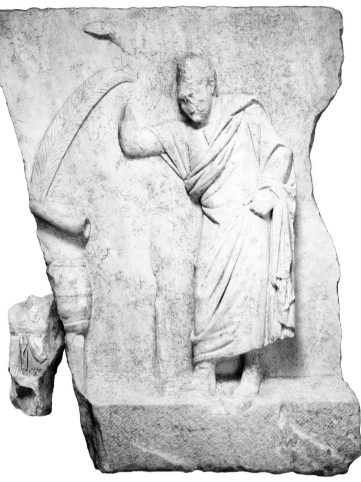

Figure 5.3. **Cat. no. 28**:
A Herald next to a Prize Table and a Prize Crown.

ments, perhaps of metal, and it has a much taller palm branch extending from inside.[13] The bottom part of a circular object preserved on a prize table on **cat. no. 27** (Fig. 5.6) could also have been a prize crown.

The typical elements of agonistic imagery — prize crowns (circular openwork fabrication objects usually decorated with flowers and gems and put on prize tables) and money bags for the winning athletes — are very popular in the coinage and public art of the cities of Roman Asia Minor.[14] Indeed, Dunbabin links the popularity of imagery in Asia Minor to its association with festivals held in honour of the emperor, as it is usually depicted together with neocorate temples or given by city goddesses to emperors on coinage.[15] Several of the second- and early third-century coins from three-time neocorate Nicomedia feature three prize crowns or three temples.[16] The occurrence of large prize crowns in the decoration of public buildings such as the theatre reliefs of Hierapolis,[17] a statue base from the nymphaeum at Side,[18] and the column capitals of the colonnaded streets

The names of the *agones* on **cat. no. 29** are inscribed on a border band which divides the composition into two layers. Below the inscribed band a prize crown in between two money bags can still be seen, and above the band, the bottom part of another prize crown and a patera or a miniature shield. Prize crowns appear on two other fragmentary reliefs of the Nicomedia frieze, **cat. nos 28 and 30**. The typology of the prize crown on **cat. no. 30** (Fig. 5.2) is almost identical to the one at the bottom register of **cat. no. 29** (and indeed both fragments could be part of the same relief panel): a circular object is divided into two bands by three thin ridges of openwork (incised with a herringbone pattern), each band is decorated with alternating laurel leaves and flowers, and a palm branch extends upwards from inside the hollow prize crown. The decorative bands of both crowns (on **cat. nos 29 and 30**) look like two laurel wreaths put on top of one another. The fragmentary prize crown on a prize table on **cat. no. 28** (Fig. 5.3) is slightly different; its bands are decorated with circular knob-like emboss-

13 The material and the usage of this container-like prize have been a debated issue. It was initially defined as a metalwork prize urn. Later on, following Dressel's publication, in the twentieth century they were defined as 'prize crowns' made of floral wreaths and precious stones (see Specht 2000 for the history of the scholarship). Specht (2000) thinks that they were basket-like containers with precious gifts inside and he further argues that the scholarship should dismiss the term prize crown and instead should use the word prize basket. Along the same lines, Erol-Özdizbay (2012) thinks they were made of ephemeral materials (mostly plants) and were not specifically meant to be put on the head but functioned like modern victory cups raised high by the winning athlete. Rumscheid (2000, 62–77), Klose (2005, 128), and more recently and thoroughly Dunbabin (2010) argue that they were possibly made of metal and initially meant to be crowns held above the heads. They explain the very large size of these prizes on some depictions, which clearly cannot be held up above the head, with the symbolic emphasis on the victory (Dunbabin 2010) or with the artists' need to show details (Rumscheid 2000). The practices of how they were held might have varied in time in different regions. What is important for our purposes is that they must have been closely associated with *agones* and victory in the eyes of contemporary viewers.

14 Prize crowns and prize tables on coinage of Asia Minor first appear during the reign of Commodus and become increasingly popular afterwards. See Dunbabin 2010 for detailed discussion of the imagery on prize crowns, prize tables, and money bags in Roman imperial art.

15 Dunbabin 2010, 311.

16 Erol-Özdizbay 2011, plate 36.

17 For the theatre reliefs of Hierapolis see Di Napoli 2002; Çubuk 2007; Benson 2014.

18 Weiss 1981.

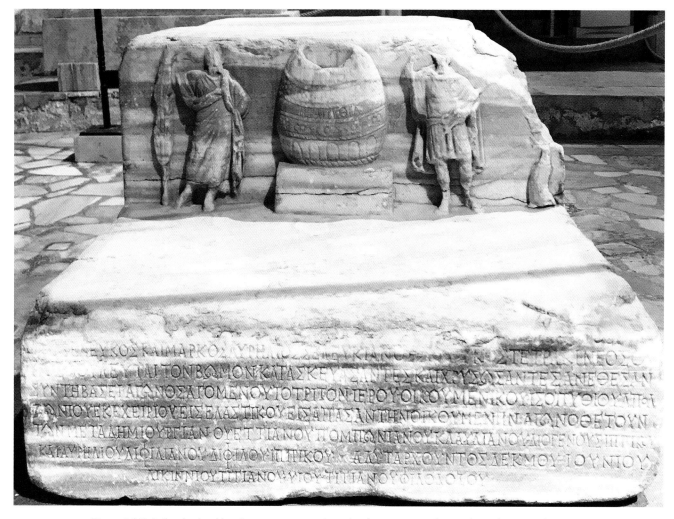

Figure 5.4. Relief with a herald and a trumpeter on either side of a prize crown, from Side, Turkey, second century.

in Perge[19] suggests that, rather than just being prizes for athletes, these crowns became generic symbols of victory and civic pride, dignifying the city in and around which prestigious *agones* were held.

Clearly, the prize crowns depicted on the Nicomedia frieze imply the city's pride in hosting sacred *agones*, with the permission and possibly in the honour of the emperor. One of the reliefs (**cat. no. 28**) (Fig. 5.3) might have symbolized the start of a competition in an *agon*. The relief features a herald dressed in a *pallium* and sandals with laces reaching to his ankles, and holding a staff with a leaf on top. He is shown looking down as if in a bowing gesture. He appears on the right side of a large prize crown placed on a prize table with a fringed red tablecloth. The elegant tablecloth is reminiscent of the Christian altar cloths of Late Antiquity.[20] The tip of a

trumpet over the prize crown indicates that the herald was accompanied by a trumpeter on the missing left part of the panel. Indeed, palm trees, a herald (dressed in a *pallium* and ankle-length laced sandals), and a trumpeter flanking a prize table with agonistic prizes are typical of agonistic imagery.[21] On the aforementioned third-century inscribed statue base from Side in southern Asia Minor, a trumpeter and a herald (dressed very similarly to the herald on **cat. no. 28**) flank a gigantic prize crown placed on a rectangular platform (Fig. 5.4).[22] On the agonistic frieze from the *scaenae frons* of the theatre at Hierapolis, victorious athletes are attended by a herald and a trumpeter, while a gigantic prize crown is placed

19 Erol-Özdizbay 2011, plate 42, pic. 56.

20 Leatherbury 2017.

21 Dunbabin 2010, 302–03. Also, see Dunbabin 2015, 199 for the pair of heralds and trumpeters which opened the competitions at an *agon* in agonistic imagery. She describes the usual costume as 'a pallium over a tunic and ankle-boots, open at the toes and laced up to the front'.

22 Weiss 1981, 327–28.

next to the imperial Severan family at the centre of the frieze.[23] A herald and a trumpeter stand beside a prize table with money bags and prize crowns on an early fourth-century agonistic mosaic from the Roman baths of Batten Zammour in southern Tunisia.[24] The specific imagery continues even to the fifth century as exemplified by the early fifth-century mosaics of Noheda Villa in Spain.[25]

The partially preserved nude figure on **cat. no. 31** (Fig. 5.5) may have been an athlete, perhaps preparing to receive his prize. If the missing circular object on top of the tall prize table with a fringed cloth on **cat. no. 27** (Fig. 5.6) was a prize crown, then this relief may have also referred to the coronation of winning athletes. The surviving small bare feet of an active figure depicted on a base or a platform connected to the tall prize table on **cat. no. 27** might have belonged to the statue of an athlete. If so, **cat. no. 27** might have designated a special spot, a victory statue/monument in Nicomedia, where the prizes were awarded.

Agonistic-themed reliefs of the Nicomedia frieze also feature certain games and performances. Several relief fragments (**cat. nos 34, 35, 36, 37**) depict parts of an active chariot race. The fragments might have belonged to the same larger relief panel with small figures of charioteers, shown in two registers racing in a counterclockwise direction (Fig. 5.7a–b). The fragments indicate that the relief panel or panels with chariot race scenes on the Nicomedia frieze had smaller figures than the other panels, shown in multiple horizontal registers with projecting frames on top and on the side-ends of the panel(s). The projecting band in between the two registers of **cat. no. 34** almost alludes to the *spina* (barrier) of a hippodrome around which the charioteers raced. In fact, Lactantius mentions a hippodrome among the many public structures that Diocletian had built in

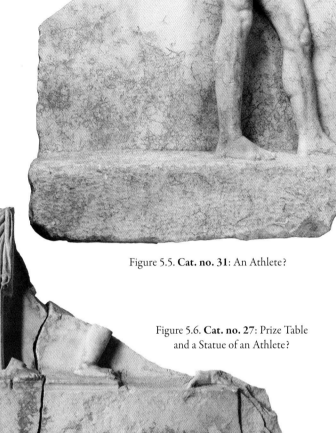

Figure 5.5. **Cat. no. 31**: An Athlete?

Figure 5.6. **Cat. no. 27**: Prize Table and a Statue of an Athlete?

Nicomedia. The charioteer visible on **cat. no. 35** wears the typical round helmet of a charioteer and a short tunic belted at the waist.[26] He leans forward with his whip flying in the air. The similar pose of the charioteers partially visible on **cat. no. 34** (the back of a charioteer on the bottom register and the leg of another on the top register), together with the open mouths and the hooves of the running horses depicted up in the air, implies the climax of an ongoing race. The motif of a chariot race in progress is among the most common depictions in Roman art, appearing on a wide range of media in both the public and private spheres.[27] The common format for a chariot race motif on Roman reliefs and mosa-

23 Di Napoli 2002; Çubuk 2007; Benson 2014.

24 Dunbabin 2016, 45; fig. 2.21a.

25 Dunbabin 2017.

26 For the imagery of charioteers and their costume in imperial art see Dunbabin 2016, 142–43.

27 Dunbabin (2016, 143–70) examines the circus imagery in Roman imperial art in two main groups: representations of chariot races in progress and depictions of individual charioteers and horses.

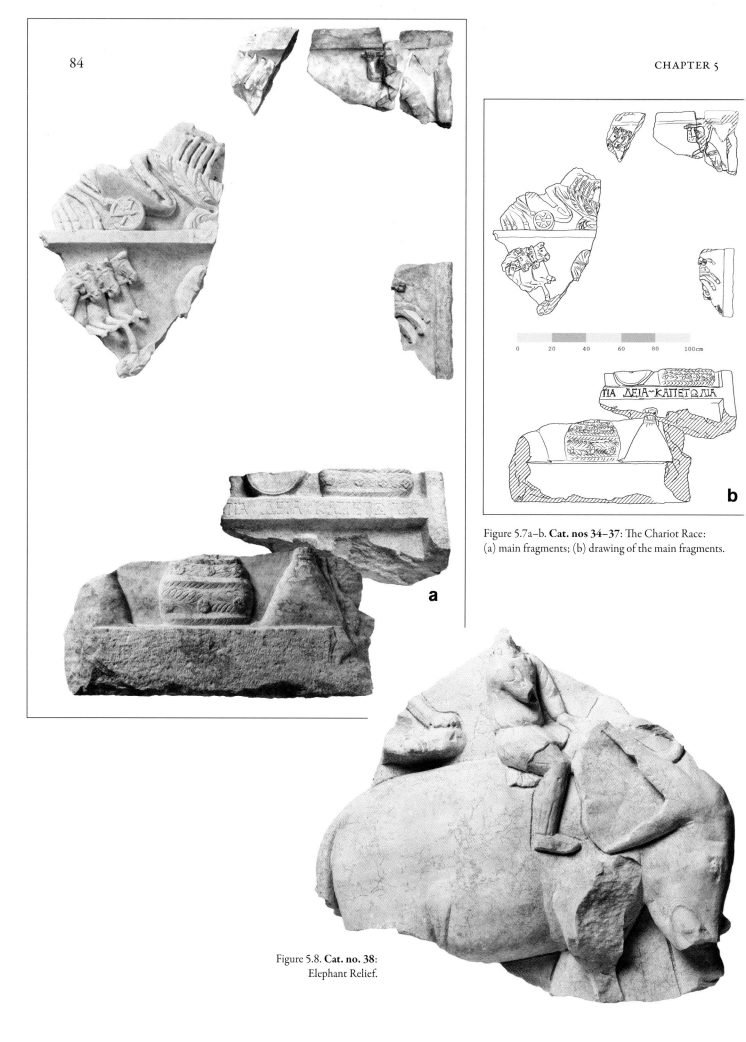

Figure 5.7a–b. **Cat. nos 34–37**: The Chariot Race:
(a) main fragments; (b) drawing of the main fragments.

Figure 5.8. **Cat. no. 38**:
Elephant Relief.

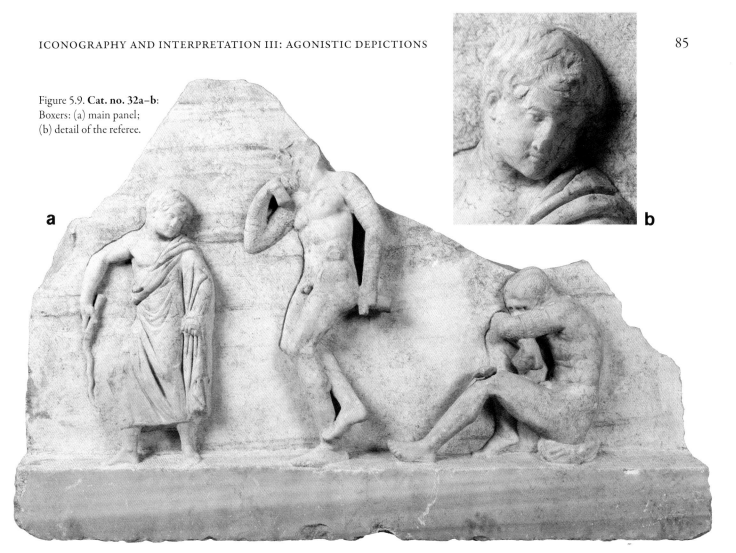

Figure 5.9. **Cat. no. 32a–b**:
Boxers: (a) main panel;
(b) detail of the referee.

ics shows charioteers racing from left to right against a background of monuments of the circus and references to the city architecture. Only on some larger mosaics do the charioteers appear to be turning counterclockwise around a *spina* of the circus.[28] One particularly close parallel to the chariot race on the Nicomedia frieze is the one depicted on the base of the fourth-century obelisk of Theodosius in Constantinople.[29] On the base of the obelisk charioteers race around a barrier with turning points at either end (*metae*), as the imperial court watch them from above. Thus, in both cases (Nicomedia and later Constantinople) the chariot race appears to be within the imperial domain.

The only other relief fragment with small-sized figures like that of the chariot race is on **cat. no. 38** (Fig. 5.8). This fragment features an elephant driven by a mahout, and the paws of a feline above on another ground line within the same relief plane. It is discussed here under

the agonistic representations mainly because of the parallel aspects of the layout of its figural composition, otherwise the iconography seems more in line with an imperial processional scene rather than an active *venatio*, a circus game involving the fight of lions and elephants. Elephants used in battle, and more often in spectacles, are not alien to Roman society and were frequently depicted in Roman art.[30] From their well-known employment by Hannibal to cross the Alps and their usage during the Pyrrhic Wars, they were originally used by Romans on the battlefield against their enemies. Initially, the enormous size and the intimidating trumpet of the animal not known in Europe must have been effective at scaring the enemy, but due to increasing familiarity with the animal and due to changes in Roman warfare, they occur in the public sphere more often as part of spectacles and processions. Ancient literary sources refer to several monumental sculptural groups of emperors shown behind elephant-drawn chariots set up at the city gates or atop arches.[31] The popularity of this motif, not only

28 See the second-century circus mosaic from Silin and fourth-century circus mosaic of Gerona, in Dunbabin 2016, 149–50; figs 6.9 and 6.10.

29 See Kiilerich 1998.

30 Toynbee 1973, Scullard 1974, and Lapatin 2018.

31 Lapatin (2018: 163–66) provides an excellent overview of

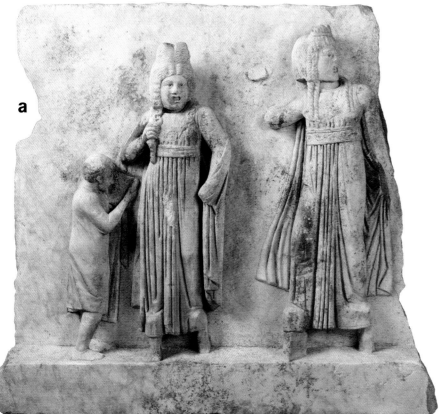

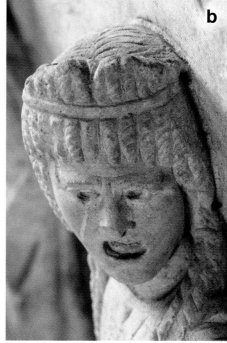

Figure 5.10. **Cat. no. 33a–d**: Tragic Actors and a Prompter:
(a) main panel; (b–c) details of the two actors; (d) detail of the prompter.

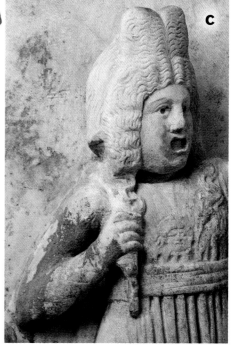

in sculpture but also on coinage, is often linked to its invocation of the imagery of Dionysos returning from India.[32] During the later Roman Empire, elephants also appear as impressive gifts in diplomatic relations between the Roman states.[33] Indeed, elephants driven by mahouts, and also lionesses, appear within the cortege of the gift-bearing Persians on the reliefs of the south pier of the Arch of Galerius to illustrate the triumph of Galerius and the riches he brought to the empire after his conquests in Persia.[34] The elephant and the feline animal on this broken Nicomedia relief might have been part of a grand spectacle: a procession for the emperors, perhaps after a triumphant return or before an *agon* held in their honour.

Another athletic contest featured among the agonistic scenes on the Nicomedia frieze is boxing. On **cat. no. 32** (Fig. 5.9a–b), two boxers are shown during the aftermath of a match in the presence of a young referee who wears a *pallium* and holds a whip. Both boxers are nude aside from the elaborate woollen boxing gloves secured all the way up to the armpits with round straps; and *caestus* strapped to the hands with leather thongs, a dangerous and destructive type of weapon which became popular in

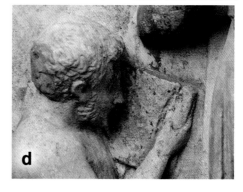

the literary and archaeological sources referring to the statues of emperors with elephant-drawn chariots from the time of Augustus to the time of Honorius.

32 Lapatin 2018, 164.

33 Cartwright 2016.

34 Rothman 1977, 442, fig. 21.

boxing during the Imperial period.[35] The pose of the victorious boxer at the centre with one foot off the ground echoes the typical boxing scenes in Roman art in which boxers are shown on tiptoes and with arched-back bodies in order to reflect the movements of the sport.[36] The defeated boxer sits on the right as he partially covers his bruised face (a cauliflower ear, swollen eyes, and a swollen nape) out of shame and sadness. Boxers, easily identified by their gloves, are typical of Roman agonistic imagery; they appear during the match or in the aftermath when being crowned.[37] What is quite unique on the Nicomedia relief is the fact that, just like the herald on **cat. no. 28**, both the winning athlete (even though his head is partially missing) and the referee are shown with their heads solemnly lowered as if in divine presence.

Tragic actors depicted on **cat. no. 33** (Fig. 5.10a–d) of the Nicomedia frieze indicate the continuity of traditional tragedy as part of the grand public spectacles in the later empire. This is significant because extant scenes of tragedy or tragic actors in the later empire are much rarer than scenes of comedy and are confined mostly to domestic contests.[38] Both of the actors on the Nicomedia relief panel wear the conventionalized, formal, and elaborately decorated costume of the tragic actor in Roman theatre: a large *onkos* (the headpiece with ringlets above the forehead of the mask); the high-platformed *kothornoi* (tragic buskins); and the long, sleeveless, belted dress.[39] They look very much like the tragic actors playing

Orestes preserved on the inscribed third-century fresco from Ephesus. There is no inscription to identify the specific tragic play depicted on the relief, but there are some visual cues; the actor in the middle holds a garland-like object,[40] the actor on the right wears a crown-like fillet, and both actors have gorgon heads on the chests of their dresses. Yet, in the absence of labels, we cannot say more than that the actors represent two young heroes. Another unique aspect of the relief is the presence of a diminutive bearded prompter on the left, reading to the actors from a scroll. There are rare examples of children, sometimes with scrolls, accompanying the actors in agonistic imagery,[41] but the existence of an adult prompter reading from a scroll on the relief is unparalleled. It is difficult to imagine a prompter actually on stage. His inclusion in the scene might have been used to upscale the actors physically and mentally for the audience, at the same time referring to a constituent element of a tragic play within the synoptic visual narrative.

The inscribed Nicomedia panel with prize crowns and money bags, along with other agonistic representations on the frieze, seems then to have served to legitimize the greatness of Nicomedia as a place where thousands of people flocked for games and festivals, also hinting at its privileged *neocoros* status. Indeed, the combination of the agonistic imagery and the subtle poses of the ordinary people such as the herald on **cat. no. 28** and the referee and the victorious athlete on **cat. no. 32** solemnly bowing their heads might suggest that these contests are being held under the watch of the emperors who are depicted as isolated from ordinary people in a godlike manner on the imperial reliefs of the Nicomedia frieze. Overall, the agonistic representations combined with several deeds of the emperors on the Nicomedia frieze might have referred to games and festivals of the imperial cult of Diocletian and Maximian.

35 For the evolution of Greek boxing gloves traced in literary and artistic representations see Lee 1997. As can be detected from representations and literary texts, boxers of the later empire typically wore long woollen sleeves which allowed them to mop up their sweat. The sleeves were strapped with tight leather thongs which had a double function: to protect the forearm exposed to blows and to help keep the *caestus* in place on the hand.

36 Thuillier (2019, 497) traces two typical representations of boxers as reflecting the nature of the actual match: first, with arched backs or tilted heads in order not to be touched; and second, standing on tiptoes. He distinguishes them from similar representations of dancers in Graeco-Roman art.

37 Parallel images of boxers include: the boxers shown on an early third-century black-and-white mosaic in the Baths of Porta Marina at Ostia (Dunbabin 2016, fig. 2.16); boxers depicted on the fourth-century mosaic of athletes at Batten Zammour (Dunbabin 2016, fig. 2.20); the pair of victorious and defeated boxers on an early fifth-century mosaic in Noheda Villa near Cuenca in Spain (Dunbabin 2017, 152–54); and the bas relief with boxers, mentioned above, discovered in a bath complex at Vareilles in France (Thuillier 2019).

38 For the images of theatre, especially of the genre of tragedy, see Dunbabin 2016, 76–84.

39 Green (2002) discusses the elements of costume in ancient Greek tragedy. Although his discussion does not detail the compo-

nents of tragic costume during the Roman period, he argues that the increasing formality of costume with conventional items (such as masks with an *onkos* and long tragic dresses) in the Hellenistic period continued on for centuries (Green 2002, 103–04). Green and Handley (1995, 96) also note the conventionalized image of the tragic actor in Roman times, which incorporated an elaborate dress that made the actor look like 'a bishop dressed for an occasion'.

40 If it is a garland, it is surely rendered very differently than the garland Victory holds on **cat. no. 20**. The object also looks like the tip of a sling. As Herakles hunts Stymphalian birds with a slingshot, one is inclined to consider this a tragedy featuring Herakles. Euripides' surviving tragedy 'Herakles' though does not feature Stymphalian birds.

41 See for example the young boy on panel B of the mosaic from Noheda Villa (Dunbabin 2017, 153, fig. 1). Dunbabin (2006, 202) also identifies the young boy with a scroll on the bronze disk in the Villa Giulia in Rome alongside scenes of tragic actors as possibly a prompter.

CONCLUSION

Ascending the throne in AD 284, during a dark period for the Roman Empire, Emperor Diocletian brought an end to the decades-long Third-Century Crisis through a series of reforms. His twenty years reigning were a period of recovery that transformed the empire in many ways. Among his reforms, the Tetrarchy (the rule of four emperors) led not only to a new form of imperial representation but also to the birth of new imperial seats (*sedes imperii*) outside of Rome. One of these cities was Nicomedia, Diocletian's own administrative capital of the empire, from which he introduced the tetrarchic system and ruled until his retirement in 305. A major monument of Roman imperial power recently found in Nicomedia (in the Çukurbağ neighbourhood of modern Izmit, Turkey) sheds light on the imperial transformation that took place under the Tetrarchy. It is an extensively preserved set of sixty-six painted marble frieze panels decorating a monumental two-storey aediculated imperial hall of a palatial complex from the Tetrarchic period, the only one of its kind ever known in Asia Minor. These monumental reliefs with exceptionally well-preserved colours present an astonishing combination of imperial, mythological, and agonistic scenes. They afford key new insights into the nexus of imperial propaganda, art, colour-coding, sculpture, and court ritual in later Roman culture.

The technical analysis of the relief panels has shown that they were produced by well-known Nicomedian sculptural workshops, the existence of which was evidenced by many epigraphic sources but few actual physical remains until this discovery. The average height of the relief panels is 1 m, while their length varies following the contours of the aediculae inside the building. Tool marks (from both chisels for carving and brushes for colouring) and lifting and fitting marks indicate the involvement of several workshops working with Proconnesian marble in a very rushed project. The style and compositional arrangements sculptors used for the reliefs show slight variations based on the themes: naturalistic for active scenes, and schematic and symmetrical for imperial processional scenes. Most relief panels of the Nicomedia frieze were carved on the ground, but worked further after they were hoisted up to their final height in order to fit them into their architectural set-

ting. They were painted on the building by painters who clearly collaborated with the sculptors and had a prime role in defining the details of the iconography, as colour-coding was extensively used to identify and differentiate figures. Most of the panels, especially the ones with imperial scenes, appear to have been designed to be seen from below, thus decorating the entablature inside the two-storeyed hall. Built in the last decade of the third century, the imperial hall appears to have come down in the mid-fourth century in a major earthquake while still in use, and was never rebuilt. Thus its frieze had a short lifespan, which also partially explains the good preservation of the colours.

Adorning one of the many new buildings of the new imperial capital erected by Diocletian, the Nicomedia frieze carries imperial scenes showing co-emperors Diocletian and Maximian and their imperial domain in war and triumph. Reflecting the victories of the new administration, these reliefs suggest that the overall design was overseen by the imperial court, members of which must have included the Nicomedian elite. Many of the motifs in these scenes — such as captive barbarians or an emperor and his soldiers in active combat — derive from traditional patterns of Roman state reliefs which propagate the victory of the involved emperors. Some other motifs, however, are unique new examples of the emerging Tetrarchic art and reflect the increasingly autocratic, ceremonial, collective, and divine rulership introduced by Diocletian and his co-emperors. Co-emperors Diocletian and Maximian, for example, appear in association with their new divine appellations, *Jovius* and *Herculius* respectively. A central relief panel showing them embracing at the heart of an *adventus* scene provides an early context for the symbolic formula of the embracing tetrarchs known in later Tetrarchic art. Despite their similarity in imperial appearance, the embracing co-emperors on this relief panel are hierarchically differentiated through small visual cues such as their height and hair colour signifying their age. The colour symbolism, hierarchical scale, and costumes employed in other imperial reliefs all reflect the new formalized court ceremonial under Diocletian, which in many ways can be regarded as the forerunner of the symbolic and

abstracted Late Antique court art of the following cen-
turies. Altogether, the imperial depictions of the frieze
provide a visual record of the co-emperors' victories
throughout the empire. These victories, however, are not
represented as historically accurate documentations of
specific events but generic and synoptic stories, shown
with just a few main characters in usually uncrowded and
graceful scenes. Besides military victories, policies of the
new administration such as the migration of barbarian
populations to inhabit the remote lands of the empire
were also part of the imperial propaganda on the frieze.
The emphasis on the deeds of just two *Augusti* may imply
that the frieze was dedicated when Caesars were not yet
a significant part of the Tetrarchic imagery. Thus, a date
between the elevation of Maximian to Augustus in 286
and the appointment of the two Caesars in 293 is prob-
able. The occasion for such a dedication could have been
the *quinquennalia* (the fifth anniversary) of Diocletian
and Maximian's co-rule, which might have been cel-
ebrated in 290/91. January 291 or 292, when consular
inauguration ceremonies took place, and the very intro-
duction of the Tetrarchy itself in 293 are the two other
possible occasions.

Two of the relief panels in the Nicomedia frieze
have been identified as foundation stories of the city of
Nicomedia by the legendary Queen Medea and King
Nicomedes I. Several other panels, including one with
an inscription, carry agonistic images such as chariot
races, boxing matches, theatrical performances, and prize
crowns; these may denote a grand festival held for the
imperial cult of Diocletian and Maximian in Nicomedia.

The overall thematic programme of the frieze, with
its combination of imperial, mythical, and agonis-
tic depictions, is paralleled in earlier imperial build-
ings especially in Asia Minor.[1] On the Severan *scaenae
frons* reliefs of the theatre at Hierapolis, for example,
the emperor (Septimius Severus) appears at the centre
with his family, next to a large prize crown, as the ben-
efactor of the festival and possibly the theatre reliefs
themselves, while reliefs on other levels depict narrative
cycles about Apollo and Artemis, the mythical founders
of the city.[2] The Nicomedia frieze does not come from
a theatre, and there is greater emphasis on the imperial
scenes. The latter of course is not surprising as different
from Hierapolis and any other Greek city in Roman Asia
Minor, Nicomedia was the city where Diocletian and

his court resided and administered the empire. On the
frieze, emperors appear several times in different con-
texts: in combat, in an *adventus*, and being crowned by
gods. Thus, here in Nicomedia we may have a building
celebrating the triumphal deeds and the imperial cult of
the co-emperors Diocletian and Maximian. Indeed, the
contemporary literary tradition includes a similar the-
matic structure for the praise of a city. The panegyric and
encomiastic *topoi* for the praise of a Greek city during the
Imperial period include four major features (which most
famously can be traced in Aristides' praise of Athens in
the *Panathenaic Oration* for Athens in the second cen-
tury and Libanius's praise of Antioch in *Oration XI* in
the fourth century): having the most sacred and fertile
physical environment, having the most ancient mythical
past, receiving divine and imperial patronage, and host-
ing the most prestigious agonistic festivals.[3] Thus on the
Nicomedia frieze, the eponymous and agonistic scenes
and depictions of the emperors' accomplishments,
especially their embrace in an *adventus* scene (perhaps
symbolically meant to take place in Nicomedia),[4] seem
to have celebrated not just the imperial cult of the co-
emperors, but also the city of Nicomedia as the new
seat of this imperial power. The thematic programme on
the frieze claims all the prestigious titles for Nicomedia
which the rival cities of Roman Asia Minor were com-
peting to attain: *metropolis*, *archaiotatos*, and *neocoros*.

Identifying the exact type of the building adorned
with the Nicomedia frieze requires further archaeo-
logical and architectural research. Based on its sheer size
and opus sectile floor, however, one can compare it to
audience halls, which also functioned as judicial courts
in Tetrarchic palatial complexes. The subjects depicted
on the frieze praise the triumphs of emperors Diocletian
and Maximian, celebrate their imperial cult, and dignify
Nicomedia as the rightly chosen place for the new impe-
rial seat. Thus, the structure can be tentatively identified
as an audience hall built for and functioning in service
of the imperial cult and justice. Themes of the reliefs
decorating the inside of the Hall of the Imperial Cult in
Nicomedia suggest the involvement of both the impe-
rial court and the local civic governing body in its com-

[1] See Şare Ağtürk 2020a for a detailed discussion of the the-
matic programme of the Nicomedia frieze.

[2] Di Napoli 2002; Çubuk 2007; Benson 2014.

[3] For the praise of Athens and its reflection in art see von Mosch
1996; for the review of the praise of Antioch see Downey 1959. Also
see Yıldırım 2004 for the visual encomia of Aphrodisias on the Basi-
lica reliefs.

[4] There are no historical records of the two emperors actually
meeting in Nicomedia, but just like the embrace motif itself, this
might have been a propagandistic rather than a factual claim; see the
discussion in Şare Ağtürk 2018.

missioning. Since it is the only surviving example of an
imperial structure from the centre of Diocletian's empire
at Nicomedia, many other aspects of the monument
require attention such as conservation, local validation,
and heritage management. It is hoped that the present
fully documented primary monograph of its reliefs will
attract this deserved attention and will help the develop-
ment of the archaeology of Nicomedia, the forerunner
of Constantinople as the capital of the Eastern Roman
Empire.

Türkçe Özet (Summary in Turkish)

M.Ö. 284'te, Roma İmparatorluğu için oldukça karanlık bir dönemde tahta çıkan imparator Diokletianus, bir dizi reform yoluyla on yıllardır süren Üçüncü Yüzyıl Krizi'ne bir son vermiştir. Diokletianus'un 20 yıllık saltanatı, imparatorluğu birçok yönden dönüştüren bir iyileşme dönemi olarak kabul edilir. İmparatorun reformları arasındaki Tetrarşi sistemi (iki *Augustus* ve yardımcıları iki *Sezar* dan oluşan dörtlü imparatorluk yönetimi sistemi) sadece yeni bir imparatorluk temsil biçimine değil, aynı zamanda Roma şehri dışında yeni idari başkentlerin (*sedes imperii*) doğmasına yol açmıştır. İşte bu şehirlerden biri de Diokletianus'un 305'te emekliliğine kadar kendi idari başkenti olarak kullandığı ve Tetrarşi sistemini kurduğu Nikomedia'dır. Konstantinopolis'ten hemen önce imparatorluk başkentliği yapan Nikomedia, günümüzde modern İzmit kent merkezinin altında yatmaktadır. Yakın zaman önce İzmit'in Çukurbağ Mahallesi'nde ortaya çıkarılan Roma anıtı, Tetrarşi Dönemi'nin yönetim merkezinde imparatorluğun yaşadığı dönüşüme ışık tutmaktadır. Küçük Asya'da şimdiye kadar ortaya çıkarılmış tek örnek olan ve Diokletianus tarafından inşa ettirilmiş bir saray kompleksinin parçası olan bu iki katlı ve aediküleli yapı, heykeller ve 66 parça boyalı mermer kabartma (rölyef) panelinden oluşan friz ile süslenmiş bir imparatorluk kabul salonu olarak tanımlanabilir. Son derece iyi korunmuş renklere sahip bu mermer kabartmalar üzerindeki imparatorlara dair sahneler ve mitolojik ve agonistik betimlemeler, Geç Roma Dönemi'nde imparatorluk propagandası ve kültü, saray ritüelleri, hukuk, sanat, renk kodlaması ve heykeltıraşlık gibi birçok konuya ışık tutmaktadır. Bu kitapta Nikomedia frizi teknik ve ikonografik olarak ilk defa detaylıca incelenerek unutulmuş Roma başkenti Nikomedia'nın tarihçesi, Tetrarşi Dönemi politikaları ve sanatı ve antik heykelcilikte renklendirme teknikleri gibi birçok konu aydınlatılmaya çalışılmıştır.

Rölyef panellerinin teknik analizi, rölyeflerin, birçok epigrafik kaynakta bahsedilen ancak varlıklarına dair gerçek fiziksel kalıntıların bu keşfe kadar çok az olduğu ünlü Nikomedia heykeltıraşlık atölyeleri tarafından üretildiğini göstermiştir. Panellerin ortalama yüksekliği 1 m'dir, uzunlukları ise bina içindeki aedikülelerin konturlarına göre değişiklik gösterir. Rölyef panelleri üze-rinde oyma için kullanılan keskilerden ve renklendirme için kullanılan fırçalardan kalan alet izleri ve kaldırma ve yerleştirme sırasında ortaya çıkan izler, rölyeflerin Prokonessos (Marmara Adası) mermeriyle çalışan birkaç atölye tarafından acele bir imparatorluk projesi kapsamında üretildiğini gösterir. Heykeltıraşların rölyefler için kullandığı stil ve kompozisyon düzenlemeleri, temalara göre küçük farklılıklar gösterir; bu bağlamda aktif sahneler için doğal ve kompleks, imparatorlara dair törensel sahneler için ise şematik ve simetrik betimlemeler tercih edilmiştir. Nikomedia frizinin rölyef panellerinin çoğu yerde işlenmiş, ancak kaldırıldıktan sonra yerleştirildikleri mimari ortama sığdırılmak için tıraşlanarak son yüksekliklerini almışlardır. Rölyefler mimarinin içine yerleştirildikten sonra heykeltıraşlarla iş birliği yaptığı anlaşılan ve renkleri ikonografinin ayrıntılarını tanımlamak için kullanan boya ustaları tarafından renklendirilmiştir. Boya izleri, özellikle imparatorların betimlendiği rölyeflerin, aşağıdan görülmek üzere tasarlanmış ve iki katlı salonun üst katına yerleştirilmiş olabileceğine işaret eder. Muhtemelen üçüncü yüzyılın son çeyreğinde inşa edilen bu imparatorluk kabul salonu, hala kullanımdayken dördüncü yüzyılın ikinci yarısında büyük bir depremde çökmüştür ve sonraki dönemlerde tekrar ayağa kaldırılmamıştır. Dolayısı ile rölyeflerin bina içindeki ömrü kısa süreli olmuştur.

Diokletianus tarafından imparatorluğun yeni başkentinde inşa edilen birçok yeni binadan birinin içerisini süsleyen Nikomedia frizi, imparatorlar Diokletianus ve yardımcısı Maximianus' un savaşlarının ve zaferlerinin anlatıldığı birçok imparatorluk tasviri içerir. Bu da bize yeni yönetimin politik propagandası ile yüklü bu mermer kabartmalarının genel tasarımının, imparatorlar ya da içinde Nikomedialı yöneticilerin de bulunduğu saray eşrafının öngörüsünde yapıldığına işaret eder. Kabartmalar üzerindeki imparator ve askerlerinin savaştaki zaferleri ya da sonrasında aldıkları esir barbarlar gibi motiflerin çoğu, geleneksel Roma devlet kabartmalarında sıklıkla kullanılan desenlerden türemiştir. Bununla birlikte, diğer bazı motifler, ortaya çıkan Tetrarşi Dönemi Sanatı'nın eşsiz yeni örnekleridir ve Diokletianus ve yardımcı imparatorlarının getirdiği kolektif, giderek otokratikleşen, törensel ve ilahi hükümdarlık biçimini

yansıtmaktadır. Örneğin, imparatorlar Diocletianus ve Maximianus, sırasıyla yeni ilahi ünvanları *Jovius* ve *Herculius* ün atribütleri ile birlikte görünürler. İki imparatorun bir *adventus* (imparatorların törensel şehre girişi) sahnesinin merkezinde kucaklaştıklarını gösteren uzun kabartma paneli, Tetrarşi Dönemi Sanatı'nda Venedik ve Vatikan'daki meşhur porfir taşı örneklerinden bilinen sembolik kucaklaşan tetrarklar motifi için öncü model olarak düşünülebilir. Bu paneldeki iki imparator, saç stili, kıyafet gibi hükümdarlık görünümlerindeki benzerliklerine rağmen, boyları ve yaşlarını gösteren farklı saç renkleri gibi küçük görsel ipuçları ile hiyerarşik olarak birbirlerinden ayrılmışlardır. Rölyefler üzerindeki renk sembolleri, hiyerarşik ölçek ve kostümler, Diocletianus Dönemi'nde ortaya çıkan ve birçok yönden Geç Antik saray sanatındaki sembolik ve soyutlaşmış motiflerin öncüsü olarak kabul edilebilir. Genel olarak kabartmalar üzerindeki imparatorluk tasvirleri imparatorların askeri zaferlerinin görsel bir kaydını sağlar. Ancak bu zaferler, belirli olayların tarihsel belgeleri gibi değil, genel ve özet öyküler ile çok kalabalık olmayan, sadece birkaç ana karakterin oluşturduğu sahnelerle temsil edilmiştir. Askeri zaferlerin yanı sıra, uzun süren askeri seferler ya da yeni yönetimin barbar nüfusa uyguladığı zorunlu göç politikaları da friz üzerindeki imparatorluk propagandasının bir parçası olarak tasvir edilmiştir. Rölyeflerde özellikle iki *Augustus*'un eylemlerine yapılan vurgu, frizin yardımcı *Sezar*lar henüz Tetrarşi Dönemi tasvirlerinin önemli bir parçası olmadan önce adanmış olabileceğini gösterir. Bu nedenle, friz, Maximianus'un 286'da *Augustus* titrini alarak yükseltilmesi ile iki *Sezar*'ın atanmasıyla Tetrarşi'nin resmi olarak ilan edildiği 293 aralığına tarihlenebilir. Bu durumda frizin 290/91'de kutlanmış olabilecek Diocletianus ve Maximianus'un ikili imparatorluğunun beşinci yıldönümüne (quinquennalia) ithafen yapılmış olması muhtemeldir. Diğer iki olasılık ise frizin 291 ve 292 yıllarının Ocak aylarında düzenlenen Konsül ataması törenlerine ya da 293'de Tetrarşi'nin ilanı için düzenlenen törenlere ithaf edilmiş olmasıdır.

Nikomedia frizindeki kabartma panellerden ikisi, Nikomedia'nın efsanevi kraliçe Medea ve sonrasında Hellenistik kral I. Nikomedes tarafından kurulma öyküleri olarak tanımlanmıştır. Aralarında at arabası yarışları, boksörler, tiyatro gösterileri, atletlere verilen ödül taçları ve para keseleri betimlemelerinin yanı sıra, bazı festival isimlerinin yazılı olduğu kabartmalar ise Nikomedia'da muhtemelen Diocletianus ve Maximianus'un imparatorluk kültü için düzenlenen büyük bir festivale işaret eder.

Nikomedia frizinin imparatorlara dair sahneler, kentin ilk kuruluş efsaneleri ve agonistik betimlemelerin birleşiminden oluşan genel tematik programı, Küçük Asya'da daha önce inşa edilmiş bazı yapılarla paralellik gösterir. Örneğin, Hierapolis'te Severus Dönemi'ne ait tiyatro scaenae'sindeki kabartmaların merkezinde imparator Septimius Severus, festivalin başlatıcısı ve muhtemelen tiyatro kabartmalarının banisi olarak dev bir ödül tacının yanında, ailesiyle birlikte görülürken diğer seviyelerdeki kabartmalarda, şehrin efsanevi kurucuları Apollo ve Artemis hakkındaki anlatı döngülerine yer verilmiştir. Ancak agonistik tasvirlerin yoğunluğuna rağmen Nikomedia frizi bir tiyatro yapısına ait değildir ve dahası frizde imparatorlara dair sahnelere daha fazla vurgu yapılmıştır. Nikomedia'nın Hierapolis ve diğer Küçük Asya kentlerinden farklı olarak imparator Diocletianus'un ikamet ettiği ve imparatorluğun idari başkenti olarak kullandığı bir şehir olduğu düşünüldüğünde, bu imparatorluk vurgusu hiç de şaşırtıcı olmaz. Frizde imparatorlar farklı bağlamlarda, bir *adventus* sahnesinde, savaşta ve tanrılar tarafından taçlandırılırken karşımıza çıkar. Bu bağlamda frizin süslediği yapının Nikomedia'da, Diocletianus ve Maximianus'un imparatorluk kültü ve zaferlerini kutsanması ve agonistik oyunlarla kutlanması ile ilişkilendirilebilir. Aynı döneme ait edebi gelenek, bir şehrin övgüsü için benzer bir tematik yapı içerir. İmparatorluk döneminde Yunan kentlerinin övgüsü için yazılan- ikinci yüzyılda Aristides'in yazdığı Atina Övgüsü (Panathenaic Oration) ya da dördüncü yüzyılda Libanius'un Antakya Övgüsü (Oration 11) gibi-yazılarda övülen kentler için dört özellik ön plana çıkar; en kutsal ve verimli fiziksel ortama sahip olmak, en eski efsanevi geçmişe sahip olmak, kutsal imparatorluk himayesinde almak ve en prestijli agonistik festivallere ev sahipliği yapmak. Bu bağlamda, Nikomedia frizindeki, kentin kuruluşuna dair tasvirler, agonistik tasvirler ve imparatorların bulunduğu sahneler sadece imparatorluk kültünü değil, imparatorluk gücünün yeni merkezi olarak Nikomedia şehrini de onurlandırmaktadır. Frizin tematik programı, Nikomedia için, Roma İmparatorluk Dönemi Küçük Asya'sının rakip şehirlerinin ulaşmak için yarıştığı tüm prestijli sıfatları metropolis (en büyük), arkeototos (en eski) ve neokoros (en kutsal-imparatorluk kültüne sahip) iddia etmektedir.

Nikomedia friziyle bezenmiş binanın kesin mimari türünü belirlemek için daha fazla arkeolojik ve mimari araştırma gerekmektedir. Bununla birlikte, anıtsal merdivenlerle ulaşılan yapının büyüklüğü ve opus sectile taban döşemesi, Tetrarşi Dönemi Sarayları'nda yargı mahkemeleri olarak da işlev gören kabul salonlarıyla

karşılaştırılabilir. Frizde tasvir edilen konular imparatorlar Diokletianus ve Maximianus'un zaferlerini övmekte, imparatorluk kültünü kutlamakta ve Nikomedia'yı yeni imparatorluk başkenti için doğru seçilmiş kutsal bir yer olarak onurlandırmaktadır. Bu bağlamda yapı, imparatorluk kültü ve mahkeme salonu olarak kullanılan bir imparatorluk kabul salonu olarak tanımlanabilir. Bu İmparatorluk Kültü Salonu'nun ve içini süsleyen frizin banileri, imparatorlar ve aralarında Nikomedialı yerel yöneticilerin de olduğu saray eşrafı olmalıdır. Diokletianus Dönemi Roma İmparatorluğu'nun Nikomedia'daki merkezinden günümüze ulaşabilen tek örnek olan bu yapı, birçok yönü ile Dünya kültür mirasına katkı sağlar. Nikomedia frizinin detaylarının işlendiği bu monografi ile bu anıtın hakkettiği ilgi ve öneme ulaşacağı ve Doğu Roma İmparatorluğu'nun başkenti Konstantinopolis'in öncüsü olan Nikomedia'nın arkeolojisinin gelişmesine yardımcı olacağı umulmaktadır.

THE RELIEFS — A CATALOGUE

Conventions of the Catalogue

This catalogue presents sixty-six relief panels of the Nicomedia frieze discovered in Çukurbağ since the initial rescue excavations in 2001. About twenty of these panels are large and almost fully preserved, but the rest survive only partially and thus are smaller in scale. Fragments which still preserve the relief background are classified as a panel in this catalogue. Much smaller fragments chipped off from the reliefs and insufficiently preserved to be attributed to any of the panels, such as small drapery fragments and limbs of the figures, are classified within the Catalogue of the Smaller Relief Fragments in Appendix I. The reliefs presented in this catalogue are arranged internally on the bases of parallel themes and iconography, thus the sequence followed does not reflect their find-places or parallel technical features.

All the available inventory numbers ever assigned to each piece are provided under each entry and a concordance chart is given in Appendix II. Not all the reliefs discovered during the 2001 excavation were given an excavation or museum catalogue number. If available, these numbers are provided and can be distinguished by the year included at the beginning of the inventory number, such as 2001/5. Reliefs discovered during the 2009 expedition seem to have all received an excavation number. However, since the excavation diaries and all the written records are lost, I was only able to trace some of these numbers in the existing excavation photos in the museum archives; whenever available these numbers are provided and can be distinguished again by the year, such as 2009/18. Because of the ongoing legal investigation, the reliefs found in 2009 were kept in large wooden boxes in groups and not all of them received an individual museum inventory number; museum inventory numbers are provided for those that received them. Throughout the TÜBİTAK Project, after classifying them thematically, I gave each relief a new catalogue number. These numbers are also recorded on the backs or sides of each block with permanent pen. In 2018, the museum officials gave most reliefs new official inventory numbers some of which overlap with the TÜBİTAK Project inventory numbers.

The dimensions of each entry include the height (from top to bottom), the length (from left to right), the maximum depth of the relief (from the front of the sculpture to the backplane to which the figures are attached), the preserved width (thickness) of the whole marble block out of which reliefs and the projecting plinth were carved, and also the height of the plinth on which figures stand. For the fragmentary panels the measurements are the preserved maximum dimensions such as preserved maximum height, length, and thickness.

The first section of each entry mentions the extant condition of each piece. We do not have written records of the in-situ position of the relief panels but whenever it was possible to trace the find-spot of a relief panel from the available excavation photos, I also included this information in this section (also see Fig. 2.1). The account of polychromy on each panel is again included in this section and is mostly limited to the traces of colour visible to the naked eye, unless there is extra available information on the pigments from our archaeometric analysis. Bibliographical information (if available) is also mentioned in this section: reliefs found during the 2001 rescue excavation were published in Zeyrek and Özbay's article in 2006; **cat. no. 16** and **cat. nos 25 and 26** were published by myself in two separate articles in 2018 and 2020. All the other reliefs are being published for the first time in this book, thus most catalogue entries do not include separate bibliographical information. The second section for each entry discusses the technical details of each relief panel, including carving, finishing, lifting, and joining, as evidenced by the traces of tool marks. Finally, a short description and iconographical discussion of the figural representations on the reliefs are provided. A more detailed discussion of major iconographic motifs is provided in Chapters 3 to 5.

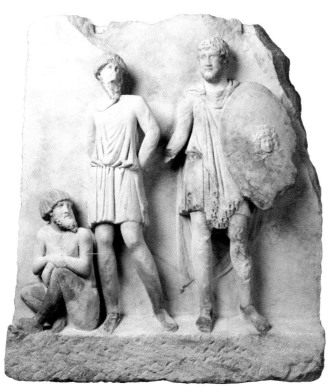

I. TWO CAPTIVES AND A ROMAN SOLDIER

TÜBİTAK No. 01, Mus. New Inv. No. 2018–3

DIMENSIONS – Height: 105, Length: 93, Thickness of the Block: 20, Depth of the Relief: 10, Height of the Plinth: 13 cm

EXTANT CONDITION – The block is slightly broken off on the top right corner and in the middle above the standing captive figure (B) (see Description below); otherwise it preserves its original length and height. The broken head and the neck of this figure were attached during the restoration, but it is still missing the tip of the nose, the mouth, and the chin. The block was discovered during the initial rescue excavation at Çukurbağ in 2001, but it was not dug out until 2009. The block's in-situ condition (but not the exact find-spot) is mentioned in Zeyrek and Özbay's article on the 2001 excavation; they state that the break on the top right corner is fresh.[1]

Preserved polychromy on the surface includes yellow for the hair and beards of the captives, reddish yellow for the Roman soldier's beard and hair, red for the trousers of the seated captive, and black paint for the shoes of all figures. There are traces of very well-preserved red paint on the belt of the soldier on the right and traces of black paint on his tunic above the right knee. On the shield, there are slight traces of blue paint on the right side of the Medusa's chin. In concentric rings going inwards, the oval shield has a red

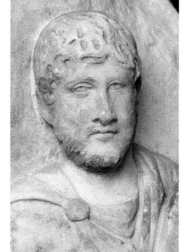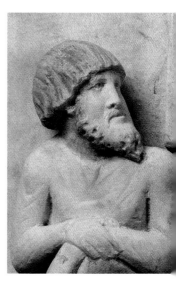

frame around the rim, then a white band, and then a thinner dark brown band.

TECHNICAL DETAILS – Two small rectangular holes for dowels or metal clamps at the top of the relief: both holes are 4.5 cm deep and measure approximately 4.5 cm × 4.5 cm; they are 42 cm apart. The pXRF analysis traced metal residue in the cuttings. They could have been cut for metal dowels used to vertically connect the relief panel to an architectural element above or they could have once had the one short end of a clamp shaped like the letter 'Π' used to tie the panel to the background wall.[2] The block, weakened by the holes, is broken off at the top, revealing the depth of the holes. A bigger rectangular hole in the middle of the top section is a wide lewis hole used for lifting up the block. It measures 5.5 cm (width) by 9 cm (length) and is 5.5 cm in depth. The location of the lewis hole on the top surface behind the figured plane indicates that most of the relief was carved on the ground and the panel was lifted up later. The depth of an average lewis hole needs to be at least 10 to 12 cm in order to safely carry the block up. The shallow depth of the lewis cutting on the panel indicates that the top part of the relief was cut down once the block had been lifted onto the building in order to fit it to the height of the architectural setting. The top of the plinth, or the ground on which the figures stand, is perpendicular to the figured plane.

TOOL MARKS – The background of the figures on the front and the faces of the figures are cleanly finished with the use of flat chisels and rasps. There are deep drill marks in the right ears of both captives. The drill has also been used for the beards of the captives, for the hair, for the fringes of the Roman soldier's cloak, and for the rendering of the irises in the eyes of all the figures. The top surface of the plinth on

[1] Zeyrek and Özbay 2006, 296–97, Abb. 13 III.B.l.d.

[2] For the use of metal dowels and metal clamps in the shape of the letter 'Π' in Roman architecture see Adam 1994, 100–01.

which the figures stand is finished with a claw chisel; the same fine claw chiselling was begun on the right corner of the front face of the plinth, but was left unfinished. Thus, one can clearly see the rougher point chisel marks on the three-quarters of the plinth from the left, and fine claw chisel marks on the rightmost quarter of the plinth. Rough point chisel marks are on the two sides (lateral faces) and on the back of the relief block.

DESCRIPTION AND DISCUSSION – The relief shows three figures standing on a plinth, 13 cm in height. The first figure on the far left (A) is shown frontally, seated on the ground with his arms folded, holding his left ankle with his right hand. His head is sharply turned to his upper left as he is submissively looking at the standing figure (the Roman soldier) in the far left (C). His bob-cut thick blonde hair, his long moustache and long beard parted at the tip, and his drapery (a loose long-sleeved tunic, trousers, and soft shoes) distinguish him from the Roman soldier and mark him as a barbarian captive. The figure in the middle (B) is another captive seen frontally, standing with his left leg bent and with his hands possibly tied behind him. His hands are not rendered at the back. He wears a loose thigh-length tunic, belted at the waist as indicated by an overfold over the waist; trousers; and shoes. As is the case for figure A, his tunic forms V-shaped creases on the torso and the arms. His lower face is partially broken off, but he has the same hairstyle and parted beard as the seated captive (A). He too is shown looking at the Roman soldier (C) on the right. The frontally shown Roman soldier also wears a thigh-length tunic belted at the waist, trousers, and shoes. Unlike the captives, he also wears a *sagum* (the military cloak of the commanders) fastened over his right shoulder with a yellow brooch; and in his left hand carries a large oval shield, at the centre of which is the image of Medusa wearing a double-winged hat fastened with straps below her chin. Along the front side of his cloak, falling over his tunic, are fringes, perhaps indicating the high status of the triumphant soldier. The back of his cloak is longer and hangs down from his back, forming a triangle behind his legs. The shield has a red band around the rim, followed (on the inner side) by a white band, and then by a brown encircling line. The soldier's broken-off right hand was possibly rendered as holding the ropes used to tie the wrists of the standing captive. The Roman soldier has reddish curly hair and beard. His pupils are clearly carved. His thick eyelids and his classicizing serene and aloof look brings to mind Antonine portraiture. Iconographically the relief is related to the rest of the captive series: **cat. nos 2 to 8**.

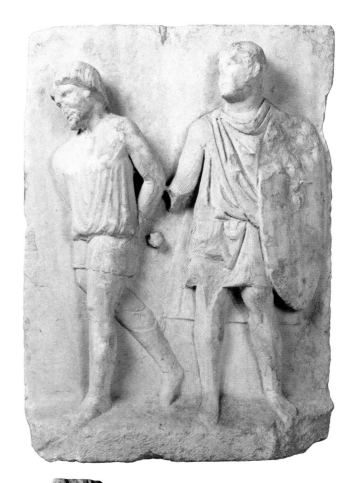

2. A BOUND CAPTIVE AND A ROMAN SOLDIER

Mus. Inv. No. ÇKBĞ 2001/5, Exc. Inv. No. ÇKBĞ 2001/16 (A), TÜBİTAK No. 02

DIMENSIONS – Height: 98, Length: 73, Thickness of the Block: 23, Depth of the Relief: 10, Height of the Plinth: 8 cm

EXTANT CONDITION – The relief block was recovered during the 2001 rescue excavation and published in Zeyrek and Özbay's article.[3] There is no information available on its exact find-spot. It has some minor chipping at the corners and sides, but preserves its full height and length. The face of the captive has some minor damage on the nose and on the hair above the forehead. The Roman soldier's nose and right thigh are also chipped off.

[3] Zeyrek and Özbay 2006, 299–301, Abb. 16.

The left corner of the base is chipped off probably in order to fit the block to its location. The top part of the Roman soldier's shield is damaged due to hoe impact. Also, his right knee and the part of his tunic above the knee are broken.

No traces of polychromy are visible to the naked eye.

TECHNICAL DETAILS – The small rectangular recess on top in the middle of the front surface is the right size for a dowel to connect the panel vertically to its architectural neighbour on top, but it is cut too close to the figured plane, and so it cannot have been used to insert a dowel. Indeed, it seems to be trimmed away along with the top surface of the block within the architectural setting. Another possible usage of this partially preserved cutting might belong to the marble block's earlier life as an architectural element. The string course with horizontal mouldings on the left side-end of the relief block clearly shows that the relief was carved from an earlier architectural block, perhaps from the cornice of an entablature. Zeyrek and Özbay consider the details of the left side to be 'clean finished', thus not an indication of re-carving, but evidence for the block's starting position in a narrative cycle of reliefs.[4] However, the re-carving of the relief from an architectural spolia also explains the shorter length of the panel and the shorter height and the sloping top of the plinth compared to the blocks of the same captive series. Clearly, the sculptor had to carve the figures and the plinth from the already defined dimensions of the architectural block and thus had limitations.

TOOL MARKS – The background of the figures has been polished with flat chisels and rasps. The drill has been used as a channelling tool for outlining the figures and for sketching the folds of the drapery of the clothing. Rough claw chisel marks are visible on the front surface of the plinth. Punch marks made with a point chisel on the top corner of the Roman soldier's shield are indicative of secondary 'intended' use in antiquity. Tool marks on the top of the relief block are very interesting: three-quarters of the top surface of the relief block on the right side is polished with a fine claw chisel, while the remaining quarter of it on the left shows only rough point chisel marks.

DESCRIPTION AND DISCUSSION – Two figures stand on a ledge about 8 cm in height. The figure on the left side of the block is a captive with his hands tied up or handcuffed at the back. His torso and face are shown in three-quarter view, while his legs are in profile. His right knee is sharply bent, his right heel is raised, and his raised right shoulder is

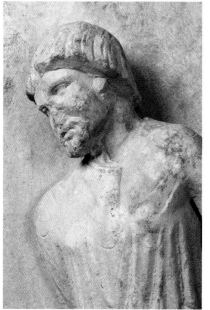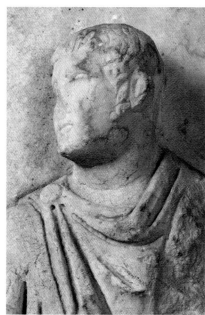

depicted from a foreshortened perspective as he appears to be walking towards the left of the block. He wears a loose thigh-length tunic belted at the waist. The V-shaped neckline of his tunic is also echoed in the V-shaped folds over his torso. He wears trousers and closed shoes underneath. The details of the face (nose, part of the forehead) are lost due to abrasion and chipping, but his long moustache, his thick, bob-cut hair, and his drapery suggest that he is a captive from the same ethnic group as the captives in **cat. no. 1**. Unlike the captives of **cat. no. 1** he has a short beard. The area underneath the beard on his neck is left unfinished and the left ear is not clearly defined; the latter appears only as a bulb underneath the hair. The Roman soldier on the right stands in a contrapposto pose. Although his right hand is chipped off, his outstretched right arm suggests that he is holding the tied-up hands of the captive in the same manner as the Roman soldier in **cat. no. 1**. The soldier wears a knee-length long-sleeved tunic, a cloak (*sagum*) fastened with a circle brooch over the right shoulder, trousers, and sandals or shoes with sketchily indicated straps. The folds of his *sagum* form a thick V-shaped neckline; the cloak falls down on his back in a rectangular shape with a large tassel on the right corner. He carries an oval-shaped (foreshortened) shield with the image of Medusa with a double-winged hat. This is the same type of shield that the Roman soldier holds on **cat. no. 1**. Although his face is damaged, the lack of a beard, the curly lock of hair (or the so-called youth lock) in front his ear, and his full cheeks and very thick neck suggest that he is younger than the Roman soldier on **cat. no. 1**. The short-bearded captive may also be younger than the captives of the same ethnic group on **cat. no. 1**.

4 Zeyrek and Özbay 2006, 300.

3. CAPTIVES WITH FLOPPY CAPS LED BY ROMANS

Mus. Inv. No. ÇKBĞ 2009/36, Exc. Inv. No. ÇKBĞ 2009/69,
TÜBİTAK No. 03, Mus. New Inv. No. 2018–4

DIMENSIONS – Height: 98, Length: 105, Thickness of
the Block: 29, Depth of the Relief: 12, Height of the Plinth:
7.5 cm

EXTANT CONDITION – According to the excavation
photos from 2009, the block was found underneath an ae-
dicular architrave frieze, with its figured side facing down at
the southern part of the excavated area. There is a fresh break
along the right side-end of the block. Some parts of the re-
lief are missing, including the top parts of the captives' hats,
the right upper arm of the kneeling captive, the right lower
arm of the armoured figure, the upper part of the spear he
is holding, and the face and right arm of the crowned figure
on the far right. The right hand and the lower right leg of the
kneeling captive have been restored; as well as the right arm,
left hand, and spear of the armoured figure.

Colour deterioration and oxidation have caused stains
on the relief, which are visible on the background above the
head of the standing captive on the left, on the front of the
plinth, on the cloak of the crowned figure, and the body
armour of the Roman soldier.

Traces of ancient paint are still detectable on the figures.
The colour yellow is preserved on the hair and the beards of
the captives and on the crown of the figure at the far right of
the relief. Bright red, presumably cinnabar, is preserved on
the hats and belts of all three captives, on the lips of the two
standing captives, on the upper lip of the armoured Roman
figure, on the kneeling captive's trousers, on the helmet of
the Roman figure (especially on the crest and on the metal
protection above his forehead), and on the sash of the scab-
bard of the Roman soldier. Brownish-red is preserved on the
hair and beard of the crowned figure on the right; blue is
preserved on the trousers of the standing captive on the far
left, and black on the shoes and legging straps of the Roman
soldier.

TECHNICAL DETAILS – Traces of the initial outlining of
the figures with a drill are still visible in between the shoul-
ders of the two standing captives on the left of the block.
The relief gets about 1.5 cm deeper towards the right; thus,
the top surface of the plinth on the right, the part on which
the crowned figure stands, is wider than the left side. The
left side-end and the top of the block have rough quarry-
pick marks. There are no traces of cuttings for clamps or lift-
ing devices on top of the relief panel. The panel might have
been carved on the building. Alternatively, if the relief panel
was mostly carved on the ground and hoisted in the build-
ing, the lewis cutting used to lift the panel could have been

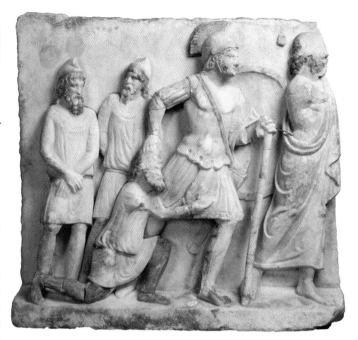

completely shaved off along with the top part of the relief to
fit to the height of its location. The background of the fig-
ures, as well as the exposed faces and limbs of the figures, are
polished with flat chisels and rasps. Claw chisel marks are
visible on the front surface of the plinth facing the viewer;
while the top side of the plinth has finer claw chisel marks.
The plinth slightly slopes outwards and its height is shorter
than the average height of the plinths throughout the entire
frieze.

DESCRIPTION AND DISCUSSION – The scene on the
block shows three captives being led towards the right by
an armoured figure and a crowned figure. On the left of
the relief are the two standing captives shown frontally, of
which the one on the far left (A) stands with his left knee
bent. He has long curly blonde hair, a long moustache, and a
thick curly beard parted into two halves at the tip. Modelled
only in paint, his eyebrows have the same blonde colour as
his beard. His lips are painted in red; his nose is big and an-
gular. He wears the so-called 'Phrygian cap' (a soft flexible
hat with an upturned top) which has a red lining around
the rim. He also wears a knee-length sleeved tunic with V-
shaped folds over the chest and arms, a red rope functioning
as a belt around the waist, trousers possibly painted in blue,
and soft shoes. His sketchily defined hands are tied up at the
front. His head is turned towards his left as he looks at the
other captive (B), who is shown dressed similarly and with
almost the same facial features as the first captive (though
his legs are partially blocked by the kneeling captive figure in
front of him). The second standing captive's hands seem to
be tied up at the back. His right shoulder is slightly raised,
and his head (shown in three-quarter view) is sharply turned
towards his right to look at the other standing captive.
In front of him is a kneeling captive shown in profile with

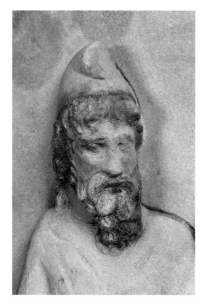

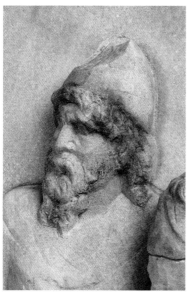

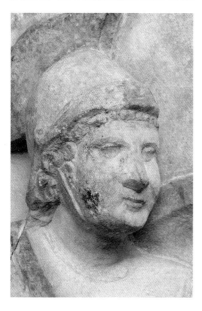

his left knee bent and his right leg parallel to the ground (C). The dress, facial features, hairstyle, and beard of this kneeling figure are also the same as those of the two standing captives, indicating that they all belong to the same ethnic group. Unlike the blue trousers of A, however, his trousers are painted in bright red (cinnabar), which is preserved very well. The colour contrast between the trousers of the two must have helped the visual distinction of the two captives from a distance, who were otherwise shown in an identical outfit. It seems that the kneeling captive's head is being pushed down by the armoured figure, who is depicted as larger. The upper right arm of the kneeling captive is missing, but he holds an unknown object in between his tied-up hands; the way he opens his hands can be read as a token gesture for asking for mercy. The armoured Roman (D) is shown in profile, holding the kneeling captive's head and marching towards the right. He is fully armed with a body cuirass (a *lorica*), a crested helmet secured with a red band below his chin, and metal knee-guards fastened with cross leather straps on the back of the lower legs. The cuirass ends with five semicircular embellishments over the hips. Beneath his cuirass the figure wears a knee-length tunic over which a kilt with eleven fringed leather lappets (*pteryges*) is fastened. Underneath the armour, he also wears a short-sleeved jerkin (unseen) to which fringed arm lappets (*pteryges*) are attached at the shoulder (on his right arm). Strapped on his left arm is an oval shield. He wears the red sash of his scabbard diagonally over his right shoulder, and his sword in the scabbard hangs on the side of his left leg. The left arm is broken at the wrist, but the left hand holds a long spear. The lower part of the spear is restored from several broken pieces; the missing part seems to have been supported with a strut visible above the shield. A pXRF analysis revealed extensive use of Egyptian blue for the metal parts of his armour, including the bowl and side straps of his helmet and knee guards. The neck protection and the crescent of his imperial helmet, however, are painted in red, indicating that they are made of different materials. The simple decoration and composite neck protection might indicate the 'Intercisa' helmet type of the later Roman Empire, or it may be just a simplified rendering by the sculptor.[5] He has an oval face with full cheeks and a full chin, without facial hair. His curly locks of hair framing his forehead are visible beneath the protective band of the helmet. Next to the armoured figure, another figure (E), also larger in size than the captives, is shown in profile marching towards the right. His right arm stretched towards the right is missing. He wears a long cloak wrapped around his body, but leaving his right shoulder and the right side of his torso naked. His head is very damaged, but he seems to have brownish curly hair and a beard; over his hair, he wears a crown painted in yellow. The corner of his long cloak thrown over his left shoulder ends in a large fringe. His crown and the bare feet are indicative of his divine or priestly nature. Indeed, the larger scale of the two triumphant figures, D and E, might indicate that they are divine figures, perhaps Mars, and Jupiter or Neptune; but in the absence of certain attributes, it is hard to be certain.

The artists' use of hierarchical scale (smaller captive barbarians vs larger triumphant Romans or divinities) and colour codes on the relief block seem to have helped the reading of the narrative. The contrasting colours used for the figures next to each other, the painted eyebrows, and the sketchily sculpted hands are all revealing of how the sculptor relied on painted details for the legibility of the frieze.

5 Travis and Travis (2014, 72–74) link the less flamboyant nature of the later third- and early fourth-century helmets to Diocletian's regulations, which opened up new state arm factories in which arms with simplified designs were mass produced. Klumbach (1973), however, sees the change as part of an 'orientalisation' of style under the Tetrarchy. Yet, one should be careful about the typology and chronology of the armour represented on Roman monumental sculpture as in some cases artists employed stylistic conventions in their representations or liked to follow archaic conventions, using equipment representative of the earlier Classical period; see the discussion in Travis and Travis 2014, 24–30.

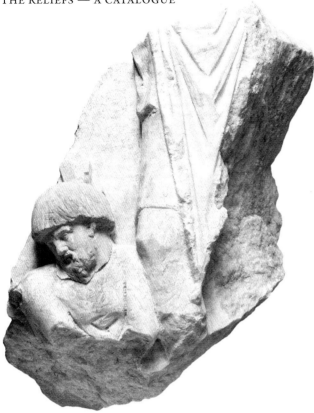

leg and partial torso of the triumphant figure can be seen in profile. The figure wears a knee-length belted tunic, trousers, and a *sagum*, which has V-shaped folds and forms a triangle. A big tassel hangs down from the corner of the *sagum*. An unknown rectilinear object above the head of the captive could be part of a trophy to which the captive is bound.[6]

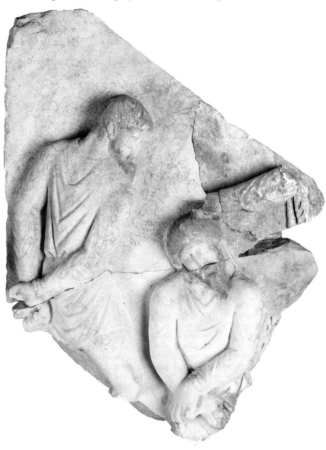

4. A RELIEF FRAGMENT WITH A CAPTIVE AND A ROMAN CAPTOR

Mus. Inv. No. ÇKBĞ 2009/32, Exc. Inv. No. ÇKBĞ 2009/58, TÜBİTAK No. 04, Mus. New Inv. No. 2018–5

DIMENSIONS – Height: 52, Length: 39, Depth of the Relief: 8 cm

EXTANT CONDITION – The fragmentary relief is only a small section of a larger block broken on all sides. There is no information available on its exact find-spot. The broken head of the captive (14 cm in height from the tip of the beard to the top of the head) is restored.

There are traces of red paint on the captive's lips, tunic, and yellow paint on his hair and beard.

TECHNICAL DETAILS – Drill marks used for the outlining of both figures and defining the arms of the captive are visible. The back of the relief block has rough quarry-pick marks.

DESCRIPTION AND DISCUSSION – The fragmentary block shows a captive barbarian on the left and a triumphant Roman soldier standing above him. Only the head and upper torso (shown frontally) of the captive are preserved; arms coming together in front of the torso indicate that his hands are tied up at the front. The head is tilted down towards his right. His thick, blonde, bob-cut hair, and pointed blonde beard suggest that he too is a barbarian, and of the same ethnicity as the captives on **cat. no. 1**. Only the left

5. TWO BOUND CAPTIVES AND A CAPTOR

Bottom part: Mus. Inv. No. ÇKBĞ 2009/10, Exc. Inv. No. ÇKBĞ 2009/18, top part: Mus. Inv. No. ÇKBĞ 2009/33, Exc. Inv. No. ÇKBĞ 2009/59, both parts together: TÜBİTAK No. 05, Mus. New Inv. No. 2018–6, joined but non-restored fragment with a sleeved arm from the right side: TÜBİTAK No. 67

DIMENSIONS – Height: 86, Length: 64, Thickness of the Block: 16, Depth of the Relief: 7.5 cm

EXTANT CONDITION – The relief is restored from two parts (top and bottom) found separately in the museum storage. Excavation photos from 2009 show that the top part with the heads of captives was found with its figured side facing up next to a fallen column on the north-western part of the excavation area. The original block is broken on

6 For similar examples of captive barbarians bound to trophies on Roman imperial coinages and cuirassed statue breastplates, see Gergel 1994, especially figs 12.6 and 12.7.

all three sides and partially on the left; the left side of the top part is the original side-end of the block. Another fragment preserving only the left lower arm of a figure and a piece of fringed drapery found in a separate pile in another storage room of the museum, comes from the missing right side of the relief. This part, however, has not gone through any conservation or restoration treatment. Thus, the colour of the marble is much darker than the restored parts on the left. (Dimensions of this separate fragment are H: 25.5 cm, L: 24 cm, and Thickness of the Block: 16 cm.)

The visible polychromy includes traces of orange-red paint on both figures' hair and beards, and traces of a somewhat lighter-toned red paint on their tunics. Scratchy brown patterns, especially on the front surface of the top block, are due to post-antique colour deterioration and oxidation.

TECHNICAL DETAILS – As evidenced by the back and the left side of the block, the relief block is re-carved from an earlier architectural soffit with mutules. Rectangular mutules on the back consist of eighteen circular shallow mouldings. The mutules of the original architectural block are partially chiselled off, to make a deep concave cutting along the left side of the relief. The surface of the large concave cutting has then been cleared with claw chisels. The section closer to the figured plane on the left side has been subsequently smoothed into a precise rectangular band (7.5 cm in width). Thus, rather than connecting to another relief block or another architectural element, it seems that this left side of the block was prepared to be seen within its architectural setting. It must have been a corner block and therefore had its left side exposed. Another relief block, **cat. no. 9**, is also re-carved from the same architectural soffit, indicating that both were produced by the same workshop. Tool marks visible on the front surface of the relief include flat chisels and rasps for the background of the figures. The tip of a flat chisel is used to indicate the fringes of the drapery on the separate fragment on the right.

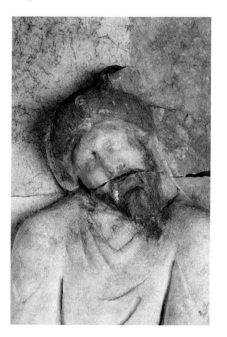

DESCRIPTION AND DISCUSSION – Of the two bound male captives, the one on the viewer's left is shown standing with his back turned to the viewer and his hands tied behind his back. The right leg is broken off, but the bent right knee suggests that he is about to kneel. The ropes tied on his right wrist appear like a doubling-ring bracelet. He wears a long-sleeved thigh-length loose tunic belted at the waist, possibly with a rope, and he wears trousers underneath. The loose and fine fabric of his drapery is suggested through V-shaped creases both at the back of his tunic and on his trousers. His face is depicted in profile; he has thick orange-red hair, a long moustache, and a long, pointed beard parted into two at the tip. The captive on the right is shown frontally being pushed down to the ground with his hands bound at the front and his head tilted to his right side. The rope visible on his left wrist is double-ringed. He is dressed just like the other captive; however, the frontal view makes visible the V-shaped neckline of his loose tunic. His thick orange-red bob-cut hair, long moustache and beard are the same as those of the captive on the left, indicating that they are of the same ethnicity. Remnants of a hand grabbing his hair and pushing him down, and fringes of a cloak on his left, show the existence of a captor on the viewer's right. Indeed, the later-found fragment with the extended left arm of a cloak-wearing figure belongs to this side of the relief. The deeply carved eye sockets framed with bulging eyebrows and the tilted head of the captive emphasize his torment. The arm on the later-found fragment probably belongs to a triumphant (Roman or divine?) figure, bringing down the captive from the head. An orange hue of red is visible under the ankle on the fragment. The folds in the arm and the fringed drapery at the right indicate that the figure was shown as wearing a sleeved tunic and also a fringed cloak. The fringes of his cloak continue on the restored part on the left side of the kneeling captive.

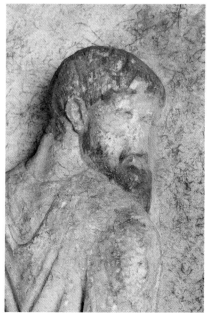

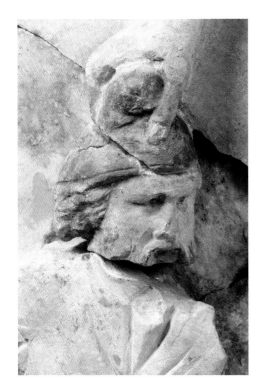

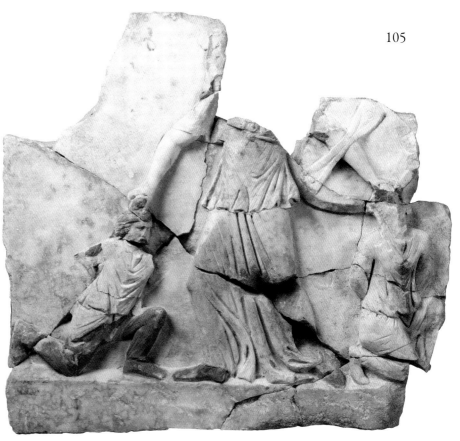

6. ATHENA AND TWO KNEELING CAPTIVES

Fragment with the torso of the captive on the right: Mus. Inv. No. ÇKBĞ 2009/8, fragment with the extended arm of Athena: Mus. Inv. No. ÇKBĞ 2009/9, rest of the panel with the lower bodies of the captives and Athena: Mus. Inv. No. ÇKBĞ 2009/31, Exc. Inv. No. ÇKBĞ 2009/57, all parts restored: TÜBİTAK No. 06, Mus. New Inv. No. 2018–7

DIMENSIONS – Height: 100, Length: 94, Thickness of the Block: 22, Depth of the Relief: 6, Height of the Plinth: 12 cm

EXTANT CONDITION – The block is restored from eight main broken pieces in different sizes. Excavation photos from 2009 do not reveal any information on its exact find-spot. The majority of the top part and right bottom part are missing. Extant sections on both the left and the right sides of the panel have been flattened with claw chisels, suggesting that this is the exact length of the individual block, with its sides joining to other architectural elements or frieze slabs.

Bright red paint (presumably cinnabar) is preserved on the shoes, trousers, hat, and lips of the kneeling captive on the viewer's left; on the shoes of the goddess Athena and on the outer rim of her shield; on the string knot below the chin of Medusa; and on the tunic of the kneeling captive on the viewer's right. Yellow is preserved on the hair and beard of the kneeling captive on the viewer's left, on the hair of Athena, and on the hair of the seated captive on the viewer's right. Blue paint is faintly preserved in the form of two bands at the hems of Athena's peplos, one above the shoes

and one on the overfold above the waistline; it is also preserved on the tunic of the captive on the left, and the trousers of the captive on the right, and on the butterfly-shaped handle of Athena's shield.

TECHNICAL DETAILS – On the top of the relief block (above the kneeling captive on the left) is a partially preserved socket, about 5 cm in depth and about 3.5 cm in width. The original length of the socket is not clear as the block is broken off from the left of the socket on the left top. This is most likely a clamp hole; it could have been a trimmed-down lewis hole, used for lifting the block after figures were carved on the ground, but this is less likely, as it is not in the middle. Just like on **cat. no. 5**, there are scratchy brown patterns around the left shoulder and right elbow of the seated captive on the right, possibly due to colour deterioration within the specific chemical composition of the soil with which the blocks were covered after falling down.

TOOL MARKS – Most of the top of the block is missing but, to the right of the dowel/lewis hole, a small section of the original top of the relief (prepared with rough point chisel) is preserved. Smooth finishing on the front of the plinth has been achieved with fine rasps and abrasives; medium-sized claw chisel marks on both the left and right joining sides of the relief, as well as finer claw chisel marks on the inside of Athena's shield, are visible. A drill has been used for the iris of the seated captive on the right and for defining the folds of drapery, which is especially clear on Athena's peplos. The background of the figures has been polished with a flat chisel and rasps, traces of which can clearly be detected.

DESCRIPTION AND DISCUSSION – The goddess Athena, identifiable from her aegis with the head of Medusa, stands at the centre with two kneeling captives on her sides. Although her face and upper torso are missing, the blonde lock of hair falling down on her right shoulder indicates that she was represented as having long blonde hair, perhaps with a helmet on top. Her torso is shown frontally, while her legs, especially the right leg bent at the knee, are shown in profile. Her arms are outstretched; she holds the kneeling captives on each side of her by their heads. Strapped on her left arm is an oval shield. The butterfly-shaped handle strap of the shield is connected to the thicker rim of the shield with two circular nails, the knobs of which are visible. She wears a long peplos with an overfold reaching down to her upper thighs. Folds of her dress form V shapes over the torso and vertical lines over the legs. The windblown folds of her dress at the hem respond to the movement of her left leg, and the border of the overfold above the thighs plays in the breeze. These 'moving' borders of the peplos are also painted in blue, a different colour from the rest. The peplos is secured with a double-knotted rope (painted in red) below the breasts. Above the peplos, she wears her aegis, the circular border of which covers her right shoulder. The frontal head of Medusa on her aegis is also visible above the double-knot of her belt. The war goddess's large size is noticeable. She would dwarf the kneeling captives even if they stood up. The captive on the left side kneels with his left knee bent and right leg parallel to the ground, with his toes and knee touching the ground. His hands are tied at the back. He wears the 'Phrygian cap', the upturned tip of which is being held by Athena; a sleeved tunic with V-shaped folds over the chest; trousers; and soft shoes. He has blonde curly hair, a long moustache, and a beard. The drapery and the facial features indicate that he belongs to the same ethnic group as the captives represented on **cat. no. 3**. The head of the kneeling captive on Athena's left is missing, but remnants of yellow paint right below Athena's left hand indicate that he did not have a hat, and that Athena is pushing him down by the hair. His lower body, his drapery (a sleeved tunic with V-shaped folds and trousers), his hands tied at the back, and the possible lack of a hat connect him especially to the captives on **cat. no. 1**. This slight difference in the costume and hair of the two captives in the block is due to the artist's intention to refer to two ethnically different captives, perhaps Dacians and Germans, over which Athena became triumphant. The artist also relied on paint to differentiate between the two captives by depicting them with differently coloured costume. The costume is generic for both barbarians — trousers, loose tunic, and soft shoes — but the captive on the left has a blue tunic and red (cinnabar) trousers, while the one on the right has the reverse: a red tunic and blue trousers.

7. FRAGMENT WITH A BOUND CAPTIVE AND A CAPTOR

TÜBİTAK No. 07, Mus. New Inv. No. 2018–8

DIMENSIONS – Height: 62, Length: 44, Thickness of the Block: 23, Depth of the Relief: 8.5 cm

EXTANT CONDITION – It was found during the 2001 rescue excavation and initially published by Zeyrek and Özbay.[7] There is no information available on its exact findspot. This is only a fragment of a larger relief panel, broken on all sides. The upper torso and lower legs (from knees down) of the frontal standing figure are missing.

Traces of blue paint are visible on the tunic of the bound captive.

TECHNICAL DETAILS – The plane behind the projecting figures has been polished with rasps; a drill has been used for outlining the figures.

DESCRIPTION AND DISCUSSION – A frontal figure wears a belted tunic with V-shaped folds over tight-fitting trousers. Both arms of the figure disappear behind his back, indicating that his hands were tied behind him. On the viewer's right, the right hand of a larger standing figure holds a loop-shaped string extending from the back of the bound figure, and thus is the captor. He wears a sleeved tunic and possibly a cloak. The motif is clearly related to the series of reliefs depicting bound captives with triumphant Roman captors (**cat. nos 1 to 8**), especially to **cat. nos 1 and 2**.

7 Zeyrek and Özbay 2006, 301, Abb. 17.

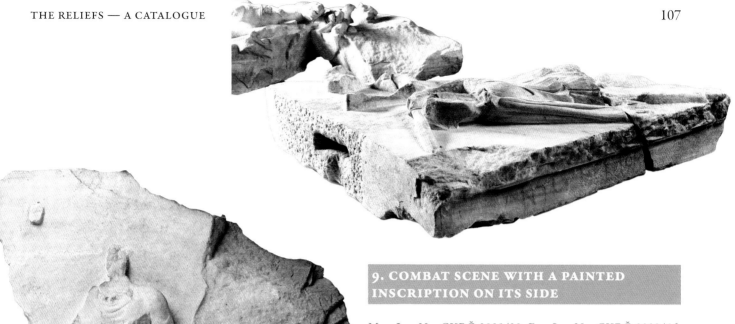

8. FRAGMENT WITH A CAPTIVE

TÜBİTAK No. 08, Mus. New Inv. No. 2018–9

DIMENSIONS – Height: 40, Length: 67, Thickness of the Block: 21, Depth of the Relief: 8 cm

EXTANT CONDITION – The fragment was recovered during the 2001 rescue excavation.[8] There is no information available on its exact find-spot. Upper left side of a relief panel, broken on all sides except for the partially surviving top left side.

No traces of polychromy are visible to the naked eye.

TECHNICAL DETAILS – On the top left corner of the block, a right slanting side section of a lewis hole measuring about 3.5 in width and 7 cm in depth still survives. Use of a drill for outlining the figures and use of rasps for polishing the background of the figures are visible.

DESCRIPTION AND DISCUSSION – On the left of the block is the upper torso of a frontal figure wearing a sleeved tunic. The head is completely missing, but the traces of curls at the tip of his beard are visible on his torso. The pose of the arms, especially the right arm bent from the elbow, indicates that he is a captive with bound hands. The remaining right arm of another standing figure (slightly bigger) to his right might be another captive or, as is more likely, his captor, a triumphant Roman as on **cat. nos 1, 2, and 7**. On the upper left above the bound prisoner is the remnant of a strut once supporting a spear-like object from the lost left side of the block.

8 Zeyrek and Özbay 2006, 302, Abb. 18.

9. COMBAT SCENE WITH A PAINTED INSCRIPTION ON ITS SIDE

Mus. Inv. No. ÇKBĞ 2009/30, Exc. Inv. No. ÇKBĞ 2009/56, TÜBİTAK No. 09, Mus. New Inv. No. 2018–10

DIMENSIONS – Height: 91, Length: 89, Thickness of the Block: 24, Depth of the Relief: 8 cm

EXTANT CONDITION – Found in the north-western section of the excavated area, slightly to the east of the top part of **cat. no. 5**, with its figured side facing down. It is a broken fragment from a frieze panel with the original right side-end missing. The lewis cutting at the central top of the panel, however, indicates that the surviving length of the block is close to the original length. The block is also slightly chipped off on the upper left corner. Rejoined from two pieces. The bottom piece with the legs of a Roman soldier has modern pickaxe marks and scratchy brown marks due to colour deterioration, while the upper part of the top piece has white spots, possibly due to modern cleaning. There is a

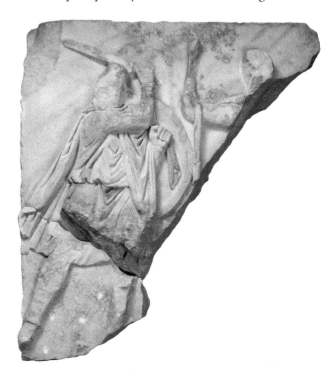

lot of damage and chipping on the face and the lower body of the Roman soldier on the viewer's left. On the right, only remnants of a right arm holding a spear and the head of another soldier are preserved.

The red colour is preserved on the warrior's cloak and belt on the left; yellow colour survives on his helmet, on the handle of his shield, on the handle of his sword, and also on the spear of the partially surviving warrior on the right of the relief panel.

TECHNICAL DETAILS – In the middle of the top surface of the relief block is a wide rectangular socket, carved to insert a metal lewis to lift the panel up. The lewis cutting measures about 18 cm in length, 5 cm in width, and is 8 cm deep. Its placement in the middle of the top of the relief and the almost fully preserved depth indicate that the block was carved on the ground and the lewis hole was made later for hoisting. After hoisting, the top of the relief panel seems to have been trimmed down a few centimetres to fit into the architecture (depth of an average lewis socket needs to be at least 10 to 12 cm in order to safely carry an architectural stone block up). The back of the panel has three mutule blocks (each consisting of eighteen circular shallow mouldings). The bed moulding to the right of the mutules indicates that the panel was re-carved from an earlier architectural soffit of a cornice block. This is probably the same architectural soffit also used for the re-carving of **cat. no. 5**, indicating both **cat. nos 5 and 9** were produced by the same workshop. On the left plain side of the mutules, an inscription in red paint reads ΑΝΤΩΝΕΙΝΟΣ (ANTONEINOS). The approximate letter height is 5 cm. The location of the inscription on the joining side of the block (which was not meant to be seen) and the letters, written in a careless manner, indicate that this is a note for the builders, perhaps mentioning the workshop, the sculptor, or the painter who was given the commission for this relief panel.

TOOL MARKS – The background of the figures on the front surface of the panel is polished with rasps. Drill marks are visible for the rendering of the folds in the drapery of the soldier on the left of the panel.

DESCRIPTION AND DISCUSSION – Two Roman soldiers in a combat scene are detectable on the preserved left section of the panel. The warrior on the left is dressed in a sleeved tunic, trousers, and a cloak (*sagum*) fastened with a brooch over his right shoulder. His head is broken off, but traces of a helmet with back protection can be seen. His chipped-off head is sharply turned towards the left, while his lower body is directed towards the right. The right arm is bent from the elbow and his hand, holding a sword, is raised up above the head to attack an enemy on the left. The windblown cloak responds to his action. In his left hand the soldier tightly holds the handle of his shield. The handle

consists of a large strap (perhaps of leather) attached to the inside of the shield with nails, which have visible round heads. On the right, the right arm and head of another soldier are partially preserved. He wears the same helmet with back protection and holds a spear in his right hand. The brooch of his *sagum* above the right shoulder and his helmet, the same type that the other soldier wears, suggest that they belong to the same attacking group of Roman soldiers in a combat scene. The type of helmet with a rounded bowl, a neck guard, and a reinforcing peak that is attached to the helmet with circular knobs on the sides, can be classified as an imperial Gallic type[9] and it also appears on the heads of bearded figures on two broken frieze fragments (Appendix I, SRF 1 and 2). This indicates that there was another panel like **cat. no. 9** with similarly dressed soldiers on the Nicomedia frieze.

10. THE LARGE COMBAT

Mus. Inv. No. ÇKBĞ 2009/26, Exc. Inv. No. ÇKBĞ 2009/48(B), TÜBİTAK No. 10, Mus. New Inv. No. 2018–11

DIMENSIONS – Height: 98, Length: 194, Thickness of the Block: 20, Depth of the Relief: 11, Height of the Plinth: 11 cm

EXTANT CONDITION – Restored from four large pieces, unearthed in the north-eastern corner of the excavation area together, but broken along the cracked areas during the transportation of the slab to the museum. According to the excavation photos from 2009, the block was found fallen with the figured side up on the opus sectile floor next to two fallen columns. The full length and the height of the block are preserved. The lower left corner of the frieze is missing. The right arm, leg, and head of the armoured figure on the left (A), along with parts of his sword, are chipped off. The break on the top left side of the relief block is an intentional ancient cutting to fit it into its architectural setting, perhaps in its secondary use. The head of the mounted warrior (B) has been reattached. The horse's head and the front and rear right leg are missing. The upper face of the fallen warrior underneath the horse (C) is damaged. His right hand is missing. The head, the right arm, and the lower right leg of the warrior seen from the back (E) are chipped off. His right foot is restored. The tip of the shield of the figure (D) holding on to it is restored. The right hand and the left leg except for the foot of the fallen warrior on the right corner (F) are chipped off. Both of his hands are missing. The small break on the top right corner of the frieze block is modern.

9 Travis and Travis 2014, 61–71.

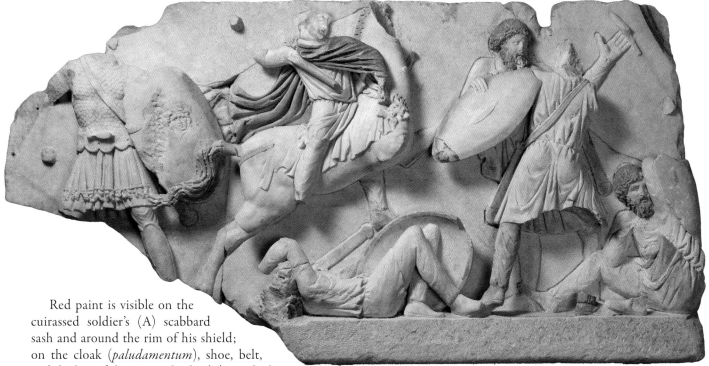

Red paint is visible on the cuirassed soldier's (A) scabbard sash and around the rim of his shield; on the cloak (*paludamentum*), shoe, belt, and the lips of the imperial rider (B); on the harness of the horse; on the rim of the shield with the diamond symbol, on the trousers and shoes of the soldier seen from the back (E). Brownish-red paint is visible on the hair and beard of the rider and two of the defeated soldiers (D and F). Yellow paint is visible on the tail and mane of the horse, and on the spear of the rider. Multispectral imaging and pXRF analysis have revealed remnants of Egyptian blue on the *paludamentum* of the imperial rider which now looks red to the naked eye; this indicates that the *paludamentum* was once painted in purple. At the time of the panel's discovery in 2009, much more polychromy was preserved. Excavation photos show that the eyebrows, eyes, and a horseshoe-shaped moustache of the imperial rider were defined with black paint. The black paint has faded away today due to exposure to outside elements. Also, on the back of the block is a builder's sign made with red paint.

TECHNICAL DETAILS – Despite the breakage on the left lateral face and a small missing part on the top corner of the right lateral face, the full original width of the block is preserved. On the back of the frieze slab there are thick traces of mortar, perhaps used as a binder. Also on the back is a small painted (now illegible) sign in red, perhaps referring to its workshop or to its intended location in the architectural setting. On the top right side of the panel there is a rectangular cutting about 3 cm in length. Weakened by this hole, the front surface of the panel broke at this point revealing the 7 cm depth of the cutting. Point chisel marks indicate that the cutting was enlarged along the width of the block on the top surface towards the back plane, perhaps to open up space for the arm of a clamp connecting the slab to the back wall. The cutting might also have been carved for a dowel but then broken and used for

a different connecting mechanism. There are traces of another such cutting on the top left side (107 cm apart from the one on the right) but it is broken off along with the left corner of the relief slab. The break on this upper left corner, behind the right shoulder of the armoured figure (A), seems intentional, with clear point chisel marks indicating that this part of the relief panel was chipped off to fit into an architectural join, perhaps an afterthought on the part of the builders who could not fit it in its pre-planned spot after it was carved on the ground. If the panel was carved on the ground, how such a large block was hoisted and placed in its architectural setting is not evident on the block. One possibility is that the hole(s) made for the lifting of the block was trimmed out during the installation. The cutting on the top right side of the block is too short in length (3 cm) and too wide (9 cm) to be a lewis hole, but these two 107 cm apart cuttings on the top surface of the block could have been tong holes used in the lifting of the block, which were later used as clamp holes to secure the slab in its place.

TOOL MARKS – The initial outlines drawn to lay out the figures are still visible, especially around the lower body of the horse and the fighting figures on the right. The outline drawn for the legs of figure D does not align with his upper body. There are tooth chisel marks on the front face of the plinth. A drill has been used for the folds of drapery, hair, and beard, for the irises of the figures (especially clear on D and F), and for the tail of the horse. There are post-antique punch marks on the shield of the armoured warrior on the far left. Point chisel and tooth chisel marks are visible on the left lateral face of the block.

DESCRIPTION AND DISCUSSION – The relief slab depicts a combat scene with an armoured Roman soldier and a mounted imperial figure attacking four soldiers of the defeated side, two of whom have already fallen down. The variety of movement and overlapping of figures make the scene complex. On the left is a Roman soldier (A) clad in elaborate body armour, consisting of a scale cuirass (*lorica squamata*) with five semicircular embellishments and a kilt with ten leather flaps (*pteryges*) ending with fringes. His armour also includes metal greaves fastened with strings around the back of the legs, as can be seen on his surviving left leg. Underneath the armour are his knee-length tunic and trousers. His right arm and right leg from the knee are missing. Originally, he seems to have been represented holding a sword in the right hand. The strut once supporting the bent right arm is still visible. The elaborate baldric of his scabbard with floral designs crosses over his right shoulder. The circular tip of the scabbard is summarily outlined underneath his shield on his left. His oval-shaped shield, with an encircling red band around the rim, is embossed with the head of Medusa wearing a winged headdress and with flanking strings tied under her chin.

Next to the armoured figure is a mounted imperial figure (B) attacking the enemies in front of him with his spear. In contrast to the elaborate armour of A, he is clad in a knee-length tunic belted at the waist, trousers, and a *paludamentum* fastened with a brooch over his right shoulder. The pXRF analysis of the pigments on his *paludamentum* has shown that, although it now appears red, it was originally painted in imperial purple. Indeed, all the other emperor representations on the Nicomedia frieze appear unarmoured (except **cat. no. 20**) and wearing the imperial purple cloak over their trousers and tunics. The imperial figure's outstretched right arm was holding a spear forced towards the right. His reared-up horse attacks the soldiers with its front legs. The elaborate saddle on which B sits is made of lion skin and is strapped onto the horse with bands. The head of the lion (with mane, eyes, and nose) on the breast of the horse faces right and is rather small compared to its larger skin. The folds of the saddle, the hems of the warrior's tunic, the folds of his *paludamentum*, and the horse's tail are blown towards the left by the wind, responding to the rightward attack. With his *paludamentum* painted in imperial purple and his lion-skin saddle, this figure might be the Emperor Maximian himself, perhaps accompanied by his praetorian guard (A) in a battle. The top part of his reattached head is missing, but the overall rendering of his portrait with a short-cut beard is consistent with other imperial figures on the Nicomedia frieze. Yet he does not have the distinctive retroussé nose (of Maximian), as on **cat. nos 14, 16, and 20**. His short beard is not detailed with stippled carving as on **cat. nos 14, 16, and 20** either, but is just painted, like the imperial figure on **cat. no. 15**. The traces of black paint on the details of his face, found during the initial discovery of the relief, indicate that for much of the facial details the artists relied on paint, which has mostly disappeared today.

Underneath the horse of the imperial figure is a fallen soldier lying on the ground with his knees bent (C). He is shown in profile, except that the tip of his right foot and his head are facing the viewer. The right arm is missing from the wrist. The head is damaged, but one can see the traces of his long curly hair and beard. Next to his legs in the background, the inner side of his shield with a curved red rim band can be seen, as well as his scabbard above his outlined left arm. The front hooves of the reared-up horse touch the two standing warriors of the vanquished side; one is depicted from behind (E), the other one frontally holding onto E's shield (D). The head of E is missing. His lower body is completely freed from the background. He is clad in a knee-length belted tunic, trousers, and soft shoes. The sash crossing over his right shoulder belongs to his scabbard, which hangs down on his left. He holds an oval-shaped shield with a rim painted in red. The diamond-shaped embossment in the middle of his shield also appears on the shields of the walking figures on **cat. no. 11**. The remnants of a strut on the

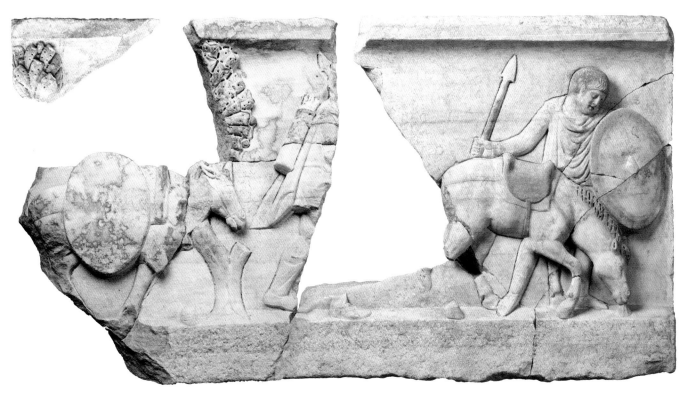

right side of the relief and the tip of a spear indicate that E's missing right arm was originally depicted extending towards the right and holding a spear. Holding onto E's shield with his right hand is another man (D) facing the viewer. Mostly obscured by E's body, most of his body is left as an outline on the front surface of the relief. The size and orientation of his legs do not correspond with his upper body. His overly large left arm and hand are raised up, almost in a gesture of surrender, and reach to the sharp tip of E's spear on the right. His scabbard hangs down below the right arm of E. Despite the sketchy and inaccurate rendering of his body, his face is carved in detail with bob-cut curly hair, a long curly beard, and a moustache painted in brownish-red. His wrinkled forehead, wide-open eyes, and parted lips give him an anguished expression. Sitting down in the right corner is another soldier of the defeated side (F). He too has brownish-red curly hair and beard, and lips painted in red. He wears the sleeved tunic, trousers, and the soft shoes, and raises up his shield with his right arm bent as if to protect himself from an attack coming from the viewer's right. His startled gaze and open mouth are directed towards the right end of the block.

Artists have employed several iconographic details to help the audience to identify the victorious Roman side and the defeated side, but the overall composition lacks the specific details to be understood as a representation of a historical battle all by itself. The armies are clearly differentiated with the emblems on their shields; the Roman soldier's shield is embossed with the head of Medusa, while the soldiers of the defeated side have shields with diamond sym-

bols. Shields with the Medusa head appear in the hands of other Roman soldiers on the Nicomedia frieze, such as **cat. nos 1 and 2**. The shields with diamond symbols are shown as part of the armoury of exhausted marching soldiers in a military expedition on **cat. no. 11**. Thus if viewed together, **cat. nos 10 and 11** might have had a more specific historical reference: the soldiers on **cat. no. 11** appear as migrating or being deported after their defeat by the emperor and his army in **cat. no. 10**. Neither the diamond nor the head of Medusa appear on the official military insignia of Roman armoury recorded in the *Notitia dignitatum*, a detailed manuscript on the Roman administration and army units during the later Roman Empire, surviving in a sixteenth-century copy.

11. A MILITARY MARCH OF THE IMMIGRANTS IN THE COUNTRYSIDE

The right section of the panel with the horse and the spear-bearer: Mus. Inv. No. ÇKBĞ 2009/29, Exc. Inv. No. ÇKBĞ 2009/55, the restored whole extant panel: TÜBİTAK No. 11, Mus. New Inv. No. 2018–12, the unrestored fragment of the top left corner: TÜBİTAK No. 70, Mus. New Inv. No. 2018–64

DIMENSIONS – Height: 106, Length: 262 (preserved length, original length was probably around 3 m), Thickness of the Block: 20, Depth of the Relief: 8, Height of the Plinth: 18, Height of the Top Band: 8 cm

EXTANT CONDITION – The relief slab is restored from seven broken pieces. According to the excavation photos from 2009, two pieces of the panel (one with the tree

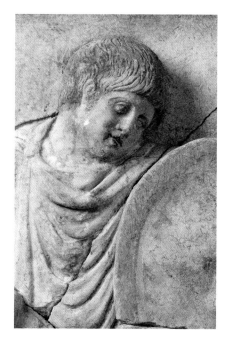 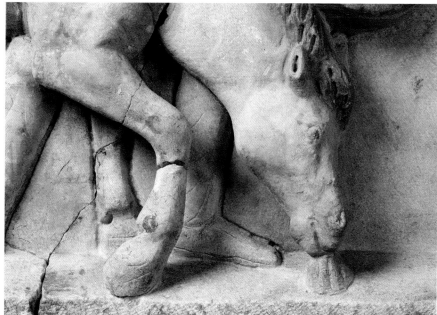

trunk, another with the feet of the horse) were recovered from the north-western section of the excavated area, close to **cat. nos 5 and 9**, jumbled up in between other architectural pieces. The bottom left corner, a larger piece from the top left corner, and a large piece in the middle are missing. Another fragment with a band along the top and leaves of a tree, found later in a box in museum storage, can also be assigned to the top left corner of the large panel. (The dimensions of the fragment are **DIMENSIONS** – Height: 32 cm, Length: 62 cm, Thickness of the Block: 20 cm, and Height of the Top Band: 8 cm.) Because of the missing parts in between the fragment and the other surviving part of the panel, the restoration of this fragment is not possible. The lower part of the tree on this top left corner, a large part of the tree in the middle, the top of the mule's harness, its tail and rear legs, and the lower part of its right front leg are missing. Most of the body of a quiver-carrying figure in the middle, as well as the tail and the lower part of the weary horse's rear right leg, are chipped off. The horse's lower front right leg and upper rear right leg have been restored.

Different hues of red paint are visible on the saddle and the harness of the horse on the right; around the rim of the shield with the diamond insignia; on the lips of the spear-bearing soldier on the right; and on the leaves of both trees. A brown inner encircling line is also still visible on the shield on the right. Yellow paint on the mule's mane and side of its saddle, on the horse's mane, and on the soldier's hair and the bottom part of his spear are visible. Multispectral imaging and pXRF analysis have shown traces of Egyptian blue used for the military equipment, the tip of the spear on the right, the diamond embossed decorations of the shields, and the arrows in the quiver of the figure in the middle.

TECHNICAL DETAILS – This relief slab is the only panel with a protruding top band in addition to the plinth at the bottom framing the figures. The width of this horizontal ledge is 8 cm; 5 cm of the part closer to the figured plane is polished, while the remaining part towards the top surface of the slab, which was not meant to be seen, is left rough. The plinth on which figures stand has a slight downward slope. The rectangular clamp hole on the right part of the top surface (aligned with the spear of the weary soldier on the right) measures about 6 cm × 2 cm and is about 4 cm in depth. The other clamp hole on the top left corner of the block is visible on the top surface of the separate fragment with the tree leaves. Its dimensions are similar to those of its counterpart on the right: 6 cm × 2 cm and 3 cm in depth. Extending from the clamp holes towards the back plane of the relief panel are rectangular channels, possibly carved to accommodate the arm of the clamp, securing the block to the back wall it was placed in. There are rough quarry-pick marks and traces of mortar on the back of the relief panel.

TOOL MARKS – Both lateral faces of the slab are finished with point chisels. On the front surface of the relief, initial outlines from which figures are worked out are clearly visible, especially around the tree and the bodies of the weary horse and the spear-bearing soldier next to it. The background of the figures and flat surfaces of the figures have been polished with rasps; rasp marks are especially clear on the shield of the weary soldier. Flat chisels used for polishing the bottom part of the top band and tooth chisel marks are visible on the front surface of the plinth. A drill and the tip of a flat chisel have been used for rendering the leaves, and the mane and ear of the horse.

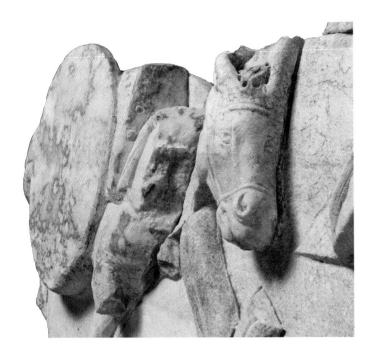

DESCRIPTION AND DISCUSSION – The top left corner of the relief panel has at least thirteen bell-shaped leaves from the top part of a tree, and a top band, which are now preserved in a separate fragment. Next to this tree is a heavily loaded mule. On top of the mule is a thick wooden triangle-shaped saddle painted in yellow with two circular protrusions on its right side. The saddle is strapped onto the mule with a harness. The bridle of the harness frames the mule's face and the back band (of the harness) stretches along the right buttock of the animal. Attached to the right side of the saddle is a large oval-shaped shield with a diamond symbol in the middle, shown from a front angle. Right above the mule's head is another tree with thick bell-shaped leaves, the details of which were made with the use of a drill. The top of the tree reaches up to the top border band, while its trunk touches the bottom border of the relief, right in front of the mule. This tree trunk in front of the mule consists of two main branches; the branch on the right is cut off, while the branch on the left extends up behind the mule, possibly supporting the now-missing part of the tree. Landscape elements are rare on the Nicomedia frieze but there are at least three other slabs with trees (**cat. nos 26, 54, 55**) with a similar treatment of bulky triangular trunks and large bell-shaped foliage, perhaps referring to some sort of an oak tree. In front of the mule is the back of a man in profile walking towards the right. He wears a belted tunic, trousers, a cloak hanging down from his back, and shoes. He carries his tube-shaped quiver containing five arrows, fastened to his back with a strap. The strap passes through a small circular loop on the right side of the quiver and extends towards the warrior's right shoulder. The head, arms, and right leg are missing; only the right foot stepping on the ground can be seen. The tip of his spear can be seen above

his head in an outlined form. To the right of this figure is a horse. The horse's tail and the lower part of its rear right leg are broken; otherwise its body is well preserved. Trying to walk towards the right, the animal appears exhausted, with its right front leg sharply bent from the knee, and the hoof unable to step firmly on the ground. The horse's head is lowered with its yellow-painted thin mane hanging down his chest. The object under its snout could be a tuft it is sniffing or its own long tongue hanging out of its mouth and touching the ground, suggestive of the animal's hunger or thirst. Fastened to its back with red straps is a two-layer rider's saddle. The yellow-painted saddle of the bottom layer is fastened with two long bands extending horizontally on the animal's back and front, and the red-painted saddle on top (with protrusions at its sides to secure the rider) is attached to the horse by a band that runs vertically around the horse's girth. The horse, however, does not have bridles, perhaps as a sign of his slow, riderless movement. Shown walking alongside the exhausted horse is a soldier. He wears a sleeved tunic, trousers, shoes, and a cloak (*sagum*) fastened with a brooch on his right shoulder. He holds a spear in his extended right hand and a shield with a diamond symbol in his left hand. His body is shown frontally behind the horse, while his right-facing head is shown in profile. His head is sharply tilted down, indicative of his exhaustion. He has short straight hair, painted yellow, with a thin tress in front of his ear. With his lock of hair in front of the ear and his clean-shaven face, he appears young.

Overall, there is no active movement in the scene; it is static. The lowered heads, the horse's stagnant pose, the mule's heavy load, and the cut-off branch of a tree all indicate a long, tiring march in the countryside. Indeed, trees as designators of countryside as opposed to cities are common in Roman reliefs. The Roman army, for example, appears surrounded by oak and pine trees in the encampment scenes in the countryside or engaged in cutting such trees to open up roads through the forest for the Roman army on Trajan's Column.[10]

10 Coarelli 2000, 101, plate 57.

The panel possibly belongs to the same narrative cycle as **cat. no. 10**, where the defeated soldiers likewise hold shields displaying diamond symbols. This is the side that will lose the battle or has already lost the battle. In the latter case, they might be identified as barbarians being deported after the defeat. These exhausted soldiers in despair, however, are not rendered as complete barbarians. Both of the marching soldiers wear a *sagum*, an element of dress used to distinguish the Romans from barbarians on other relief panels of the Nicomedia frieze. Furthermore, the presence of a loaded mule and military equipment suggests that they are partially prepared for this deportation, unlike, for example, Dacian soldiers fleeing towards the woods after their defeat by Trajan's army on Trajan's Column.[11] This brings to mind their possible identification as *Laeti*, barbarians who were forced to migrate and resettle in the predesignated imperial territory on condition that they provide military service for the Roman army. Indeed, tetrarchic policies that led to state-forced barbarian migration and resettlement were praised as unique achievements in a panegyric given to Constantius in 296.[12] A parallel image with barbarian immigrants carrying sacks crossing the Rhine and marching towards Mainz on the Mainz medallion has also been linked to Maximian and Diocletian's forced-migration policy in the Rhine region in the late third century.[13]

If they are not *Laeti*, the *sagum* and the military equipment of the deporting soldiers might refer to their high military rank within the barbarian army.

12. RIDERLESS HORSE

Mus. Inv. No. ÇKBĞ 2009/54, Exc. Inv. No. ÇKBĞ 2009/96, TÜBİTAK No. 12, Mus. New Inv. No. 2018–13

DIMENSIONS – Height: 105, Length: 102, Thickness of the Block: 20, Depth of the Relief: 5.5, Height of the Plinth: 14.5 cm

EXTANT CONDITION – The relief panel has been restored from two pieces. The upper left corner and the horse's front left leg are missing. There is no information available on its exact find-spot.

There are traces of red paint visible on the saddle, on the bands of the harness that go around the horse's flank and girth, and on the bridle; traces of yellow paint are visible on the mane of the horse.

TECHNICAL DETAILS – Along the right end of the relief block there are crude point chisel marks extending towards the figured surface on the front of the panel, even damaging

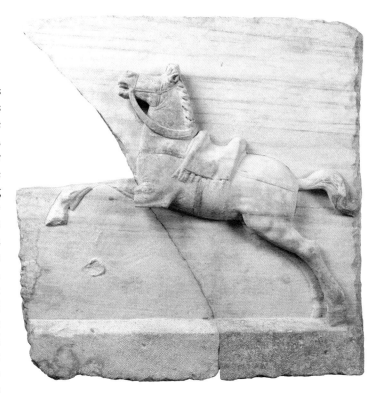

the tip of the tail of the horse and the right corner of the plinth it is standing on. Similar point chisel marks can be traced on the surviving part of the left lateral face of the panel. This suggests that the builders could not fit it in its pre-planned spot after it was carved on the ground and had to trim it quickly during the installation. There are traces of mortar on the back of the relief panel, perhaps used as a binder. It is carved in exceptionally low relief, with the horse projecting out only 5.5 cm. The plinth is not set completely perpendicular to the figured plane; its outer edge on top slightly slopes down.

TOOL MARKS – Rasp marks on the front surface of the relief where the horse is projecting out. Medium-sized claw chisel marks are clearly visible on the front and top surface of the plinth. A drill has been used for the nostril, ear, and the mane of the horse.

DESCRIPTION AND DISCUSSION – A riderless horse is shown running towards the left in left profile with its front legs reared up, mouth open, and head raised up. Its saddle has fringes and raised protrusions on the front and back to secure the rider. The saddle and harness are of the same type as those of the weary horse on **cat. no. 11** and much more modest than those of the horses of the victorious Roman imperial figures on other relief slabs. Its open mouth is suggestive of its pain and its rider has already fallen off; the horse is related to the defeated side in a battle, and thus can be connected to **cat. nos 10 and 11**. This motif of a riderless horse in battle scenes is typical in Roman art, one of the earliest and well-known examples being the riderless horse on the battle reliefs of the Aemilius Paullus Monument at Delphi, often thought to reference a historical moment in the battle at Pydna.[14]

11 Coarelli 2000, 197, plate 150.

12 See Chapter 3, p. 62.

13 Bastien 1973.

14 For the most recent and extensive discussion of Aemilius Paullus's Pydna Monument, see Taylor 2016.

along the width of the top surface of the relief block is a small carved channel, 4 cm in width. This cutting is possibly for a clamp used to connect the panel to the background. Also interesting is the head of the soldier, which is cut off with a point chisel. These marks, where the face would have been, could either be related to a repair or to a secondary use. The face of the earlier figure could have been damaged, chiselled off, and replaced by a plaster face mounted to the relief. Tooth chisel marks on the front face of the plinth form a clear contrast with the rough tool marks of the protruding side border connected to the plinth. There are rough point chisel marks on the back of the relief slab.

DESCRIPTION AND DISCUSSION – A soldier shown in left profile is striding towards the left. Most of his body is concealed by the break and the shield he is holding, but his trousers and soft shoes are visible at the bottom of the relief. He carries a spear with a sharp tip extending diagonally towards the left corner of the relief, and a large circular shield, in the middle of which is the image of Medusa wearing a winged headdress. Evidently, he is a Roman soldier.

13. A STRIDING ROMAN SOLDIER (CORNER SLAB)

TÜBİTAK No. 13, Mus. New Inv. No. 2018–14

DIMENSIONS – Height: 100, Length: 95, Thickness of the Block: 20, Depth of the Relief: 6, Height of the Plinth: 16 cm

EXTANT CONDITION – Found in the central-west section of the excavated area. Restored from two pieces with a narrow break in the middle. The soldier's head and upper body, along with the middle part of the relief slab, are chipped off.

Slight traces of red paint around the rim of the circle shield and yellow paint on the pole of the spear are visible to the naked eye.

TECHNICAL DETAILS – The relief slab is clearly meant to be a corner block within its architectural setting. Two-thirds of a thick bulky protruding border on the right front side of the relief slab (originally 15 cm in width) was cut off and flattened with a tooth chisel from the top towards the middle. The remaining third of it was left still protruding, with rough tool marks, indicating that it was not meant to be seen. This protruding section might have been concealed by a corner architectural joint. Also, a small section at the bottom of the right of the plinth is deliberately cut off to fit the block into its architectural setting. These marks suggest that there was a miscommunication between the builders and the sculptors in a rushed project, and the carving of the relief was finished after it was lifted into place. Extending

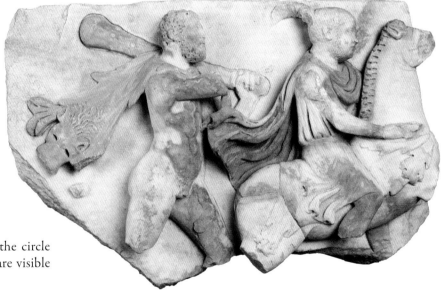

14. HERAKLES CROWNING THE EMPEROR MAXIMIAN

Mus. Inv. No. ÇKBĞ 2009/4, Exc. Inv. No. ÇKBĞ 2009/4, TÜBİTAK No. 14, Mus. New Inv. No. 2018–15

DIMENSIONS – Height: 68, Length: 105, Thickness of the Block: 21, Depth of the Relief: 10 cm

EXTANT CONDITION – Found in the south-eastern section of the excavated area, fallen vertically on its left side next to a column base. The relief block is broken on all sides except the top surface. Thus the lower legs of Herakles, of the horse, and of the emperor are missing. The left corner

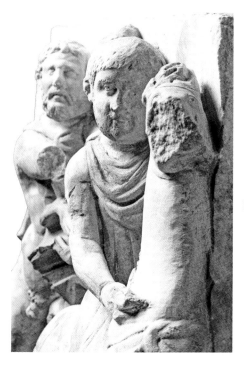 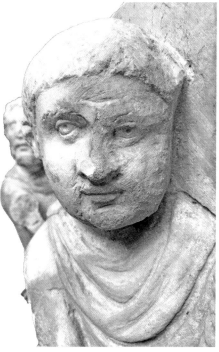 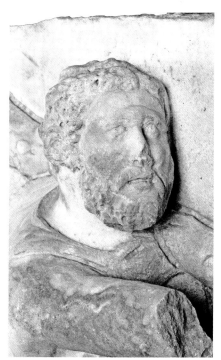

of the lion-skin cloak, the right arm of Herakles from the elbow, the wreath that Herakles is holding up over the emperor's head, the tail of the horse, the lower face of the horse, and part of its reins are also missing. There is minor chipping on the right upper arm of the emperor, on the reins he is holding, and on the nose and penis of Herakles. The breakage on the top left corner of the block is fresh.

The polychromy is well preserved on the relief. There is yellow paint on the lion-skin cloak, the club of Herakles, and the mane of the horse. A light brownish-red is preserved on the hair and beard of Herakles and on the beard of the emperor. Red is preserved on the rider's cloak, on the belt, on lower skirts of his tunic, in two bands around the right wrist of his sleeve, on his trousers, on the reins he is pulling with his right hand, and on the harness bands of the horse. Multispectral screening has revealed a large amount of a complex paint mixture containing Egyptian blue overlaying the red on the cloak indicating that it was originally painted in imperial purple.[15]

TECHNICAL DETAILS – On the top surface of the block there are two rectangular cuttings in different sizes. They are not aligned: the smaller one is closer to the figured surface and the large one is further away from the figured surface. The one on the right, aligned with the emperor's head, is a lewis hole and measures 4.5 cm × 17 cm and is 7.5 cm deep; the smaller rectangular hole aligned with Herakles' club is a clamp hole and measures 3 cm × 6 cm and 3 cm in depth. The location of the lewis cutting (for lifting) on the top surface of the panel behind the figured plane and its shallow

15 For details of the polychromy, see Chapter 2, pp. 38–41.

depth indicate that the relief panel was carved mostly on the ground and then lifted up into place; the top of the block was then trimmed down to the right height in the building. The cutting for the lewis was probably made at the centre of the top edge of the block for balanced lifting. If this is the case, the location of the lewis hole also gives us an idea about the approximate original length of the relief panel. The surviving length of the frieze panel is 105 cm, but according to the position of the lewis hole it should have been at least 150 cm in length. The thickness of the block decreases towards the top. Also on the top surface of the block is a precisely carved horizontal line dividing the surface into two rectangles; the wider rectangle is closer to the figured plane and is 8 cm in width and has rough point chisel marks, while the narrower rectangle is slightly lower and 5 cm in width. This division suggests that the block was re-carved from an earlier architectural element for secondary use.

TOOL MARKS – The outline drawn for the figure of Herakles, especially for his club and lion skin, is clearly visible. The background and the skin of the figures are cleanly finished with the use of flat chisels and rasps. A drill was used for the hair and beard of Herakles, for the irises of both figures, and for the mane and the ear of the horse. There are rough point chisel marks on the back of the relief slab.

DESCRIPTION AND DISCUSSION – Herakles and an imperial figure riding on a horse are shown in profile facing towards the right. Herakles is naked aside from his wind-blown lion-skin cloak hanging down from his right shoulder. He carries his club over his left shoulder. He has curly hair and beard and a severe expression with deeply carved

cycbrows, a deep wrinkle on his forehead, and irises set high up in the eye to give him an upward gaze. His extended lower right arm and hand are missing, but the remnants of a circular wreath right above the imperial figure's head indicate that Herakles was shown crowning this figure with his right hand.

The mounted imperial figure's short beard and full cheeks suggest that he is younger than Herakles. He wears a long-sleeved and belted knee-length tunic with two red bands around the wrist, trousers, and a cloak fastened over his left shoulder with a circular brooch. His cloak, most likely a *paludamentum* as it was originally painted in imperial purple, and a crown put on his head by Herakles suggest that the rider represents an emperor. The facial features of the emperor, especially his retroussé nose and short-cut beard, are very similar to those of the embracing co-emperor on the right on **cat. no. 16**. Besides the physical clues, the emperor's affinity with Herakles helps us identify the figure as the young Maximian. Emperor Maximian, co-ruler of the Roman Empire with Diocletian between 286–305, who appears with a distinctively retroussé nose, assumes the title *Herculius*, and is depicted being crowned by Herakles on Diarchic and early Tetrarchic coinage. Like his purple *paludamentum*, the painted bands on the wrists of the emperor's sleeved tunic also appear on other imperial figures on **cat. nos 15 and 16**.

The emperor's *paludamentum* and the lower part of his tunic are shown being blown by the wind, giving movement to the frieze. The red-coloured object he is holding in his right hand is part of the horse's reins, originally hanging down from its nose, but now chipped off. The legs and the face of the horse are broken off but the slightly raised-up frontal body suggests that it was probably shown running with its front hooves raised up and its rear legs touching the ground. The saddle on which the emperor sits is a lion skin, as the lion paws can be seen over the horse's body. The horse's bridle on its forehead and the harness bands fastened around its girth and the right buttock are also visible.

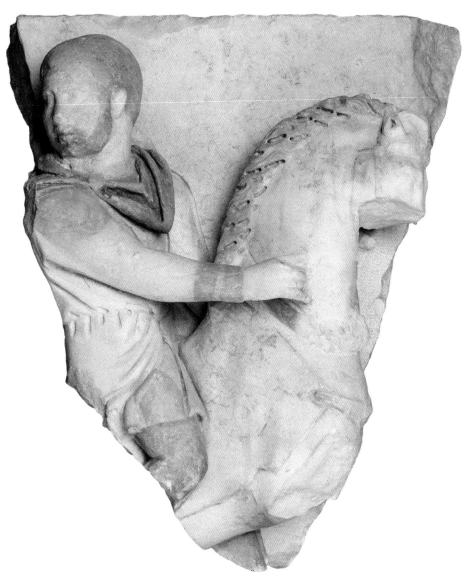

15. THE MOUNTED EMPEROR

TÜBİTAK No. 15, Museum New Inv. No. 2018–16

DIMENSIONS – Height: 59, Length: 53, Thickness of the Block: 22, Depth of the Relief: 12 cm

EXTANT CONDITION – The frieze slab is broken on all sides; only part of the top surface of the block remains. The rider's back, along with the back of his *sagum*, his right lower leg, and the horse's lower face and legs are all chipped off along with the rest of the relief block. There is no information available on its exact find-spot.

Yellow paint is used for the mane of the horse and the sleeved tunic of the rider, as can be seen on his right shoulder in two bands around his wrist, and on the skirt of his tunic. Tones of red colour are visible on the rider's cloak, trousers, hair and beard, and on bands of the bridle and saddle of the horse. The multispectral screening has revealed paint containing Egyptian blue on the cloak, suggesting that it was originally not red but purple, thus perhaps an imperial *paludamentum*.

TECHNICAL DETAILS – The relief is carved from a thick slab (22 cm). On the back of the slab, over the rough quarry-pick marks, traces of a painted sign in red are visible. The sign might have consisted of several letters, now

all faded; the visible part seems to be two letters, perhaps a Pi (with a superimposed dot) and an Iota. The sign might refer to the workshop or to the intended location of the slab within the building. Under the chin of the imperial rider, there is a crude area left unfinished by the sculptor, indicative of his speedy work and his heavy reliance on painting for the details of the frieze. Indeed, although he used a drill for the rendering of the horse's mane and the folds of the rider's belted tunic, the sculptor did not use any detailed chiselling tool for the hair and the beard of the riding emperor, but merely painted them onto the face. Other

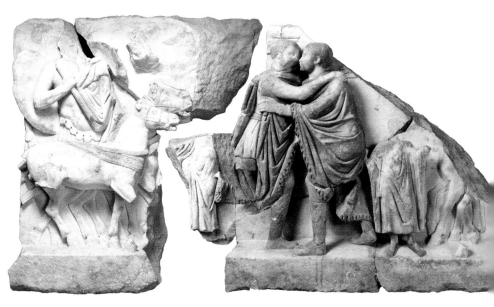

tool marks visible on the relief include point chisel marks on the top surface; tooth chisel marks on the background below the horse's broken face, and around the rider's head; with flat chisels and rasps for the backgrounds and skins of the figures on the front surface. The outline that was initially made to carve out the emperor is also visible around his left arm.

DESCRIPTION AND DISCUSSION – The broken slab still retains a mounted imperial figure clad in a sleeved tunic belted at the waist, trousers, and a *paludamentum* fastened with a circular brooch over his right shoulder. He has short brownish-red hair and beard. Although the horse's direction is towards the right, the riding figure's head is sharply turned back, as if alerted by an alarm coming from behind. The folds on the lower skirts of his tunic appear windblown towards the left; perhaps the back of his *paludamentum* (now missing) appeared in the same windblown manner, just as the clothing of the riders on **cat. nos 10 and 14**. His extended right arm holds the horse's reins, the red-coloured straps of which are visible on the animal's forehead and neck. The lower part of the horse's head is missing, but the yellow mane, the forehead, the right eye, and the ear are visible. The riding figure is seated on a leather saddle fastened with a strap going around the animal's breast. The strap band is attached to the saddle through a circular perforation on the right corner of the saddle. The rider's left leg (with trousers in red) is also visible. The *paludamentum*, which was originally painted in imperial purple, as well as the golden bands around the wrist of his sleeved tunic, and his short-cut brownish-red hair and beard are all similar to the emperors depicted on **cat. nos 10, 14, and 16**, suggesting that he too is an emperor.

16. THE EMBRACE OF THE EMPERORS IN AN *ADVENTUS* SCENE

The left side with the horses: Mus. Inv. No. ÇKBĞ 2009/20, Exc. Inv. No. ÇKBĞ 2009/41, TÜBİTAK No. 16, Mus. New Inv. No. 2018–21, the head of the emperor on the left and its background: Mus. Inv. No. ÇKBĞ 2009/15, Exc. Inv. No. ÇKBĞ 2009/29, the middle part with the embracing emperors including two diminutive figures on their sides: Mus. Inv. No. ÇKBĞ 2009/21, Exc. Inv. No. ÇKBĞ 2009/42, the diminutive figure on the left: TÜBİTAK No. 17, Mus. New Inv. No. 2018–18, the embracing emperors and the chariot on the right, excluding the diminutive figure on the left: TÜBİTAK No. 18, Mus. New Inv. No. 2018–17, chariot on the right alone: Mus. Inv. No. ÇKBĞ 2009/22, Exc. Inv. No ÇKBĞ 2009/43.

DIMENSIONS – Height: 104, Length: 270, Thickness of the Block: 30, Depth of the Relief: 13, Height of the Plinth: 14 cm

EXTANT CONDITION – Parts of the relief panel were found scattered on the western and central sections of the excavated area; some pieces (like the head of the emperor on the left) came from the mixed-up dirt mound on the southwestern part of the area. The panel has been assembled from ten main fragments. Two pieces are still separate: the left side of the relief with the armoured figure and horses, and a small piece with a diminutive figure pulling the reins of the horses. The other surviving parts have been joined. The left section of the original relief block, which would have contained an imperial chariot pulled by the horses and a standing figure holding a shield (since the outside of the oval shield is visible behind the right arm of the armoured figure), is missing. Despite the missing left section, this relief is the longest surviving block (2.7 m) among all the surviving relief blocks of the Nicomedia frieze. Judging by the composition and also by the location of the lewis hole at the centre

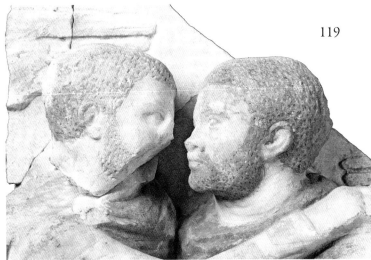

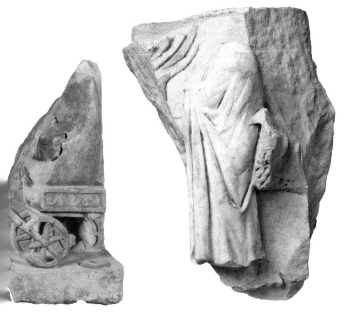

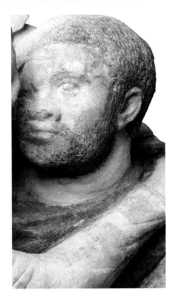

top surface, the original length must have been about 4 m. Besides the missing left section, the head of the armoured figure (probably a lictor), the front legs of the horses pulling the ceremonial chariot on the left, the head and feet of the diminutive figure controlling the reins, and the part of the plinth below his feet are missing. In the middle, the lower face, the right leg of the emperor on the left and parts of his *paludamentum* (behind his shoulder, behind his hip and the part on his right leg) are missing. His lower left leg, the lower part of his torso (the section between his belt and the right arm), and his head have been restored. The side of his right hand along with his little finger is chipped off. Only the left wing of the Victory hovering above his head is visible. The complete body of the Victory is missing, but the tip of her right wing is visible above the heads of the horses on the left. The left hand and the left leg of the other embracing emperor on the right have been restored, and a fringed section from his *paludamentum* between his legs is missing. There is a small chipped area on the back of his head. Only the right wing of another Victory behind his head is visible. The head and both hands of the frontal diminutive figure on the right are missing. The heads and bodies of the horses of the chariot and the upper body of a figure, perhaps another military guard, whose foot is visible in between the horses' hooves, are missing. The front wheel of the chariot and the seat have been restored. Several other small broken pieces belonging to the rear wheel or the wheels of the other chariot on the left (now missing) have been found (see the smaller frieze fragments catalogue).

The traces of ancient paint visible to the naked eye on the relief include different shades of red on the ceremonial harness of the horse on the left; on the outer border of the shield behind the armoured figure; on the hair and beards of the embracing emperors; on their *paludamenta*, trousers, belt, and shoes; on the shoes of the diminutive figure on the right; and on the seat and box of the horse chariot. Blue paint is still visible on the wings of the Victories behind the heads of the emperors. Tones of yellow can be traced on the horse's mane; on the large stick (possibly a *fasces*) the armoured figure is holding; on the hem, shoulder, and two wristbands of the tunic of the

emperor on the left; on the double wristbands of the tunic of the emperor on the right and on two horizontal bands on the lower left leg of his trousers. The chariot's wheels are also painted in yellow. The two lines of paint drips in red are visible on the front face of the plinth under the feet of the emperor on the right. Initial multispectral and microscopic screening and pXRF analysis have revealed that the *paludamenta* of the emperors were painted in imperial purple through the application of a large amount of Egyptian blue and a thin layer of organic pink colourant over red paint. The ultraviolet (UV) analysis also revealed the isolated remains of organic pink on the neck of the emperor on the right, suggesting that a pinkish flesh colour might have been used for the imperial figures' skin. Furthermore, technical analysis has been used to test the different shades of red paint used to differentiate the hair of both emperors; brownish grey for the emperor on the left, and a brighter tone of red for the one on the right. Visible-induced luminescence (VIL) imaging of the heads of the emperors has shown differences in the application of paint layers, particularly in the use of Egyptian blue, while pXRF has revealed different proportions of elements in the composition of pigments used for the heads.

TECHNICAL DETAILS – Above the heads of the embracing emperors on the top surface of the relief block, the right side of a cutting for a lewis (about 3 cm in width and 2 cm in depth) survives. The full extent of its width along with its left end are completely broken. Its central location on the top surface behind the figured plane indicates that most of the relief was carved on the ground and then lifted up into place. The shallow depth of the cutting, however, indicates that this is the bottom of the lewis hole, and the top part of it was cut down to fit the panel into the architecture. Thus at least the top part of the relief seems to have been shaped on the building. Another partially preserved cutting on the top of the relief block, above the head of the armoured figure on the left, extends towards the back of the relief. This larger cutting (about 16 cm in length and 3 cm in width) is broken

towards the back of the relief but could have been the remnants of an architectural join, securing the panel to the back wall of its architectural setting.

The right lateral face of the relief block (directly behind the chariot) is finished with claw chisels. Both the background of the figures on the front of the relief panel and the upper surface of the plinth on which the figures stand are cleanly finished with a flat chisel and rasps. The front surface of the plinth, however, shows claw chisel marks consistently applied diagonally from right to left, leaving a textured but finished look. A drill, flat chisels, and several smaller chisels were used for various details such as folds of drapery and facial features. The corner of the flat chisel was used to incise the lines of stubble and short hair of the embracing emperors. Rough quarry-pick marks and traces of mortar are visible on the back of the relief block.

DESCRIPTION AND DISCUSSION – The relief panel seems to represent the culmination of an *adventus* (imperial entrance into a city) procession approaching from both left and right. The procession ends at the centre of the block with the embrace of the two emperors, who appear reaching towards each other, having just descended from their ceremonial chariots.

On the far right is a four-wheeled ceremonial chariot with gold-coloured, six-spoked wheels, the beginnings of the chariot pole, and a box with elaborately carved floral designs supporting a throne-like seat (a *cathedra*). Although the colour of the chariot appears red to the naked eye, VIL analysis has detected a large amount of Egyptian blue, indicating that it was originally painted in imperial purple. The portion of the relief that depicted the full extent of the pole of the ceremonial chariot is missing, but the adjoining fragment shows the forequarters of a horse, traces of eight additional legs and hooves of horses, and the leg of a man wearing trousers. The presence of at least three horses indicates that the chariot is a *quadriga*. A headless, diminutive figure leads the chariot, depicted frontally wearing a long cloak covering all of his body and arms, tight trousers, and red shoes. Perhaps he held the reins of the horses with the missing hand of his raised left arm. Immediately to the left of this figure are the central figures of the two embracing emperors. The two are clad in similar imperial clothes: long-sleeved tunics with gold bands at the shoulder and at the hem (visible on the figure on the left) and also at the wrist (visible on both), red trousers with horizontal gold bands (visible on the figure on the right), closed soft leather shoes in red (visible on both), red belts (visible on the figure on

the left), and elaborate fringed *paludamenta* with V-shaped folds, fastened with a brooch over the right shoulder. As mentioned above, the UV and VIL analyses on the *paludamenta* have shown that they were brightly coloured in purple. The emperor on the left is slightly taller than the one on the right. Now-lost flying Victories with blue-coloured wings hovered beside their heads; the preserved part of the wing of the Victory on the left is much higher than the one on the right. (As explained in Chapter 3, the preserved tips of two blue-coloured wings on either side, could have also belonged to *aquillae* (eagle-topped standards for Roman legions), but within this imperial context they are identified as the wings of Victories.) Although the lower part of the face of the emperor on the left is missing, both figures have the short, military hair and beard styles typical of the later third century; stippling across the surface of the marble creates a buzz-cut effect. Both figures have rounded heads and thick necks, but the retroussé nose of the figure on the right and the wider eye sockets of the figure on the left seem distinctive. The most conspicuous difference, however, is the hair colour of the two figures: the hair of the taller emperor now has a light grey-brown hue while the hair of his counterpart is reddish.

On a smaller fragment, to the left, behind the taller emperor, is another diminutive figure holding the reins of horses. The figure is clad in a cloak which covers most of its body and arms. The cloak is attached to the corner of the taller emperor's fringed *paludamentum*. The two large fragments from the left side of the relief panel display the four horses of a ceremonial *quadriga*, part of the right wing of the Victory hovering above the head of the emperor on the left, and a military guard. The guard's head and left arm are broken off. The inner part of a shield he once held in his left hand is partially preserved above his left shoulder. He stands behind the horses, and his legs are not depicted. He wears a body cuirass (*lorica*) ending with six semicircular embellishments and a military skirt of leather lappets (*pteryges*), of which seven are visible. He also wears a cloak thrown over his left shoulder. The thick yellow stick he carries in the right hand is probably *fasces*, which help us identify him as a lictor (imperial bodyguard). Only the horse in the foreground is shown in full profile, walking towards the right; the other three horses are depicted as overlapping heads and hooves. The harness strapped against the right flank of this horse is a ceremonial one, consisting of a wide red band with floral designs and three tassels that hang down; one tassel in the middle has an image of Medusa attached. Two poles (broken) emerge behind the horses and extend towards the left, where they would have connected with a second imperial chariot, now lost. The back of another oval shield, fully preserved behind the right arm of the lictor, indicates the existence of another military figure next to the lictor, now lost.

At the centre of the relief panel the distinctive 'Tetrarchic embrace', a motif popularly known from the porphyry embracing portraits of tetrarchs in Venice and the Vatican, helps us identify the embracing figures as two of the tetrarchs.[16] As is typical of late third-century imperial portraiture, both emperors have short military beards and hairstyles that were stippled across the surface of the marble for a buzz-cut effect. Their imperial attire, as well as their entourage in the procession, look almost identical at first glance. Indeed, the formulaic and nearly identical representations of the co-emperors are typical of the Tetrarchic period. This change towards abstraction and symmetry in imperial representations is often seen as a reflection of the new tetrarchic political ideology which propagated the harmony, similarity, and brotherhood between the co-emperors despite their lack of familial kinship.[17] This stylistic change in imperial portraiture seems to have evolved slowly, as in early Diarchic representations on coinage, Diocletian and Maximian still retain their individualistic facial features: bulging cheekbones and deep eye sockets for Diocletian, retroussé nose for Maximian.[18] On the slightly later sculptural examples, especially in the case of the porphyry statues of embracing tetrarchs mentioned above, it becomes almost impossible to differentiate the co-rulers in their physical appearance. On the Nicomedia frieze, however, unlike in the porphyry parallels, it is possible to distinguish the identities of the co-emperors using the individual physiognomic features of their portraits and the hierarchical cues in the composition of the panel. Diocletian, the senior figure on the left with greyish hair and deep eye sockets, is slightly taller than Maximian, who has reddish hair and a retroussé nose, and his Victory (to judge from the position of her wing) is also set at a higher level than that of his counterpart.

Similar representations of tetrarchic hierarchy can be seen on other contemporary examples.[19] Among the enthroned tetrarchs on the north face of the south pier of the Arch of Galerius in Greece, Diocletian's pronounced frontality and hand gesture imply his status as the leader of the four.[20] Similarly, in the over-life-sized frescoes of the nimbate tetrarchs on the south wall niche of the cult room at Luxor, Diocletian holds a sceptre and a globe as signs of his prime authority granted by Jupiter.[21] Overall, the meeting of Emperor Diocletian with his co-ruling Emperor Maximian on this relief seems to be one of the earliest examples of diarchic propaganda in the late third century. The motif of the

intimate imperial embrace first seen on the Nicomedia relief should be considered as the forerunner of the more generic 'Tetrarchic embrace' which later became the hallmark of Tetrarchic art.

The similarity of the co-emperors on the Nicomedia frieze applies to their imperial presence but not to their individual portraits. They both appear unarmed (possibly because they both have lictors protecting them) wearing the purple imperial *paludamentum*. Besides this specific cloak, their ceremonial costume includes tunics and trousers with golden bands (made with paint). Similar purple *paludamenta* and double yellow or red armbands on the dress of the imperial figures on **cat. nos 14, 15**, and perhaps **10** in the Nicomedia frieze indicate that those panels also portray tetrarchic emperors.

The iconographic details of the relief panel exhibit many parallels with contemporary *adventus* depictions on state reliefs and frescoes.[22] Yet the emphasis in the Nicomedia relief seems to be on the meeting of the emperors rather than on their entry into a city.[23] Located at the centre of a larger *adventus* procession shown on other relief panels (see **cat. nos 17 and 18**) and as the longest of all surviving relief panels of the Nicomedia frieze (originally approximately 4 m in length), this panel must have had a central position within the overall frieze.

17. GENIUS OF THE ROMAN PEOPLE?, GODDESS ROMA?, VICTORY, AND TOGATE ROMANS

Mus. Inv. No. ÇKBĞ 2001/2, Exc. Inv. No. ÇKBĞ/2001/3 (A), TÜBİTAK No. 22

DIMENSIONS – Height: 101.5, Length: 99, Thickness of the Block: 17, Depth of the Relief: 9, Height of the Plinth: 16 cm

EXTANT CONDITION – The partially preserved relief panel was found during 2001 rescue excavations on the north-eastern side of the excavated area. It was initially published by Zeyrek and Özbay.[24] It is the left side of a longer relief panel, with its left side-end still preserved. The complete right side and the upper left corner of the relief, where the head and the upper body of a standing figure holding a cornucopia would have been, are missing. The lower part of the cornucopia and the right arm of the small Victory are missing.

Shades of yellow paint are visible on the cornucopia that the standing figure on the left is holding; on the dress, spear,

16 See the full discussion of the 'Tetrarchic embrace' in Şare Ağtürk 2018.

17 L'Orange 1972; Rees 1993; 2002; Smith 1997.

18 Şare Ağtürk 2018; Smith 1997.

19 Rees 1993, 186.

20 Rothman 1977, 444; Rees 1993, 186–87.

21 McFadden 2015, 129–32.

22 For *adventus* scenes, see Koeppel 1969.

23 For comparison, see Chapter 3, p. 56.

24 Zeyrek and Özbay 2006, 293–94, Abb. 10a.

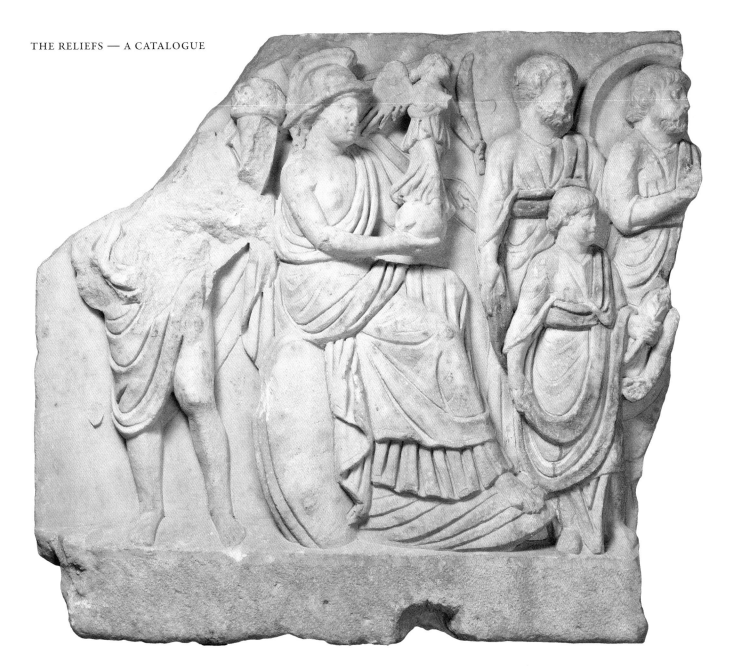

and helmet of the goddess Roma; on the wings and dress of the small Victory as well as the leaf she is holding; and on the hair and beard of the Roman civilian at the far right (E), where the panel is broken. Shades of red paint are preserved on the hair of Roma, on the hair and the beard of the Roman civilian next to her (D), and on the bands of the togas of all the Roman civilians. Egyptian blue traced through VIL imaging on the red-looking bands (*latus clavus*) on the edges of the togas indicates that the bands were actually painted in purple.

TECHNICAL DETAILS – The relief panel is narrower in width compared to most of the blocks (17 cm at the widest point) and it starts tapering closer to the top. The cutting on the left corner of the plinth indicates that this part of the relief is shaved off later on the building to fit the panel in its architectural setting. Another semicircular cutting (about 9 cm in length) on the front of the plinth, extends towards the bottom of the relief. It seems to have been opened up also for an architectural join (perhaps a beam) below the panel. The back of the plinth to the left of this semicircular cutting has also been chiselled off, forming a concave abrasion. All of these marks indicate that the builders had some issues fitting the block into its architectural setting and had to recut it on the building, especially the bottom of the relief.

All of the cuttings mentioned above have point chisel marks. The back of the panel has rough quarry-pick marks. On the front surface of the plinth, marks of two different tools can be traced; the top section of the front of the plinth, starting right below the feet of the figures and extending about 3–4 cm, was smoothed with flat chisels, while the rest of the plinth was left rough with claw chisel marks. The initial deep outlining of the figures with a drill is still visible on the background, especially around the left hand of

the goddess Roma. Flat chisels and rasps were used for the smoothing of the background as well as the faces and bodies of the figures.

DESCRIPTION AND DISCUSSION – The relief displays divinities and togate Roman civilians in a procession directed towards an arch on the right. On the far left of the relief panel, the lower body of a frontal figure holding a cornucopia in the left hand is preserved. The stick-like object the figure held in the right hand is missing, but a strut that once supported it is visible next to his right knee. The figure wears only a hip-mantle, the edge of which seems to be thrown over his missing right arm. He might be a representation of the Genius of the Roman People (*Genius Populi Romani*) since, unlike the togate Genius of the Roman Senate, the Genius of the Roman People usually appears half-draped, wearing only the hip-mantle in his depictions in Rome.[25] Next to him is the armed goddess Roma, sitting on three overlapping shields and holding a small Victory on a globe in her right hand and a spear in her left hand. Clad in a crested helmet, an undergarment, a chiton, and a himation she rests her bare feet on a stepped platform. Even though one can see the hems of her long dress painted in yellow, there are no remnants of paint for the top part of the undergarment or the chiton and it looks as if her one breast is exposed through her himation, just like the representations of Virtus (goddess of military virtue). Indeed, an alternative identification for this figure could be Virtus, and the figure holding the cornucopia could be Honos (personification of military honour). With their very similar iconography, these two gods are usually mistaken for the *Genius Populi Romani* and Roma, but Virtus is usually shown standing, not seated on shields like the figure on the Nicomedia relief.[26] Furthermore, the top part and the sleeve of the chiton might have originally contained paint, which has not survived to the present day.

In front of the goddess, Romans wearing the imperial toga — two bearded adults and at least one child — advance towards an arched structure at the upper right of the relief. The extended right arm of the small Victory standing on the globe is missing from the elbow, but the circular chipping on the head of the togate figure (D) in front of her suggests that she may have appeared as crowning him. The other bearded togate figure (E) appears to have already entered through the arch. His body is partially preserved but he might have been holding something in his bent right arm. In front of the bearded adults there is a smaller togate boy (F) holding the band of his toga in his right hand and a branch in his left. Only the right arm of another child (G) in front of him is preserved on the broken right side of the panel. The togas

that all of the figures wear can be classified as *togae praetextae*, with purplish border bands (*lati clavi*), indicating the high rank of the wearers.[27] As is typical of the early imperial togas, the large togas are draped around the body such that they form U-shaped folds (*sinus*) hanging over the right leg, a tighter set of folds around the waist (*balteus*), and a further clump of folds over the chest (*umbo*) pulled from a lower level. The presence of children among the togate civilians and the crowning of one of the togate adults (D) by the Victory makes it more likely that these togate figures in the procession are the leading members of the imperial family or imperial court rather than the members of the Roman Senate. One far-off possibility is that the two bearded men refer to the new Caesars: Constantius I and Galerius, and one of the children refers to a young Constantine as Constantius's future heir. However, in the absence of any iconographic evidence, it is hard to make such an identification.

Overall, the style of the relief seems formulaic, with rather stiff figures with disproportionately large heads. Distinguished by his small size and clean-shaven face, the togate child at the front almost looks like a miniature adult. The small Victory's left wing is not carved at all, and her right wing and facial features are rendered rather crudely, almost in an impressionistic manner without any detailed carving. The artist seems to have employed hierarchical scale between the divinities and the civilians, as the seated goddess would dwarf the togate civilians when standing.

This panel may have been situated to the left of the relief panel with the embrace of the co-emperors, behind Diocletian's entourage (**cat. no. 16**), forming the starting point of a procession leading to the meeting of the two emperors. If this is the case, the architectural element (the arch) on the right side of the relief panel could be a reference to the city in which this *adventus* procession and the meeting of the co-emperors are taking place. The possible existence of the goddess Roma on the panel, however, is not enough to identify the city as Rome. She probably represents the Roman *imperium* itself, just as on the reliefs of the Arch of Galerius, in which Galerius appears accompanied by Roma when meeting with the Persian delegation on his eastern expedition.[28] There is not a single recorded meeting of the co-emperors in Nicomedia in literature (as they were constantly on military duty in remote parts of the empire).[29] Yet, the scene is better understood as a metaphoric *adventus* of the diarchs, whose initial co-rule was declared in 286 in Nicomedia and transformed into the Tetrarchy with the inclusion of two Caesars in 293, again in Nicomedia.

25 Kunckel 1974, 49, 52.

26 Bieber 1945.

27 Cleland, Davies, and Llewellyn-Jones 2007, 189–92.

28 Rothman 1977, 453.

29 Barnes 1982, 31–32; also see the discussion in Şare Ağtürk 2018, 422.

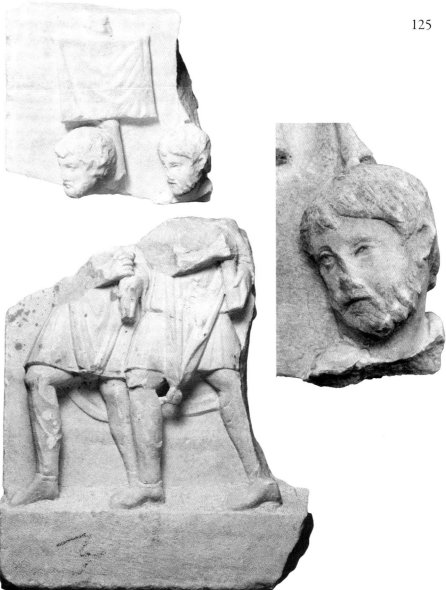

18. STANDARD-BEARERS (*VEXILLARII*)

Bottom part with legs: Mus. Inv. No. ÇKBĞ 2001/15, Exc. Inv. No. ÇKBĞ 2001/4, top part with heads: Mus. New Inv. No. 2018–83, top and bottom parts together: TÜBİTAK No. 24

DIMENSIONS – Height: *c.* 102, Length: 60, Thickness of the Block: 16, Depth of the Relief: 8, Height of the Plinth: 15 cm

EXTANT CONDITION – Surviving left side of a larger relief panel consists of two fragments; the fragment on top was found in the 2001 excavation from the north-east of the site,[30] and the bottom fragment was found in the 2009 rescue excavation. There is no information available on the exact find-spot of the bottom fragment. The middle section between the two fragments and the right side of the relief, where more standard-bearers must have been depicted, are missing. The absence of the middle section between the two fragments has prevented the restoration.

Shades of red are visible on the hair and the beards of the figures and a hue of yellow is preserved on the pole of the banner.

TECHNICAL DETAILS – Two types of tool marks are visible on the bottom of the relief panel: rough point chisel marks towards the back plane and claw chisel marks towards the figured plane where the panel had an architectural join

indicate a rough-form anathyrosis. The back of the panel has rough quarry-pick marks. The faces and the background of the figures were finished with flat chisels and rasps. A drill was used for the outlining of the figures, for the folds of the drapery, and the irises in the eyes. The plinth carries fine claw chisel marks applied vertically on the top of the plinth on which the figures stand, and applied diagonally on the front of the plinth.

DESCRIPTION AND DISCUSSION – Three standard-bearers directed towards the left in a processional scene can be detected on the surviving relief. The heads and lower bodies of two figures and the left foot of a third figure on the right have been preserved. Both figures have short hair and beards painted in brownish-red. They each wear a knee-length belted tunic, trousers tucked into their soft shoes, and a distinctive cloak fastened with a brooch over the right shoulder. On the front of the body, one corner of the cloak falls in between the two legs in a triangle-shaped overfold with a pompon at the end. The oval edge of the cloak falls behind the figures, indicated with two semicircular bands

[30] Zeyrek and Özbay 2006, 295, Abb. 11.

behind the knees on the background of the relief. The figures appear striding towards their right with their left legs shown in left profile, their right legs and upper bodies frontal, and their heads in three-quarter view. They carry a long pole with a circular knob-like tip and a rectangular banner attached right below the tip, perhaps a *vexillum*, a military standard displaying the name and emblem of the legion. V-shaped folds on the banner indicate that it is made of textile. Multispectral imaging for the lost pigments has not revealed any traces of a painted inscription or emblem on the banner. The figures support the weight of the standards with both hands; the left hand lifts the stick up from the bottom, while the bent right arm reaches across to support the weight. Surviving fragments of two other left hands holding poles in the same manner (Appendix I, SRF 16 and 17) from the Nicomedia frieze most probably belonged to the two other standard-bearers on the missing right side of the relief. This relief also might have been part of the *adventus* procession. If so, the direction of the figures indicates that they were part of the entourage behind Emperor Maximian on **cat. no. 16**.

19. FRAGMENT WITH THE LOWER BODY OF A ROMAN SOLDIER?

TÜBİTAK No. 25, Mus. New Inv. No. 2018–23

DIMENSIONS – Height: 57, Length: 52, Thickness of the Block: 15, Depth of the Relief: 5, Height of the Plinth: 15 cm

EXTANT CONDITION – Found in the north-western corner of the site, next to **cat. no. 9** during the 2009 rescue excavations, this is a smaller fragment from a larger relief panel with only the lower body of a figure and the tip of a round object on the right preserved. The right foot from the knee down and the part of the plinth on which it rested are missing.

Traces of red paint are visible on the ankle of the left foot.

TECHNICAL DETAILS – The relief is carved unusually low, with the plinth projecting only 5 cm out. A drill was used for the outlining of the figure; the background was finished with fine claw chisels and rasps. The front surface of the plinth has been smoothly finished with rasps and polished with abrasives. This fine level of finishing for the plinth appears also on **cat. nos 6, 32, and 33**.

DESCRIPTION AND DISCUSSION – The fragmentary relief has the lower body of a figure shown in right profile (with a frontally shown left leg), walking towards the right. The figure wears a knee-length tunic and trousers tucked into soft shoes. There is no trace of a standard on the sur-

viving fragment; however, the distinctive cloak with a pompon-edged triangular overfold hanging in between the legs also appears on the standard-bearers of **cat. no. 18**. The pose of this figure may also connect it to the similar poses of these *vexillarii* on **cat. no. 18**. The circular object on the right corner of the relief might be the bottom tip of a shield. Also on the right corner, above the plinth, the outline of another object, perhaps a sword, is visible. The fragment could belong to another processional scene of triumphant legions directed towards the right, thus forming a counterpart of the *vexillarii* on **cat. no. 18** who are directed towards the left.

20. EMPEROR AND THE VICTORY

Exc. Inv. No. ÇKBĞ 2009/54, TÜBİTAK No. 19, unrestored fragment with the tip of Victory's wing on the right: TÜBİTAK No. 64, Mus. New Inv. No. 2018–58

DIMENSIONS – Height: 95, Length: 78, Thickness of the Block: 19, Depth of the Relief: 9 cm

EXTANT CONDITION – The relief panel is broken at the bottom and on both sides. It was found fallen on the opus sectile floor, with its figured side facing up at the centre of the excavation area in 2009. It was stolen immediately after its discovery. Restorers at the art dealer where this smuggled relief was put up for auction inserted two metal bars into the bottom to lift the panel up, and the other ends of the bars were inserted in a modern artificial base for display. Both of the emperor's legs are broken from the knees. His left lower leg, which was left on site when the relief panel was stolen, was found in the museum depot and rejoined to the rest of the emperor after the panel was returned to

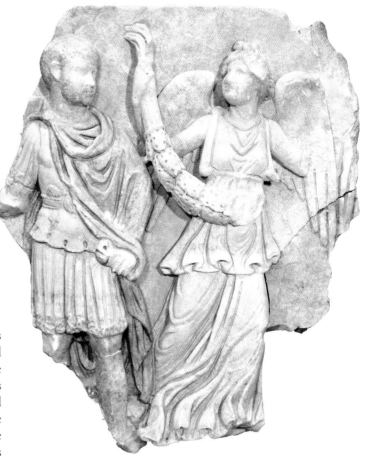

Kocaeli Archaeology Museum. Two other broken fragments from the bottom right of the relief panel were also found in the museum depot and can be rejoined to the panel: one with the tip of Victory's left wing and the drapery folds of a figure next to Victory, and a piece of the background from below the tip of the wing. The modern artificial base and the inserted metal bars, however, have complicated the actual restoration of these fragments so far. The emperor's right arm is missing from below his bent elbow. The rest of a yellow object (perhaps the rim of a shield) extending from behind the emperor's nape is completely missing. The excessive folded drapery that the emperor holds in his left hand is slightly chipped off. There is chipping on Victory's hair above the left cheek. The right side of the garland she holds is also chipped off. Her feet are missing. Her left forearm is missing from the elbow. There is minor chipping on her left knee.

Tones of red are visible on the hair, beard, belt (*cingulum*), *paludamentum*, and trousers of the emperor; as well as on the horizontal painted lines on the lappets of his kilt (*pteryges*), above the fringes. Red paint is also clear on the drapery folds of the right shoulder of the missing figure on the right of the panel as well as on Victory's belt, the brooch on her right shoulder, and as horizontal decorative bands on the hems of her skirt below and on the overfold over her thighs. Remnants of cinnabar can still be observed on the emperor's and Victory's lips. Yellow is visible on the object behind the emperor's nape, on the fringes of the protective flaps of his armour on the kilt and over the arm, and on the semicircular embellishments of the cuirass, perhaps imitating gilding. Victory's hair and the garland she is holding are also painted in yellow. Small vestiges of purple can still be seen on the folds of the *paludamentum* behind the emperor's legs and on the folds of the drapery of the missing figure on the right of the panel. Microscopic imaging revealed Egyptian blue preserved on several parts of both cloaks (of the emperor's and the other missing figure's) suggesting that the well-preserved red is just a primer of a complex multilayered painting. There is a purple drip line behind the left leg of the emperor, on the front surface of the panel. Microscopic analysis also showed traces of black used for the details of the emperor's eyes.

TECHNICAL DETAILS – The lewis hole above the head of the Victory on the top surface of the panel measures 20 cm in length, 2.5 cm in width, and 7.5 cm in depth. The right wall of the lewis cutting slants inwards approximately 1.5 cm at the bottom. The centre of the lewis hole is aligned with the head of the Victory, indicating that she was possibly at the centre of the composition, as lewis holes are usually cut at the centre of the marble block for balanced lifting. At the right end of the lewis hole there is another cutting, 4 cm in length, which extends along the width of the block from the front plane above the left wing of Victory towards the back of the block. This channel-like cutting could have been used for fitting the block to its architectural setting. A very similar cutting on the top surface of **cat. no. 13** extends along the width of the block. The sculptural rendering of the faces is rather crude with details left to paint. Patches of paint on the background plane overflow from the outline of the emperor's dress, and a dripped line of paint behind his left leg indicate that the paint was applied hastily with a thick brush when the panel was in the upright position, possibly after its installation within the architecture.

TOOL MARKS – A drill has been used for outlining the figures and also for the folds of the drapery and the decorative details of the garland. The emperor's hair and beard

have been chiselled with the tip of a small chisel to give a buzz-cut effect. The same technique was used for the carving of the feathers of Victory's wings. Rasps and flat chisels were used for the background of the figures. Rough point chisel marks on the top surface of the panel and the depth of the lewis hole indicate that the top part of the panel was trimmed down by at least a few centimetres, as the original average depth of lewis cuttings ranges from 10–12 cm for secure lifting. Also, point chisel marks on the back wall of the lewis hole towards the back plane of the relief panel suggest that this part of the original lewis hole was further cut to be used in the joining system, during the installation into the architecture, thus converted into a clamp cutting. Rough quarry-pick marks are still visible on the back of the marble block.

DESCRIPTION AND DISCUSSION – An imperial figure on the left stands frontally, with his head turned towards the viewer's right, facing a garland-bearing Victory. The facial features and the outfit of the imperial figure indicate that he is in fact the emperor. He wears a long *paludamentum* painted in imperial purple and fastened with a brooch over his right shoulder. He holds the excessive fold of the *paludamentum* in the left hand. Underneath his *paludamentum*, the emperor appears in full body armour and trousers. His cuirass ends with five yellow semicircular embellishments over the hips. The fringed ends of his *pteryges*, which consist of eleven flaps for the kilt and four arm lappets (originally attached to a jerkin worn underneath the cuirass, but unseen on the relief), are also painted in yellow, possibly in imitation of gilded metal. Over his cuirass, wrapped around his waist, the emperor also wears a thick military belt (*cingulum*). The *cingulum*, which has a round knot over the navel, is elaborately tied at the front, with one excessively long end tucked over the belt again and hanging over the right hip. The emperor's right elbow is bent, indicating that it extended towards the left and that the missing right hand was holding something. If the yellow round object extending behind his right shoulder was actually the rim of a (now missing) shield, then he might have appeared holding the handle of a shield in his right hand. The emperor has the typical late third-century short beard and hairstyle that were stippled across the surface of the marble for a buzz-cut effect. He has a round head and a retroussé nose. His gaze is directed towards Victory, who appears striding towards the right, but with her head tilted up and sharply turned to the left, looking back at the emperor. She wears a chiton with a long overfold fastened with a brooch over her right shoulder and with a rope tied around her body right underneath her breasts in a typical Hellenistic manner.[31] The tightening of

the rope forms *kolpoi* on the sides of her breasts. The hems of her dress (both above the ankles and on the overfold) respond to her movement, as the folds appear to be blown in the air. Both her pose and her dress are very similar to that of Medea on **cat. no. 25**. Her blonde hair has a bow-knot above the forehead and also a bun over the nape. She has a round face with a big rough nose, details of which are defined with paint rather than with carving. Two large wings in low relief appear spread-open behind her shoulders. She appears holding the tips of a large garland painted in yellow with both hands; the right part of the garland and her left lower arm are missing, but on the *kolpos*, below the left breast, one can still see part of the strut that once supported the garland extending towards the right. Next to Victory's left wing, the outline of a shoulder with three vertical folds of drapery extending down is preserved. This drapery is rendered in high relief and painted in imperial purple, suggesting the existence of another imperial figure, perhaps wearing a *paludamentum*, at the missing right side of the panel. Indeed, the lewis hole cut just above the head of Victory on the top surface of the panel implies that she was at the centre of the composition. She might have been flanked by two emperors, one on each side. Despite the overall lack of refined interest in carving individual portraits with physiological details on the frieze, the retroussé nose and round face of the emperor on this panel are similar to the facial features of the young Maximian on **cat. no. 14**. The almost fully preserved emperor on the left, then, might have been Maximian, with Diocletian shown on the other side of Victory. Within the Nicomedia frieze this is the only relief which shows the emperor in military costume. The scene might refer to a *profectio* scene (ceremonial departure of the emperor(s) for war), with Victory alluding to future triumphs. According to the literary tradition, in a real-life *adventus* (triumphant entry of the emperor into a city), the emperor changes his military attire to a civilian costume before the city gates, while he remains clad in military attire in a *profectio*.[32]

[31] This type of dress could also be classified as an over-girded peplos, see notes ?

[32] See Chapter 3, p. 60 n. 96.

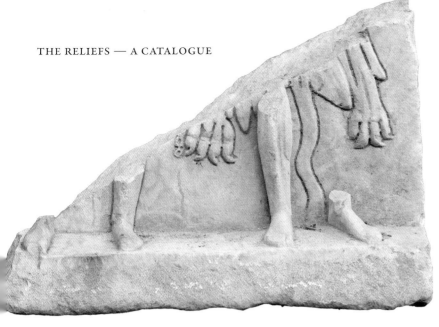

21. RELIEF FRAGMENT WITH EMPEROR? AND HERAKLES?

TÜBİTAK No. 20, Mus. New Inv. No. 2018–19

DIMENSIONS – Height: 55, Length: 80, Thickness of the Block: 20, Depth of the Relief: 12, Height of the Plinth: 11 cm

EXTANT CONDITION – Found during the 2009 excavation, on the central-western side of the area, close to the relief with the embrace of the co-emperors (**cat. no. 16**) and the emperor and the Victory (**cat. no. 20**). The fragment belongs to the bottom right corner of a larger relief panel, the top and left side of which are completely missing. On the fragment, the left leg of the figure in lion skin on the right is missing, as are the legs of the standing figure on the left.

Red paint is visible on the soft shoes and trousers of the standing figure as well as the fringed edge of a cloak, which the standing figure was wearing, next to the lion skin's paw on the left. A purplish-red drip line extending down from the fringe of the cloak suggests that the cloak was actually painted in imperial purple. Yellow paint is preserved on the lion skin.

TECHNICAL DETAILS – The back of the relief and the preserved part of its right lateral face have rough point chisel marks. A drill was used for outlining the figures and for the details of drapery. Two different types of chisels were used for the front surface of the plinth. 3–4 cm of the top part of the front of the plinth, just under the feet of the figures, is finished with flat chisels, while the rest towards the bottom of the plinth is left with claw chisel marks. The bottom of the plinth is also finished with claw chisels, with further cutting in the middle along the width with a point chisel, possibly done later to fit the panel into its architectural setting.

DESCRIPTION AND DISCUSSION – The fragment shows the feet of two frontally standing figures. Fine folds

and red paint on the right leg of the figure on the left indicate that he wore red trousers, tucked into soft shoes also coloured in red. The fringed edge of an imperial cloak painted in purple (possibly a *paludamentum*) that this figure once wore is visible right next to the lion's paw in the middle of the fragment. The feet of the figure on the left are not clearly defined, but the detailed rendering of the calf muscle on his right leg suggests that the figure is not wearing shoes or trousers. A lion skin with paws (four claws on each side) and a tail falls down behind the figure, identifying him as Herakles. Considering the association between Herakles and Emperor Maximian, who assumed the title *Herculius*, it is likely that the panel once showed a scene in relation to Emperor Maximian. Indeed, Emperor Maximian also appears being crowned by Herakles on **cat. no. 14**.

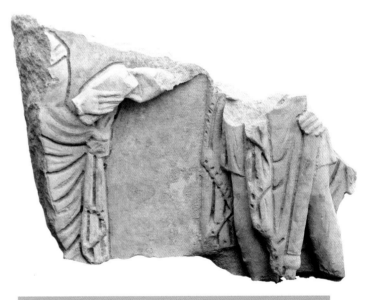

22. THE EMPEROR? HANDING OVER A CODICIL-DIPTYCH

TÜBİTAK No. 21, Mus. New Inv. No. 2018–20

DIMENSIONS – Height: 41, Length: 53, Thickness of the Block: 20, Depth of the Relief: 8–8.5 cm

EXTANT CONDITION – The fragment belongs to the middle part of a relief panel broken on all sides. There is no information available on its find-spot.

Red paint is visible on the trousers and the fringed *paludamentum* of the figure on the right, and yellow paint is visible on the sceptre he is holding. The red paint preserved on the *paludamentum* is consistent with the tone of cinnabar used as an underlayer to create purple with the addition of layers of Egyptian blue and pink on other reliefs with the imperial domain.

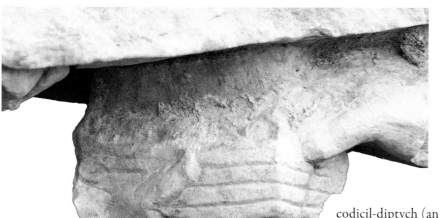

TECHNICAL DETAILS – Unlike many of the relief panels, which have rough quarry-pick marks on their backs, the back of this relief fragment was worked with a bush hammer, which left a pattern consisting of groupings of small circular dots. On the front surface of the relief, drill marks are visible around the figures and the details of the drapery, especially on the fringes of the *paludamentum*.

DESCRIPTION AND DISCUSSION – The fragment shows parts of two figures exchanging a codex made of tablets. Only the hands and part of the drapery of the figure on the left survive. He is shown in right profile, facing the larger figure on the right. He appears heavily draped with a large cloak/toga covering his left shoulder. His left hand holds the overfolds of the drapery gathered at his side. In his right hand, he holds a book of tablets (four leaves of the book defined through incised lines on the top side). The larger figure on the right hands the codex to the smaller figure with his right hand. Only the lower body of this figure survives. Shown in left profile, he wears trousers, a tunic, and a fringed *paludamentum*. In his left hand, he holds a sceptre with a knobbed end. The larger size, the imperial cloak, and the sceptre suggest that this figure is imperial, perhaps *Jovius* Diocletian, since he holds the sceptre. The sceptre, the sign of the earthly authority that Jupiter grants to the emperor, distinguishes Diocletian from the other tetrarchs on the frescoes of the imperial chamber at Luxor.[33] Clearly, the vital part of the story depicted is the handing over of the small codex by the emperor. The typology of the codex indicates that it is actually a *codicilli*/codicil-diptych, an appointment letter to an office granted by the emperor.[34] These letters consisted of flat rectangular pieces of wood joined together, with wax-coated surfaces on which the official inscription

was written.[35] Several such codicils granting various offices (rectangular in shape with lines on the side indicating the pages inside the diptych) are illustrated in the *Notitia dignitatum*.[36] The well-known *Missorium* of Theodosius, a silver dish made in Constantinople to celebrate the tenth anniversary of Theodosius's rule in 388, perhaps offers the best parallel imagery. On this fourth-century plate, the emperor seated in the middle appears as handing a codicil-diptych (an appointment letter) to a heavily draped senior official shown in smaller scale on the left.[37] The codicil-diptych shown on the late third-century Nicomedia relief could be the earliest illustration of the type which became popular in the imagery of fourth- and fifth-century consular diptychs.[38] Cameron, in his discussion of the origin and the function of Late Antique consular diptychs,[39] suggests that the actual institutionalization of consular games (which celebrated the inauguration of the consul in the first week of January) happened during the Tetrarchy in the new Tetrarchic capitals and the whole ceremony started with the emperor's handing of the letter of appointment (codicil-diptych) to the new consul.[40] If his argument is right, then we can even claim that the scene on the fragmentary relief, paired with references to games and festivals on other Nicomedia reliefs, commemorates the inauguration of a consul in Nicomedia. Besides the emperors Diocletian and Maximian who acted as the sole consuls in 290 and 293, there appear two plausible names in the consul lists of the late third century: Cassius Dio (whose family came from Bithynia) who became the consul in 291, and Afranius Hannibalianus, Maximian's closest comrade, the leader of the victory over Germanic tribes who became consul in 292. With our current state of knowledge, however, it is safe to say that this codicil scene denoted an imperial investiture and this ceremonial offering of an official appointment or title existed within the overall theme of the triumph of the emperor(s) as well as the triumph of Nicomedia.

33 McFadden 2015, 129–32.

34 For the origin of codicil-diptychs and their imagery see Grigg 1979, Olovsdotter 2005, 87, and Cameron 2013, 175–80.

35 Cameron 2013, 176.

36 The *Notitia dignitatum* was a detailed document about the administrative organization of the later Roman Empire.

37 Almagro Gorbea 2000.

38 For *codicilli* represented on the consular diptychs between AD 380 and 450, see Olovsdotter 2005, 87–88. Also see Chapter 3, p. 65 n. 115.

39 Also see Chapter 3, p. 65 n. 117.

40 Cameron 2013, 201–04.

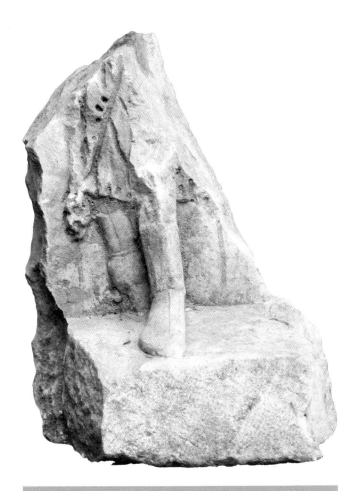

figure once held is visible next to the foot. The sceptre and the fringed *paludamentum* are very similar to those of the imperial figure on **cat. no. 22**, and suggests that this fragment, like **cat. no. 22**, might have been part of a depiction of the Emperor *Jovius* Diocletian.

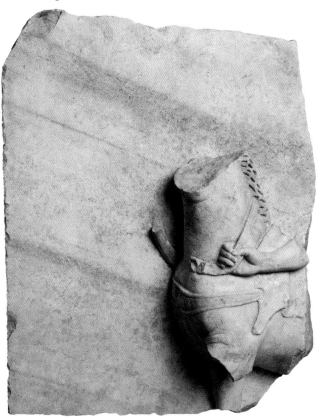

23. AN IMPERIAL FIGURE WITH A SCEPTRE

TÜBİTAK No. 56, Mus. New Inv. No. 2018–50

DIMENSIONS – Height: 42, Length: 23, Thickness of the Block: 20, Depth of the Relief: 12, Height of the Plinth: 10.5 cm

EXTANT CONDITION – The relief fragment is broken on all three sides, preserving only the bottom part with a plinth. There is no information available on its find-spot.

Red paint is visible on the shoe, trousers, and fringed cloak of the standing figure, while yellow paint is visible on the sceptre behind the foot. Two purplish-red lines dripped from the cloak down to the plinth suggest that the fringed cloak was actually painted in imperial purple, the Egyptian blue component of which faded away in time revealing mostly the iron-based red visible to the naked eye today.

TECHNICAL DETAILS – A drill has been used in the rendering of the folds and fringes of the drapery. The top surface of the plinth is finished with flat chisels and rasps while the front surface has claw chisel marks applied diagonally.

DESCRIPTION AND DISCUSSION – The relief fragment has the right foot and the sceptre of an imperial figure standing frontally on a plinth. The partially surviving figure seems to be wearing soft shoes (with a sketchy vertical band stretching from the toe to the ankle), trousers, and a long, fringed cloak, a *paludamentum*, originally painted in imperial purple. The knobbed end of the golden sceptre that the

24. AN IMPERIAL HORSE AND A RIDER

Exc. Inv. No. ÇKBĞ 2009/45, TÜBİTAK No. 23, Mus. New Inv. No. 2018–22

DIMENSIONS – Height: 68, Length: 57, Thickness of the Block: 24, Depth of the Relief: 12 cm

EXTANT CONDITION – Found with its figured-face up in 2009 in the south-eastern part of the excavated area, next to the relief of the boxers (**cat. no. 32**), a column, and broken hand of a colossal free-standing sculpture. The fragment is from the upper left corner of a relief panel. Right and bottom parts are missing. The head and left front leg of the horse on the surviving fragment are missing.

Yellow paint on the mane of the horse and remnants of red paint on its harness are visible.

TECHNICAL DETAILS – A cutting on top of the relief panel measures 6 cm × 3 cm and 4.5 cm in depth. A small channel (opened with point chisels from one side of the cutting) extends towards the back plane of the panel. The cutting therefore could be the short end of a hole for a clamp

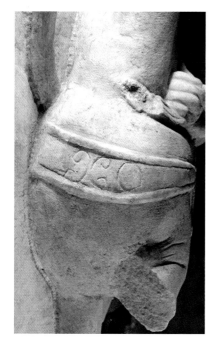

in the shape of the letter 'Π', used to secure the panel to the back wall. Rough pick marks on the back of the relief are visible. The left side-end (lateral face) of the panel is worked with claw chisels, while point chisel marks are visible on the top surface. The background of the figures and the figure surfaces are smoothly finished with rasps and flat chisels.

DESCRIPTION AND DISCUSSION – The fragment contains the front body of a horse, whose head and legs are chipped off, carved in left profile, and the right hand of a figure holding the harness of the horse. The leather saddle and the floral embellishments in the band surrounding the girth of the horse's harness indicate that the horse belongs to a high-ranking person. Ceremonial harnesses of the emperors' horses on **cat. nos 10, 14, and 16** are parallel examples on the Nicomedia frieze. Thus, in this fragment we might have another imperial figure in a ceremonial context.

25. MEDEA SLAYING HER SONS

The top left corner with a Fury: TÜBİTAK No. 26, Mus. New Inv. No. 2018–24, main panel with Medea: Mus. Inv. No. ÇKBĞ 2001/59, TÜBİTAK No. 28

DIMENSIONS – Height: 101, Length: 158 cm (the sum of the lengths of two surviving parts; the original length including the missing part in the middle was approximately 200), Thickness of the Block: 21, Depth of the Relief: 10, Height of the Plinth: 15 cm

EXTANT CONDITION – The relief consists of two separate parts assigned to the same relief panel upon our technical analysis. According to the previous museum director of Kocaeli Archaeology Museum, İlksen Özbay, the larger block with Medea was found in 2003, dragged from the excavation area in Çukurbağ by looters for illegal export. This part was initially published by Zeyrek and Özbay, who identified the scene as Victory with two Erotes and dated the relief to the second century AD.[41] The relief fragment with a snake-bearing figure came from Çukurbağ after 2003, but there is no detailed record of when exactly and under what

circumstances it came to the museum. The technical analysis, however, leaves no doubt that the fragment belonged to the upper left corner of the relief panel with Medea. Despite a missing part in the middle, these two parts together partially preserve all sides of the original relief panel. The lower body of a snake-holding figure (a Fury) and the head of the snake on the small fragment are missing. On the larger fragment, which formed the centre and the right side of the original relief panel, Medea's right arm, the handle and the front part of the sword she is holding in her right hand, and her lower left arm are missing. Only windblown hair strands of a figure once depicted in between the snake-holding Fury and Medea are preserved on the broken left side of this part. There are small fractured areas on Medea's and the children's hair. The breakage on the top right of the front surface reveals the depth of the clamp hole located on the top right surface of the block.

Shades of red are visible both on the hair of the snake-bearing Fury and the flying hair of the now-missing figure in the middle, as well as on the hair of Medea. A yellowish colour is visible on the rope of Medea's dress and on the hair of the children on the right.

TECHNICAL DETAILS – The background of the relief and the faces of the figures have been finished with flat chisels and rasps; the drill was used for the figures' outlines, drapery folds, and hair, while the front and top surface of the plinth has been left with claw chisel marks. Roundels were used to carve the scales of the snake. There are rough point chisel marks on the sides and on the back of the relief panel. On the top left surface of the part with Medea is the bottom of a rectangular lewis hole measuring about 18 cm × 4 cm, and only 4 cm in depth. The placement of the lewis hole behind the figured plane and its shallow depth indicate that the relief was mostly carved on the ground; the cutting was made to insert a lewis for lifting the panel up, and then after hoisting, the top of the panel was trimmed to fit the panel to the height of the architectural setting. Indeed, along the upper left part above the figures in both fragments, with Medea and the Fury, one can even see the original incised line that the sculptor used to measure the limits of trimming. The location of the lewis cutting also helps us understand the approximate length of the relief panel. The lewis holes are usually carved at the centre of gravity on the top parts of the blocks, for secure lifting. Thus, despite the missing parts in the middle and the bottom left corner of the original relief panel, the location of the lewis hole on the top left surface of the part with Medea indicates that the original relief panel was about 2 m in length. Traces of two clamp holes (both measuring about 4 cm × 2 cm) on the top corners, one above the head of the Fury and another partially broken one above the heads of Medea's sons, indicate that the panel was originally connected to an architectural element behind. The continuous incised line for 'trimming', the location of

41 Zeyrek and Özbay 2006, 304, 311; Abb. 20.

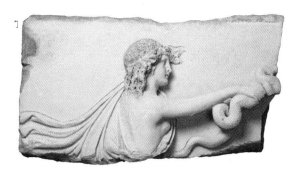

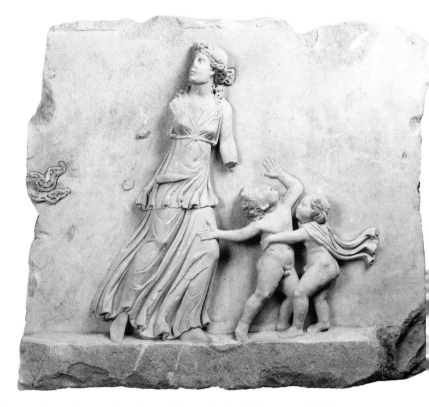

the same-sized clamp holes on the upper parts of both fragments with the Fury and Medea, and the related mythical iconography prove that they are parts of the same panel. The right corner of the plinth is deliberately chiselled off for an architectural join.

DESCRIPTION AND DISCUSSION – In the middle of the relief slab Medea is directed towards the right, while looking back to the left towards the snake-bearing Fury. Her (now partially broken) sword is directed towards two nude boys, one of which seems already to have been stabbed, as he appears with both arms outstretched, held from falling by the smaller boy on the right.

Medea wears a thin-textured chiton with a long overfold through which the details of her body are visible underneath. In the typical Hellenistic manner, the chiton is secured with a rope tied into a double-knot right underneath her breasts.[42] Her drapery forms small *kolpoi* on the sides of her breasts above the rope. With her left leg bent and right heel off the ground she appears to be rushing towards the right while her head is sharply turned in the opposite direction, her eyes directed towards the top left. The hems of her dress (both above the ankles and on the overfold) respond to her movement as the folds appear to be swaying in the air. She has an elaborate hairstyle: the top part of her curly

hair forms a bow-knot above the head (now partially broken off); below, the hair is parted into equal halves above the forehead, rolled on the sides, and brought together into a loose bun at the nape of her neck; long curls freed from the bun are left hanging down on both her shoulders. The remains of the strut once supporting her right arm and the tip of a sword she was once holding in this hand are visible. Her left lower arm is also missing, but the tips of her fingers are still intact on the head of the left one of the two little boys, as she is shown violently pulling his hair with this hand while forcing her sword on him with her other hand. The position of the nude boy's lower body mimics Medea's pose: left knee bent, right heel off the ground rushing towards the right in a vain effort to escape Medea's attack. His head is pulled up by Medea's hand, his mouth is open in pain, and his arms are outstretched to the sides in an escape pose. He has full cheeks and chin, and his tongue is visible in his open mouth. His wavy hair is painted in yellow. Another child, nude except for his air-blown cloak, embraces the first boy from the waist with his left arm. He is shown in profile

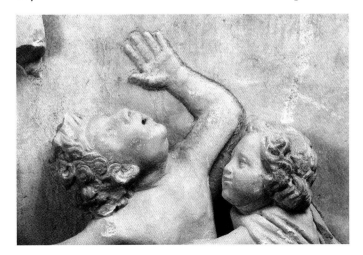

42 Such garments with long overfolds can also be classified as over-girded *peploi*, but due to its thin texture, here it is classified as a chiton, see note ? above. Both the chiton and peplos are full-length garments; thin, linen chitons usually with sewn sleeves are indicated with closely packed folds in representations, while the thicker woollen peplos with an overfold has broad thick folds, see Lee 2015, 106–07.

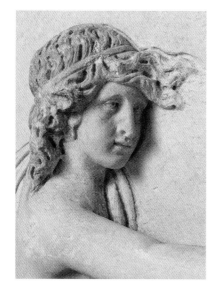

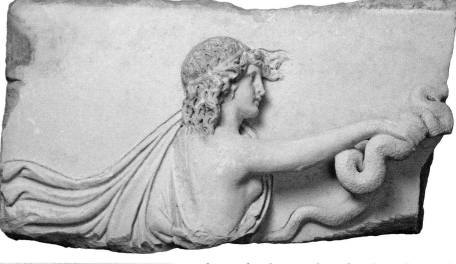

facing left with his knee bent. He appears to be holding the already attacked boy, preventing him from falling. His facial features and wavy yellow hair are similar to those of the first boy. On the far left, at the broken side of the main block, remnants of two flames or curly hair strands, painted in red, are visible swaying in the air. These could belong to the dying Glauce, Jason's new wife, to whom Medea gave a burning gown as a wedding gift before killing her own sons as revenge for Jason's betrayal. Indeed, on Roman sarcophagi, Glauce is typically portrayed as a woman with wild (perhaps burning) hair falling down before Medea.[43] Medea's old-fashioned chiton and her sharp backward glance on the Nicomedia frieze also appear similar on the Roman sarcophagi. However, unlike the Roman sarcophagi, on which Medea is shown escaping with the bodies of her already dead sons, on the Nicomedia panel she appears in the very act of slaying them before her escape.

The fragment from the top left part of the Medea panel preserves the upper part of a female figure in right profile advancing towards the right, holding a scaly coiling snake in her extended right hand. She wears a cloak wrapped around her body, covering only the left shoulder and exposing the nude right side of her upper body, including the right breast. The overfolds of the cloak thrown over her left shoulder appear to be swaying in the wind behind her. Two strands of her wild shoulder-length hair flow in the air towards the right. She wears a thin diadem over her hair and a large earring with a pendant hanging down from her right ear. The exposed right breast and the snake she is holding help her identification as a Fury (Erinys). The Furies, the deities of curse and vengeance, especially associated with the rights of deceased relatives who were killed by their kin, are very popular figures in the imagery of Orestes', Herakles', and Alkmeon's story cycles.[44] All three of those mythological characters are known to have been driven crazy by Furies after killing their family members: Orestes after killing his mother Clytemnestra, Herakles after killing his wife and children, and Alkmeon after killing his mother Eriphyle. Among the common attributes of Furies are the coiling snakes in their hands and a dress exposing one breast as a signifier of their wild nature.[45]

Despite the fratricide and filicide she committed, Medea does not appear frequently as being chased by a Fury in the existing Medea iconography of antiquity.[46] Also, in none of the existing literary tradition does the story relate her to the city of Nicomedia. Her appearance on the Nicomedia frieze might indicate that a new local eponymous myth was manufactured through phonetic parallelism between the Greek words Medeia and Nikomedeia.[47] This made-up etymological association of 'Medeia' and 'Nikomedeia' could also explain the unusual existence of a Fury and a more positive view of Medea (as a founder heroine) on the relief panel compared to the typical Medea cycle depicted on Roman sarcophagi. Together with the Istanbul relief panel (**cat. no. 26**), which has the depiction of the foundation myth of Nicomedia, the Medea relief could have stood as a reference to the mythical eponymous local histories created for Nicomedia on the frieze.

43 LIMC vi 'Medeia', nos 51–58 (entry by M. Schmidt.) Also see Buchanan 2012 for a recent overview of representations of Medea on Roman sarcophagi.

44 LIMC iii 'Eriyns', 22–84; 96–97 (entry by H. Sarian).

45 For example, LIMC iii 'Eriyns', 68.

46 For details see Chapter 4, pp. 76–78.

47 Greek Νικομήδεια is Latin Nicomēdia, Greek Μήδεια is usually spelled Mēdea in Latin. The transliteration from Greek is Nikomedeia and Medeia.

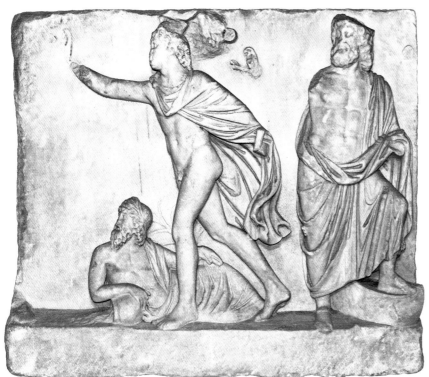
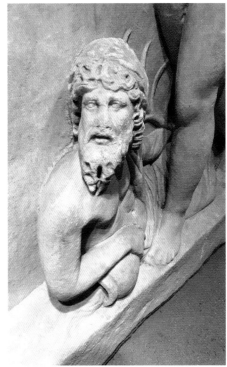

26. POSEIDON AND A FOUNDING HERO (NICOMEDES I?)

Istanbul Archaeological Mus. Inv. 5344 T, TÜBİTAK No. 27

DIMENSIONS – Height: 106, Length: 129, Thickness of the Block: 20, Depth of the Relief: 10, Height of the Plinth: 15 cm

EXTANT CONDITION – The relief block was found in Çukurbağ in Izmit and was taken to Istanbul Archaeological Museum on 25 May 1957. There is no information available on its find-situation. The overall stylistic, technical, and iconographical features (discussed below) indicate that it was part of the Nicomedia frieze. The left side of the original panel is missing. On the right of the panel, the right arm from the shoulder, the left hand, and a spear-like object once carried in the left hand of the bearded figure (Poseidon) are missing. The body and the left wing of a large bird above the head of the semi-nude figure in the middle are missing. Also, the right extended forearm and a floral object in the right hand of the semi-nude figure, as well as his left forearm and a torch-like object he once held in his left hand, are missing. Traces of the trunk and foliage of a tree along the broken left side of the panel can be seen, but the rest of the tree is missing. The faces of the standing figures are worn down, with small chipped areas on their heads and faces. The penis of the semi-nude figure in the middle is also chipped off, perhaps deliberately in the later usage.

There are no traces of paint visible to the naked eye on the relief.

TECHNICAL DETAILS – The original length of the panel must have been longer since the block is broken off on the left side. Rough point chiselling from the top to the bottom of this broken side is indicative of the later reuse of the block in antiquity. Alternatively, this side might have been shaved off by the builders, in order to fit the panel into its architectural setting. The figures and their background are well finished with flat chisels and rasps, while claw chisel marks are still visible on the front and top surfaces of the plinth. The back and the right lateral face of the block still carry the rough point chisel marks. A drill has been used for the details of hair and foliage, as well as for accenting drapery folds and outlining the figures. On top of the block is a small rectangular hole (3 cm × 2 cm) for one end of a now-lost metal clamp used to secure the block to the back wall. Another cutting on the top right corner of the block (10 cm × 4 cm and 5 cm in depth) was possibly made for a lateral clamp, to connect the panel to another architectural element on the right.

DESCRIPTION AND DISCUSSION – Three main figures occupy the Istanbul relief: from right to left, the god Poseidon stands on a ship's prow; next to him is a semi-nude hero with an eagle, of which only the right wing survives, hovering above his head; and a river god reclines below the hero's feet. Despite their different body postures, all of the figures' heads and gazes are directed towards the left, where the traces of a tree's trunk below and foliage above can be seen at the broken left end of the block.

Poseidon stands on the right with his left foot resting on a miniature ship's prow, a typical pose of the Lateran Poseidon type.[48] One can trace the remains of a spear or more likely a trident (another attribute of Poseidon) that he once held in his left hand. The broken traces of a circular strut above his left shoulder must have supported the top part of the trident, which extended down diagonally and, in the middle, was carved together with his drapery folds, with its (now broken off) bottom touching the plinth in front of the ship. The head of the god is shown in three-quarter view, facing to the left. His facial features are worn, but one can clearly make out his curly beard and curly hair falling on his nape. The top part of his head is missing but on the sides one can also detect the leaves of a crown over his head. He wears a long cloak draped over his left shoulder, covering his lower body down to the ankles while revealing his bare frontal chest. The folds of the cloak, stripped off from his right shoulder, are rolled down at the lower abdomen and thrown over his now-missing left forearm. His bare right arm, which must have been completely free from the relief's background, is also missing, but the arm's raised pose can be seen from the breakage below the right shoulder. Thus, originally the right arm probably extended high up in a pose of excitement. He wears sandals or boots with sketchily indicated straps. His left leg is shown in three-quarter view, pointing in the opposite direction from his head, and resting on a rather bulky ship, the stern of which is indicated only summarily as a curving ridge.

Next to Poseidon in the middle of the relief is a young hero stepping forward with his right heel off the ground, reaching towards the viewer's left with his extended right arm and left leg. His legs and head are in profile, while his torso is in three-quarter view. His windblown cloak, fastened with a round brooch above the right shoulder, forms V-shaped folds over his upper torso and covers only the left shoulder and the arm, revealing most of his young nude body. His left forearm is missing. The remnants of a stick he once held in his left hand do not reach down to the plinth, and the stick's circumference gets wider going upwards. Parts of broken wavy carvings preserved above his left shoulder might be an extension of the stick, once perhaps forming the flames of a torch (the stick). It is more likely, however, that these wavy carvings once belonged to the hair of a sacrificial animal that the eagle behind the young hero's head was clutching onto; just like the head of a sacrificial animal the eagle threw to show the founder the foundation site of Nicomedia in Libanius's account (*Or.* LXI.4). The hero's right hand, extended towards the left, is also broken, but the remaining outlines on the background of the relief indicate that he was also carrying something (perhaps a branch) in this hand. The top part of the figure's head is broken off and his face is

also worn down, but his curly hair, framing his forehead and reaching down to his nape, is clearly visible. Together with his beardless face, his hairstyle is reminiscent of Hellenistic royal portraits of Nicomedes I and Seleucus I.[49] Although mostly broken, the cylindrical curve of a *polos*-like headdress he once wore is visible over his head at his left. Above his head is the large right wing of an eagle. The broken strut above the flames, behind the left shoulder of the hero, possibly supported the body and left wing of the eagle projecting out from the relief. As mentioned above, broken wavy carvings below the eagle could have belonged to a sacrificial animal hanging down from the claws of the eagle. The figure might be the founding hero of Nicomedia, perhaps Astacos or King Nicomedes I, who are both mentioned as founding heroes guided by Poseidon in the literary tradition.[50]

Reclining on the ground under the hero is a river god, holding a jar turned on its side with water flowing from its mouth.[51] He rests his bent right arm on the jar and holds a reed in his left hand. Smaller in scale than Poseidon and the hero, his body is shown in profile while his head is sharply turned towards the viewer's left. Just like Poseidon, the cloak he wears covers his left shoulder and lower body, revealing his right arm and bare chest. Since he is situated behind the legs of the hero, his body is carved in lower relief. His lower body, rendered in a compact bulk, is completely wrapped in the cloak, revealing only the bottom of one of his feet behind the left foot of the hero above. He has a moustache and a long beard that has its curls parted in two halves from the centre. His curly hair framing his face is crowned with a laurel wreath. The tip of his nose is missing, but his sharply turned head and parted lips give him a startled expression. The water coming from his jar flows towards the left on the upper surface of the plinth. A little further left of this water at the broken left corner of the block is the trunk of a tree, the leaves of which (rendered with drill holes) are also detectable above in front of the extended right arm of the hero.[52]

The river god depicted on the panel is possibly the god of the River Sangarios, which is a major river in Bithynia and referred to as the source of Nicomedia's fertile terrain in ancient literary sources.[53] His appearance, together with Poseidon, who is very popular on the coins of earthquake-shaken Nicomedia, indicate that the event depicted on the relief is taking place in Nicomedia. The story may well be

[48] LIMC VII 'Poseidon', no. 39, p. 478 (entry by E. Simon).

[49] Smith 1988, plate 74. 15 and plate 76. 1–2. On the circulation of images of Hellenistic kings in Roman Asia Minor see Romeo 2017.

[50] See Chapter 4, pp. 72–73 n. 10.

[51] On the iconography of river gods see LIMC IV.1 'Fluvii', 139–48 (entry by C. Weiss); Ostrowski 1991; Gais 1978.

[52] Very similar bulky tree trunks and their foliage above, rendered with the use of drill holes, appear on two other blocks on the Nicomedia frieze.

[53] See Chapter 4, p. 72.

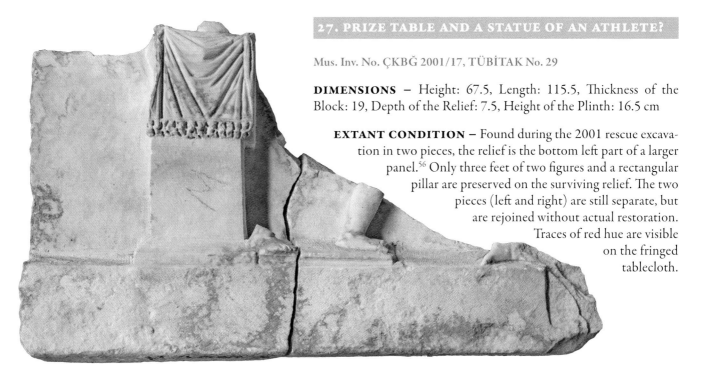

27. PRIZE TABLE AND A STATUE OF AN ATHLETE?

Mus. Inv. No. ÇKBĞ 2001/17, TÜBİTAK No. 29

DIMENSIONS – Height: 67.5, Length: 115.5, Thickness of the Block: 19, Depth of the Relief: 7.5, Height of the Plinth: 16.5 cm

EXTANT CONDITION – Found during the 2001 rescue excavation in two pieces, the relief is the bottom left part of a larger panel.[56] Only three feet of two figures and a rectangular pillar are preserved on the surviving relief. The two pieces (left and right) are still separate, but are rejoined without actual restoration. Traces of red hue are visible on the fringed tablecloth.

the foundation of Nicomedia since Poseidon appears as a major actor in the foundation myths of Nicomedia in the literary tradition.

The literary accounts reveal two founding heroes for Nicomedia: Astacos, the son of Poseidon in the eighth century BC; and Nicomedes I, the Hellenistic king in the third century BC. According to Libanius's account, King Nicomedes first tries to found the city on top of the town of Astacos, but an eagle sent by Poseidon snatches the sacrificial animal from an altar at Astacos and leads Nicomedes across the gulf (to the north-east) to the location for the new city, which he names after himself. In general three main motifs consistently reoccur in the foundation stories of the Roman cites of Asia Minor in the literary tradition: a guiding eagle (throwing sacrificial meat on an altar to show the location); a serpent or a serpentine river at the foundation site; and the planting of trees on the foundation site.[54] A specific type of coin imagery, issued in Nicomedia during the reigns of Gordian III and Maximinus Thrax and often said to represent the foundation story of Nicomedia,[55] also depicts a wreathed beardless young man in front of a sacrificial altar with a snake and an eagle hovering above him. The parallel iconography on the Istanbul relief and Libanius's account of the foundation of Nicomedia suggest that the semi-nude hero guided by an eagle on the panel is the founder, Nicomedes I.

TECHNICAL DETAILS – Visible tool marks include claw chisels applied diagonally from right to left on the top and front surface of the plinth; a drill for the folds and fringes of the tablecloth; flat chisels and rasps for the surface of the pillar, the skin of the feet, and the background of the figures; and rough point chisel for the back of the relief panel.

DESCRIPTION AND DISCUSSION – On the left part of the panel is a tall altar-like pillar (about 48 cm in height) placed on the left part of a rectangular platform (26 cm in length and 2.5 cm in height). The top part of the pillar is covered by a rectangular cloth with V-shaped wrinkles and fringes at the hem. The surviving bottom part of a bulbous object placed on top of the cloth could be an agonistic prize crown given to athletes. If so, the altar-like pillar is most likely a prize table. Prize tables with prize crowns and money bags are very popular, especially in agonistic-themed art and numismatics of the second- and third-century Roman world.[57] Indeed, on another relief from the Nicomedia frieze (**cat. no. 28**), a very similar type of table with a fringed red cloth supports a large prize crown. The two small feet of an active figure directed towards the right share the same platform (or the base) with the prize table, suggesting that this could be a representation of an athlete statue. Zeyrek and Özbay in their initial publication of this relief, however, interpreted the scene as part of a purification ceremony next to an altar after war and linked this relief to the processional scene with the goddess Roma and togate civilians on **cat.**

54 Ogden 2017, 99–174. Ogden (2017, 150) also discusses Libanius's account of the foundation of Nicomedia and how it is heavily influenced by the foundation stories of Syrian Tetrapolis and Daphne.

55 See the discussion on Chapter 4, p. 74.

56 Zeyrek and Özbay 2006, 298, Abb. 15.

57 Dunbabin 2010.

no. 17.[58] The similar iconography used for the prize table on **cat. no. 28**, however, makes the interpretation of this scene as a prize crown placed next to an athlete statue more likely. The statue itself could be a reference to a major victory monument in urban Nicomedia, as a way of saying that 'the prize is given by the statue of a famous certain athlete'. In either case, if this is a purification scene or an agonistic scene then it is hard to make sense of the foot of a small fallen figure visible on the right corner of the surviving relief.

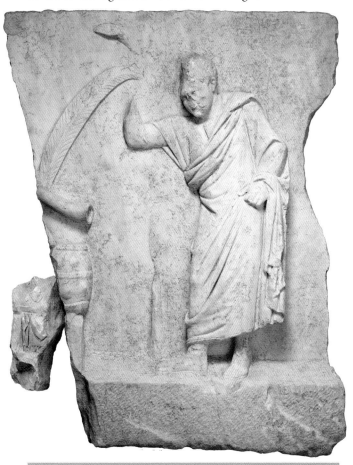

28. A HERALD NEXT TO A PRIZE TABLE AND A PRIZE CROWN

Mus. Inv. No ÇKBĞ 2009/38, Exc. Inv. No. ÇKBĞ 2009/71, TÜBİTAK No. 30, Mus. New Inv. No. 2018–25, unrestored part from the left with a prize table: Mus. New Inv. No. 2018–84

DIMENSIONS – Height: 102, Length: 84, Thickness of the Block: 20, Depth of the Relief: 11, Height of the Plinth: 15 cm

EXTANT CONDITION – The relief panel was found during the 2009 excavation at the south of the excavated area, among several other architectural elements including a column and architrave blocks. Preserved in two pieces, one

consisting of most of the right side of the relief and the other a small part from the bottom of the left side with the prize altar. These two pieces are still separate. The left lateral face and the middle part of the right lateral face are missing. There are cracks and missing parts on the left side of the standing figure's head as well as on his nose, mouth, and chin. The middle part of the staff the figure is holding is missing. The left side of the relief, along with part of the trumpet and the upper left part of the prize crown are missing.

Hues of red are visible on the hair of the standing figure and on the knobby decorations of the prize crown, as well as on the fringed tablecloth on the prize table. Yellow paint on the outside and blue paint on the bottom inner side of the trumpet are visible. Scratchy brown patterns, especially on the front surface of the block on the right, are due to post-antique colour deterioration and oxidation.

TECHNICAL DETAILS – There are no traces of cuttings either on the surviving top or bottom of the block to give clues about its lifting or joining in the architectural setting. Claw chisel marks applied diagonally from right to left are visible on the front and top surfaces of the plinth. A drill was used for the outlining of the figure, the folds of his drapery, his irises, and the folds of the tablecloth. Flat chisels and rasps were used for smoothing the skin and clothing of the figure as well as the background. Smaller fine chisels and the side of the corner of the flat chisels were used for the details of the prize crown and the palm branch. On the top and bottom parts of the right side of the relief panel are point chisel marks, indicating that this was the original right side-end. There are point chisel marks on the top and bottom surfaces of the block and densely struck at right angles on the back of the relief panel.

DESCRIPTION AND DISCUSSION – On the surviving part of the relief panel, a standing male figure shown in three-quarter view stands facing a prize altar with a large prize crown that has a long palm branch extending from inside it. The face of the figure is damaged but he appears to be a young male with short hair and a hair lock in front of his right ear and a clean-shaven face. With his right knee bent, he lowers his head and leans on a staff topped with a

58 Zeyrek and Özbay 2006, 298–306.

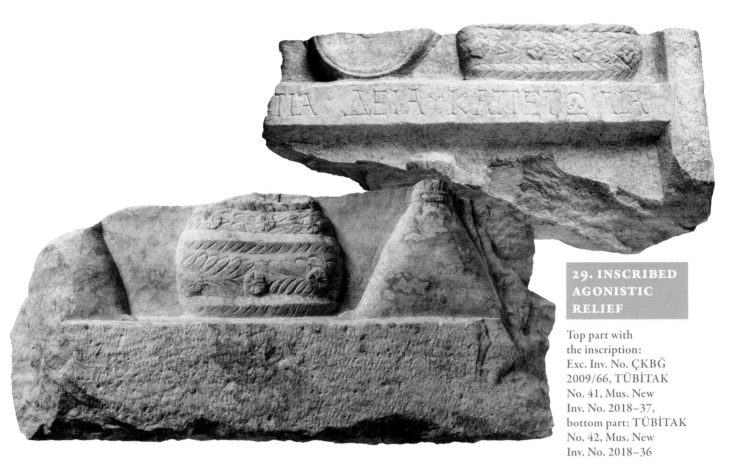

29. INSCRIBED AGONISTIC RELIEF

Top part with the inscription: Exc. Inv. No. ÇKBĞ 2009/66, TÜBİTAK No. 41, Mus. New Inv. No. 2018–37, bottom part: TÜBİTAK No. 42, Mus. New Inv. No. 2018–36

leaf. He wears a long *pallium* wrapped around his body, the overfolds of which are gathered on his left forearm. Below the *pallium* he wears thin-soled sandals with crossed laces reaching up to the ankles. He might be a herald announcing the winner of an agonistic game. Indeed, he stands in front of a large prize crown placed on a rectangular prize table (or prize altar) which is decorated with a fringed red tablecloth. The form of the prize crown conforms with the typical prize crown typology represented in Roman sculpture, mosaics, and coins.[59] This specific agonistic prize, especially popular on the third-century coins of Roman Asia Minor, becomes a symbol of victory in imperial art. It appears at least five times on the Nicomedia frieze. Three thin ridges of open-work (incised with herringbone pattern) at the top, middle, and bottom horizontally divide the prize crown into two bands. In each band there are circular knob-like embossed decorations, perhaps of metal. On top of the prize crown is a very tall palm branch, which extends upwards perhaps from inside the rim of the prize crown. Also, the bottom part of a trumpet appears above the rim of the prize crown. The trumpet could indicate the existence of a trumpeter on the other side of the prize table on the missing left section of the relief panel. Indeed, palm trees, a herald, and a trumpeter flanking a prize table with agonistic prizes are typical of agonistic imagery.[60] With its agonistic theme, **cat. no. 28** is related to **cat. nos 29 to 37** in the Nicomedia frieze.

[59] For recent discussion of the depictions of prize crowns in Roman art see Rumscheid 2000, 79–89; Dunbabin 2010; Erol-Özdizbay 2012; Specht 2000. See the discussion on pp. 80–82.

[60] See discussion in Chapter 5, p. 82 n. 21.

DIMENSIONS – Height: 76, Length: 125, Thickness of the Block: 19, Depth of the Relief: 5, Height of the Plinth: 16 cm

EXTANT CONDITION – Found in two pieces in a mixed dirt pile on the south-western part of the excavated area during the 2009 excavation. The top, the left side, and the bottom right corner of the panel are missing. The trace of the breakage, similar iconography, tool marks, and the size of the two pieces indicate that they are two parts of the same relief panel.

There are no traces of paint visible to the naked eye.

TECHNICAL DETAILS – Two pieces form the lower right side of a relief panel, missing most of the top part and the bottom right corner. Besides the plinth at the bottom, the relief has two protruding bands (ledges): a horizontal band with an inscription dividing the front surface into two sections, and a vertical band framing the relief along the right side-end. Both point chisel and claw chisel marks are visible on the front of the plinth. The vertical band on the right side-end also exhibits traces of two different tools; the left side of the band closer to the figured plane is smoothed with a flat chisel, while the right side is left with rougher claw chisel marks. A flat chisel is used for the details of the figures, such as the details of the openwork on the prize crown and the creases of the mouths of the money bags, as well as for smoothing the background of the figures. There are rough pick marks on the back of the panel. The letters of the inscription on the protruding middle band are carefully cut in a highly refined manner with the help of fine point chisel.

DESCRIPTION AND DISCUSSION – Although partially preserved, a prize crown flanked by two money bags on the bottom register, and the bottom part of another prize crown and a patera? on the top register can be seen on the relief. These objects are related to the agonistic festivals that have their names inscribed in the middle band of the relief. Triangular money bags have mushroom-shaped mouths tied with a rope. The claw-like fringes at the corners of the bags indicate that they are made of a sack-like hard textile. The prize crown on the bottom register, in accordance with the typical iconography of the object, appears to be woven from reeds or thin metal and decorated with alternating rosette-like flowers and double laurel leaves in two horizontal bands. The woven ridges at the bottom, in the middle, and on the rim have herringbone patterns made with the use of a flat chisel. The floral ornamentation almost looks like two laurel victory wreaths put on top of each other. Another leaf, perhaps a palm leaf, extends up from the rim of the prize crown. The bottom band of another prize crown visible on the top register has the same woven protrusion, with a herringbone pattern at the bottom, and in the middle has a decoration of alternating flowers and laurel leaves. A second strip of herringbone pattern is partially preserved on the top where the relief is broken. The bottom part of an oval object next to this crown is probably the inside of a libational patera or the outside of a miniature shield.

An inscription on the middle band of the relief gives the names of agonistic festivals, perhaps held in Nicomedia and in which these prizes were given to the victorious athletes. The surviving part of the inscription reads [ΟΛΥΜ] ΠΙΑ · ΔΕΙΑ · ΚΑΠΕΤΩΛΙΑ. The inscription could refer to three different agones held in Nicomedia or one very important agon, which gained all these three epithets: Olympia, Deia, and Capitolia. From coins and inscriptions, thirty-eight imitations of Olympic festivals and nine imitations of Capitolia have been traced so far.[61] None of these accounts mention Nicomedia as a city in which Olympics or Capitolia were held. In her detailed study of epigraphic and numismatic evidence for the agonistic festivals held in Bithynia, Erol-Özdizbay lists the Asklepeia, Severeia, Demetria, Pythia, and 'unknown festivals' as the *agones* held in Nicomedia.[62] The inscription on the Nicomedia frieze indicates that imitations of the prestigious Olympics and Capitolia were also held in the new capital of the East with the special permission of the emperor. The agonistic prizes, together with the inscribed names of the major *agon(es)* held in Nicomedia on the relief, clearly function as propaganda for the self-image of the city, commemorating the imperial privilege given to the city as well as the imperial cult that was likely associated with these festivals.

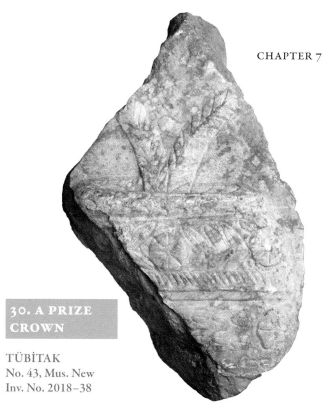

30. A PRIZE CROWN

TÜBİTAK
No. 43, Mus. New
Inv. No. 2018–38

DIMENSIONS – Height: 43, Length: 25.5, Thickness of the Block: 16, Depth of the Relief: 4 cm

EXTANT CONDITION – The relief fragment is broken on all sides, but still preserves the top and right side of a prize crown. There is no available information on its find-spot.

There are slight traces of red and blue paint on the rosette-like flowers used to decorate the crown.

TECHNICAL DETAILS – The typology of the prize crown and the way its details are rendered with a flat chisel make it similar to the prize crowns on **cat. no. 29**. The fragment might be a broken piece from the left side of **cat. no. 29** or part of another relief panel with agonistic prizes.

DESCRIPTION AND DISCUSSION – The partially preserved prize crown on the relief is typologically almost identical to the prize crowns on **cat. no. 29**: woven ridges of thin metal or more likely reed at the bottom, in the middle, and on top (the latter forming the rim of the crown) divide the prize crown into two bands. Each band is decorated with a pattern where single flowers alternate with three laurel-leaf pairs in a row. The precise rendering of rosette-like flowers and their multiple colours — blue for the one in the middle of the top band and red for the one at the bottom band — suggest that these flowers might really be rosette-shaped gems woven into the crown. Indeed, there are several examples of representations where prize crowns are shown decorated with colourful gems. Among the examples, the mosaics from Batten Zammour in Tunisia and Piazza Armerina in Sicily are almost contemporary with the Nicomedia frieze.[63] A pair of palm leaves placed inside the prize crown emerges upwards from the rim.

 61 Klose 2005, 126.
 62 Erol-Özdizbay 2011, 197–223.

 63 Dunbabin 2010, 322, 323, 338, 339.

TECHNICAL DETAILS – Point chisel marks on the left side of the relief panel indicate that this is the bottom part of the left lateral face of the original panel. The body of the nude figure and the background of the figured plane are smoothed with flat chisels and rasps. There are thick claw chisel marks on the front and top surfaces of the plinth. The large drill hole on the right side of the abdomen is probably for a metal support for the extended (now missing) right arm of the figure.

DESCRIPTION AND DISCUSSION – The relief preserves the lower part of a nude male shown in right profile walking towards the right. The bent right arm of the figure was probably projecting up and out of the relief as it seems to have been held up with a metal support, for which a deep circular cutting was made on the right side of the abdomen. The complete nudity of the figure and the find-spot close to the other agonistic-themed reliefs suggest that the figure represents an athlete, very likely a victorious one. Indeed, the relief could be thematically connected to the relief on **cat. no. 28**, on which a herald and possibly a trumpeter stand on either side of a prize table with a prize crown. However, **cat. no. 31** cannot be the missing left side of **cat. no. 28**, as the claw chisel marks on the front surfaces of the two reliefs face different directions.

31. AN ATHLETE?

TÜBİTAK No. 44, Mus. New Inv. No. 2018–39

DIMENSIONS – Height: 70, Length: 71, Thickness of the Block: 23, Depth of the Relief: 10, Height of the Plinth: 15 cm

EXTANT CONDITION – The relief was found under a large architrave block close to **cat. no. 16** in the central part of the excavated area during the 2009 excavations. It is the bottom left corner and middle part of a larger relief panel which has the lower body of a nude figure preserved. The upper body above the abdomen is missing, including the arms. The penis is chipped off.

There are no preserved colours visible to the naked eye. Scratchy brown patterns, especially on and behind the nude figure's legs, are due to post-antique colour deterioration and oxidation.

32. BOXERS

Mus. Inv. No. ÇKBĞ 2009/24, Exc. Inv. No. ÇKBĞ 2009/46, TÜBİTAK No. 31, Mus. New Inv. No. 2018–26

DIMENSIONS – Height: 103, Length: 155, Thickness of the Block: 20, Depth of the Relief: 8, Height of the Plinth: 15 cm

EXTANT CONDITION – Found in the south-eastern part of the excavated area in 2009, having fallen on its plinth, standing upright, next to a column and **cat. no. 24**. The relief panel still preserves its full length. Yet, the top left side corner and the top and most of the middle part of the right side are missing. The face of the boxer in the middle and the tip of the nose of the trainer on the left are missing.

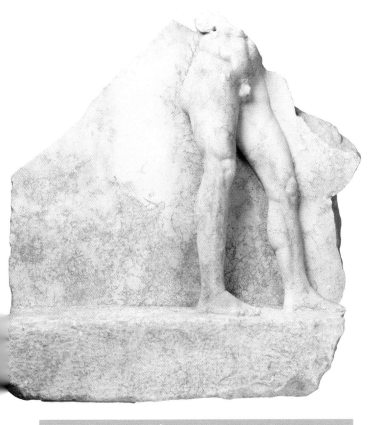

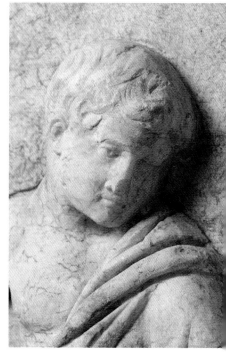

The left knee of the seated boxer on the right is loosely restored. There is a small cracked part in the middle of the bottom of the plinth.

Hues of red paint are visible on the boxers' gloves, especially on the cube-like protrusions on the tips of the gloves, and on the hair of the trainer/herald. Yellow is visible on the toga of the trainer/ herald. Brown scratchy marks on the front surface of the marble is due to oxidation. Blue-grey horizontal veins of the specific Proconnesian marble are clearly visible on the front surface.

TECHNICAL DETAILS – This relief panel is the only one among the surviving Nicomedia relief panels that carries special cuttings for clamps or dowels at the bottom of the plinth. On all other surviving panels clamp cuttings are on the top surfaces. Two oval holes measuring approximately 3 cm × 2 cm and 5 cm in depth, cut next to each other at the bottom right corner, towards the back of the block, indicate that the panel was secured to an architectural element from below. Since the top of the relief panel is missing, we cannot tell whether the panel was also clamped on top. A drill was used for outlining the figures and for the folds of the drapery. The texture of the long boxing gloves is indicated through stippling with fine point chisel. The background of the relief and the bodies of the figures are flattened with flat chisels and rasps. Marks of a fine claw are visible on the top of the plinth, while the front surface of the plinth is smoothed perfectly with the use

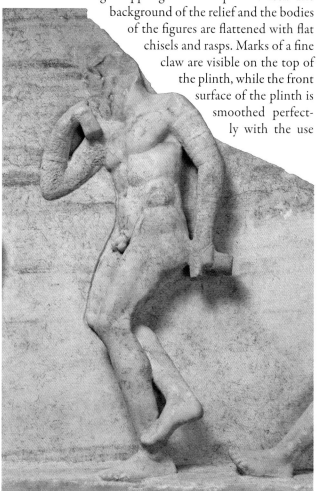

of powder abrasives. There are point chisel marks on the surviving parts of the lateral faces and rough quarry-pick marks on the back of the relief.

DESCRIPTION AND DISCUSSION – Three figures occupy the boxing scene on the relief. On the left, the young beardless figure with short hair and a lock of hair in front of his right ear appears to be the referee. His torso and left leg are shown frontally, while his bent right leg is shown in left profile. He wears a *pallium* thrown over his left shoulder; the excess folds are gathered around his left arm and hang down on his left. His feet are bare and he holds a whip in his right hand. His head is lowered and sharply turned over his left shoulder towards the boxer in the middle, as if in a bowing gesture. Iconographically, the referee is almost identical to the young referee shown in the middle of four boxers on a bas relief recently found in a Roman bath complex at Vareilles in France.[64] His dress, facial features, and the position of his tilted head are also very similar to those of the herald figure on **cat. no. 28**. The large figure in the middle is the victorious boxer, shown in left profile. He is nude aside from his long elaborate boxing gloves. The gloves he wears cover both of his arms and reach up almost to his shoulders. The gloves consist of a sheepskin sheath strapped with bracelet-like bands (perhaps of leather): three on the upper arm and two on the lower arm. The stippling is used to distinguish the curly wool texture of the gloves. The gloves also have brass knuckles with thick cube-like inserts (perhaps of metal) strapped to them with leather thongs; thus they can be classified as Roman *caestus*, a truly dangerous and destructive type of weapon which became popular in boxing during the Imperial period.[65] The right leg of the figure is off the ground behind the left, and the right toes cross in front of the left leg. This specific pose of the boxer conforms with the boxing images (with boxers usually shown on tiptoes) and literary texts that describe the sport as involving lots of choreographic moves in order not to get hit; and thus should not be mistaken for a dance move.[66] Behind him, on the right side of the panel, is another nude boxer wearing

[64] Thuillier (2019, 498, fig. 5) shows the detail of the referee.

[65] See discussion in Chapter 5, p. 87 n. 35.

[66] See discussion in Chapter 5, p. 87 n. 36.

the same type of boxing gloves. Shown in left profile, he appears to be the defeated side as he sits on a small cushion hiding his bruised face in his arms. He has harsh injuries from the *caestus*: a cauliflower ear, swollen eyes, and a swollen nape. Clearly the scene on the relief refers to a boxing game during an agonistic festival, with the victorious athlete shown in the middle. Boxers are typical of the Roman agonistic imagery, easily identified by their gloves; they appear during the match or aftermath when being crowned.[67] What is quite unique on the Nicomedia relief is the fact that both the winning athlete (even though head is partially missing) and the referee are shown with their heads solemnly lowered down as if in divine presence. This is also the case for the herald on **cat. no. 28**.

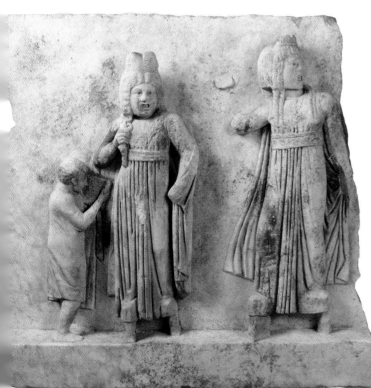

33. TRAGIC ACTORS AND A PROMPTER

Mus. Inv. No. ÇKBĞ 2009/5, Exc. Inv. No. ÇKBĞ 2009/5, TÜBİTAK No. 32, Mus. New Inv. No. 2018–27

DIMENSIONS – Height: 104, Length: 118, Thickness of the Block: 21, Depth of the Relief: 10, Height of the Plinth: 15 cm

EXTANT CONDITION – Found on the south-eastern part of the excavated area in 2009 having fallen on its plinth, standing upright. The right side-end of the relief panel is broken, while most of the left side-end is preserved with a

small missing part in the middle. The actor on the right is missing the left arm from below the shoulder and the right arm from the elbow. There is a small cracked section in the middle of the long dress of the actor in the middle.

Hues of red are visible on the hair and tunic of the prompter on the left, and on the tunic and the hair of the mask of the actor in the middle. Traces of yellow are visible on the cloak of the actor on the right. Yellowish-brown patterns on the right leg of the actor on the right and on the background of the relief are stains due to deterioration.

TECHNICAL DETAILS – The relief panel is broken on the right side-end but preserves most of the left side-end, which still carries traces of point chisel marks. There are also rough point chisel marks on the top surface; the shallow rectangular cutting (2 cm in depth) on the left corner of the top surface is for a now-lost lateral clamp. Other tool marks visible on the panel include those of a drill used for the outlining of the figures, the details of the drapery folds, and the holes in the masks; flat chisels for the background of the figures; claw chisels for the top surface of the plinth; flat chisels, rasps, and abrasives for the smooth front surface of the plinth; and a quarry pick on the back of the panel.

DESCRIPTION AND DISCUSSION – On the relief panel, two elaborately dressed tragic actors stand frontally while a bearded prompter, dwarfed by the grandiose size of the actors, reads to them from a scroll on the left. The prompter, shown in right profile, wears a knee-length *pallium* which covers all of his body. The excess folds and one edge of the *pallium* hang at his left side. He also wears thin-soled sandals with thin straps meeting to form a band around the ankle. He reads from a scroll which he has unrolled with his right hand. Obscured by the open scroll, his left arm is not carved. The actor in the middle wears a tight, sleeved tunic and a

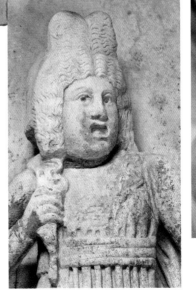

67 See discussion in Chapter 5, p. 87 n. 37.

very long sleeveless dress with the head of Medusa above the chest. The elaborate dress with the tightly packed vertical pleats (reminiscent of the flutes of a Doric column) is fastened with a broad belt below the breast line. The broadness and the horizontal bands (formed with incised lines) of the belt might indicate that a metal belt is depicted. On top of this dress, the actor also wears a cloak which covers his left hand and most of his left arm. With his right hand the actor holds an object that extends from behind the right shoulder and appears to be a garland. The wavy hair of the tragic mask is parted into two halves, with curly hair strands falling over the torso on both sides. The eyes and mouth of the mask are widely cut to allow the actor to see and speak through

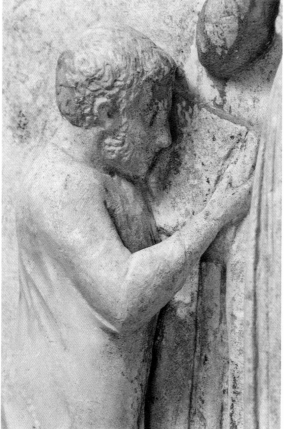

curly *onkoi*) and high-platformed buskins, this specific style of sleeveless belted dress also seems to have been a conventional item of tragic costume. On a later third-century sarcophagus of Proconnesian marble from Rome, Melpomene, the Muse of tragedy, wears the same sleeveless dress with a large belt among the other Muses.[70] Thus both actors on the Nicomedia relief panel reflect the conventionalized, formal, and elaborately decorated costume of the tragic actor in Roman theatre.[71] There is no inscription to identify the specific tragic play represented on the relief, but there are some visual cues: the actor in the middle holds a garland-like object, the actor on the right wears a crown-like fillet, and both actors have Medusa heads on the chest of their dress. In the absence of

the mask. The exaggeratedly large *onkos* (the headpiece above the forehead of the mask); the high-platformed *kothornos* (tragic buskin); and the long, sleeveless, belted dress which even covers half of the *kothornoi* make the actor seem very tall. This may be a reference to his acting in a very large theatre in which the added height from the specific tragic costumes is used to increase the visibility of the actors. The other tragic actor on the right is slightly taller than the one in the middle and is dressed almost identically, except for his more elaborate belt with spiral and floral designs instead of horizontal incisions. His body is shown frontally, while his head with a large tragic mask is shown in right profile, turned over his left shoulder. His tragic mask is a variation of the one in the middle, with a very conventional tragic hairstyle with vertical lines of corkscrew curls framing the face. A circular fillet, perhaps referring to a diadem, crowns the *onkos*. The style of the mask with a large open mouth, clean-shaven face, and high *onkos* with corkscrew curls and a fillet on top are typical of the masks of young tragic heroes, as shown on other known Roman depictions.[68] For example, the tragic actor representing young Orestes on a third-century wall painting from Ephesus (with labels of characters) wears not only an almost identical tragic mask, but the same high *kothornoi* and the long sleeveless belted dress.[69] Besides the distinctive masks (with open mouths and tall

labels, though, we cannot say more than that the actors represent two young heroes.

The existence of an adult prompter reading from a scroll on the relief is unparalleled.[72] It is difficult to imagine a prompter actually on stage. His inclusion in the scene might have been used to upscale the actors physically and mentally for the audience. The scroll he is reading from might be a reference to a reliance on an original written Greek tragedy of the past. The contemporary form of the written word would be a codex, as seen in an imperial scene on **cat. no. 22**, and so the scroll may represent an older textual format and theatrical tradition.

The representation of Greek tragic actors on this relief panel can be associated with the imperial propaganda of the Nicomedia frieze as a whole, since the theatre, as a part of agonistic festivals, became an emblem of civic pride and imperial propaganda in Roman Asia Minor. As such, the Sebasteion, the imperial cult building of Aphrodisias, welcomes the worshippers with a frieze of forty masks that decorate the first storey of its propylon.[73] The images of Emperor Septimius Severus and his family decorate the agonistic frieze of the *scaenae frons* of the theatre at Hierapolis.

68 See Green and Handley 1995, 94–95, figs 69 and 71.

69 Strocka 1977, 48, no. 65.

70 Green and Handley 1995, 101, fig. 76.

71 See discussion in Chapter 5, p. 87 n. 39.

72 See discussion in Chapter 5, p. 87 n. 41.

73 Jory 2002.

34. THE CHARIOT RACE

Mus. Inv. No. ÇKBĞ 2009/1, TÜBİTAK No. 34,
Mus. New Inv. No. 2018–29

DIMENSIONS – Height: 70, Length: 45,
Thickness of the Block: 11, Depth of the Relief:
6 cm

EXTANT CONDITION – The relief possibly
belongs to the middle part of a larger panel bro-
ken on all sides. There is no available informa-
tion on its find-spot. Aside from the intact left
leg of the horse in the middle, the lower legs of
all three horses on the bottom register of the
relief are missing. Only the head of the fourth
horse and the back of a charioteer on the right
survive. On the top register, the bottom part of
a chariot with a wheel and one leg of the chariot-
eer as well as ten hooves and lower legs of horses
survive.

Hues of red are visible on the chariot, on the bridles of
the horses, and on the belt of the charioteer.

TECHNICAL DETAILS – Unlike the other relief panels
discussed so far, this relief is carved from a thinner marble
block (11 cm in thickness) and has smaller figures arranged
in two registers. The protruding horizontal band (3.5 cm in
height) between the two registers also serves as the ground
level for the figures on the top register. A drill has been used
for the outlining of the figures, and the drill holes are still
visible next to the hooves of the horses on the left of the top
register. The background of the figures is flattened with flat
chisels and rasps. Rough pick marks are visible on the back
of the relief.

DESCRIPTION AND DISCUSSION – The two-part relief
is part of a larger panel which seems to have had a lively de-
piction of a chariot race on it. On the left of the top section
there are four horse legs and the lower part of a horse-drawn
chariot with a six-spoked wheel. On the chariot, the left leg
of a charioteer standing and leaning forward is visible. The
horses and thus the chariot are directed towards the left. On
the right of the top section, five lower halves of horse legs
appear diagonally standing on a stylized slanted floral plat-
form which appears to consist of five leaves. On the left of
the lower register four overlapping horses face towards the
right. The front bodies of three of these horses (with their
mouths open) can be seen, while only the head of the horse
on the far left survives. All the horses wear harnesses. Their
irises are carved on the top border of their eyes. Thus, they
appear to be looking up, perhaps towards the chariots on
the top register ahead of them in the race. All the legs are
broken from the knee except for the left foot of the second

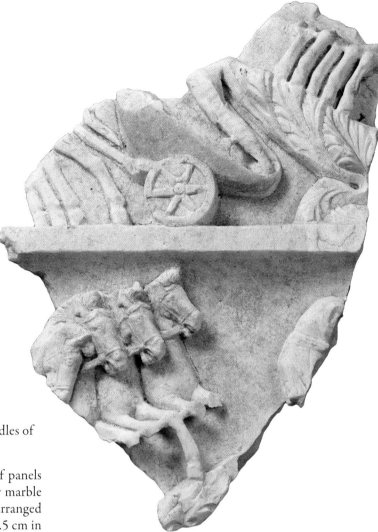

horse from the left. The open mouths and the overlapping
legs in movement indicate that they are in full action in the
middle of the race. The surviving part of a leaf at the bot-
tom indicates that these horses, like the horse legs in the up-
per section, probably stand on a stylized floor with a plant
motif. In front of the horses, on the right, the arched back
of a charioteer, who possibly controls another chariot with
four horses (which did not survive) is visible. He is shown
in movement with his back hunched in a race. He appears to
wear a typical charioteer's tunic fastened with a broad belt
under the breast.

The four-horse chariot race was one of the most popu-
lar spectacles of Roman festivals and continued into the
Byzantine period. Even after the decline and later abolition
of agonistic festivals in the fourth century (banned either
by Theodosius I in AD 393 or by Theodosius II in AD 420
or 435), chariot races continued as part of the circus spec-
tacles.[74] Indeed, a very similar depiction of a chariot race

[74] Remijsen (2015) thoroughly discusses the end of Greek ath-
letics in Late Antiquity. On p. 169 she discusses the continued popu-
larity of the horse races within the new concept of circus spectacles.
Also see Graf 2015 for the transformation of agonistic festivals from
the early Imperial period to Middle Byzantine period, including in
the Greek East.

appears on the lower register of the south face of the pedestal of the obelisk erected by Theodosius I in Constantinople. Like the Nicomedia relief, the charioteers on the relief from Constantinople appear with arched backs and the horses appear in full action with charged front legs. On the multi-registered Nicomedia relief, however, the race appears to take place in a circus or a stadium in a counterclockwise direction. The protruding band in between the two registers appears almost like a *spina* around which charioteers raced in a hippodrome. Indeed, a circus is among the public structures Lactantius (*De mort. pers.* VII.8.10) mentions as being built by Diocletian in Nicomedia.

This relief clearly relates to **cat. nos 35, 36, and 37**, which also appear to be fragments of a multi-registered relief panel with the theme of a chariot race.

and the string of the whip; H: 17 cm and L: 20 cm; the fragment with the lower body of the charioteer; H: 28 cm and L: 17 cm. The face, left arm from the shoulder, and lower left leg of the charioteer are chipped off. All together the relief seems to form the upper right corner of a relief panel framed with protruding rectangular bands running along the right side and the top. There is no available information about the find-spot. There are chipped parts on the top border and side border on the right.

Yellow paint is visible on the helmet of the charioteer, while red paint is preserved on his hair under the helmet, on his belt, and on the string of the whip.

TECHNICAL DETAILS – The small scale of the charioteer on the relief and the protruding bands on the right end and on top suggest that the relief could belong to the broken right side of **cat. no. 35** or less likely another related (now missing) relief panel depicting a chariot race with small-scale figures. Tools used include a drill for outlining the figures and flat chisels and rasps for smoothing the background on the front surface. About 2.5 cm of the top band, the part closer to the figured plane, has been worked with a small flat chisel, almost forming another smoother and smaller band at the bottom of the top border.

35. A CHARIOTEER

Fragment with the lower body of the charioteer: Exc. Inv. No. ÇKBĞ 2009/94, TÜBİTAK No. 37, Mus. New Inv. No. 2018–32, the fragment with the head and hand of the charioteer: TÜBİTAK No. 35, Mus. New Inv. No. 2018–30, the fragment with the string of the whip TÜBİTAK No. 39

DIMENSIONS – Height: 30 (approximate height of the relief when all surviving pieces are combined), Length: 50 (approximate length of the relief when all surviving pieces are combined), Thickness of the Block: 13.5, Depth of the Relief: 5, Height of the Top Band: 8, Width of the Side Band: 5 cm

EXTANT CONDITION – The relief consists of two restored fragments with the upper body and head of a charioteer, and two other separate fragments: one with the string of his whip and the other with his arched back. Dimensions of the restored part from the left side of the relief are H: 23 cm and L: 28 cm. Dimensions of the separate fragments are as follows: the fragment with the part of the top band

DESCRIPTION AND DISCUSSION – The relief contains most of the upper body of a charioteer shown in an active stance during a race. His back is arched and in his raised right arm he holds a whip to control the horses. He also wears a bowl-like yellow-coloured helmet. The folds on his right arm and upper left leg indicate that he wears a sleeved garment and trousers under his belted tunic. His outfit shows how the charioteer whose arched back survives on **cat. no. 34** would have looked. If this relief is a part of **cat. no. 34**, the charioteer might be the one controlling the horses whose lower legs are visible on the top right corner of **cat. no. 34**. Also related both in technical and thematic terms to this relief are **cat. nos 36 and 37**, which also bear small-scaled horses, a top border worked with flat chisels (**cat. no. 37**), and a side border (**cat. no. 36**). All of these reliefs, **cat. nos 34 to 37**, could be parts of the same larger relief depicting a chariot race, but it is impossible to reconstruct due to missing parts in between the surviving fragments.

36. FRAGMENT WITH HORSES IN A CHARIOT RACE

TÜBİTAK No. 38, Mus. New
Inv. No. 2018–33

DIMENSIONS – Height: 34.5, Length:
19, Thickness of the Block: 12, Depth of
the Relief: 3.5, Width of the Side Band:
5 cm

**EXTANT CONDITION AND TECHNICAL
DETAILS –** The relief is a fragment from the
right side of a larger panel with a protrud-
ing side band 5 cm in width, and is possibly
related to **cat. nos 34, 35, and 37.** Rasps and
flat chisels are used for the background of the
relief panel. Drill holes are visible under the hooves. There
is no available information about its find-spot. There are no
traces of polychromy visible.

DESCRIPTION AND DISCUSSION – Five legs of run-
ning horses and the mouth and nose of a harnessed horse are
partially preserved on the relief. Three of the horse legs stand
out clearly from the background and the two just above and
below the horse's nose are very low relief. The diminutive
scale, the band along the side of the relief, and the theme
suggest that the horses partially preserved on this fragment
are part of the chariot race depicted on **cat. no. 34.**

37. FRAGMENT WITH HORSE HEADS

Exc. Inv. No. ÇKBĞ 2009/37, TÜBİTAK No. 36,
Mus. New Inv. No. 2018–31

DIMENSIONS – Height: 24, Length: 18.5, Thickness of
the Block: 12, Depth of the Relief: 3, Height of the Top
Band: 7.5 cm

EXTANT CONDITION AND TECHNICAL DETAILS –
The relief is a fragment from a larger relief panel with a pro-
truding rectangular band on top. There is no available informa-
tion about its find-spot. The small-scale horse heads preserved on
the relief as well as the top band, the lower part of which (that is, the
part close to the figured plane) is smoothed with a small flat chisel just
like on **cat. no. 35,** suggest that the fragment is related to **cat. nos 34, 35,
and 36.** Thus, the heads of three horses partially preserved on the relief are
highly likely belong to a chariot race scene.

Red colour is preserved on the bridle bands strapped around the noses and
foreheads and along the cheeks of the horses. Besides a flat chisel, a drill was used
for outlining the heads.

DESCRIPTION AND DISCUSSION – The fragment has the heads of three overlap-
ping horses, the one on the far left only very partially preserved. With eyes directed up
above, open mouths, and a red-coloured bridle strapped around each of their heads, the
horses resemble the ones on **cat. no. 34.** They could be the horses of the racing charioteer
with a whip in hand on **cat. no. 35,** but in the absence of any connecting piece between the
two surviving fragments, this fragment with horse heads is catalogued separately.

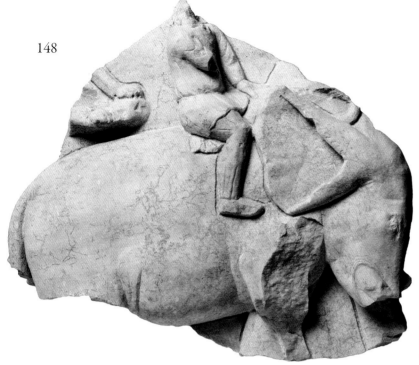

38. ELEPHANT RELIEF

Mus. Inv. No. ÇKBĞ 2009/55, Exc. Inv. No. ÇKBĞ 2009/97, TÜBİTAK No. 33, Mus. New Inv. No. 2018–28

DIMENSIONS – Height: 62, Length: 69, Thickness of the Block: 17, Depth of the Relief: 7 cm

EXTANT CONDITION – The broken relief was found underneath a large architectural block, close to **cat. nos 9 and 19** on the north-eastern corner of the excavated area during the 2009 excavations. It is broken on all sides. The trunk, tusks, and legs of the elephant and the head and right lower arm of its rider are missing.

Red paint is visible on the trousers of the rider. Inspection under infrared light also revealed traces of Egyptian blue on the elephant's chain, which the rider is holding above the head of the elephant.

TECHNICAL DETAILS – Figures are outlined with the use of a drill. Further drill marks can be seen on the paws of the feline on the top left corner. Flat chisels were used for smoothing the skin of the elephant and the background of the relief. The size of the rider is smaller compared to the other human figures represented elsewhere on the frieze (the total height of the rider, including missing head, could not have been more than 38 cm). The size of the elephant is also smaller. The remnant of another ground level on which paws of a feline are visible suggests an unusual composition on this relief, similar to the arrangement of the charioteers on the **cat. nos 34 and 35**, with smaller figures shown in multiple levels.

DESCRIPTION AND DISCUSSION – An elephant driven by a mahout occupies the centre of the broken relief panel. The large ears and the straight back of the elephant suggest that this is an African elephant, not Asian. Both Asian

and African elephants are represented in Roman art: Asian elephants usually with smaller ears, smaller heads, and convex backs, while African elephants usually have larger ears, and concave or straight backs.[75] The mahout riding the elephant wears trousers and a thigh-length belted tunic with long sleeves. He sits on a saddle holding the chain of the elephant in his left hand. On the upper left corner above the elephant, two paws and the lower left front leg of a feline standing on a separate ground level survive. Both animals are directed towards the right as in a processional scene.

Elephants used in Hellenistic and Roman Republican warfare, in spectacles including *venationes* (circus games with elephant and lion fights), and processions in the Imperial period are not alien to Roman society and were frequently depicted in the related contexts in Roman art.[76] The elephant and the feline animal on this broken Nicomedia relief might have been part of a triumphant processional scene.

39. ATTACKING WARRIOR (STOLEN AND FOUND AS A FRAGMENT)

Mus. Inv. No ÇKBĞ 2009/53, Exc. Inv. No. ÇKBĞ 2009/95, TÜBİTAK No. 51

DESCRIPTION AND DISCUSSION –

This broken piece of relief, which appears to be from the top part of a larger relief panel, was found at the western corner of the site in 2009, and was stolen immediately after. The dimensions of the relief in the Kocaeli Archaeology Museum archives appear as 40 cm in height and 73 cm in length. According to the photograph taken at the time of the rescue excavation in 2009, the relief preserves a warrior holding a sword in his upraised right hand. He wears a sleeved tunic and a cloak over the tunic.

[75] Toynbee 1973, plates 1–12; Scullard 1974, 23–24.

[76] See discussion in Chapter 5, pp. 85–86.

Hues of red for the hair, lips, and the sleeved tunic; yellow for the handle of the sword; and blue for the blade of the sword are visible in the photograph.

Thematically, this stolen relief might have been related to **cat. no. 10**, on which a lively depiction of a combat is shown. In 2018, a criminal investigation for a murder in Izmit revealed an ancient head, which appears to be the head of the warrior on this stolen relief. Smugglers seem to have cut out the head of the warrior from the rest of the panel, possibly for easy transport. The lively colours of the figure have faded away since the initial discovery of the relief, but red is still visible on the hair of the warrior.

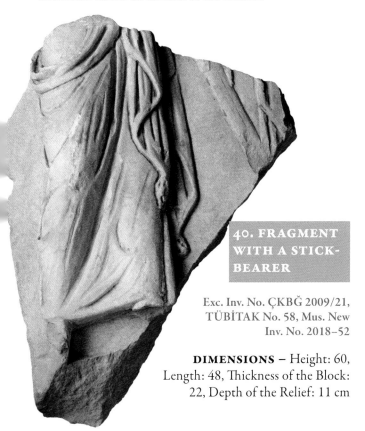

40. FRAGMENT WITH A STICK-BEARER

Exc. Inv. No. ÇKBĞ 2009/21, TÜBİTAK No. 58, Mus. New Inv. No. 2018–52

DIMENSIONS – Height: 60, Length: 48, Thickness of the Block: 22, Depth of the Relief: 11 cm

EXTANT CONDITION – The relief panel is broken on all sides, with only the lower body of a figure, holding a stick (spear? or sceptre?), preserved. A small portion of the plinth on which he originally stood and a small part of the dress of another figure on the right are preserved. The upper body and the feet of the stick-bearer are missing. There is no available information about its find-spot.

Yellow is visible on the stick, while red is preserved on the surviving folds of the drapery of the other figure on the right corner of the block.

TECHNICAL DETAILS – Tooth chisel marks on the left side of the panel next to the broken feet and the plinth indicate that this left bottom corner side of the relief panel is part of the original left lateral face. The stick-holding figure must have been the first figure on the left of the original panel. A concave

cutting on the left side, above the tooth chisel marks and in line with the hip of the spear-bearer, must have been intended to fit the block into its original architectural setting. (A very similar concave cutting appears on the bottom of **cat. no. 17**.) A drill was used for outlining the figures and for the folds of drapery. Flat chisels and rasps were used for smoothing the background of the figures on the front of the panel. There are rough quarry-pick marks on the back of the panel.

DESCRIPTION AND DISCUSSION – The fragment has the lower body of a figure shown in three-quarter view facing towards the right. He wears a large ankle-length cloak wrapped around his lower body with overfolds gathered possibly over his missing left arm and hanging down on his left side. The circular folds over his right upper leg indicate that the cloak was probably draped over the figure's left shoulder while leaving the right side of the torso completely bare, very much like the crowned, possibly divine figure on **cat. no. 3**, and like Poseidon on **cat. no. 26**. The tip of his left hand holding the stick is still visible. Next to the stick on the right are red folds of drapery, possibly belonging to another, now-missing figure on the right side of the panel. The dress and the sceptre-like stick painted in yellow (as imitation of gilding) of the surviving figure, who must have been the first on the left of a larger relief panel, suggest his divine identity.

41. FRAGMENT WITH THE TIP OF A SCEPTRE

TÜBİTAK No. 55, Mus. New Inv. No. 2018–49

DIMENSIONS – Height: 38, Length: 64, Thickness of the Block: 26, Depth of the Relief: 12, Height of the Plinth: 14 cm

EXTANT CONDITION – The relief fragment was found during the 2001 rescue excavation and initially published by Zeyrek and Özbay.[77] Broken on three sides, it is the bottom

[77] Zeyrek and Özbay 2006, 297, Abb. 14.

part of a larger relief panel. The top part of the sceptre in the middle is missing. Portions of both figures' legs are also missing: the figure on the left is missing the tip of his right foot as well as his left leg above the foot, and the figure on the right is missing his leg from above the ankle.

There is no polychromy visible today, but Zeyrek and Özbay mention red paint visible on both shoes in 2001.

TECHNICAL DETAILS – Traces of a tooth chisel applied diagonally are visible on the front surface of the plinth, while the top part of the plinth is flattened with flat chisels. A drill has been used to outline the figures. Rough point chisel marks are visible on the back and bottom of the relief panel.

DESCRIPTION AND DISCUSSION – Three feet belonging to two figures standing frontally and the tip of a sceptre in the middle are visible on the fragment. The sceptre might belong to the figure on the left, whose two feet with soft shoes are preserved. His surviving right ankle and lower leg with fabric-like folds/creases on his calf suggest that he was wearing trousers. From the figure on the right, only the right foot from the ankle down is preserved. He also wears trousers. The sceptre with a knobbed end is very similar to that of the imperial figure giving or receiving a codex on **cat. no. 22.** If we accept the sceptre as a signifier of divine identity, an association with Jupiter or with *Jovius* Diocletian is plausible for the figure on the left. But because of the very fragmentary nature of the relief panel, it is hard to draw a conclusion.

42. FRAGMENT WITH FOUR FELINE PAWS

Exc. Inv. No. ÇKBĞ 2009/67, TÜBİTAK No. 65, Mus. New Inv. No. 2018–59

DIMENSIONS – Height: 21, Length: 23, Thickness of the Block: 23, Depth of the Relief: 13, Height of the Plinth: 9 cm

EXTANT CONDITION – The fragment was found in the mixed dirt pile on the central/south-western part of the excavated area in 2009. It has the four paws of a feline standing on the plinth of the original relief panel, the rest of which is now missing. The front paw on the right and the back paw on the left are chipped.

There are no traces of polychromy visible.

TECHNICAL DETAILS – There are tooth chisel marks on the surviving section of the front surface of the plinth. Next to the back paw on the right is a line made with a drill, possibly an outline for part of another figure that is now missing.

DESCRIPTION AND DISCUSSION – The paws belong to a feline, perhaps a lion, seated frontally with front legs straight and back legs bent. Each paw appears to consist of three toes. Claws are also depicted on the back paw on the right. The fragment could also show the feet of a stool, a small throne, or another piece of furniture.

43. FRAGMENT WITH THE LEG OF A FALLEN WARRIOR

TÜBİTAK No. 45, Mus. New Inv. No. 2018–40

DIMENSIONS – Height: 28, Length: 60, Thickness of the Block: 26, Depth of the Relief: 7, Height of the Plinth: 14 cm

EXTANT CONDITION – The relief is broken on all sides; only the lower leg of a fallen warrior, resting on the surviving part of the plinth, is preserved. There is no available information about its find-spot.

A bright red colour, perhaps originally a tone of cinnabar, is visible on the trousers and the soft shoe.

TECHNICAL DETAILS – Marks of a tooth chisel are visible, applied diagonally from right to left on the front surface, and applied from left to right on the top of the plinth.

DESCRIPTION AND DISCUSSION – The orientation of the lower right leg of the warrior indicates that he was shown as having fallen on his right side, perhaps in a combat scene. He wears trousers and soft shoes, and he is parallel to the similarly dressed fallen enemies on the larger combat scene on **cat. no. 10**. Thus, he probably fulfils a similar iconographic function.

44. FRAGMENT OF A FALLEN WARRIOR

Exc. Inv. No. ÇKBĞ 2009/61, TÜBİTAK No. 46, Mus. New Inv. No. 2018–41

DIMENSIONS – Height: 25, Length: 52, Thickness of the Block: 22, Depth of the Relief: 5, Height of the Plinth: 14 cm

EXTANT CONDITION – The relief is broken on all sides, preserving only the lower body of a fallen warrior lying on the plinth. There is no available information about its find-spot.

The colour yellow is preserved on the triangular object projecting out from between the legs of the warrior. Red is visible on the trousers and shoes. The black spot on the tip of the shoe on the left is due to post-antique oxidization.

TECHNICAL DETAILS – The traces of a string course with horizontal mouldings on the back of the block shows that the relief panel is carved from an earlier architectural block, perhaps from the cornice of an entablature just like **cat. nos 2, 5, and 9**. A tooth chisel is used for the front and top surfaces of the plinth.

DESCRIPTION AND DISCUSSION – The relief fragment contains a fallen warrior lying with his bent left leg under his extended right leg. His full right leg and the left foot from the ankle are preserved. He wears tight trousers and soft shoes with a vertical band extending from toes to the ankles. The hem of his thigh-length tunic is also visible on the top right corner of the surviving fragment. A triangular object painted in yellow in between his legs must have been part of an object or figure that extended above the fallen warrior. The fragment might have been part of a combat scene related to **cat. nos 10 and 43**.

45. FRAGMENT WITH SIX FEET: A CAPTIVE SCENE?

TÜBİTAK No. 47, Mus. New Inv. No. 2018–42

DIMENSIONS – Height: 36, Length: 83, Thickness of the Block: 25, Depth of the Relief: 10, Height of the Plinth: 15 cm

EXTANT CONDITION – The fragment is from the bottom right corner of a larger relief block. There is no available information about its find-spot. It contains the feet of three figures. The small foot closest to the front plane of the plinth on the right is preserved only up to the ankle, and only the right side of the foot on the far left is preserved. The other four feet retain their lower legs from below the knee.

Red is traceable on the shoe and trousers of the second leg from the left.

TECHNICAL DETAILS – The right lateral face of the panel is finished with a fine tooth chisel. Both rough pick marks and tooth chisel marks are visible on the back of the

block. The front and top surfaces of the plinth are finished with a tooth chisel. Rasps and a flat chisel are used for the background of the figures on the front of the relief.

DESCRIPTION AND DISCUSSION – The feet of a frontally standing figure are preserved on the far left. He wears soft shoes and trousers. A cracked circular object to the right of his left leg could be the tip of a sword hanging down at his side. The slightly smaller feet of another figure facing the left are visible in the middle. He too wears trousers and soft shoes with a central vertical band extending from toe to ankle. On the right side of the fragment are the lower legs of another figure facing towards the left. His feet and legs are slightly larger than those of the figure in the middle. His right leg is behind the left leg of the small-footed figure in the middle, whose foot is shown closer to the front of the plinth. He also wears trousers and soft shoes. This crowded scene with overlapping feet suggests that the figures may have been bound captives and triumphant Romans as in **cat. no. 3**.

plinth and the background of the figures are smoothed with rasps and flat chisels. There are rough point chisel marks on the back and the bottom of the relief block.

DESCRIPTION AND DISCUSSION – A standing figure is shown frontally with a striding horse directed towards the left behind him. The figure wears trousers and soft shoes with a central vertical band extending from the toe to the ankle. The circular object hanging down on his side on the right might be the tip of his scabbard, indicating that he is a soldier. The two front hooves and one of the back lower legs with the hoof of the horse are preserved. The horse may be shown in motion, striding slowly with the front right hoof in the air. Thus, the relief could have been part of a procession.

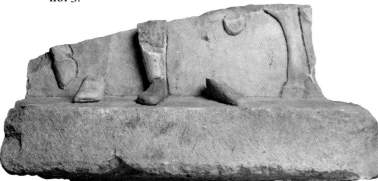

46. FRAGMENT WITH A FRONTAL FIGURE AND A STRIDING HORSE

Exc. Inv. No. ÇKBĞ 2009/89, TÜBİTAK No. 52, Mus. New Inv. No. 2018–46

DIMENSIONS – Height: 40, Length: 79, Thickness of the Block: 23, Depth of the Relief: 13, Height of the Plinth: 13 cm

EXTANT CONDITION – The fragment is the bottom part of a relief panel, broken on both sides and on the top. It only includes the lower legs of a man and a horse. The right leg of the frontal figure in the middle is partially broken from the mid-calf, while his left leg is missing from the ankle up. The second horse hoof from the left has the leg missing. There is no available information about the fragment's find-spot.

Black paint on the shoes and red paint on the circular object (perhaps the tip of a scabbard) are preserved.

TECHNICAL DETAILS – The mark of a drill used to outline the figures is visible. The front surface of the plinth is finished with a tooth chisel, while the top surface of the

47. FRAGMENT WITH A FRONTAL FIGURE

TÜBİTAK No. 53, Mus. New Inv. No. 2018–47

DIMENSIONS – Height: 47, Length: 54, Thickness of the Block: 23, Depth of the Relief: 12, Height of the Plinth: 14.5 cm

EXTANT CONDITION – The fragment is from the bottom of a larger relief panel broken on both sides and on top, preserving only the three feet of two figures standing on the plinth. The foot on the left is broken from the ankle and is also missing the toes; the foot in the middle is also broken from the ankle and the leg on the right is preserved from the knee down but with a large break below the knee. There is no information available about its find-spot.

There are no traces of polychromy visible to the naked eye.

TECHNICAL DETAILS – There are fine tooth chisel marks applied diagonally on the front surface of the plinth. The top surface of the plinth, the feet, and the background of the figures on the front of the relief are smoothed with

flat chisels. Rough point chisel marks are visible on the back. A partially preserved rough concave cutting on the bottom left of the plinth was probably opened to fit the panel into its architectural setting.

DESCRIPTION AND DISCUSSION – The fragment has three feet belonging to two frontally standing figures: the left foot of a figure on the left, and both feet of another figure wearing trousers and possibly soft shoes. The shoes must have been detailed with the use of colour, which is now lost.

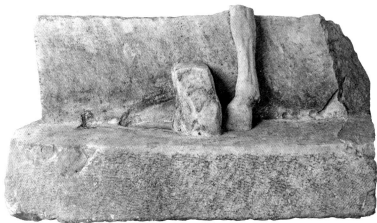

49. FRAGMENT WITH A HORSE'S HOOF AND AN UNKNOWN OBJECT

TÜBİTAK No. 57, Mus. New Inv. No. 2018–51

DIMENSIONS – Height: 38, Length: 67.5, Thickness of the Block: 20, Depth of the Relief: 13, Height of the Plinth: 14 cm

EXTANT CONDITION – This bottom left corner of a block was found in the Kocaeli Archaeology Museum garden along with some small architectural elements that were brought from Çukurbağ in 2009. There is no information available about its original find-spot.

Because of damp conditions and constant exposure to the outside elements until 2015, the fragment is somewhat deteriorated, with algae visible on its surface. Otherwise, there are no traces of polychromy visible to the naked eye.

TECHNICAL DETAILS – The fragment seems to be a corner block of a frieze, with the left side not joined to an architectural element but exposed to viewers, since the plinth continues around the left corner and protrudes out about 6 cm on the left corner. Above the plinth, the left side-end of the relief panel has fine tooth chisel marks. Two different textures are visible on the front surface of the plinth: tooth chisel marks applied diagonally from left to right are visible on most of the surface, but about 2 cm of the top part of the surface (the part closest to the figured plane) is smoothed with a fine flat chisel. A similar treatment to the front surface of the plinth can also be detected on **cat. no. 17**. Flat chisels and rasps are used for the rendering of the figures and their background. Rough pick marks are preserved on the back of the relief fragment.

48. FRAGMENT WITH FEET

TÜBİTAK No. 54, Mus. New Inv. No. 2018–48

DIMENSIONS – Height: 25, Length: 40, Thickness of the Block: 15, Depth of the Relief: 7, Height of the Plinth: 12.5 cm

EXTANT CONDITION – This fragment consists of the bottom right corner of a relief panel broken on the top and the left. The standing figure is missing from the ankles up. There is no information available about the fragment's find-spot.

There are traces of red paint on the soft shoes.

TECHNICAL DETAILS – Fine tooth chisel is used for the top surface of the plinth and the right side-end of the panel, and a thicker tooth chisel is used for the front surface of the plinth. Rough quarry-pick marks are also visible on the back of the fragmentary block.

DESCRIPTION AND DISCUSSION – The fragment preserves the two feet of a standing figure wearing soft red shoes. The feet are apart and are angled out, pointing away from each other. The right foot of the figure steps on and overlaps with a roughly cylindrical object in the background on the left side of the relief, which extends upwards beside the lower leg of the figure. It might be the front-facing foot and lower leg of another figure that is not carved in detail because of the foot in front of it.

DESCRIPTION AND DISCUSSION – The fragmentary relief block has the front hoof and lower leg of a horse next to a rectangular object (perhaps a rock) on the left. The muscles of the horse's leg are well defined. A trace of another object, perhaps another hoof, is visible on the broken right corner of the relief.

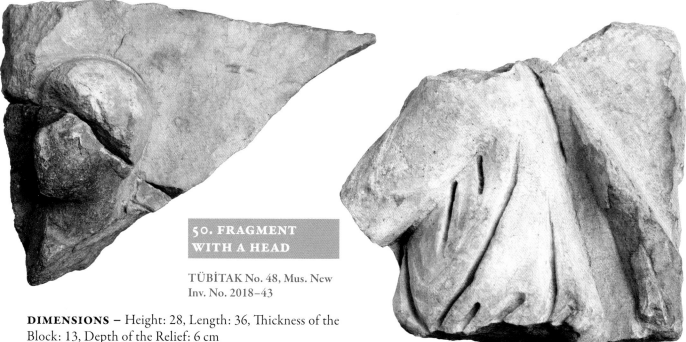

50. FRAGMENT WITH A HEAD

TÜBİTAK No. 48, Mus. New Inv. No. 2018–43

DIMENSIONS – Height: 28, Length: 36, Thickness of the Block: 13, Depth of the Relief: 6 cm

EXTANT CONDITION – The relief fragment is restored from two pieces. The top piece, containing the top of the head of a figure, was found in the closed storage of Kocaeli Archaeology Museum; the bottom piece, with the face and neck of the figure, was found outside in the Museum's garden among small architectural elements from Çukurbağ. As a result, the bottom part has deteriorated somewhat due to moss. There is no information available about the fragment's original find-spot within the excavation area.

On the top part of the head, the parts close to the background plane still retain particles of red paint.

TECHNICAL DETAILS – The fragment is from the top part of a larger relief panel with traces of point chisel marks on the preserved top surface of the block. Also on the top surface, above the head, is a clamp hole measuring 3 cm × 6 cm and about 4.5 cm in depth. A drill was used for outlining the head of the figure.

DESCRIPTION AND DISCUSSION – The head of a figure facing left is preserved on the fragment. The face and the neck are heavily damaged, but the traces of a brooch over the missing left shoulder indicates that he might have originally worn a cloak fastened with a brooch over the left shoulder. The hair is not carved in detail. It might have been painted red without carved texture, or the figure might have been wearing a smooth cap coloured in red.

51. FRAGMENT WITH A CLOAKED FIGURE

TÜBİTAK No. 66, Mus. New Inv. No. 2018–60

DIMENSIONS – Height: 27, Length: 25.5, Thickness of the Block: 21, Depth of the Relief: 8 cm

EXTANT CONDITION – The relief fragment is broken on all sides, preserving only the upper left arm and the torso of a figure. The head, lower body, and left hand of the figure are missing. There is no information available about the fragment's exact find-spot.

The are particles of red paint visible on the sleeved arm of the figure.

TECHNICAL DETAILS – Marks are visible from a drill used for rendering the folds of the tunic.

DESCRIPTION AND DISCUSSION – The fragment has the upper body of a figure in left profile. The figure wears a sleeved tunic and a cloak hanging down from behind the right shoulder. The drapery does not cling to the body, but swells loosely, especially at the back. The folds of the tunic are rendered in different sizes and face different directions and the cloak billows out, indicating that the figure was shown in some sort of action.

52. FRAGMENT WITH A FIGURE WITH LEFT ARM RAISED

Exc. Inv. No. ÇKBĞ 2009/68, TÜBİTAK No. 49,
Mus. New Inv. No. 2018–44

DIMENSIONS – Height: 59, Length: 39, Thickness of the Block: 15, Depth of the Relief: 3 cm

EXTANT CONDITION – The fragment is from the top of a larger relief panel, broken on both sides and at the bottom, while the original top screen is partially preserved. The head, the extended arm, and the upper torso of the figure are all chipped off. There is no information available about its exact find-spot.

There are no traces of polychromy visible to the naked eye.

TECHNICAL DETAILS – There are point chisel marks on the top screen of the relief block. The background of the damaged figure on the front is flattened with flat chisels and rasps.

DESCRIPTION AND DISCUSSION – The fragment has the traces of a standing figure with an upraised left arm. It could have belonged to a scene involving action and movement, such as a combat scene.

53. FRAGMENT WITH ARMS

Exc. Inv. No. ÇKBĞ 2009/62, TÜBİTAK No. 50,
Mus. New Inv. No. 2018–45

DIMENSIONS – Height: 28, Length: 32, Thickness of the Block: 10, Depth of the Relief: 3 cm

EXTANT CONDITION – The relief fragment is from the top of a larger relief panel broken on both sides and at the bottom. There is no information available about its find-spot within the excavation area.

A slight residue of red paint is visible on the outstretched arm.

TECHNICAL DETAILS – Point chisel marks on the top surface of the fragmentary relief indicate that this is the original top screen. Traces of flat chisels and rasps used to smooth the background of the projecting figures are visible.

DESCRIPTION AND DISCUSSION – The relief fragment preserves an outstretched left forearm of a figure being grasped by the right hand of another figure reaching from below. The hand of the outstretched left arm and the object it once held are chipped off. The forearm of the grasping right hand is shown from the inside, and the hem of a sleeve is visible right above the wrist. The fragment could have belonged to a combat scene or a scene with captive barbarians.

54. A TREE TRUNK

TÜBİTAK No. 68, Mus. New Inv. No. 2018–62

DIMENSIONS – Height: 53.5, Length: 33.5, Thickness of the Block: 16.5, Depth of the Relief: 5, Height of the Plinth: 16.5 cm

EXTANT CONDITION – The fragment is from the bottom right corner of a relief block with a plinth. It is broken on the left side and on top. There is also a little chipping on the right side-end. There is no information available about its find-spot within the excavation area.

Red is preserved on the broken cushion-like object resting on the plinth on the left, and yellow paint is used for the stick-like object (perhaps a spear) that extends up behind the red object next to the tree trunk. Brownish-red colouring is also traceable on the trunk.

TECHNICAL DETAILS – Tooth chisel marks, applied horizontally and slightly smoothed with the use of a rasp, are visible on the front surface of the plinth. The top surface of the plinth also retains tooth chisel marks, applied vertically. Rasps are used to smooth the background on the front surface of the relief panel. The right end of the block still has fine point chisel marks on the part of its surface that is closer to the back plane (despite the breakage on the part near the figured plane), indicating that this is the original right lateral face of the missing larger block.

DESCRIPTION AND DISCUSSION – The fragment has the bottom of a tree trunk with a worm-shaped cavity extending up from the root and revealing the inner bark of the tree. Together with the small stub of a pruned tree branch on the left, this cavity might indicate the old age of the tree, since such cavities are usually caused by the self-pruning of the branches of old trees. To the left of the tree trunk is a red cushion-like object, parted into two halves, and with a horizontal incision on its side section. This incision in the middle, the length, and the tabular shape rule out the possibility that the object could be the front part of a soft shoe of a missing figure. The yellow stick is possibly part of a spear, very much like that of the weary soldier on **cat. no. 11**. Indeed, another (somewhat larger) tree with a pruned branch can also be seen in front of the heavily loaded mule on **cat. no. 11**. This suggests that **cat. nos 11 and 55** might have been thematically related.

55. FRAGMENT WITH LEAVES

TÜBİTAK No. 69, Mus. New Inv. No. 2018–63

DIMENSIONS – Height: 44, Length: 26, Thickness of the Block: 13 cm

EXTANT CONDITION – This highly deteriorated fragment was found in the Kocaeli Archaeology Museum garden in a pile of architectural pieces brought from Çukurbağ. There is no information available about its find-spot within the excavation area. It is broken on all sides.

No colour is preserved. Greyish-green algae is visible on its front surface due to damp conditions.

TECHNICAL DETAILS – A drill and the tip of a flat chisel have been used for the rendering of the leaves.

DESCRIPTION AND DISCUSSION – Five leaves of a plant or a tree are visible on the fragment. The leaf on the far left is slightly rounded but nearly rectangular in shape, just like the leaves on **cat. no. 11**. The leaf next to it is chipped off. Following the missing leaf are four other leaves. Two of these in the middle are differentiated from the others by the use of the tip of a flat chisel, as well as by their slenderer and longer forms, which are narrower at the bottom and become wider towards the top. The fragment is evidence for the existence of another relief block depicting a landscape on the Nicomedia frieze.

56. FRAGMENT WITH A BILLOWING SKIRT

TÜBİTAK No. 59, Mus. New Inv. No. 2018–53

DIMENSIONS – Height: 32, Length: 67, Thickness of the Block: 22, Depth of the Relief: 13 cm

EXTANT CONDITION – Broken on all sides, the fragment preserves the right leg and the billowing skirt of a figure and a small portion of the background of the relief on the right. There is no information available about its find-spot.

No polychromy is visible.

TECHNICAL DETAILS – A drill was used for the folds of the drapery; a flat chisel and rasps were used for the smooth parts of the drapery. Rough point chisel marks are visible on the back of the fragment.

DESCRIPTION AND DISCUSSION – The fragment has the billowing hem of the dress of a figure directed towards the right. The right leg of the figure is visible from underneath the clinging part of the dress. The billowing hem of the drapery and the stretched right leg are indicative of the figure's rightward motion. The style of the drapery is similar to that of the small miniature Victory in the hand of the goddess Roma on **cat. no. 17**. The fragment might have belonged to a larger Victory, just like the Victory on **cat. no. 20**. Thus, it might have been part of an imperial scene.

57. TORSO OF A VICTORY

TÜBİTAK SRF No. 46, Mus. New Inv. No. 2018–71

DIMENSIONS – Height: 26, Length: 15, Depth of the Relief: 13 cm

EXTANT CONDITION – Two separate fragments form the upper body of a female figure. They were found in the Kocaeli Archaeology Museum garden with the architectural fragments that were brought from Çukurbağ in 2009 and kept outside until 2016. Exposure to rain and other outside weather conditions resulted in the discoloration and algae on the surfaces. There is no information available about its find-spot within the excavation area.

No polychromy is visible.

TECHNICAL DETAILS – A drill, flat chisels, and rasps were used for the carving of the figure.

DESCRIPTION AND DISCUSSION – The fragments retain the torso, hip, and upper right leg of a female figure shown in right profile. The missing upraised right arm was probably holding something. The figure, possibly a Victory, wears a thin chiton through which the contours of the body, including the navel, can be seen. The chiton is fastened over the left shoulder, leaving the right shoulder and breast bare; and forming a semicircular fold under the right breast. The fragment is too small to belong to the top part of **cat. no. 56**. The dress, small scale, and the upraised hand iconographically relate this Victory to the small Victory in the hand of Roma on **cat. no. 17**, crowning a figure on the right. Thus, the fragment might be part of an imperial scene.

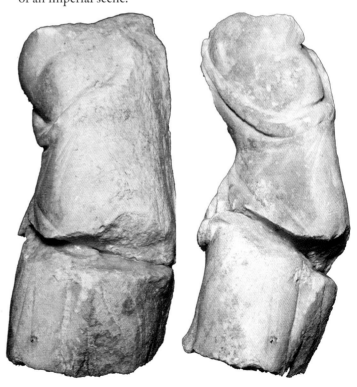

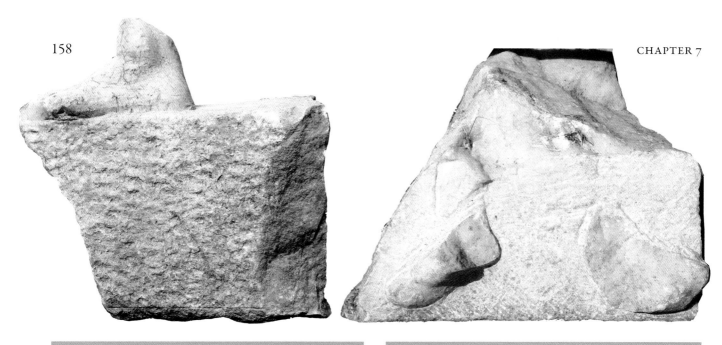

58. FRAGMENT WITH A BARE FOOT ON A PLINTH

TÜBİTAK No. 61, Mus. New Inv. No. 2018–55

DIMENSIONS – Height: 22, Length: 23, Thickness of the Block: 10, Depth of the Relief: 5.5, Height of the Plinth: 14 cm

EXTANT CONDITION – The fragment is broken on all sides except for the bottom, preserving only a piece of a plinth and the foot of a standing figure, broken just above the ankle. There is no information available about its find-spot.

There is no visible polychromy.

TECHNICAL DETAILS – On the front surface of the plinth there are marks of a round chisel applied horizontally. Fine tooth chisel marks are visible on the top surface of the plinth next to the foot.

DESCRIPTION AND DISCUSSION – The fragment preserves the bare left foot of a figure directed towards the left. It is impossible to determine the identity of the figure based on one bare foot, but since all of the imperial figures and captive barbarians on the Nicomedia frieze are shown wearing shoes, this foot might have belonged to an athlete or a mythological figure.

59. FRAGMENT WITH A FOOT AND A SEMICIRCULAR OBJECT

TÜBİTAK No. 62, Mus. New Inv. No. 2018–56

DIMENSIONS – Height: 18, Length: 28.5, Thickness of the Block: 23, Depth of the Relief: 12.5, Height of the Plinth: 14 cm

EXTANT CONDITION – The fragment was found in the pile of architectural pieces brought from Çukurbağ, in the Kocaeli Archaeology Museum garden. There is no information available about its original find-spot within the excavation area. It belongs to the lower right corner of a relief panel and is broken on top and on the left side. There is also a piece chipped off on the bottom part of the plinth.

There is no visible paint.

TECHNICAL DETAILS – Tooth chisel marks applied diagonally are visible on the front surface of the plinth. The fragment also bears point chisel marks on the right end of the plinth and flat chisel marks on the top surface of the plinth.

DESCRIPTION AND DISCUSSION – On the left side of the top surface of the plinth is the front part of a small left foot, and on the right side is the bottom of a larger semicircular object. The toes of the foot are not defined with carving, which indicated that the figure was originally shown wearing a soft shoe, with details possibly rendered with paint.

60. FRAGMENT WITH THE RIGHT LEG OF A MISSING FIGURE

TÜBİTAK No. 63, Mus. New Inv. No. 2018–57

DIMENSIONS – Height: 34, Length: 24, Thickness of the Block: 19, Depth of the Relief: 6 cm

EXTANT CONDITION – The fragment is broken on all sides, preserving only a lower leg from the knee to the ankle. There is no information available about its original find-spot within the excavation area.

A slight residue of red paint is preserved on the side of the knee.

TECHNICAL DETAILS – The figure and the background on the front surface of the relief panel are smoothed with flat chisels and rasps.

DESCRIPTION AND DISCUSSION – The fragment has the right leg of a frontally standing figure, preserved from the knee to the ankle. V-shaped folds on the leg indicate that the figure was wearing trousers, possibly coloured in red.

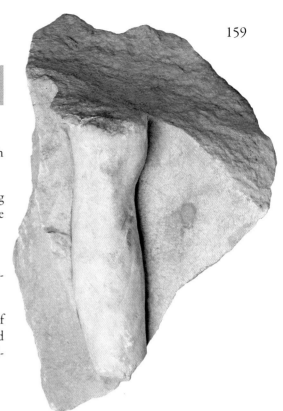

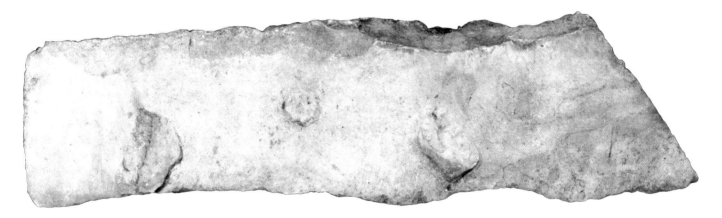

61. FRAGMENT WITH A LEWIS HOLE ON TOP

TÜBİTAK No. 71, Mus. New Inv. No. 2018–65

DIMENSIONS – Height: 18, Length: 81, Thickness of the Block: 14 cm

EXTANT CONDITION – The fragment was found in the Kocaeli Archaeology Museum garden in the pile of architectural elements brought from Çukurbağ in 2009. There is no information available about its original find-spot within the excavation area. It is from the top of a relief panel broken at the right side and at the bottom. All the figures are chipped off. There is also minor chipping on the top of the front plane. Most of the front surface of the relief has yellowish moss due to damp outside conditions.

There are no traces of paint visible to the naked eye.

TECHNICAL DETAILS – Point chisel marks are visible on the preserved top of the left lateral face and on the top surface of the relief panel. Also on the top of the panel is a large lewis hole measuring 17 cm × 4 cm and 8 cm in depth. The hole indicates that the panel was mostly carved on the ground and that the hole was cut later for hoisting the block into its architectural context.

DESCRIPTION AND DISCUSSION – All the figures on the fragmentary panel are chipped off. The bottom part of a circular strut that once supported an object is in the middle of the front surface of the fragment. On either side of the strut there are fragmentary protrusions, possibly remnants of the heads of two figures, now completely missing.

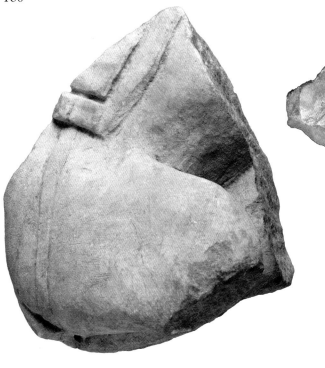

62. FRAGMENT WITH A HORSE'S REAR

TÜBİTAK No. 60, Mus. New Inv. No. 2018–54

DIMENSIONS – Height: 24, Length: 28, Depth of the Relief: 7 cm

EXTANT CONDITION – Broken on all sides, the fragment retains only the back part of a horse. The bottom of the surviving portion of the tail is chipped. There is no information available about the fragment's original find-spot within the excavation area.

A residue of red paint is detectable on the strap of the harness that is stretched over the right thigh.

TECHNICAL DETAILS – Traces of flat chisels and rasps used to smooth the skin of the horse are visible.

DESCRIPTION AND DISCUSSION – The fragment preserves the rear of a horse, which was originally facing right. A strap of a harness extending over the right buttock and the right corner of a rectangular saddle are also visible. The anus is rendered with a drill.

63. FRAGMENT WITH AN UNKNOWN OBJECT

TÜBİTAK No. 77

DIMENSIONS – Height: 6.5, Length: 17, Thickness of the Block: 16, Depth of the Relief: 8 cm

EXTANT CONDITION – The fragment is broken on all sides, retaining only a curved part of an unknown figure protruding from the background of the relief panel. There is no information available about its original find-spot.

Traces of yellow and a band painted in red are visible on the surface of the unknown object.

DESCRIPTION AND DISCUSSION – The curved form of the preserved object might indicate that it is from a body part.

64. FRAGMENT WITH PART OF DRAPERY

TÜBİTAK No. 75

DIMENSIONS – Height: 9.8, Length: 25, Thickness of the Block: 26, Depth of the Relief: 10 cm

EXTANT CONDITION – The fragment is broken on all sides, retaining only part of the drapery of a figure and the background of the panel. There is no information available about its original find-spot.

There are no traces of polychromy visible to the naked eye.

TECHNICAL DETAILS – There are point chisel marks on the back of the relief fragment. The folds of the drapery may have been defined with the use of a drill.

DESCRIPTION AND DISCUSSION – Folds and the V-shaped form of drapery can be detected on the fragmentary piece.

The catalogue page structure.

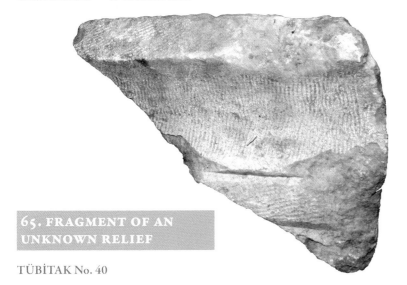

65. FRAGMENT OF AN UNKNOWN RELIEF

TÜBİTAK No. 40

DIMENSIONS – Height: 21, Length: 27, Thickness of the Block: 12, Width of the Border: 5.5 cm

EXTANT CONDITION – The fragment comes from the upper right corner of a larger relief panel with a protruding band possibly on top. There is no information available about its original find-spot.

There is no polychromy visible to the naked eye.

TECHNICAL DETAILS – The preserved front surface of the relief panel and the surface of the protruding band are worked with claw chisels, while the back of the fragment has rough point chisel marks. The transitional concave area between the band and the front surface is also worked with claw chisels. The existence of the top band is a feature shared with the fragments **cat. nos 11, 35, and 37.**

DESCRIPTION AND DISCUSSION – Aside from the right end of a band-like form, nothing figurative has survived on the fragment. Thus, the fragment cannot be assigned to any existing relief panels.

66. FRAGMENT WITH A PIECE OF FRINGED DRAPERY?

TÜBİTAK No. 74

DIMENSIONS – Height: 25, Length: 5, Thickness of the Block: 12, Depth of the Relief: 2 cm

EXTANT CONDITION – The small fragment is broken on all sides, preserving only part of a red-coloured object, perhaps fringes of a piece of drapery. There is no information available on its original find-spot.

TECHNICAL DETAILS – A contour line used to define the perimeter of the drapery is still visible. The holes, possibly indicating the fringes of the drapery, are made with the use of a drill.

DESCRIPTION AND DISCUSSION – The preserved fringes of red-coloured drapery with an outer contour might iconographically relate the fragment to the fringed *paludamenta* of the emperors on **cat. no. 16**.

CATALOGUE OF THE SMALLER RELIEF FRAGMENTS

Relief fragments catalogued below are small pieces without any relief ground, which could not be joined with the larger relief panels of the Nicomedia frieze. Overall, they indicate the existence of emperors, Roman imperial soldiers, Roman standard-bearers in a procession, horses and wheels of an imperial chariot, and captive barbarians, on some missing parts of the frieze.

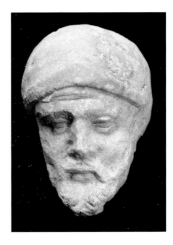

SRF 2. HEAD OF A HELMETED SOLDIER

Height: 15.5 cm; Width: 10 cm

Head of helmet-wearing soldier with curly hair and beard. Forelocks painted in yellow are visible below the triangular ridge of the yellow-coloured helmet framing the forehead.

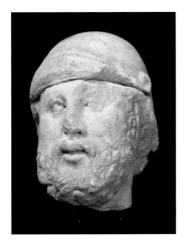
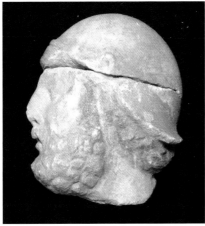

SRF 1. HEAD OF A HELMETED SOLDIER

Height: 13.5 cm; Width: 10 cm

A soldier's head wearing a yellow-painted helmet. Curly moustache and beard are painted in red. Drilled irises, parted lips, looks upwards. Restored from two pieces: head and the helmet. There is slight damage on the upper left side of the face.

SRF 3. HEAD OF A BLONDE YOUTH

Height: 14 cm; Width: 11 cm

The head of a beardless youth with curly hair painted in yellow. Damage on the nose and on the left cheek. Lower part of the head broken from the chin and below.

SRF 4. FRAGMENT OF A HEAD WEARING A PANNONIAN HAT

Height: 13 cm; Width: 12 cm

The top left part of a head with a Pannonian hat painted in yellow. Red-painted forelocks below the hat and upper part of the left eye socket are visible.

SRF 5. FRAGMENT OF A HEAD

Height: 10 cm; Width: 10 cm

Fragment of a skullcap and short curly locks of hair painted in yellow.

SRF 6. FRAGMENT WITH DRAPERY AND A STICK

Height: 10 cm; Width: 18.5 cm

The fragment preserves part of a yellow-painted stick, perhaps a sceptre, on the left, and folds of drapery painted in purple on the right.

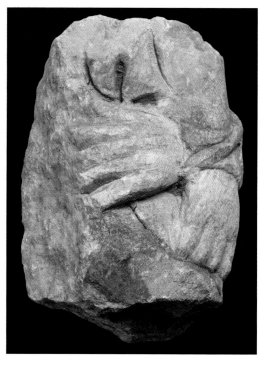

SRF 7. FRAGMENT WITH A STICK

Height: 19 cm; Width: 12.5 cm

Part of a yellow-painted stick-like object, perhaps a sceptre or a lance.

SRF 8. FRAGMENT WITH DRAPERY FOLDS

Height: 14.5 cm; Width: 13.5 cm

V-shaped drapery folds painted in purple.

SRF 10. TIED HANDS

Height: 18 cm; Width: 13 cm

The two cross-linked hands of a captive tied with a yellow-painted knot. Folds of the captive's tunic above the hand. Red-painted part below might belong to trousers of a figure.

SRF 9. FRAGMENT WITH DRAPERY FOLDS AND UNKNOWN OBJECT

Height: 5.5 cm; Width: 7 cm

A very small fragment with red-painted drapery folds and a yellow-painted unknown object.

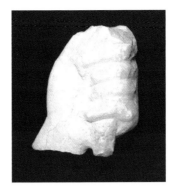

SRF 12. LEFT HAND OF A FIGURE HOLDING AN UNKNOWN OBJECT, PERHAPS HANDLE OF A SWORD

Height: 7.5 cm; Width: 6 cm

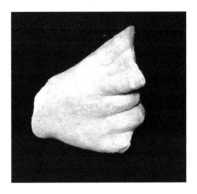

SRF 13. FRAGMENT OF A RIGHT HAND GRASPING AN UNKNOWN OBJECT WITH TWO FINGERS

Height: 7.5 cm; Width: 7 cm

SRF 11. FRAGMENT WITH PARTS OF A SOLDIER'S KILT AND CUIRASS

Height: 16 cm; Width: 10 cm

The fragment preserves two semicircular embellishments of a soldier's cuirass above the right hip and four flaps (*pteryges*) of his kilt below. Traces of red paint on the kilt.

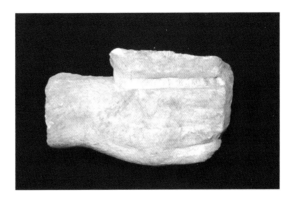

SRF 15. HAND OF A FIGURE HOLDING THE HANDLE OF AN UNKNOWN OBJECT

Height: 9.5 cm; Width: 6 cm

SRF 14. RIGHT WRIST AND HAND OF A FIGURE HOLDING AN UNKNOWN OBJECT

Height: 10.5 cm; Width: 5 cm

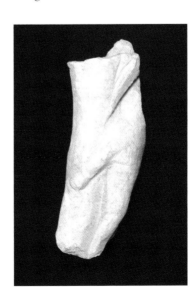

SRF 16. LEFT HAND OF A STANDARD-BEARING FIGURE

Height: 12 cm; Width: 6 cm

SRF 17. HAND OF A STANDARD-BEARING FIGURE

Height: 14.5 cm; Width: 8 cm

SRF 18. FRAGMENT OF A LEFT HAND HOLDING AN UNKNOWN OBJECT

Height: 6 cm; Width: 5 cm

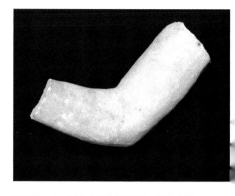

SRF 19. FRAGMENT OF AN ARM BENT AT THE ELBOW

Height: 13.5 cm; Width: 8 cm

SRF 20. FRAGMENT OF AN ARM BENT AT THE ELBOW

Height: 17.5 cm; Width: 7.5 cm

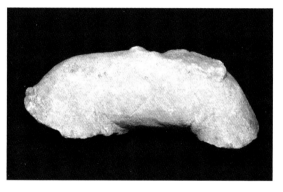

SRF 21. FRAGMENT OF AN ARM ATTACHED TO AN UNKNOWN MISSING OBJECT AT THE ELBOW

Height: 14 cm; Width: 4.5 cm

The curve of the arm might indicate that this arm belongs to a captive with hands tied behind his back.

SRF 22. FRAGMENT OF AN ARM?

Height: 7.5 cm; Width: 4 cm

SRF 23. FRAGMENT OF AN UPPER ARM

Height: 6 cm; Width: 7 cm

SRF 24. FRAGMENT OF AN UPPER ARM AND SHOULDER

Height: 12 cm; Width: 9 cm

SRF 25. FRAGMENT OF AN UPPER ARM AND SHOULDER

Height: 10.5 cm; Width: 4 cm

SRF 26. FRAGMENT OF A RIGHT FOOT CLAD IN A SOFT SHOE ON A PLINTH

Height: 17.5 cm; Width: 4.5 cm

SRF 27. FRAGMENT OF A RIGHT FOOT WITH THE ANKLE AND THREE OF THE TOES PRESERVED

Height: 12.5 cm; Width: 10 cm

SRF 29. FRAGMENT OF A SMALL FOOT WITH ALL TOES PRESERVED

Height: 3.5 cm; Width: 5.5 cm

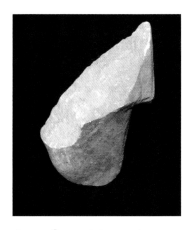

SRF 28. FRAGMENT OF A FOOT? WITH RED-PAINTED SHOE?

Height: 12 cm; Width: 9.5 cm

SRF 31. FRAGMENT OF A LEG FROM BELOW THE KNEE

Height: 23.5 cm; Width: 6.5 cm

SRF 30. LEFT LEG OF A STANDING FIGURE CLAD IN RED-PAINTED TROUSERS

Height: 23.5 cm; Width: 6.5 cm

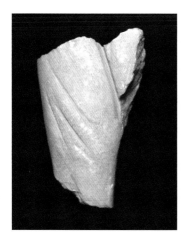

**SRF 32. FRAGMENT
OF A LEG FROM BELOW
THE KNEE, CLAD IN
TROUSERS**

Height: 13 cm; Width: 8 cm

**SRF 33. FRAGMENT
OF A LOWER LEG**

Height: 21 cm; Width: 4 cm

**SRF 34. FRAGMENT
OF A LOWER LEG**

Height: 10.5 cm; Width: 5 cm

**SRF 35. FRAGMENT
OF A LOWER LEG,
CLAD IN RED-PAINTED
TROUSERS**

Height: 19 cm;
Width: 7.5 cm

**SRF 36. THE RIGHT
KNEE AND UPPER LEG
OF A KILT-WEARING
FIGURE, POSSIBLY A
SOLDIER**

Height: 12 cm; Width: 9.5 cm

**SRF 37. THE KNEE AND
UPPER LEG OF A SOLDIER
CLAD IN A KILT**

Height: 12.5 cm; Width: 10 cm

Four flaps (*pteryges*) ending with
fringes of the kilt preserved.

SRF 38. FRAGMENT OF A LEG CLAD IN RED-PAINTED TROUSERS

Height: 17 cm; Width: 8 cm

SRF 39. FRAGMENT OF A LEG

Height: 8.5 cm; Width: 6.5 cm

SRF 40. FRAGMENT OF A KNEE CLAD IN RED-PAINTED TROUSERS

Height: 7.5 cm; Width: 9 cm

SRF 41. FRAGMENT OF A LOWER LEG CLAD IN RED-PAINTED TROUSERS

Height: 7 cm; Width: 4.5 cm

SRF 42. FRAGMENT OF A KNEE

Height: 9 cm; Width: 8.5 cm

SRF 43. FRAGMENT OF A KNEE?

Height: 11.3 cm; Width: 10.5 cm

SRF 44. FRAGMENT OF A LOWER LEG

Height: 10.5 cm; Width: 6 cm

SRF 45. FRAGMENT OF AN UNKNOWN OBJECT WITH VISIBLE FLAT CHISEL MARKS ON THE SURFACE

Height: 10.5 cm; Width: 5 cm

SRF 48. FRAGMENT OF A LEG CLAD IN RED-PAINTED TROUSERS

Height: 7 cm; Width: 5 cm

SRF 46. FRAGMENT OF A LEG?

Height: 8 cm; Width: 6 cm

SRF 49. FRAGMENT OF A LEG

Height: 7.5 cm; Width: 6 cm

SRF 47. FRAGMENT OF A LOWER LEG

Height: 13 cm; Width: 4 cm

SRF 50. FRAGMENT OF AN ANKLE CLAD IN RED-PAINTED TROUSERS

Height: 7 cm; Width: 7 cm

SRF 51. FRAGMENT OF A LEG? WITH RED PAINT

Height: 8.5 cm; Width: 6 cm

SRF 52. FRAGMENT OF A LEG
Height: 6 cm; Width: 5 cm

**SRF 54. FRAGMENT
OF A LOWER LEG**
Height: 10 cm; Width: 5 cm

SRF 55. FRAGMENT OF A LEG
Height: 7.5 cm; Width: 3.5 cm

**SRF 53. FRAGMENT
OF A LOWER LEG**
Height: 12.5 cm; Width: 4 cm

**SRF 56. FRAGMENT
OF A LEG? CLAD IN
RED-PAINTED DRAPERY**
Height: 6 cm; Width: 5 cm

**SRF 57. TOE AREA
OF A RED-PAINTED SHOE?**
Height: 5 cm; Width: 4.5 cm

SRF 58. FRAGMENT OF A LEG
Height: 6 cm; Width: 5 cm

SRF 59. FRAGMENT OF A LEG?
Height: 5 cm; Width: 4 cm

SRF 62. FRAGMENT OF A HORSE'S LEG
Height: 9 cm; Width: 7 cm

SRF 63. FRAGMENT OF A HORSE'S LEG
Height: 10 cm; Width: 7.5 cm

SRF 60. FRAGMENT OF A HORSE'S LEG
Height: 13 cm; Width: 6.5 cm

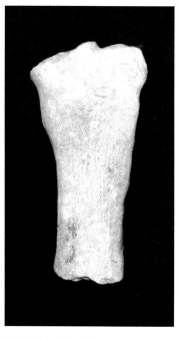

SRF 64. FRAGMENT OF A HORSE'S LEG
Height: 9.5 cm; Width: 5 cm

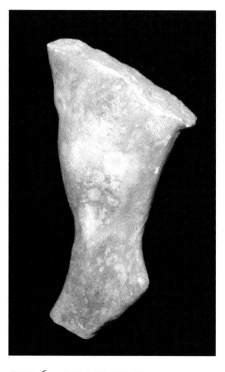

SRF 61. FRAGMENT OF A HORSE'S LEG
Height: 18 cm; Width: 10 cm

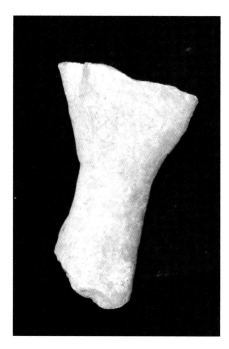

SRF 65. FRAGMENT OF A HORSE'S LEG
Height: 9.5 cm; Width: 6 cm

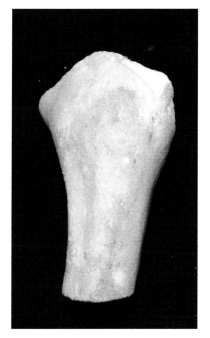

SRF 66. FRAGMENT OF A HORSE'S LEG

Height: 9 cm; Width: 5.5 cm

SRF 67. FRAGMENT OF A HORSE'S LEG WITH TRACES OF YELLOW PAINT

Height: 11 cm; Width: 7 cm

SRF 68. FRAGMENT OF A HORSE'S LEG?

Height: 10.5 cm; Width: 5.5 cm

SRF 69. FRAGMENT OF A HORSE'S LEG?

Height: 11.5 cm; Width: 6 cm

SRF 70. FRAGMENT OF A HORSE'S LEG?

Height: 7.5 cm; Width: 3.5 cm

SRF 72. FRAGMENT OF A HORSE'S LEG AND RED-PAINTED HOOVES

Height: 12.5 cm; Width: 5 cm

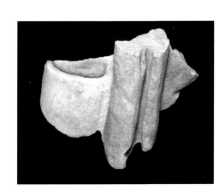

SRF 71. FRAGMENT OF A HORSE'S HOOF? WITH REMNANTS OF RED-PAINTED DRAPERY

Height: 9.5 cm; Width: 10.5 cm

SRF 74. FRAGMENT OF A HORSE'S TAIL? OR A CURVED OBJECT?

Height: 9.5 cm; Width: 4 cm

SRF 73. FRAGMENT OF A HORSE'S LEG

Height: 8 cm; Width: 3.5 cm

SRF 75. FRAGMENT OF A LEAF?

Height: 20 cm; Width: 5 cm

SRF 77. FRAGMENT OF A BUNCH OF GRAPES? WITH TRACES OF YELLOW PAINT

Height: 9.5 cm; Width: 6 cm

SRF 76. FRAGMENT OF A LEAF?

Height: 18.5 cm; Width: 7 cm

SRF 78. FRAGMENT OF AN UNKNOWN CURVED OBJECT WITH YELLOW PAINT

Height: 10 cm; Width: 4 cm

SRF 79. FRAGMENT OF AN UNKNOWN OBJECT WITH YELLOW PAINT

Height: 3 cm; Width: 10 cm

**SRF 80. FRAGMENT
OF A RED-PAINTED
DRAPERY FOLD**

Height: 9.5 cm; Width: 5 cm

**SRF 81. FRAGMENT
OF A RED-PAINTED
DRAPERY FOLD**

Height: 6 cm; Width: 3 cm

**SRF 82. FRAGMENT
OF A RED-PAINTED
UNKNOWN OBJECT**

Height: 9.5 cm; Width: 6 cm

**SRF 83. FRAGMENT
OF A YELLOW-PAINTED
UNKNOWN OBJECT**

Height: 4 cm; Width: 5.5 cm

**SRF 84. FRAGMENT
OF A YELLOW-PAINTED
STICK-LIKE OBJECT**

Height: 4.5 cm; Width: 2.5 cm

**SRF 86. FRAGMENT
OF A RED-PAINTED
CURVED OBJECT?**

Height: 9 cm; Width: 2 cm

**SRF 85. FRAGMENT
OF A YELLOW-PAINTED
LOCK OF HAIR?**

Height: 4 cm; Width: 2 cm

SRF 87. FRAGMENT OF A RED-PAINTED UNKNOWN OBJECT

Height: 7 cm; Width: 2 cm

SRF 88. FRAGMENT OF AN UNKNOWN OBJECT

Height: 9 cm; Width: 3 cm

SRF 89. FRAGMENT OF A YELLOW-PAINTED LOCK OF HAIR

Height: 5.5 cm; Width: 2 cm

SRF 90. FRAGMENT OF AN UNKNOWN DRAPED BODY PART

Height: 4.5 cm; Width: 7 cm

SRF 91. FRAGMENT OF AN UNKNOWN RED-PAINTED OBJECT

Height: 2 cm; Width: 6 cm

SRF 92. FRAGMENT WITH YELLOW AND RED PAINT

Height: 5 cm; Width: 7 cm

SRF 93. FRAGMENT WITH RED PAINT

Height: 5 cm; Width: 6 cm

SRF 94. FRAGMENT WITH YELLOW AND BLUE PAINT

Height: 5.5 cm; Width: 5 cm

SRF 95. FRAGMENT OF A YELLOW-PAINTED WHEEL, POSSIBLY BELONGING TO THE IMPERIAL CHARIOTS ON CAT. NO. 16

Height: 9 cm; Width: 3.5 cm

SRF 96. FRAGMENT OF A YELLOW-PAINTED WHEEL, POSSIBLY BELONGING TO THE IMPERIAL CHARIOTS ON CAT. NO. 16

Height: 8.5 cm; Width: 4.5 cm

SRF 97. FRAGMENT OF A YELLOW-PAINTED WHEEL, POSSIBLY BELONGING TO THE IMPERIAL CHARIOTS ON CAT. NO. 16

Height: 9.5 cm; Width: 2 cm

SRF 98. FRAGMENT OF A YELLOW-PAINTED WHEEL, POSSIBLY BELONGING TO THE IMPERIAL CHARIOTS ON CAT. NO. 16

Height: 4.5 cm; Width: 3 cm

SRF 99. FRAGMENT OF A YELLOW-PAINTED WHEEL, POSSIBLY BELONGING TO THE IMPERIAL CHARIOTS ON CAT. NO. 16

Height: 4 cm; Width: 1.5 cm

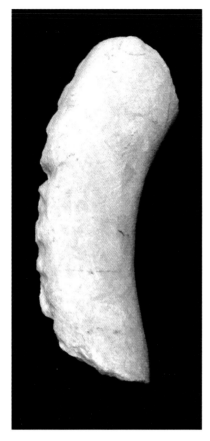

SRF 100. FRAGMENT OF AN UNKNOWN CURVED OBJECT

Height: 11 cm; Width: 4 cm

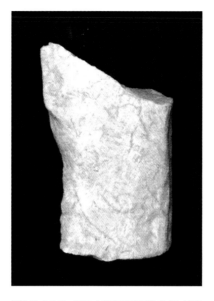

SRF 101. FRAGMENT OF AN UNKNOWN BODY PART

Height: 7 cm; Width: 3.5 cm

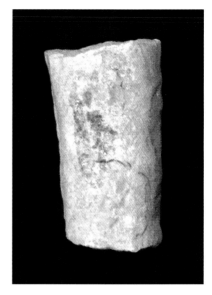

SRF 102. FRAGMENT OF AN UNKNOWN OBJECT

Height: 7 cm; Width: 3.5 cm

SRF 104. RED-PAINTED FRAGMENT

Height: 4 cm; Width: 2.5 cm

SRF 105. FRAGMENT OF AN UNKNOWN OBJECT

Height: 3.5 cm; Width: 5 cm

SRF 103. FRAGMENT OF AN UNKNOWN OBJECT

Height: 4 cm; Width: 5.5 cm

SRF 106. FRAGMENT OF A STICK-LIKE OBJECT

Height: 7.5 cm; Width: 2.5 cm

SRF 108. RED-PAINTED FRAGMENT WITH TIPS OF TWO TOES

Height: 6 cm; Width: 7 cm

SRF 109. UNKNOWN FRAGMENT

Height: 4 cm; Width: 4 cm

SRF 107. FRAGMENT OF AN UNKNOWN OBJECT

Height: 6 cm; Width: 3 cm

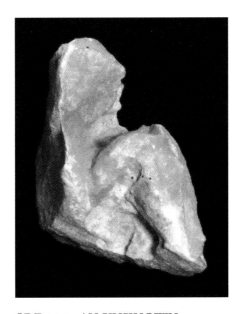

SRF 112. AN UNKNOWN CURVED FRAGMENT

Height: 7.5 cm; Width: 4 cm

SRF 111. AN UNKNOWN YELLOW-PAINTED FRAGMENT

Height: 5 cm; Width: 6.5 cm

SRF 110. AN UNKNOWN YELLOW-PAINTED FRAGMENT

Height: 5.5 cm;
Width: 4.5 cm

SRF 113. AN UNKNOWN FRAGMENT WITH RED PAINT

Height: 9.5 cm; Width: 8 cm

SRF 114. FRAGMENT OF A RELIEF PLINTH

Height: 11 cm;
Width: 17 cm

SRF 115. FRAGMENT WITH UNKNOWN CURVED OBJECT

Height: 18 cm;
Width: 15 cm

CONCORDANCE OF CATALOGUE AND INVENTORY NUMBERS

Book Catalogue No.	Excavation Inv. No.	Museum Inv. No.	TÜBİTAK Project Inv. No.	Museum Inv. No. (New)
1			01	2018–3
2	ÇKBĞ 2001/16 (A)	ÇKBĞ 2001/5	02	
3	ÇKBĞ 2009/69	ÇKBĞ 2009/36	03	2018–4
4	ÇKBĞ 2009/58	ÇKBĞ 2009/32	04	2018–5
5	ÇKBĞ 2009/59 ÇKBĞ 2009/18	ÇKBĞ 2009/33 / ÇKBĞ 2009/10	05, 67	2018–6
6	ÇKBĞ 2009/57 (for ÇKBĞ 2009/31 only)	ÇKBĞ 2009/31; ÇKBĞ 2009/8; ÇKBĞ 2009/9 (A)	06	2018–7
7			07	2018–8
8			08	2018–9
9	ÇKBĞ 2009/56	ÇKBĞ 2009/30	09	2018–10
10	ÇKBĞ 2009/48 (B)	ÇKBĞ 2009/26	10	2018–11
11	ÇKBĞ 2009/55	ÇKBĞ 2009/29	11, 70	2018–12
12	ÇKBĞ 2009/96	ÇKBĞ 2009/54	12	2018–13
13			13	2018–14
14	ÇKBĞ 2009/4	ÇKBĞ 2009/4	14	2018–15
15			15	2018–16
16	ÇKBĞ 2009/41; ÇKBĞ 2009/29; ÇKBĞ 2009/42; ÇKBĞ 2009/43	ÇKBĞ 2009/20; ÇKBĞ 2009/15; ÇKBĞ 2009/21; ÇKBĞ 2009/22	16, 17, 18	2018–21, 18, 17
17	ÇKBĞ/2001/3 (A)	ÇKBĞ 2001/2	22	
18	ÇKBĞ 2001/4	ÇKBĞ 2001/15	24	2018–83
19			25	2018–23
20		ÇKBĞ 2009/54	19, 64	2018–58
21			20	2018–19
22			21	2018–20
23			56	2018–50
24	ÇKBĞ 2009/45		23	2018–22
25		ÇKBĞ 2001/59	26, 28	2018–24
26			27	IAM Inv. 5344 T
27		ÇKBĞ 2001/17	29	
28	ÇKBĞ 2009/71	ÇKBĞ 2009/38	30	2018–25, 84

Book Catalogue No.	Excavation Inv. No.	Museum Inv. No.	TÜBİTAK Project Inv. No.	Museum Inv. No. (New)
29	ÇKBĞ 2009/66 (top part)		41, 42	2018–36, 37
30			43	2018–38
31			44	2018–39
32	ÇKBĞ 2009/46	ÇKBĞ 2009/24	31	2018–26
33	ÇKBĞ 2009/5	ÇKBĞ 2009/5	32	2018–27
34		ÇKBĞ 2009/1	34	2018–29
35	ÇKBĞ 2009/94 (lower body)		35, 39, 37	2018–30, 32
36			38	2018–33
37	ÇKBĞ 2009/37		36	2018–31
38	ÇKBĞ 2009/97	ÇKBĞ 2009/55	33	2018–28
39	ÇKBĞ 2009/53	ÇKBĞ 2009/95	51	
40	ÇKBĞ 2009/21		58	2018–52
41			55	2018–49
42	ÇKBĞ 2009/67		65	2018–59
43			45	2018–40
44	ÇKBĞ 2009/61		46	2018–41
45			47	2018–42
46	ÇKBĞ 2009/89		52	2018–46
47			53	2018–47
48			54	2018–48
49			57	2018–51
50			48	2018–43
51			66	2018–60
52	ÇKBĞ 2009/68		49	2018–44
53	ÇKBĞ 2009/62		50	2018–45
54			68	2018–62
55			69	2018–63
56			59	2018–53
57			SRF 46	2018–71
58			61	2018–55
59			62	2018–56
60			63	2018–57
61			71	2018–65
62			60	2018–54
63			77	
64			75	
65			40	
66			74	

Bibliography

Abbe, M. B. 2015. 'Polychromy', in E. A. Friedland, M. G. Sobocinski, and E. K. Gazda (eds), *The Handbook of Roman Sculpture* (Oxford: Oxford University Press), pp. 173–89.

Abbe, M. B. and T. Şare Ağtürk. 2019. 'The New Corpus of Painted Imperial Roman Marble Reliefs from Nicomedia: A Preliminary Report on Polychromy', *Technè*, 48: 101–10.

Adam, J. 1994. *Roman Building: Materials and Techniques*, trans. A. Mathews (London: Batsford).

Albustanlıoğlu, T. 2006. 'Dokimeion Işığı Altında Roma İmparatorluk Döneminde Mermer Kullanımı; İmparatorluk Yönetimindeki Anadolu Mermer Ocaklarının İşletme Stratejisi ve Organizasyonu' (unpublished doctoral thesis, Ankara Üniversitesi).

Almagro Gorbea, M. (ed.). 2000. *El disco de Teodosio* (Madrid: Real Academia de la Historia).

Altınoluk, S. 2010. *Eskiçağ'da Irmak Tanrıları* (Istanbul: Türk Eskiçağ Bilimleri Enstitüsü Yayınları).

Armstrong, A. J. 1998. 'Roman Phrygia: Cities and Coinage' (unpublished doctoral thesis, University of London).

Asheri, D. 1978. 'On the "Holy Family" of Astakos', in E. Schwertheim, S. Şahin, and J. Wagner (eds), *Studien zur Religion und Kultur Kleinasiens* (Leiden: Brill), pp. 93–98.

Ashmole, B. and N. Yalouris. 1967. *Olympia: The Sculptures of the Temple of Zeus* (London: Phaidon).

Aylward, W. 2009. 'Lewises in Hellenistic and Roman Building at Pergamon', in M. Bachmann (ed.), *Bautechnik im Antiken und vorantiken Kleinasien*, BYZAS, 9 (Istanbul: Ege Yayınları), pp. 309–22.

Bagnall, R. S. and others. 1987. *Consuls of the Later Roman Empire* (Atlanta: Scholars Press).

Barbagli, N. 2020. 'The Emperors in the Province: A Study of the Tetrarchic Images from the Imperial Cult Chamber in Luxor', in F. Guidetti and K. Meinecke (eds), *A Globalised Visual Culture? Towards a Geography of Late Antique Art* (Oxford: Oxbow), pp. 91–135.

Barnes, T. D. 1982. *The New Empire of Diocletian and Constantine* (Cambridge, MA: Harvard University Press).

——1996. 'Emperors, Panegyrics, Prefects, Provinces and Palaces (284–317)', *Journal of Roman Archaeology*, 9: 532–52.

Bastien, P. 1973. 'Le Médaillon de Plomb de Lyon', *Bulletin des Musées et Monuments Lyonnais*, 4: 73–92.

Bastien, P. and C. Metzger. 1977. *Le trésor de Beaurains, dit d'Arras* (Arras: Commission départementale des monuments historiques du Pas-de-Calais).

Bayburtluoğlu, C. 1967. 'İzmit'te Bulunmuş Olan Arkaik Kuros Başı', *Belleten*, 31: 331–34.

Beckmann, M. 2011. *The Column of Marcus Aurelius* (Chapel Hill: University of North Carolina Press).

Bekker-Nielsen, T. 2008. *Urban Life and Local Politics in Roman Bithynia* (Aarhus: Aarhus University Press).

——2013. '[Review of] Richard A. Talbert, Rome's World: The Peutinger Map Reconsidered', *Mouseion*, 11: 145–48.

——2020. 'Nikomedia and Nikaia from Hellenism to Late Antiquity: Parallel Lives or a Tale of Two Cities?', in A. Lichtenberger and others (eds), *Imperial Residence and Site of Councils: The Metropolitan Region of Nicaea / Nicomedia*, Asia Minor Studien, 96 (Bonn: Habelt), pp. 19–41.

Bellefonds, P. L. D. 2011. 'Pictorial Foundation Myths in Roman Asia Minor', in E. S. Gruen (ed.), *Cultural Identity in the Ancient Mediterranean* (Los Angeles: Getty Research Institute), pp. 26–47.

Benson, B. 2014. 'The Creation of Shared Memory: The Theatre Reliefs from Hierapolis' (unpublished Master's thesis, the University of North Carolina at Chapel Hill).

Berenson, B. 1954. *The Arch of Constantine or the Decline of Form* (London: Chapman and Hall).

Bergmann, M. 1977. *Studien zum römischen Porträt des 3. Jahrhunderts n. Chr.*, Antiquitas. Reihe 3, Abhandlungen zur Vor- und Frühgeschichte, zur klassischen und provinzial-römischen Archäologie und zur Geschichte des Altertums (Bonn: Habelt).

——2012. 'Discussions of LSA 4, LSA 439, LSA 840 and LSA 841', in *Last Statues of Antiquity (LSA) Database*, University of Oxford <http://laststatues.classics.ox.ac.uk> [accessed 3 October 2020].

——2019. 'Zur Datierung und Deutung der Chlamysfiguren aus rotem Porphyr', *Acta ad archaeologiam et artium historiam pertinentia*, 300: 73–113.

Bieber, M. 1945. '*Honos* and *Virtus*', *American Journal of Archaeology*, 49: 25–34.

Bittel, K. 1939. 'Archäologische Funde aus der Türkei: 1934–38', *Archäologischer Anzeiger*, 1–2: 156–71.

Boatwright, M. T. 2000. *Hadrian and the Cities of the Roman Empire* (Princeton: Princeton University Press).

Bosch, C. 1937. *İzmit Şehrinin Muhtasar Tarihi* (Istanbul: Devlet Basımevi).

Boschung, D. 2006. 'Die Tetrarchie als Botschaft der Bildmedien. Zur Visualisierung eines Herrschaftssystems', in D. Boschung and W. Eck (eds), *Die Tetrarchie: Ein neues Regierungssystem und seine mediale Präsentation* (Wiesbaden: Reichert), pp. 349–80.

Bostan, I. 2001. 'İzmit', *Islam Ansiklopedisi*, 23: 530–42 <https://islamansiklopedisi.org.tr/izmit#1> [accessed 1 April 2021].

Brennan, P. 1984. 'Diocletian and the Goths', *Phoenix*, 38: 142–46.

Brinkmann, V., R. Wünsche, and U. Wurnig (eds). 2004. *Bunte Götter: Die Farbigkeit antiker Skulptur; Eine Ausstellung der Staatlichen Antikensammlungen und Glyptothek München in Zusammenarbeit mit der Ny Carlsberg Glyptotek Kopenhagen und den Vatikanischen Museen, Rom; Glyptothek München, Königsplatz, 16. Dezember 2003 bis 29. Februar 2004* (Munich: Staatliche Antikensammlungen und Glyptothek).

Brixhe, C. 1991. 'Étymologie populaire at onomastique en pays bilingue', *Revue de philologie*, 65: 67–81.

Buchanan, S. 2012. 'Representing Medea on Roman Sarcophagi: Contemplating a Paradox', *Ramus*, 41: 144–60.

Bülow, G. and H. Zabehlicky (eds). 2011. *Bruckneudorf und Gamzigrad: Spätantike Paläste und Großvillen im Donau-Balkan-Raum; Akten des internationalen Kolloquiums in Bruckneudorf vom 15. bis 18. Oktober 2008* (Bonn: Habelt).

Burns, T. S. 1994. *Barbarians within the Gates of Rome: A Study of Roman Military Policy and the Barbarians, ca. 375–425 A.D.* (Indianapolis: Indiana University Press).

Burrell, B. 2004. *Neokoroi: Greek Cities and Roman Emperors* (Leiden: Brill).

Caldelli, M. 1993. *L'Agon Capitolinus: storia e protagonisti dall'istituzione domizianea al IV secolo*, Studi pubblicati dall'Istituto italiano per la storia antica, 54 (Rome: Istituto italiano per la storia antica).

Çalık Ross, A. 2007a. *Nicomedia* (Istanbul: Delta Yayınları).

—— 2007b. 'İzmit'te Arkeoloji ve Yüzey Araştırmaları', in I. Altun (ed.), *Uluslararası Kocaeli ve Çevresi Kültür Sempozyumu Bildirileri* (Kocaeli: Kocaeli Büyükşehir Belediyesi Kültür Yayınları), pp. 909–22.

—— 2013. 'Nikomedia (İzmit) Arkeoloji Çalışmaları ve Kentin Vizyonu', in Z. Dilek and others (eds), *38. ICANAS (Uluslararası Asya ve Kuzey Afrika Çalışmaları) Kongresi Bildiri Özetleri Kitabı* (Ankara: Atatürk Kültür, Dil ve Tarih Yüksek Kurumu), pp. 879–97.

—— 2016. 'A Tale of Two Roman Cities: Nicomedia and Thessaloniki in the Time of Galerius', in M. C. Atalay (ed.), *Proceedings of the I. International Thessaloniki Art and Design Symposium, 03–06 March 2016* (Istanbul: Symposium Booklet), pp. 331–42.

Cambi, N., J. Belamarić, and T. Marasović (eds). 2009. *Dioklecian, tetrarhija I Dioklecijanova Palača o 1700. obljetnici postojanja: zbornik radova s. medunarodnog simpozija održanog od 18. do 22. rujna 2005. u Splitu = Diocletian, Tetrarchy and Diocletian's Palace on the 1700th Anniversary of Existence: Proceedings of the International Conference Held in Split from September 18th to 22nd 2005* (Split: Književni Krug).

Cameron, A. 2013. 'The Origin, Context and Function of Consular Diptychs', *The Journal of Roman Studies*, 103: 174–207.

Carlson, J. 2010. 'Narrative Reliefs of the Arch of Constantine and the Panegyrici Latini', *New England Classical Journal*, 37: 163–76.

Carrié, J. M. 1994. 'Dioclétien et la fiscalité', *Antiquité Tardive*, 2: 33–65.

Cartwright, M. 2016. 'Elephants in Greek & Roman Warfare', in *Ancient History Encyclopedia* <https://www.ancient.eu/article/876/> [accessed 16 March 2016].

Çelebi, E. 1998. *Evliyâ Çelebi Seyahatnâmesi*, II, ed. Z. Kurşun, S. A. Kahraman, and Y. Dağlı (Istanbul: Yapı Kredi Yayınları).

Claridge, A. 2015. 'Marble Carving Techniques, Workshops, and Artisans', in E. A. Friedland, M. Grunow Sobocinski, and E. Gazda (eds), *The Oxford Handbook of Roman Sculpture* (Oxford: Oxford University Press), pp. 108–23.

Cleland, L., G. Davies, and L. Llewellyn-Jones (eds). 2007. *Greek and Roman Dress from A to Z* (London: Routledge).

Coarelli, F. (ed.). 2000. *The Column of Trajan* (Rome: Colombo).

Corcoran, C. 2006. 'Before Constantine', in N. E. Lenski (ed.), *The Cambridge Companion to the Age of Constantine* (Cambridge: Cambridge University Press), pp. 35–58.

Corcoran, S. 2000. *The Empire of the Tetrarchs: Imperial Pronouncements and Government, AD 284–324*, rev. edn (Oxford: Oxford University Press).

Coulton, J. J. 1974. 'Lifting in Early Greek Architecture', *Journal of Hellenic Studies*, 94: 1–19.

Creed, J. L. (ed. and trans.). 1984. *Lactantius: De mortibus persecutorum* (Oxford: Clarendon).

Çubuk, N. 2007. *Hieropolis Tiyatro Kabartmaları* (Istanbul: Arkeoloji Sanat Yayınları).

D'Andria, F. and T. Ritti. 1985. *Le sculture del teatro: i rilievi con i cicli di Apollo e Artemide*, Hierapolis, scavi e ricerche, 2 (Rome: G. Bretschneider).

Deckers, J. G. 2020. 'Neue Befunde zur Wandmalerei im Kaiserkultraum des Ammontempels von Luxor', in S. Blaauw, E. Enss, and P. Linscheid (eds), *Contextus Festschrift für Sabine Schrenk*, Jahrbuch für Antike und Christentum, 41 (Münster: Aschendorff), pp. 222–44.

Del Bufalo, D. 2012. Porphyry: Red Imperial Porphyry: Power and Religion (London: U. Allemandi & Co.).

Del Monte, M., P. Ausset, and R. A. Lefevre. 1998. 'Traces of Ancient Colours on Trajan's Column', *Archaeometry*, 40: 403–12.

Di Napoli, V. 2002. 'Il fregio a tema agonistico del teatro di Hierapolis (Frigia): iconogra a e iconologia nell'arte Romana imperial', *Annuario della Scuola archeologica di Atene e delle Missioni italiane in Oriente*, 80: 379–412.

—— 2015. 'Figured Reliefs from the Theatres of Roman Asia Minor', *LOGEION: A Journal of Ancient Theatre*, 5: 260–93.

Dodge, H. 1991. 'Ancient Marble Studies: Recent Research', *Journal of Roman Archaeology*, 4: 28–50.

Dörner, F. K. 1941a. 'Ein neuer Porträtkopf des Kaisers Diokletian', *Die Antike*, 17: 139–46.

——1941b. *Inschriften und Denkmäler aus Bithynien*, Istanbuler Forschungen, 14 (Berlin: Mann).

——1972. 'Nikomedeia', *Der Kleine Pauly*, 4: 116–18.

Downey, G. 1959. 'Libanius' Oration on Antioch (Oration XI)', *Proceedings of the American Philosophical Society*, 103: 652–86.

Dunbabin, K. M. D. 2006. 'A Theatrical Device on the Late Roman Stage: The Relief of Flavius Valerianus', *Journal of Roman Archaeology*, 19: 191–212.

——2010. 'The Prize Table: Crowns, Wreaths, and Moneybags in Roman Art', in B. L. Guen (ed.), *L'argent dans les concours du monde grec* (Paris: Presses universitaires de Vincenne), pp. 301–45.

——2015. 'The Agonistic Mosaic in the Villa of Lucius Verus and the Capitolia of Rome', *Journal of Roman Archaeology*, 28: 192–222.

——2016. *Theatre and Spectacle in the Art of the Roman Empire* (Ithaca: Cornell University Press).

——2017. 'Athletes, Acclamations, and Imagery from the End of Antiquity', *Journal of Roman Archaeology*, 30: 152–73.

Duncombe, J. (trans.). 1784. *Select Works of the Emperor Julian and Some Pieces of the Sophist Libanius*, II (London: T. Cadell).

Duyuran, R. 1947. 'İzmit'ten Yeni Getirilen Arkeolojik Eserler', *Türkiye Turing ve Otomobil Kurumu Belleteni*, 71: 13–15.

Ebcioğlu, İ. 1967. 'İzmit Definesi', *İstanbul Arkeoloji Muzeleri Yıllığı*, 19: 166–74.

Elsner, J. 2000. 'From the Culture of Spolia to the Cult of Relics: The Arch of Constantine and the Genesis of Late Antique Forms', *Papers of the British School at Rome*, 68: 149–84.

Erim, K. 1986. *Aphrodisias: City of Venus Aphrodite* (London: Muller, Blond and White).

Erol-Özdizbay, A. 2011. 'Roma İmparatorluk Dönemi'nde Pontus-Bithynia Eyaleti'nde Agon'lar ve Agonistik Sikkeler' (unpublished doctoral thesis, İstanbul Üniversitesi).

——2012. 'Perge Sikkelerinde Agonistik Ödül Taçları', *Adalya*, 15: 203–21.

Fellows, C. 1852. *Travels and Researches in Asia Minor: More Particularly in the Province of Lycia* (London: John Murray).

Ferris, I. M. 2011. 'The Pity of War: Representations of Gauls and Germans in Roman Art', in E. S. Gruen (ed.), *Cultural Identity in the Ancient Mediterranean* (Los Angeles: Getty Research Institute), pp. 185–202.

——2013. *The Arch of Constantine: Inspired by the Divine* (Stroud: Amberley).

Fine, S., P. Schertz, P. Heinrich, and D. Sanders (forthcoming). 'The Arch of Titus in Color: Polychromy and the Spoils of Jerusalem Panel', in S. Fine (ed.), *The Arch of Titus: From Rome to Jerusalem and Back* (University Park: Penn State University Press).

Fıratlı, N. 1953. 'Bithynia Araştırmalarına Birkaç İlave', *Belleten*, 17: 15–25.

——1960. 'Adapazarı-Tersiye Köyü Tümülüsü', *İstanbul Arkeoloji Muzeleri Yıllığı*, 9: 22–25.

——1971. *İzmit Şehri ve Eski Eserleri Rehberi* (Istanbul: MEB).

Foss, C. 1996. *Survey of Medieval Castles of Anatolia*, II: *Nicomedia* (Oxford: British Institute of Archaeology at Ankara).

——2020. 'Nicaea and Nicomedia: The Lives of Two Rival Cities', in A. Lichtenberger and others (eds), *Imperial Residence and Site of Councils: The Metropolitan Region of Nicaea / Nicomedia*, Asia Minor Studien, 96 (Bonn: Habelt), pp. 5–19.

Fraser, J. B. 1838. *A Winter's Journey from Constantinople to Tehran*, I (London: Richard Bentley).

Gais, R. M. 1978. 'Some Problems of River-God Iconography', *American Journal of Archaeology*, 82: 355–70.

Gazdac, C. 2018. 'The Tetrarchs: Do We All Look the Same?', in H. Gitler and G. Gambash (eds), *The Faces of Power: Roman Gold Coins from the Victor A. Adda Collection* (Jerusalem: The Israel Museum), pp. 148–56.

Gergel, R. A. 1994. 'Costume as Geographic Indicator: Barbarians and Prisoners on Cuirassed Statue Breastplates', in L. Bonfante (ed.), *The World of Roman Costume* (Wisconsin: The University of Wisconsin Press), pp. 191–213.

Gölcük, R., Ş. Aydıngün, and K. Çibuk. 2020. 'Kocaeli Müze Müdürlüğü Nikomedia Batı Nekropolü Kazıları', in A. Lichtenberger and others (eds), *Imperial Residence and Site of Councils: The Metropolitan Region of Nicaea / Nicomedia*, Asia Minor Studien, 96 (Bonn: Habelt), pp. 117–31.

Gorny & Mosch. 2013. *Kunst der Antike*, Auction catalogue 218, 18 December 2013 (Munich).

Graf, F. 2015. *Roman Festivals in the Greek East from the Early Empire to the Middle Byzantine Era* (Cambridge: Cambridge University Press).

Green, R. 2002. 'Art and Theatre in the Ancient World', in M. M. McDonald and J. M. Walton (eds), *The Cambridge Companion to Greek and Roman Theatre* (Cambridge: Cambridge University Press), pp. 93–104.

Green, R. and E. Handley. 1995. *The Images of Greek Theatre* (Austin: University of Texas Press).

Griffiths, E. 2006. *Medea: Gods and Heroes of the Ancient World* (London: Routledge).

Grigg, R. 1979. 'Portrait-Bearing Codicils in the Illustrations of the *Notitia dignitatum*', *The Journal of Roman Studies*, 69: 107–24.

Güneş, A. 2015. '16. ve 17. Yüzyıllarda İznikmid Şehri', in H. Selvi and H. B. Çelik (eds), *Uluslararası Akça Koca ve Kocaeli Tarihi Sempozyumu Bildirileri*, I (Kocaeli: Kocaeli Büyükşehir Belediyesi Yayınları), pp. 425–45.

Güney, H. 2012. 'The Resources and Economy of Roman Nicomedia' (unpublished doctoral thesis, University of Exeter).

——2013. 'Antik Çağ'da Nikomedıa (İzmit) Kentinin Jeopolitik Önemi', in Z. Dilek and others (eds), *38. ICANAS (Uluslararası Asya ve Kuzey Afrika Çalışmaları) Kongresi Bildiri Özetleri Kitabı* (Ankara: Atatürk Kültür, Dil ve Tarih Yüksek Kurumu), pp. 1467–91.

——2015. 'Poseidon as a God of Earthquake in Roman Asia Minor', *Revue numismatique*, 6th ser., 172: 293–315.

Hadjitryphonos, E. 2011. 'The Palace of Galerius in Thessalonike: Its Place in the Modern City and an Account of the State of Research', in G. Bülow and H. Zabehlicky (eds), *Bruckneudorf und Gamzigrad Spätantike Paläste und Großvillenim Donau-Balkan-Raum* (Bonn: Habelt), pp. 203–19.

Hammer, J. 1818. *Umblick auf einer Reise von Constantinopel nach Brussa und dem Olympos, und von da zurück über Nicäa und Nicomedien* (Pest: Adolph Hartleben).

Hekster, O. 2014. 'Alternatives to Kinship? Tetrarchs and the Difficulties of Representing the Non-Dynastic Rule', *Journal of Ancient History and Archaeology*, 1.2: 14–20.

Hekster, O. and others. 2019. 'Accommodating Political Change under the Tetrarchy (293–306)', *Klio*, 101: 610–39.

Hölscher, T. 2004. *The Language of Images in Roman Art* (Cambridge: Cambridge University Press).

Hunter, F. 2009. 'Barbarians and their Equipment on Roman Provincial Sculpture', in V. Gaggadis-Robin, A. Hermary, and M. Redde (eds), *Les ateliers de sculpture régionaux: techniques, styles et iconographie; actes du X^e Colloque internationale sur l'art provincial romain; Centre Camille Jullian, Aix-en-Provence 21–23 mai 2007* (Aix-en-Provence: Centre Camille Jullian), pp. 793–802.

İznik, E. 2011. 'İmparator Diocletianus'un "Tavan (En Yüksek) Fiyatlar Fermanı" "Edictum de pretiis rerum Venalium"', *Tarih Araştırmaları Dergisi*, 30.49: 97–130.

Jacobson, D. M. 2007. 'Hellenistic Cities and Nicomedia', in I. Altun (ed.), *Uluslararası Kocaeli ve Çevresi Kültür Sempozyumu Bildirileri*, I (Kocaeli: Kocaeli Büyükşehir Belediyesi Kültür Yayınları), pp. 651–57.

Jones, M. and S. McFadden (eds). 2015. *Art of Empire: The Roman Frescoes and Imperial Cult Chamber in Luxor Temple* (New Haven: Yale University Press).

Jory, J. 2002. 'The Masks on the Propylon of the Sebasteion at Aphrodisias', in P. Easterling and E. Hall (eds), *Greek and Roman Actors* (Cambridge: Cambridge University Press), pp. 238–54.

Karababa, Ü. 2008. 'Function and Architecture of the Principal Residences of the Tetrarchy: An Assessment of their Capitalness' (unpublished doctoral thesis, Bryn Mawr College).

Kelly, K. A. 1986. 'Motifs in Opus Sectile and its Painted Imitation from the Tetrarchy to Justinian' (unpublished doctoral thesis, Columbia University).

Kiernan, P. 2003. 'Imperial Representations under Diocletian and the Tetrarchy (A.D. 284–305)' (unpublished master's thesis, University of Cincinnati).

Kiilerich, B. 1998. *The Obelisk Base in Constantinople: Court Art and Imperial Ideology*, Acta ad archaeologiam et artivm historiam pertinentia, series altera in 8°, 10 (Rome: G. Bretschneider).

Kitzinger, E. 1995. *Byzantine Art in the Making: Main Lines of Stylistic Development in Mediterranean Art 3rd–7th Century* (reprint. Original edition 1977) (Cambridge, MA: Harvard University Press).

Kleiner, D. E. E. 1992. *Roman Sculpture* (New Haven: Yale University Press).

Klose, C. 2015. 'A Farewell to Methods?', in C. Klose, L. C. Bossert, and W. Leveritt (eds), *Fresh Perspectives on Graeco-Roman Visual Culture: Proceedings of an International Conference at the Humboldt-Universität, Berlin, 2nd–3rd September 2013* (Berlin: Humboldt-Universität), pp. 99–116.

Klose, D. O. A. 2005. 'Festivals and Games in the Cities of the East during the Roman Empire', in V. H. C. Howgego and A. Burnett (eds), *Coinage and Identity in the Roman Provinces* (Oxford: Oxford University Press), pp. 125–35.

Klumbach, H. 1973. *Spätrömische Gardehelme* (Munich: Beck).

Kneafsey, M. 2016. '*Adventus*: Conceptualising Boundary Space in the Art and Text of Early Imperial to Late Antique Rome', in M. J. Mandich and others (eds), *Proceedings of the Twenty-Fifth Annual Theoretical Roman Archaeology Conference, Leicester 2015* (Oxford: Oxbow), pp. 151–63.

Koçel-Erdem, Z. 2012. 'Astakos Kazısı', *Türk Eskiçağ Bilimleri Enstitüsü Haberler*, 34: 23–25.

Koeppel, G. 1969. 'Profectio und Adventus', *Bonner Jahrbücher des Rheinisches Landesmuseums in Bonn*, 169: 130–94.

Kolb, F. 1987. *Diocletian und die erste Tetrarchie: Improvisation oder Experiment in der Organisation monarchischer Herrschaft* (Berlin: De Gruyter).

Koyunoğlu, Ö. 1953. 'İzmit'ten Gelen Bronz Eserler', *İstanbul Arkeoloji Müzeleri Yıllığı*, 6: 31–37.

Krevans, N. 1997. 'Medea as Foundation Heroine', in J. J. Claus and S. I. Johnston (eds), *Essays on Medea in Myth, Literature, Philosophy, and Art* (Princeton: Princeton University Press), pp. 71–83.

Kristensen, T. M. and B. Poulsen (eds). 2012. *Ateliers and Artisans in Roman Art and Archaeology*, Journal of Roman Archaeology Supplementary Series, 92 (Rhode Island: Journal of Roman Archaeology).

Kunckel, H. 1974. *Der Römische Genius* (Heidelberg: Kerle).

L'Orange, H. P. 1972. *Art Forms and Civic Life in the Late Roman Empire* (Princeton: Princeton University Press).

—— 1984. *Das spätantike Herrscherbild von Diokletian bis zu den Konstantin-Söhnen 284–361 n. Chr.* (Berlin: Mann).

Laflı, E. 2018. 'Roman Portrait Grave Steles from Nicomedia and Bithynia (Northwestern Turkey)', *Pontica*, 51: 434–49.

Landskron, A. 2006. 'Das "Partherdenkmal" von Ephesos: Ein Monument für die Antoninen', *Jahreshefte des Österreichischen Archäologischen Institutes in Wien*, 75: 144–54.

Lapatin, K. 2018. 'A Puzzling Pachyderm', in C. M. Draycott and others (eds), *Visual Histories of the Classical World: Essays in Honour of R. R. R. Smith* (Turnhout: Brepols), pp. 159–68.

Laubscher, H. P. 1975. *Der Reliefschmuck des Galeriusbogens in Thessaloniki*, I (Mann: Archaeologische Forschungen).

——1976. *Arcus Novus und Arcus Claudii, Zwei Triumphbögen an der Via Lata in Rom* (Göttingen: Vandenhoeck und Ruprecht).

——1993. 'Ein Tetrarchisches Siegesdenkmal in Iznik (Nikaia)', *Jahrbuch des Deutschen Archäologischen Instituts*, 108: 375–97.

Lazzarini, L. 2010. 'Six Coloured Types of Stone from Asia Minor Used by the Romans, and their Specific Deterioration Problems', *Studies in Conservation*, 55: 140–46.

Leatherbury, S. V. 2017. 'Textiles as Gifts to God in Late Antiquity: Christian Altar Cloths as Cultic Objects', in C. Brons and M. L. Nosch (eds), *Textiles and Cult in the Ancient Mediterranean* (Oxford: Oxbow), pp. 243–57.

Lechevalier, J. 1800. *Voyage de la Propontide et du Pont-Euxin* (Paris: Dentu).

Lee, M. M. 2015. *Body, Dress and Identity in Ancient Greece* (Cambridge: Cambridge University Press).

Lee, H. M. 1997. 'The Later Greek Boxing Glove and the "Roman" Caestus: A Centennial Reevaluation of Jüthner's "Über antike Turngeräthe"', *Nikephoros*, 10: 161–78.

Levi, A. C. 1952. *Barbarians on Roman Imperial Coins and Sculpture* (New York: American Numismatic Society).

Liverani, P. 2018. 'Reflections on Colour Coding in Roman Art', in P. Jockey (ed.), *Les arts de la couleur en Grèce ancienne… et ailleurs: approches interdisciplinaires* (Athens: École française d'Athènes), pp. 367–85.

Lukanc, I. 1991. *Diocletianus: Der römische Kaiser aus Dalmatien* (Wetteren: Fondation Numismatica Antica).

MacCormack, S. 1972. 'Change and Continuity in Late Antiquity: The Ceremony of "Adventus"', *Historia: Zeitschrift für Alte Geschichte*, 21: 721–52.

Madigan, B. 2012. *The Ceremonial Sculptures of the Roman Gods*, Monumenta Graeca et Romana, 20 (Leiden: Brill).

Magie, D. 1950. *Roman Rule in Asia Minor* (Princeton: Princeton University Press).

Marasović, K., D. Matetić Poljak, and D. Gobić Bravar. 2012. 'Colored Marbles of Diocletian's Palace in Split', in P. Pensabene and E. Gasparini (eds), *ASMOSIA X: Proceedings of the Tenth International Conference* (Rome: L'Erma di Bretschneider), pp. 1003–19.

Margetić, D. 2015. 'Unpublished Antoniniani of Diocletian and Maximian *VIRTVS AVGVSTORVM* from the Mint of Siscia', *Numizmatičke Vijesti*, 57.68: 11–20.

Marlowe, E. 2016. 'The Multivalence of Memory: The Tetrarchs, the Senate, and the Vicennalia Monument in the Roman Forum', in K. Galinsky and K. Lapatin (eds), *Cultural Memories in the Roman Empire* (Los Angeles: J. Paul Getty Museum), pp. 240–63.

Maschek, D. 2018. 'Not *census* but *deductio*: Reconsidering the "Ara of Domitius Ahenobarbus"', *The Journal of Roman Studies*, 108: 27–52.

Mayer, E. 2002. *Rom ist dort, wo der Kaiser ist: Untersuchungen zu den Staatsdenkmälern des dezentralisierten Reiches von Diocletian bis zu Theodosius II* (Mainz: Verlag des Römisch-Germanischen Zentralmuseums).

——2013. 'The Architecture of Tetrarchy', in R. B. Ulrich and C. K. Quenemoen (eds), *A Companion to Roman Architecture* (Oxford: Wiley Blackwell), pp. 106–26.

McFadden, S. 2015. 'The Luxor Temple Paintings in Context: Roman Visual Culture in Late Antiquity', in M. Jones and S. McFadden (eds), *Art of Empire: The Roman Frescoes and Imperial Cult Chamber in Luxor* (New Haven: Yale University Press), pp. 105–35.

McNally, S. 1996. *The Architectural Ornament of Diocletian's Palace at Split*, British Archaeological Reports International Series, 639 (Oxford: Tempus reparatum).

Mori, A. C. 2018. 'Riflessioni sul palazzo imperiale di Milano alla luce delle recenti indagini', in R. Passarella (ed.), *Milano e la chiesa di Milano prima di Ambrogio* (Milan: Biblioteca Ambrosiana), pp. 95–121.

Mortensen, E. 2017. 'Narratives and Shared Memories of Heroes in the Aphrodisian Cityscape', in E. Mortensen and B. Poulsen (eds), *Cityscapes and Monuments of Western Asia Minor* (Oxford: Oxbow), pp. 42–55.

Mosch, H. C. von. 1996. 'Das Panegyrische Münzprogramm Athens in der Kaiserzeit', in M. Flashar, H.-J. Gehrke, and E. Heinrich (eds), *Retrospektive: Konzepte von Vergangenheit in der griechisch-römischen Antike* (Munich: Biering and Brinkmann), pp. 159–78.

Müller, S. 2012. 'Dextrarum iunctio', in *The Encyclopedia of Ancient History* <https://doi.org/10.1002/9781444338386.wbeah22079>.

Niewöhner, P. and U. Peschlow. 2012. 'Neues zu den Tetrarchenfiguren in Venedig und ihrer Aufstellung in Konstantinopel', *Istanbuler Mitteilungen*, 62: 341–67.

Nikšić, G. 2011. 'Diocletian's Palace — Design and Construction', in G. Bülow and H. Zabehlicky (eds), *Bruckneudorf und Gamzigrad Spätantike Paläste und Großvillen im Donau-Balkan-Raum* (Bonn: Habelt), pp. 187–203.

Nixon, C. and B. Rodgers (trans.). 1994. *In Praise of Later Roman Emperors: The Panegyrici Latini* (Berkeley: University of California Press).

Ogden, D. 2017. *The Legend of Seleucus: Kingship, Narrative and Mythmaking in the Ancient World* (Cambridge: Cambridge University Press).

Olovsdotter, C. 2005. *The Consular Image: An Iconological Study of the Consular Diptychs*, British Archaeological Reports, International Series, 1376 (revised doctoral thesis, Göteborg University, 2003) (Oxford: John and Erica Hedges).

Olszewski, M. T. and H. Saad. 2017. 'Interpol à la recherche d'une mosaïque volée à Apamée en Syrie: la fondation d'Antioche', *Archeologia*, 551: 4–5.

Østergaard, J. S. 2018. 'Polychromy, Sculptural, Greek and Roman', in *Oxford Classical Dictionary Online* <https://doi.org/10.1093/acrefore/9780199381135.013.8118>.

—— 2019. 'Reconstruction of the Polychromy of Ancient Sculpture: A Necessary Evil?', *Technè*, 48: 110–20.

Ostrowski, J. A. 1991. *Personifications of Rivers in Greek and Roman Art* (Warsaw: Jagiellonian University Press).

Öztüre, A. 1981. *Nicomedeia yöresindeki yeni bulgularla İzmit tarihi* (Kocaeli: Avni Öztüre Yayınları).

Öztürk, H. and E. Demirhan. 2019. 'Nikomedeia'dan Yeni Yazıtlar', in H. Selvi, B. Çelik, and A. Yeşildal (eds), *Uluslararası Orhangazi Sempozyumu ve Kocaeli Tarihi Sempozyumu Bildirileri* (Kocaeli: Kocaeli Büyükşehir Belediyesi Yayınları), pp. 135–36.

Öztürk, H., R. Gölcük, and K. Çibuk. 2019. 'Khrestion ve Ailesinin Mezarı Nikomedia'da Yeni Bir Nekropolis', *Phaselis*, 5: 157–60.

Palagia, O. 2005. 'Fire from Heaven: Pediments and Akroteria of the Parthenon', in J. Neils (ed.), *The Parthenon* (Cambridge: Cambridge University Press), pp. 225–61.

——2006. 'Marble Carving Techniques', in O. Palagia (ed.), *Greek Sculpture: Function, Materials, and Techniques in the Archaic and Classical Periods* (Cambridge: Cambridge University Press), pp. 243–79.

Panzanelli, R., E. Schmidt, and K. Lapatin. 2008. *The Color of Life: Polychromy in Sculpture from Antiquity to the Present* (Los Angeles: J. Paul Getty Museum).

Pelcer-Vujačić, O. 2015. 'Society in Lydia and Phrygia from the 1st to 3rd Century AD' (unpublished doctoral thesis, University of Belgrade).

Perrot, G., E. Guillaume, and J. Delbet. 1872. *Exploration archéologique de la Galatie et de la Bithynie, d'une partie de la Mysie, de la Phrygie, de la Cappadoce et du Pont*, I (Paris: Firmin Didot).

Peyssonel, C. D. 1745. *De relation d'un voyage fait à Nicomedie à à Nicée en 1745* (Paris: Imprimeurs l'Institut national de France).

Pogorzelski, R. 2015. *Der Triumph: Siegesfeiern im antiken Rom; Ihre Dokumentation auf Ehrenbögen in Farbe* (Mainz: Nünnerich-Asmus).

Polatel, O. 2012. 'The Transformation of a City's Name from Nikomedia to Izmit', *History Studies* (Special Edition for Prof Dr Enver Konukçu): 279–95.

Popović, I. (ed.). 2011. *Felix Romuliana-Gamzigrad* (Belgrade: Institute of Archaeology).

Price, S. 2005. 'Local Mythologies in the Greek East', in V. H. C. Howgego and A. Burnett (eds), *Coinage and Identity in the Roman Provinces* (Oxford: Oxford University Press), pp. 115–25.

Prusac, M. 2011. *From Face to Face: Recarving of Roman Portraits and the Late-Antique Portrait Arts* (Leiden: Brill).

Rees, R. 1993. 'Images and Image: A Re-examination of Tetrarchic Iconography', *Greece & Rome*, 2nd ser., 40: 181–200.

——2002. *Layers of Loyalty in Latin Panegyric, AD 289–307* (Oxford: Oxford University Press).

——2004. *Diocletian and the Tetrarchy* (Edinburgh: Edinburgh University Press).

——2005. 'The Emperors' New Names: Diocletian Jovius and Maximian Herculius', in L. Rawlings and H. Bowden (eds), *Herakles and Hercules: Exploring a Graeco-Roman Divinity* (London: Classical Press of Wales), pp. 223–39.

Remijsen, S. 2011. 'The So-Called "Crown-Games": Terminology and Historical Context of the Ancient Categories for Agones', *Zeitschrift für Papyrologie und Epigraphik*, 177: 97–109.

——2015. *The End of Greek Athletics in Late Antiquity* (Cambridge: Cambridge University Press).

Robert, L. 1960. *Hellenica: Recueil d'epigraphie, de numismatique et d'antiquites grecques*, XI–XII (Paris: Maisonneuve).

——1977. 'La titulature de Nicée et de Nicomédie: la gloire et la haine', *Harvard Studies in Classical Philology*, 81: 1–39.

Romeo, I. 2017. 'A Distant Memory: New Seleucid Portraits in Roman Hierapolis', in E. Mortensen and B. Poulsen (eds), *Cityscapes and Monuments of Western Asia Minor* (Oxford: Oxbow), pp. 256–65.

Rose, B. C. 2021. 'Reconsidering the Frieze on the Arch of Constantine', *Journal of Roman Archaeology*, 34: 1–36.

Rothman, M. S. P. 1977. 'The Thematic Organization of the Panel Reliefs on the Arch of Galerius', *American Journal of Archaeology*, 81: 427–54.

Rumscheid, J. 2000. *Kranz und Krone: Zu Insignien, Siegespreisen und Ehrenzeichen der römischen Kaiserzeit* (Tubingen: Wasmuth).

Ruppienè, V. 2021. 'Pavements and Revetments in the Audience Hall (Basilika) and its Vestibule of the Late-Antique Imperial Palace in Trier (Germany)', in V. Ruppienè (ed.), *Stone and Splendor: Interior Decorations in the Late Antique Palaces and Villas; Proceedings of a Workshop Held in Trier, April 25–26 2019*, Forschung zu spätantiken Residenzen, 1 (Trier: Wiesbaden), pp. 37–55.

Russell, B. 2013. *The Economics of the Roman Stone Trade* (Oxford: Oxford University Press).

Şahin, S. 1974. 'Neufunde von antiken Inschriften in Nikomedeia (Izmit) und in der Umgebung der Stadt' (unpublished doctoral thesis, University of Münster).

Santini, M. 2017. 'Bellerophontes, Pegasos and the Foundation of Halikarnassos. Contributions to the Study of the Salmakis Inscription', *Studi classici e orientali*, 63: 109–43.

Şare, T. 2011. 'Dress and Identity in the Arts of Western Anatolia: The Seventh through Fourth Centuries BCE' (unpublished doctoral thesis, Rutgers, the State University of New Jersey).

Şare Ağtürk, T. 2015. 'Painted Reliefs from Nicomedia: Life of a Roman Capital City in Colour', in *Antiquity* Project Gallery, 89(346) <http://archive.antiquity.ac.uk/projgall/sare346> [accessed 1 April 2021].

——2017. 'İmparatorluk Başkenti Nicomedia'nın Renkli İhtişamı: Çukurbağ Kurtarma Kazılarında Ortaya Çıkarılan Görkemli Roma Anıtı', in H. Selvi and others (eds), *Uluslararası Gazi Süleyman Paşa ve Kocaeli Tarihi Sempozyumu Bildirileri: Proceedings of the III. International Symposium on Gazi Süleyman Paşa and History of Kocaeli* (Kocaeli: Kocaeli Büyükşehir Belediyesi Yayınları), pp. 343–58.

——2018. 'A New Tetrarchic Relief from Nicomedia: Embracing Emperors', *American Journal of Archaeology*, 122: 411–26.

——2020a. 'The Self-Image of a New Imperial Capital City on the Tetrarchic Reliefs of Nicomedia', in A. Lichtenberger and others (eds), *Imperial Residence and Site of Councils: The Metropolitan Region of Nicaea / Nicomedia*, Asia Minor Studien, 96 (Bonn: Habelt), pp. 107–16.

——2020b. 'Myth and Eponymy on the Tetrarchic Frieze from Nicomedia', *Journal of Roman Archaeology*, 33: 417–31.

Scullard, H. H. 1974. *The Elephant in the Greek and Roman World* (Ithaca: Cornell University Press).

Sezer, S. S. 2015. 'Nikomedia Antik Kenti'nden Heykeltıraşlık Eserleri', *Pamukkale Üniversitesi Sosyal Bilimler Enstitüsü Dergisi*, 20: 78–99.

Smith, R. R. R. 1988. *Hellenistic Royal Portraits* (Oxford: Clarendon).

——1997. 'The Public Image of Licinius I: Portrait Sculpture and Imperial Ideology in the Early Fourth Century', *The Journal of Roman Studies*, 87: 170–202.

——2006. 'The Use of Images: Visual History and Ancient History', in T. P. Wiseman (ed.), *Classics in Progress: Essays on Ancient Greece and Rome* (Oxford: Oxford University Press), pp. 59–103.

——2013. *The Marble Reliefs from the Julio-Claudian Sebasteion* (Darmstadt: Von Zabern).

——2015. 'The Greek East under Rome', in B. E. Borg (ed.), *A Companion to Roman Art* (Oxford: Wiley Blackwell), pp. 474–95.

Sourvinou Inwood, C. 1997. 'Medea at a Shifting Distance: Images and Euripidean Tragedy', in J. J. Claus and S. I. Johnston (eds), *Essays on Medea in Myth, Literature, Philosophy, and Art* (Princeton: Princeton University Press), pp. 253–97.

Specht, K. 2000. 'Krone oder Korb für den Sieger', *Altmodische Archäologie: Festschrift für Friedrich Brein, Forum Archaeologiae*, 14/III/2000 <http://farch.net> [accessed 1 April 2021].

Squarciapino, F. M. 1943. *La scuola di Afrodisia* (Rome: Governatorato di Roma).

Srejović, D. 1994. 'The Representations of Tetrarchs in Romuliana', *Antiquité Tardive*, 2: 143–52.

Srejović, D. and C. Vasić. 1994. 'Emperor Galerius' Buildings in Romuliana', *Antiquité Tardive*, 2: 123–41.

Stefanidou-Tiveriou, T. 2009. 'Die Palastanlage des Galerius in Thessaloniki. Planung und Datierung', in N. Cambi, J. Belamarić, and T. Marasović (eds), *Dioklecian, tetrarhija i Dioklecijanova Palača o 1700. obljetnici postojanja = Diocletian, Tetrarchy and Diocletian's Palace on the 1700th Anniversary of Existence: Proceedings of the International Conference Held in Split from September 18th to 22nd 2005* (Split: Književni Krug), pp. 389–409.

Strocka, V. M. 1977. *Die Wandmalerei der Hanghäuser in Ephesos* (Vienna: Österreichisches Archäologisches Institut).

Talbert, R. 2010. *Rome's World: The Peutinger Map Reconsidered* (Cambridge: Cambridge University Press).

Taylor, M. 2016. 'The Battle Scene on Aemilius Paullus's Pydna Monument: A Reevaluation', *Hesperia*, 85: 559–76.

Texier, C. 1862. *Asie Mineure: Description géographique, historique et archéologique des provinces et des villes de la Chersonnese d'Asie* (Paris: Firmin Didot).

Thuillier, J. P. 2019. 'Scène de boxe sur un bas-relief inédit de Gaule Narbonnaise: ré exions sur le ceste romain', *Journal of Roman Archaeology*, 32: 495–504.

Töpfer, K. M. 2018. 'Roman Imperial Art between Official Policy and Local Perception', in A. Aurenhammer (ed.), *Sculpture in Asia Minor* (Vienna: Österreichisches Archäologisches Institut), pp. 43–57.

Toynbee, J. M. C. 1973. *Animals in Roman Life and Art* (Ithaca: Cornell University Press).

Traversari, G. 1993. *La Tyche da Prusias ad Hypium e la 'scuola' microasiatica di Nicomedia* (Rome: G. Bretschneider).

Travis, H. and J. Travis. 2014. *Roman Helmets* (Stroud: Amberley).

Turgut, M. and T. Aksoy. 1996. 'Kocaeli İli Üçtepeler Köyü Büyük Tümülüs Kurtarma Kazısı', in *VI. Müze Kurtarma Kazıları Seminerleri, Held on 24–26 Nisan 1995 in Didim* (Ankara: T. C. Kültür Bakanlığı), pp. 399–414.

Üçer-Karababa, İ. 2008. 'Function and Architecture of the Principal Residences of the Tetrarchy: An Assessment of their Capitalness' (unpublished doctoral thesis, Bryn Mawr College).

Ulugün, F. Y. 2004. *Tarih Öncesi ve Helenistik Dönem Bithynia*, Kocaeli ve çevresi tarihi, Series I (Izmit: Kocaeli Yüksek Öğrenim Derneği).

——2007. *Roma Dönemi Bithynia* (Izmit: Kocaeli Yüksek Öğrenim Derneği).

——2010. *Bizans Dönemi Bithynia* (Izmit: Kocaeli Yüksek Öğrenim Derneği).

Vermeule, C. 1962. *Maximianus Herculeus and the Cubist Style in the Late Roman Empire, 295 to 310* (Boston: The Museum of Fine Arts).

Vickers, M. 1973. 'Observations on the Octagon at Thessaloniki', *The Journal of Roman Studies*, 63: 111–20.

Walden, C. 1990. 'The Tetrarchic Image', *Oxford Journal of Archaeology*, 9: 221–35.

Ward-Perkins, J. B. 1980a. 'Nicomedia and the Marble Trade', *Papers of the British School at Rome*, 48: 23–69.

——1980b. 'The Marble Trade and its Organization: Evidence from Nicomedia', *Memoirs of the American Academy in Rome*, 48: 325–38.

——1994. *Roman Imperial Architecture* (New Haven: Yale University Press).

Weber, U. 2013. *Versatzmarken im Antiken Griechischen Bauwesen* (Wiesbaden: Harrassowitz).

Weiss, P. 1981. 'Ein Agonistisches Bema und die isopythischen Spiele von Side', *Chiron*, 11: 315–46.

——1984. 'Lebendiger Mythos. Gründerheroen und städtische Gründungstraditionen im griechisch-römischen Osten', *Würzburger Jahrbücher für die Altertumswissenschaft*, 10: 179–208.

——1996. 'Alexandria Troas: Griechische Traditionen und Mythen in einer romischen Colonia', in E. Schwertheim and H. Wiegartz (eds), *Die Troas: Neue Forschungen zu Neandria und Alexandria Troas*, I, Asia Minor Studies, 22 (Bonn: Habelt), pp. 157–73.

Weitzmann, K. 1979. *Age of Spirituality: Late Antique and Early Christian Art, Third to Seventh Century* (New York: Metropolitan Museum).

Williams, S. 1985. *Diocletian and the Roman Recovery* (London: Batsford).

Williams-Thorpe, O. 2008. 'A Thousand and One Columns: Observations on the Roman Granite Trade in the Mediterranean Area', *Oxford Journal of Archaeology*, 27: 73–89.

Wolfgang, T. 2006. 'Die "Pompeius-Säule" in Alexandria und die Vier-Säulen-Monumente Ägyptens. Überlegungen zur tetrarchischen Repräsentationskultur in Nordafrika', in D. Boschung and W. Eck (eds), *Die Tetrarchie: Ein neues Regierungssystem und seine mediale Präsentation* (Wiesbaden: Reichert), pp. 249–322.

Wood, S. 1986. *Roman Portrait Sculpture 217–260 A.D.: The Transformation of an Artistic Tradition* (Leiden: Brill).

Wootton, W., B. Russell, and P. Rockwell. 2013. 'Stoneworking Techniques and Processes' (version 1.0), in *The Art of Making in Antiquity: Stoneworking in the Roman World* <http://www.artofmaking.ac.uk/content/essays/3-stoneworking-techniques-and-processes-w-wootton-b-russell-p-rockwell/> [accessed 1 April 2021].

Yegül, F. K. 1986. *The Bath and Gymnasium Complex at Sardis* (Cambridge, MA: Harvard University Press).

Yıldırım, B. 2004. 'Identities and Empire: Local Mythology and the Self Representation of Aphrodisias', in B. E. Borg (ed.), *Paideia: The World of the Second Sophistic* (Berlin: De Gruyter), pp. 23–52.

——2008. 'The Date of the Reliefs from the Colonnades of the Civil Basilica', in C. J. Ratté and R. R. R. Smith (eds), *Aphrodisias Papers*, IV: *New Research on the City and its Monuments*, Journal of Roman Archaeology Supplementary Series, 70 (Portsmouth, RI: Journal of Roman Archaeology), pp. 107–29.

Yoncacı-Arslan, P. 2016. 'Towards a New Honorific Column: The Column of Constantine in Early Byzantine Urban Landscape', *METU Journal of the Faculty of Architecture*, 33.1: 121–45.

Zeyrek, T. H. 2005. *Nikomedeia İÖ 264/263–İS 358: Arkeolojik açıdan genel bir değerlendirme* (Istanbul: Ege Yayınları).

Zeyrek, T. H. and R. Asal. 2004. 'İzmit (Nikomedia) Seka Fabrikası Buluntuları 2003 Yılı çalışmaları Ön Raporu', *Araştırma Sonuçları Toplantısı*, 22.1: 1–9.

Zeyrek, T. H. and İ. Özbay. 2006. 'Statuen und Reliefs aus Nikomedeia', *Istanbuler Mitteilungen*, 56: 273–316.

Zivić, M. 2011. 'Artistic Achievements in the Imperial Palace', in I. Popović (ed.), *Felix Romuliana, Gamzigrad* (Belgrade: Institute of Archaeology), pp. 107–41.

Page numbers in *italics* refer to images, maps, and tables.
Numbers preceded by n. refer to footnotes

STUDIES IN CLASSICAL ARCHAEOLOGY

All volumes in this series are evaluated by an Editorial Board, strictly on academic grounds, based on reports prepared by referees who have been commissioned by virtue of their specialism in the appropriate field. The Board ensures that the screening is done independently and without conflicts of interest. The definitive texts supplied by authors are also subject to review by the Board before being approved for publication. Further, the volumes are copyedited to conform to the publisher's stylebook and to the best international academic standards in the field.

Titles in Series

In Preparation